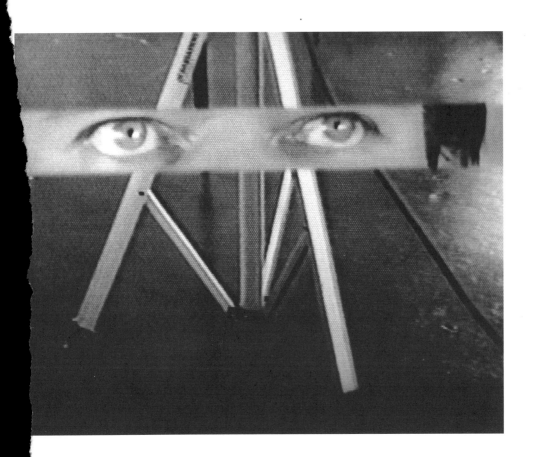

EXCLUSIVE MEMORY

A PERCEPTUAL HISTORY
OF THE FUTURE

TOM SHERMAN
edited by DAVID DIVINEY

ART GALLERY OF NOVA SCOTIA

ART METROPOLE

"Invention, it must be humbly admitted, does not consist in creating out of void, but out of chaos; the materials must, in the first place, be afforded: it can give form to dark, shapeless substances, but cannot bring into being the substance itself."

— Mary Wollstonecraft Shelley, *Frankenstein, or the Modern Prometheus* (Revised Edition, 1831)

FOREWORD

The Art Gallery of Nova Scotia (AGNS) and Art Metropole (AM) are pleased to partner on *Exclusive Memory: A Perceptual History of the Future*, an anthology of texts and text-image works by the Nova Scotia–based artist Tom Sherman. Both the AGNS and AM have for some time maintained a relationship with Sherman as both an artist and a peer. As well, Sherman's long-standing connections to Nova Scotia and Toronto, and to various communities therein, are reflected in the evolution of his practice and the topics his work explores. These relationships and the histories they encompass feature prominently and unfold in the texts and text-image works that have been brought together in *Exclusive Memory*.

Having come to Canada from the United States in the early 1970s, emigrating from the Detroit area to Toronto, Sherman quickly became entrenched in Toronto's nascent artist-run centre scene. He started working at A Space in 1972 as an advocate of the video medium and later as a curator while practising as an interdisciplinary artist. With the establishment of Art Metropole not long after Sherman's arrival, his earliest performances, video screenings, and text-based works found a public platform in the program of this centre and those of similar grassroots arts organizations across Toronto. His *Text as Performance*, a collaboration with Colin Campbell and Lisa Steele, took place at AM in May 1975. This performance opened a show of his texts as visual objects (photo-enlarged text panels), foreshadowing a career-long engagement with language and the written word. A year later, in August 1976, AM screened an evening of experimental 16 mm films by Andrew Lugg. This screening included *Trace* (1972), a cinematic version of Sherman's *Hyperventilation* performance (1970), his very first video work. Later in 1976, AM released *Video by Artists*, a collection of essays and artists' contributions exploring the new medium of video. Besides Sherman's introduction, the photo on the cover of this publication is a now-iconic portrait of Sherman himself wearing ping-pong balls over his eyes as a demonstration of the ganzfeld effect, a perceptual shift accomplished through experimentation with sensory deprivation. In 1978, AM published *3 Death Stories*, Sherman's first book, which is exemplary of his imagist prose. These are some highlights of the formative era from which Sherman's voice emerged.

Appropriately, this publication opens with a text that reflects on Sherman's coming of age as an artist parallel to the birth of the artist-run centre network itself. In "The Faraday Cage," he discusses his close connections to the early history of AM, remarking on its ambitions as an internationally minded yet regional and urban centre. That is, while AM served the interests of its General Idea founders as a vehicle for their *FILE Megazine* and multiples, it also saw the development of a local art scene as a key symbiotic component of those initiatives. Through opportunities offered by AA Bronson, Sherman honed his own interests in an "internal" subjectivity of waking dreams through sensory deprivation linked to personal narratives he also observed in the muses of his fellow Toronto-based artists. Rather than adopt the perspectives of those who imagined that art should be produced from an objective and universal position, in "The Faraday Cage," Sherman tracks tensions between differing artists' strategies and affects, often oppositional to each other, as he considers this to be a more direct, honest, and authentic description of the times. These concerns of the internal/ external, subjective/objective, and local/international dualities that have been carefully managed by centres like AM since their inception, are made explicit in Sherman's opening text and revisited throughout *Exclusive Memory*. The way Sherman uses language to navigate such concerns gives shape, texture, and weight to this moment and environment described in "The Faraday Cage," setting the tone and direction for this book.

Although a more recent history, Sherman's ties to Nova Scotia have nonetheless been decades in the making. Beginning with his purchase of a house in the village of Port Mouton in the mid-1980s, the province's South Shore has served as Sherman's home base in Canada. The influence of this place on his practice is quite clear in his texts (see, in particular, "On Shore" and "Rare Species Are Common") and in many of the text-image works found in Part III of this book. Sherman has also developed a video catalogue that is arguably the most extensive moving-picture portrayal of rural Nova Scotia created to date. His subjects have included country music, drag races, fishing, political events, forests, beaches, wildflowers, seabirds, bacteria, and all sorts of spiders and insects.

A selection of these video documents and a few early titles from Sherman's Toronto days were added to the Art Gallery of Nova Scotia's permanent collection in 2012. These videos have also been screened at the Art Gallery of Nova Scotia in both its Halifax and Yarmouth locations. Notably, *Alley 9* (2009), a video document of singers and dancers at a karaoke bar in Liverpool made in collaboration with his partner Jan Pottie, and *Michael Swim's Catch* (2011), a video document of the captain of *Queen Anne's Revenge* bringing in a catch of fish to Port Mouton, were exhibited at the AGNS's Western Branch in Yarmouth in June 2012. It was around then, if not several years earlier, that the dialogue about this anthology began, when Sherman presented the manuscript for "The Faraday Cage" to the AGNS alongside the framework for a broader book project built around this text. Sherman's initial proposal and outline, coupled with the editorial and design processes that followed, have resulted

in a publication that sheds light on the many facets of a highly innovative artistic practice spanning half a century.

Tom Sherman is an artist whose name should be familiar to a wide audience. Beyond the AGNS and AM, his work has been featured in hundreds of national and international exhibitions, festival and broadcast contexts, including the Vancouver Art Gallery, the Art Gallery of Ontario, the Images Festival (Toronto), the National Gallery of Canada, the Festival international du film sur l'art, the Musée d'art contemporain de Montréal, the Museum of Modern Art (New York), the Whitney Museum of American Art, Ars Electronica (Linz), the Wiener Konzerthaus (Vienna), the Musée d'art moderne de Paris, *documenta X* (Kassel), Tate Britain (London), Montevideo (Amsterdam), the Impakt Festival (Utrecht), INVIDEO (Milan), the Museo Nacional Centro de Arte Reina Sofía (Madrid), Transitio_MX (Mexico City), and the 39th Venice Biennale. In 2003, Sherman received the Canada Council's Bell Canada Award in Video Art, and he was honoured with the Governor General's Award in Visual and Media Arts in 2010. The accolades bestowed upon him are too numerous to list in full, as are the significant contributions he has made to the discourse of contemporary art. For over fifty years, Sherman has remained at the vanguard of discursive shifts within media art and theory.

In editing *Exclusive Memory*, David Diviney, senior curator at the AGNS, has worked closely with Sherman for nearly a decade. Diviney's attention to the details of their countless exchanges across this period and to the value of Sherman's writing is evident in his thoughtful introduction and assembly of this book's contents. His careful organization of Sherman's texts, text-image works, and other elements encourages a slow and focused study of the material and concerns they raise.

Appreciation also goes to Peggy Gale and Caroline Seck Langill, who have authored insightful essays for this publication. Gale and Langill have each written about Sherman's work before and therefore know the artist and his art-making quite intimately. The original research and scholarship they share here provides a critical frame around Sherman's practice, sharpening an understanding of how his texts and text-image works operate, and of the wide-ranging histories and philosophies they involve.

Funding from the Canada Council for the Arts and the Government of Nova Scotia has made this book possible, as has the support of the Ontario Arts Council and the Toronto Arts Council. Thank you to Goose Lane Editions, our publishing partner, for guiding this complex project through the different phases of the editorial and design processes, which gave form and structure to this book.

Finally, we need to acknowledge the artist himself, Tom Sherman, for continuing to produce compelling text-based works. Sherman's words are always fresh, vital, and poetic. His perspective is adaptive and elastic, and his powers of description are formidable. Like his videos, his writing is driven by an urge to analyze and take stock of the immediate environment and commit this experience to memory. Such thinking is readily apparent in the texts and text-image works that comprise this publication.

Exclusive Memory: A Perceptual History of the Future is the latest addition to a lineage of anthologies centred on Sherman's descriptive, speculative prose. The first, *Tom Sherman: Cultural Engineering*, was published in 1983 by the National Gallery of Canada, and the second, *Before and After the I-Bomb: An Artist in the Information Environment*, was published in 2002 by the Banff Centre Press. *Exclusive Memory* picks up where these previous collections left off, sparking renewed interest in Sherman's ongoing investigation into the intersections of art, technology, and life itself. In covering a period from 1974 to the present day, *Exclusive Memory* acts as a retrospective exhibition in book form. Revealed within these pages is the expansive reach of Sherman's texts and text-image works in the timelessness of his voice and clear, forward-looking vision.

— Sarah Moore Fillmore, Interim Director and CEO, Art Gallery of Nova Scotia,
 and Jonathan Middleton, Executive Director, Art Metropole

ACKNOWLEDGEMENTS

I have been profoundly influenced by two significant people in my life. Jan Pottie, my lifelong partner and wife, inspires me daily with her intelligence and amazing observational skills. Jan's curiosity is wide open. She sees things before I do and often sees right through them. She studies people and culture like a scientist and writes and talks beautifully. As a biologist and activist, she has helped me define my values to the core. I aspire to be as focused and accurate. With Jan came the adventure of our daughter, Yolande Pottie-Sherman. Yolande is an artist, a natural and accomplished painter with great drawing skills. I have always been fascinated by the depth of her perceptual skills, the uncanny ways she sees, comprehends, and articulates image. Yolande is also an insightful geographer at Memorial University in St. John's, Newfoundland, where her refined perceptual gifts illuminate her research and writing. She is highly disciplined in the way she puts the world in order through elegant description, her pictures, and articles.

I also express my gratitude to several key people who have helped shape my thinking, in conversations and correspondence, as well as those who have influenced me from a distance through their work. This book is a description of environments and living conditions, perceptual contexts I've shared with many exceptional individuals, including Peggy Gale, Caroline Seck Langill, Brian Molyneaux, John Orentlicher, Richard Kerr, Eldon Garnet, Tom Shelton, Bernhard Loibner, Norman White, Gertrude Stein, H.G. Wells, Alain Robbe-Grillet, Vito Acconci, Jean Piaget, Lev Vygotsky, Nikola Tesla, Wilhelm Reich, George Boole, Michael Faraday, William S. Burroughs, Henry Miller, Charles Bukowski, Neil Young, Smokey Robinson, Gregory Bateson, Marshall McLuhan, Mary Shelley, Franz Kafka, Ishmael Reed, John Brockman, Barrington Nevitt, John Watt, Heidi Grundmann, Robert Adrian, August Black, Clive Robertson, Willard Holmes, Arthur C. Danto, Edwin Way Teale, Gerald Ferguson, Garry Neill Kennedy, E.O. Wilson, George Kubler, James J. Gibson, Claude E. Shannon, R. Murray Schafer, Andy Warhol, R. Bruce Elder, Isabel Pedersen, Steve Reinke, Andrew Lugg, Lynne Cohen, Jay Yager, Rodney Werden, AA Bronson, John Oswald, Lisa Steele, Tanya Mars, Colin Campbell, Philip Monk, Roy Ascott, Jean Piché, Sol LeWitt, Douglas Huebler, Lawrence Weiner, Kenneth White, Alyce Sherman, Ben Sherman, Jon Perez, Nicole Gingras, Joni Mitchell, Leonard Cohen,

Ed Dorn, Gordon Lightfoot, Yevgeny Zamyatin, Michael Snow, Roger Mayer, Joe Bodolai, Scott Didlake, and Geert Lovink.

I am particularly fortunate to have had the critical attention and support of Peggy Gale and Caroline Seck Langill over the years. The analysis and insights they offer in their respective essays for this book give me fresh objective understandings and generous, well-structured guidance for others to consider the relative value of my vision of the past and future.

Two institutions were particularly significant in providing me with the space to learn and citizenship to vastly extended communities over the years. My time as video officer and head of media arts at the Canada Council for the Arts between 1981 and 1987 was very important to me, as was my time as a research professor teaching video art and media art history and theory at Syracuse University between 1991 and 2022. The people I met through these institutions, especially the students, and the experience in these powerful, privileged learning contexts gave me access to the overviews expressed in this volume.

This book is the result of David Diviney's sustained, generous interest in my work. David, along with Sarah Moore Fillmore at the Art Gallery of Nova Scotia and Ray Cronin, took notice of my cumulative declarative statements from and about Nova Scotia as far back as 2010. David more recently reintroduced my text-based work to Jonathan Middleton, who graciously brought Art Metropole in as co-publisher, closing a circular loop back to my emergence as an artist in Toronto in the early 1970s when I began publishing my writing as a form of visual and media art, including publications by Art Metropole in its beginning years. David, Sarah, and Jonathan recognized my work as a contemporary form of communications art relevant in a media-saturated present day and decided to publish this book as a print exhibition by the Art Gallery of Nova Scotia and Art Metropole. I am grateful for their attention and the audiences they bring to my work.

— Tom Sherman

INTRODUCTION

EXCLUSIVE MEMORY:
A PERCEPTUAL HISTORY OF THE FUTURE

— David Diviney

Tom Sherman is an innovator and a builder. His pioneering work with video, beginning in the early 1970s, focused on critiquing the effects of mass media, revealing the ways media culture engineers conformity and passivity. By the late 1970s, he was making video art for television that confronted the motives of televised programming itself, as it was being broadcast to audiences in Metro Toronto, his home at the time, and throughout Ontario.[1] A selection of videos from this period — *Theoretical Television* (1977), *Television's Human Nature* (1977), *Envisioner* (1978), *Individual Release* (1978), and *East on the 401* (1978) — was shown in the exhibition *Canada Video*, part of the 39th Venice Biennale in 1980. Alongside Sherman, this program for the Canadian Pavilion included artists Colin Campbell, Pierre Falardeau, Julien Poulin, General Idea, and Lisa Steele. For Sherman and his contemporaries, video was quickly becoming the medium of choice for carrying ideas and images formed with written and spoken language. Organized by the National Gallery of Canada and curated by Bruce W. Ferguson, *Canada Video* went on to shock the art world, as it was one of the first exhibitions to really demonstrate the extent to which this new medium had infiltrated artistic practice.

More than forty years later, Sherman's early video work is widely recognized for its significant contribution to the establishment of video in and of itself as a legitimate art form and an instrument for advancing critical perspectives in media literacy. Sherman's research findings from the outset were manifest in his texts and text-image works, a combination of conceptual art and descriptive, speculative prose. Today his work often still begins with writing, which is the focus of this book, whether it ends in performance, sculptural installation, video, or a hybrid of these and other genres.

1 From 1976 to 1978, Sherman curated and produced *Afterimage*, a thirteen-week, half hour program of experimental film and video art on TVOntario. In 1978, he was a researcher and writer for *Fast Forward*, a TVOntario series on the digital revolution which was broadcast extensively on PBS in the United States.

Fittingly, the title of this anthology of texts and text-image works, *Exclusive Memory,* was previously used by Sherman for a 1987 video performance firmly rooted in his exploration of written and spoken language as a means of shaping environments in time and space. This work was eventually extended into a gallery-based installation made up of numerous parts: three 60-minute video recordings displayed over six monitors, a 60-minute computer-generated video image-scroll displayed on a single monitor, and a painted aluminum panel. The original video performance was recorded in 1987 at the Western Front, an artist-run centre in Vancouver. The complete version of this work was first exhibited at the Vancouver Art Gallery from April 15 to June 5, 1989, in an eponymously titled exhibition curated by Gary Dufour. It is now included in that institution's permanent collection. Over the subsequent decades, the component elements that comprised the Vancouver installation, namely the series of video monologues, have been exhibited and collected by museums including the Museum of Modern Art in New York and the National Gallery of Canada in Ottawa. These video recordings have also been screened and broadcast as single-channel works in several other contexts, nationally and internationally, often accompanied by the following narrative description:

> *Exclusive Memory* is based on excerpts of a 6-hour monologue by Sherman
> to a machine, a computer-based, video sensing robotic entity of the artist's
> own creation. Sherman is observed providing an experience transfer to
> his machine in a conversational monologue. The machine can apparently
> understand natural language. Sherman is interested in relationships
> between people and machines, especially apparently intelligent artifacts.
> Sherman assumes his machine is interested in everything, although credit
> card histories and all forms of dead animals emerge as the machine's
> primary obsessions.[2]

With this anthology, the title is meant to act as a marker for a "story" authored by a single individual, an exclusive release of perspectives and insights by Sherman himself. And, in perhaps an even more direct reference to his 1987 video performance, it serves to re-evoke his interest in relationships between people and technological devices while foregrounding the importance to his broader practice of processes such as experience, perception, and memory. Sherman posits that the progress of past, present, and future events are measured in two parts: memory and hope. As he states, "I consider that time is divided into memory and hope, that perception and experience are recorded in writing, video or other media (written in memory) and then there is what lies outside of memory (and that is hope . . .)."[3] The texts and text-based works that make up this book explore and expand upon this thinking, revealing the wide reach of Sherman's visionary interpretation of time and space as conveyed through his writing.

2 This narrative description is based on a text written by Sherman and originally published in the handout
 accompanying the exhibition *Exclusive Memory* at the Vancouver Art Gallery in 1989.
3 Tom Sherman, email to David Diviney, October 6, 2014.

Sherman is a true product of the formative days of Canada's artist-run centre network. After emigrating from the United States to Canada in 1971, first to London, Ontario, and then settling in Toronto as a landed immigrant in 1972, he soon began working at A Space, one of the first artist-run centres in Canada, and helped establish a video facility there for artists wanting to investigate this new medium.[4] Throughout the '70s, he developed and fine-tuned his practice against the backdrop of Toronto's cultural milieu, producing and exhibiting text-based works, performance, sculptural installation, and, of course, video. His work was the result of his experimentation with radio, audio, and video technologies and, like the artist-run centres themselves, Sherman was pushing the boundaries of institutional conceptions of aesthetics. In support of his art-making, he built Tesla coils and studied other invisible phenomena (microwave propagation, negative ion generators, infrasound transducers, and Faraday cages), all the while writing on a nearly daily basis.

An exemplary work from those early days was *Faraday Cage*, which Sherman unveiled in a solo exhibition at A Space on May 16, 1973. Consisting of a six-by-six-foot enclosure relatively free of electromagnetic radiant energy (radio and television waves, microwaves, and electronic smog), this installation made concrete his agreement with Marshall McLuhan's warnings about media pollution and information overload.[5] As a participatory work, visitors were encouraged to enter the small room he had built in order to fully experience this demonstration of the concept of shielding (i.e., to potentially "feel" that the electromagnetic fields were indeed being blocked, and that they were then being protected when inside this enclosed space). Like his texts and text-image works, Sherman's *Faraday Cage* (1973) is at once an object and a constructed thought: a conceptual and philosophical exercise that merges elements of language, image, and ideas. Considering the escalating presence and influence of media in our daily lives, as with McLuhan's prophetic theories, this sculptural critique of the Information Age has stood the test of time.

The core of this anthology is a text, which uses that 1973 work and exhibition at A Space as a jumping-off point. The value of this previously unpublished text — aptly titled "The Faraday Cage" — is primarily as a window into the immediate scene within which Sherman found himself while in Toronto from 1971 to 1976. It also establishes his ongoing interest in phenomenology. "The Faraday Cage" was written in descriptive prose and endnoted by a series of text-based works made and exhibited as visual art during the period covered in the essay. These include pieces such as *This Message Is about the Condition of Your Body* (1974), *12 of 50 Car Crashes with Fires* (1974), and *Voluntary Handcuffs* (1975), which, alongside many of the others, were issued as stand-alone works in *Tom Sherman: Cultural Engineering*, an anthology of forty-four texts and text-image works edited by Willard Holmes and published

4 A Space began as an alternative commercial gallery three years before the centre's not-for-profit incorporation in January 1971.
5 For example, see Marshall McLuhan's *Understanding Media: The Extensions of Man* (New York: McGraw-Hill, 1964).

by the National Gallery of Canada in 1983.[6] This type of work is illustrative of 1960s and '70s art-making strategies in its use of text and language as a medium and, as touched upon earlier, can be thought of as literary conceptualism, idea-centred works of art with visceral (sensual) and poetic characteristics.

"The Faraday Cage," comprising Part I, is a massive introductory chapter, appearing almost like a book within the book itself. In this lengthy text, Sherman is describing an environment in time and space, as he does in the texts and text-image works that follow. As has been suggested, it is within that environment where Sherman found his footing as an artist. The lasting impression of that Toronto scene he was part of in the '70s underscores the significance of this opening text, and it should be evident that the rest of this anthology rides the energy and experience it tracks. It should also be quite clear that this text is not an essay in the traditional sense; rather, this is the work of a visual artist who is using words to create a narrative-based image stream within the conventions of a memoir. In its free-flowing structure, "The Faraday Cage" is perhaps closer to a sequence of vivid flashbacks than it is to any sort of rhetorical exercise. This work depicts actual events in the life of the author as truthfully as his memory permits. Sherman makes a sincere attempt to recall and record things exactly as they were from his perspective, not shying away from viewpoints that may at times seem outdated or problematic in today's world. There are a handful of terms and references to sensitive topics, for example, that deviate from contemporary standards and guidelines around suggested language use. Stylistically speaking, Sherman's choice of words here should be read as a blend of brutal honesty, evocativeness, and precision. The way written language is being used in this text to shape ideas and images sets the tone for *Exclusive Memory* as the voice that was discovered here, somewhere between 1971 and 1976, echoes throughout the other sections of this anthology.

Part II expands upon and updates "The Faraday Cage" with an additional seven texts that use descriptive prose in similar but somewhat divergent ways. As with "The Faraday Cage," these texts are visual narratives centred on perception and experience, not unlike a naturalist's observational logs. While ranging in focus and content, they are consistent in Sherman's determined use of explicit, declarative language to give form to ideas and images. Whereas "The Faraday Cage" was written several decades after the fact, accounting for the subtle delay in reflection that can be sensed in Sherman's words, the texts comprising Part II were written in closer proximity to the moments and contexts being examined. Sherman's voice also shifts here from the somewhat naïve and anti-heroic tone that tints "The Faraday Cage," to one that expresses his perceptions and experiences with a different manner of confidence and sophistication. Throughout, he maintains his preoccupations

6 These texts were written by Sherman between 1974 and 1982. This anthology accompanied the exhibition *Cultural Engineering*, a ten-year survey of Sherman's video, installation, and text-based works that took place at the National Gallery of Canada from May 16 to July 10, 1983.

with technological devices and reports as accurately as possible on the role of the artist. Moreover, there is a real effort to ground the artist in a variety of societal and environmental contexts. The shapes of these environments are urban, rural, technological (networks), social, political, and in some cases, simply a beach on Nova Scotia's South Shore, as in the previously unpublished texts "On Shore" and "Rare Species Are Common."

Like Toronto, Nova Scotia has played an integral role in the establishment of Sherman's backstory and the development of his work. Beginning with the video *East on the 401: You Can't Watch Television and Drive a Car at the Same Time* (1978) and reinforced by his first visit to the province a year later, Sherman has been "obsessed" with Nova Scotia.[7] In 1984, he purchased a home in the small coastal village of Port Mouton and from that day forward has spent more and more time on Nova Scotia's South Shore. Since recording his *Exclusive Memory* videos in 1987 — the work is, in part, a spatial dialogue between Port Mouton and Vancouver — he has made well over fifty video works that feature this region of Nova Scotia as their primary content. These videos are complemented by an equivalent number of text-based works of similar subject matter. This surge in productivity and momentum can be partially explained by the fluidity of production afforded by digital video and new opportunities for online distribution. However, Sherman's obsession with the analysis of this region of Nova Scotia is largely driven by a sense of urgency to describe and fortify an environment under siege, ravaged by the exploitation of resources and a way of life threatened by the forces of urbanization. This increasingly intense focus aligns with contemporary thinking about "the rural" in social theory as applied to artistic practice and is also mirrored in the evolution of his text-image works as made visible in Part III.[8]

Seeing that Sherman's interest in the effects of pairing his writing with photographs extends as far back as the early 1970s, Part III offers a selection of thirty-three text-image works made between 1973 and the present day. Though some of these works have been exhibited in galleries before, and others published in journals and periodicals, to date the vast majority have only been shared through intermittent broadcasts from the artist's personal email account. Sherman describes his text-image works as "sets," a collection of well-defined and distinct elements that has the potential to be realized as an object (of thought) in its own right. Each "set" involves the juxtaposition of a short text (top) and a photo image (bottom). This idiosyncratic structuring balances the weight and importance of the text and the image too, so as to avoid the image becoming illustration for the text or the text becoming caption for the image. As a compositional device, this concentrates attention on the dynamic exchange between the two elements, prompting a kind of back-and-forth reading where neither the text

7 Tom Sherman, email to David Diviney, September 21, 2020.
8 For example, see Lucy Lippard's *The Lure of the Local: Senses of Place in a Multicentered Society*, (New York: The New Press, 1997).

nor the image is viewed as the clear starting or finishing point.[9] While non-chronological in sequence, these examples reveal a temporal shift in his work from the nature of technology to nature in broader, more fundamental terms. Again, this shift can be attributed, in part, to his deepening connection to rural Nova Scotia. These examples also highlight his continuous use of written, visual, and spoken language as a means of measuring and forming mental images. In many ways, the thirty-three text-image works included here can be compared with those descriptive texts end-noting "The Faraday Cage"'s social and environmental history.

Exclusive Memory closes with two afterwords that break from the voices of the project partners in the foreword and this introduction, and that of the artist in the first three chapters. The decision to include not one but two afterwords seemed appropriate given the layered complexity of this book as an intellectual exercise and the multiplicity of ways Sherman's texts and text-image works can be read. While these concluding essays are decidedly unique in scope and direction, as are the scholarly pursuits of those who authored them, there are moments of convergence and overlap that speak to a shared appreciation and understanding of the indelible mark Sherman has left on the art world and its many audiences. Together these essays further contextualize this book, its wide-sweeping conversations about Sherman's practice, and his use of text to shape what are arguably some of the most dynamic and critically engaged works of visual art or "pictures" one will encounter.

In her essay, "Writing Images: Tom Sherman Texts and Photographs," Toronto-based independent curator and critic Peggy Gale examines the merit of this book in terms of the fact that its contents have been authored by an artist who is actively writing art history. Coming from the position of a historian of contemporary art, she looks at what makes these texts and text-image works effective in their first-person analysis and documentation of lived experiences within various scenes (artist-run centres, bureaucracies, urban/rural settings, Listserv communities, etc.). As someone who was a central part of many of these scenes herself, Gale's words go a long way in supporting and verifying Sherman's accounts.

The second essay, by Toronto-based Caroline Seck Langill, expands upon this line of inquiry but does so from the perspective of a writer and academic who is primarily looking at the intersection of art and science. Her essay, "Tom Sherman: Naturalism through Video — Increasing the Depth of Field," focuses on Sherman's video work, drawing attention to the mobility of this aspect of his practice into other forms of creative expression, such as the texts and text-image works found in this book. Langill couches Sherman's art and writing in the discourse of communication and information theory, providing insights into person/machine relationships and technology (hardware, software, firmware, wetware, etc.) as an extension or manifestation of language. Considering that Sherman's practice emerged out of

9 Tom Sherman, text message to David Diviney, June 6, 2021.

certain scenes, parallel to and in dialogue with the technocultural evolution (the devolution of mass media into interactive new media), Gale's and Langill's essays jointly outline how this background led Sherman into the broader environment, the cultural environment beyond or at the fringes of technology, and the natural environment itself.

It should be noted that Peggy Gale edited *Before and After the I-Bomb: An Artist in the Information Environment*, an anthology of fifty texts and text-image works by Sherman that was published by the Banff Centre Press in 2002.[10] Like *Before and After the I-Bomb* and its predecessor *Cultural Engineering*, this book brings together a collection of his text-based works with the hope of studying his writing for its value as art and history. This anthology of forty-one texts and text-image works — the majority of which are previously unpublished and/or follow *Before and After the I-Bomb* — revises Sherman's attempts as an artist to deal with overlapping thoughts, mainly about technological devices, visual culture, and the world around him. As he states, "These texts are annotations . . . descriptive statements by an artist going about the process of making art. Sometimes I'm describing a thing, sometimes an idea, or connections between things and ideas. The narrative is the definition of perception, my perspective, taking account of the background, not only the foreground. My texts are a kind of talking aloud (voice). Could be a whisper."[11]

The texts and text-image works that comprise *Exclusive Memory: A Perceptual History of the Future* were chosen to sweep across nearly five decades of art practice and to operate in radically different environments and ecologies. While each of these works were created at specific moments in time, as the book's subtitle suggests, they extend beyond a mere depiction of past events in their forward-looking vision. Within this there are aspects of the way Sherman's descriptions change according to the times and shifting contexts that warrant examination.[12] Also demanding careful attention are how his ideas are distilled from recorded observation, how his writing is occasionally isolated and free-floating, and how he mixes ethnographic research methods with transhumanism and perceptual philosophy. Whether his approach is distanced and general, or magnified and specifically matter-of-fact, Sherman's texts and text-image works remain highly detailed, unquestionably current, and altogether precise.

10 As the book cover states, *Before and After the I-Bomb* is "a collection of essays spanning three decades of thought and inquiry about art, culture and nature in the information era. . . . His essays document the times when others were blanking, and suggest kinder possibilities for the future of technology in an evolving human culture inextricably bound to Earth's ecosystem."

11 Tom Sherman, email to David Diviney, July 15, 2020.

12 In discussing the way his texts shift over the length of time, Sherman states, "I think there is some future anticipated in the shape of the past." Tom Sherman, text message to David Diviney, September 30, 2021.

PART I

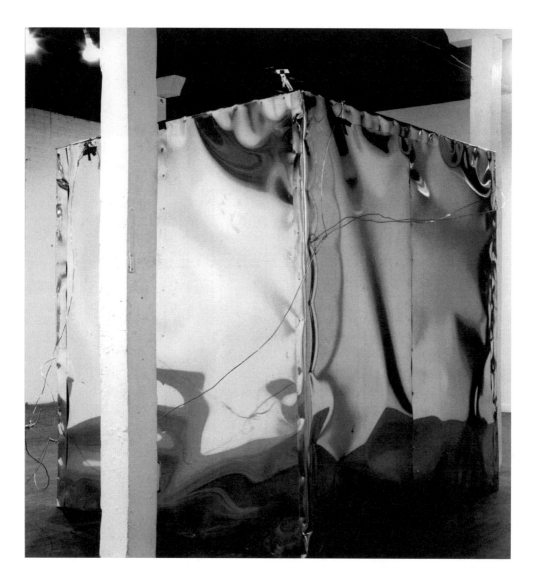

Tom Sherman's *Faraday Cage* installation at A Space, Toronto, May 15-26, 1973.
Photo: Lisa Steele.

THE FARADAY CAGE

On May 16, 1973, I unveiled my *Faraday Cage* at A Space, an artist-run centre in downtown Toronto. My *Faraday Cage* was a six-foot-square enclosure of aluminum sheeting attached to electrical "ground" by thick aluminum wire. The idea was to replicate the electromagnetic-free space that British physicist and experimenter Michael Faraday had developed to facilitate his nineteenth-century investigations into the phenomenon of electricity. Faraday needed to create a space free of electromagnetic radiation to run some delicate tests on static electricity and he came up with a grounded tent of tinfoil. My *Faraday Cage*, built over a century later, was positioned as a sculptural object, a metal enclosure that engineered a six-foot-square cube of negative, radio-free space, in the middle of downtown Toronto, a major city with scores of radio and television stations and microwave transmitters, and an electrical grid pumping an electromagnetic smog of radio-frequency energy through every building and lung and every cubic centimetre of Toronto's air.

My interests and experiments differed from Faraday's. My "cage" asked the visitors to A Space's gallery to contemplate the invisible, electromagnetic forces bombarding their bodies (yes, radio waves of all frequencies and amplitude are blowing through our bodies at the speed of light constantly and incessantly) and offered them a chance to find refuge in the electromagnetic-free space of my cage. There was a printed statement in the gallery to explain how the cage worked, outlining its origins in Faraday's experiments. To amplify the normal presence of invisible and undetected electromagnetic radiation, I strung long copper-wire radio antennas across the ceiling above the cage, attached to the walls by glass insulators. The installation was effective in that it brought to mind the invisible reality of the intense electromagnetic radiation normally present in the city, and it created the opportunity to find temporary shelter in the cage within the gallery.

I would greet visitors and encourage them to enter my cage. I would escort them into the interior of the cage with a transistor radio blaring the most obnoxious commercial radio

I could tune in. When we entered the cage, the radio signal would be instantly lost, and the radio would hiss with the sweet emptiness of white noise. My cage was painted flat black inside, and had a light lock, like a photography darkroom, a short corridor that delivered my subjects into a pitch-black aluminum box. I'd turn the radio off, cutting off the empty hiss, and ask them to contemplate the radio-free nature of the space, and leave them in the cage. It was quite awkward being so close to a stranger in absolute darkness. Most visitors would spend half a minute in the cage, and then emerge from its door and thank me for an interesting, albeit perplexing, experience. But there were people who stayed and wanted me to close the door behind them, insuring they were truly insulated from electromagnetic radiation and secure in this special place for meditation about radio waves and the noise of the city in general.

I spent a couple of nights in the cage, putting my sleeping bag on the metal floor and curling up to sleep. One of the downsides of my cage was the nature of the aluminum alloy I had used to construct it. After a while, there was a subtle taste of aluminum in your mouth. The space was dominated by its metallic composition. It was also an uncomfortable, cramped space. If you bumped into a wall it really banged in a deep, resonate concussion. Also, the absence of light was spatially misleading. The cage felt bigger than it was inside, and one felt clumsy in the cage, no matter how still one stayed. Over the course of a few weeks, a couple of hundred people tried the cage, with probably a dozen getting into the experiment seriously. Some spent evenings when the gallery was closed meditating and generally inhabiting the cage. People had meetings, their meals, slept, and had sex in the *Faraday Cage*. It was funny to listen to people having sex because the walls would bang like a cross between an auto accident, a funhouse, and rock and roll.

Some people would talk to me about what it was like to be radio-free, as if there was a sensual dimension beyond the psychological space I had constructed. I recall that Joe Bodolai was particularly intrigued with this boundary between mind and body. Joe was extremely bright and open-minded and really considered it possible for humans to sense electromagnetic waves without instruments. But more importantly to me, he understood the peculiarity of the space I had created. In a technology-obsessed, future-driven city like Toronto, I had created a conceptual space of refuge. Joe was jamming on the irony of my gesture, since I was already known as an advocate for technological art through my early work in video and audio.

I met Joe Bodolai at A Space in the summer of 1972. We were showing video and film by artists in sporadic screenings here and there, and Joe showed up pitching a spaghetti western he had made in Super 8 with his college buddy Ben Burtt. They had made this elaborate parody of the final gunfight scene in *High Noon*, the classic western where Gary Cooper, playing a small-town sheriff named Will Kane, has to make a stand against a nasty gunslinger, Frank Miller, who comes to settle an old score at high noon. In the original 1952 film, the

cutting back and forth and the tension created before the guns are drawn is incredible, but in Bodolai and Burtt's version this suspense-packed scene was drawn out to complete absurdity. The moments before the protagonists draw and fire are stretched into a scene that seemed at least twenty minutes long. In fact this scene ends up being their whole film. It was really funny, but also painfully long and radical enough as comedy to be considered art. It was formally minimal and quite elegant. We showed it on a video monitor, in black and white, to an audience of maybe a dozen. Joe enjoyed the screening immensely. Ben later went on to work with George Lucas on the *Star Wars* films as a sound designer. The sounds of the laser swords that have become synonymous with Lucas's films were made by Burtt striking a telephone pole guy wire with a hammer.

Joe had studied art history, could write, and ended up being a regular contributor to *artscanada* when it was edited by Anne Trueblood Brodzky. *Artscanada* was the only national art magazine in Canada at the time, and although Brodzky's editorial style was a bit stiff, Joe seemed to be able to do whatever he wanted. I remember one time he interviewed himself and got it published. Joe, who was constantly running comedy routines on everyone he came into contact with, had some real currency in the art scene in Toronto. He was also freelancing for CBC Radio; through Joe I met Danny Finkleman and ended up working for the CBC myself. Joe was also the gallery director and curator of the Electric Gallery, a private gallery owned by Sam and Jack Markle. The Markle brothers had a neon sign company and were using the Electric Gallery as a showcase for their custom neon work. Under Joe's influence, the gallery had become serious, with exhibitions by Michael Hayden, who was then beginning to get large public commissions for his computer-controlled light sculptures, and Norman White, one of the most important artists to ever work in electronics and robotics in Canada. When people talk about interactivity and physical computing today, they should do their homework and take a look at what Norman was doing way back when Toronto was a small city with an odd Electric Gallery.

The Electric Gallery was on Avenue Road, just above Dupont. The building was wrapped in aluminum and had a narrow vertical slit made of smoked glass facing the street. You could see people and traffic going by from the inside, but you couldn't see into the gallery from the street. The current show was happening on the gallery's main floor, and downstairs there was a showroom for assorted works by the artists, along with some kitsch produced by the Markle brothers. They made bright Day-Glo-coloured pop-art neon drawings of daisy-like flowers coming out of neon tracings of Coke bottles, that kind of thing, for decorating apartments or business interiors. There was one particularly offensive object, a real porcelain toilet with the outline of a blue-neon hand reaching out of the bowl, representing someone being flushed down the toilet. This was Jack Markle's recurring nightmare. Sam was the more philosophical and less neurotic brother, and he was fond of saying, "There's nothing worse than electric art that doesn't work." Of course he was right. Despite the questionable taste of the brothers, they

let Joe Bodolai do his thing, and he had a nice string of shows. I remember seeing a show by Robert Watts, the American Fluxus artist, where Watts had transformed video data from the sky above Toronto, with rolling clouds varying the intensity of the light, into a single video monitor that had a simple array of video-pong-like objects that emitted the worst kind of primitive electronic music I had ever heard. I challenged Watts because I thought the system was reducing the sublime sky into an artificially stupid display. He told me that that was the point. Not knowing much about the "life is art," irreverent Fluxus movement at the time, I remember being dumbfounded by his response.

Norman White's early shows at the Electric Gallery were also frustrating. I thought White was simply taking circuits from *Popular Mechanics*, say, circuits for building electronic garage-door openers, and putting these circuits in beautiful Plexiglas boxes. White was beginning to build responsive, robotic objects that questioned the fixed "objectness" of sculpture and dealt with the audience in completely new ways; but all I could see were the attractive blinking lights and his craftsmanship. I hated the fact that I was responding to the way his electronic objects looked, and not to the systems and ideas at their foundation. I didn't think his systems were stripped down far enough. The concepts were not apparent. But Joe Bodolai knew what Norman was doing before it was clear to Norman himself.

Crazy things were happening at the Electric Gallery. When you went to Av Isaacs's gallery, or to Carmen Lamanna's, you always knew what to expect. But Joe Bodolai's curatorial hand was more radical, less predictable. Michael Hayden actually had a show in the fall of 1972 at the gallery that was nothing more than a video document of him getting his shoulder-length straight hair cut by a team of nude female hair stylists. Not only was this excessive and boring and politically out of step with the emerging awareness of how women were being depicted as objects through the male gaze, but Hayden had somehow linked this ritualized and eroticized haircut with a move toward corporate conformity. He served Kentucky Fried Chicken at the opening and had a Colonel Sanders stand-in (maybe it was the original Colonel Sanders? — it sure looked like Colonel Sanders!) representing him as the artist. I don't remember Hayden even being at the opening. Nobody really knew what the hell was going on, other than the tape was narcissistic and shallow, which was a very common analysis of video art at the time. I do remember meeting Gale Garnett over fried chicken that afternoon. She was a Toronto-based pop singer who had the huge hit "We'll Sing in the Sunshine" back in 1964. She had come to the show in a see-through dress made of sheer white cotton fabric, like the material used to make delicate, transparent curtains. Gale was a great, enthusiastic conversationalist and she was telling me what she thought Michael had intended, when we were pushed out of the gallery as the opening was over. As we hit the street, the autumn sunlight was brilliant. We stood there for some time continuing our conversation about pop art and cultural icons and the significance of the multiple art object. I found her absolutely stunning.

In March 1973, Joe gave me a solo show at the Electric Gallery. He told me he didn't have any expectations of sales — he just wanted me to do a serious, thoughtful show. As a precursor to the *Faraday Cage* installation at A Space a few months later, I installed an array of sound sculptures, engineering the acoustic space of the Electric Gallery through various intensities of pink noise. Pink noise corresponds to the audible range of white noise, which is hypothetically the complete spectrum of sound, including frequencies below (infrasound) and above (ultrasound) human hearing. White noise is emitted, for example, when a television plays without a signal — the screen hisses with the sound of video "snow." For this show I used televisions as the source for the pink noise that sculpted the space. I turned the screens toward the walls and routed the audio into woofers, mid-range speakers, and tweeters that distributed the sound throughout the gallery via plastic pipes and various forms of wooden enclosures. With the gallery completely unlit, except for the subtle glow of ambient light from the television screens pressed against the walls, the space became acoustically sculpted. I had done my homework and knew quite a bit about acoustic engineering. There were parts of the gallery that were noticeably cooler in acoustic temperature, and in certain areas the pressure of the audio, despite a limited volume, was quite uncomfortable. Standing waves created dead spots where it seemed the amplitude was diminished, but by moving only a foot or two there would suddenly be low tones hugging and crawling across the floor and high-pitched ringing tones sweeping across the ceiling. The whole room was filled to the brim by no more than 45 decibels of pink noise, but the space was thick with sound that was rich in nuance, perceptually and psychologically complex. People told me they experienced the damnedest things — things that were simply not there. They heard voices and music (there were no voices or music programming in my acoustically engineered Electric Gallery) and felt something or someone touching the backs of their necks and the sensitive skin behind their knees.

Joe and I had had the best time installing this show. I had my tech together, and all the gear, including the tunable crossover circuits, worked beautifully without much fuss. But to actively engineer a space acoustically demands a lot of time, as you have to move the speaker enclosures around in the space physically so you can properly tune the room with your ears. Joe was the best curator because he completely identified with the mission and was willing to take the time to get it right. We spent two full evenings maximizing the effects of the installation. In 1973, the idea of a systems aesthetic was still very much alive. The conceptual and minimal concerns of the 1960s made it possible to look at perception in a bare-bones, matter-of-fact way. Technological art, as opposed to art using traditional media, was governed by a different kind of thinking: the inherent logic or balance between form and content in an artwork involving a system composed of television-driven pink noise, tuned speaker enclosures, and a specific gallery space is quite different than it is in a drawing or painting or sculpture conceived to be put on a base. A systems aesthetic demands that the artist look at the total situation and embrace the system, listening to the technology and letting it speak to the space

and to others. Control is always the name of the game when making art, but in a cybernetic context, letting the system do its thing is essential to the aesthetic resolution of technology-based art. The artist engineers a situation where the audience of the work, in this case a site-specific acoustic environment, takes the place of the artist in performing and perceiving the work. While I didn't ask the audience to reconfigure the system, the work had to be performed by moving around within the acoustically sculpted gallery. The *system*, and its configuration by the artist, is the work of art.

Again, as with the *Faraday Cage* at A Space later that spring, I had chosen to reduce the apparent content of my work to an environment. At the core of the *Faraday Cage* installation was a cube of negative space, with even the electromagnetic carriers of radio and television in Toronto shut out. John Watt, an artist who had just graduated with a BFA from the Nova Scotia College of Art and Design, told me the interior of my Faraday cage was a "black hole." He meant it was a space inside a space that transported you into another psychological dimension. I knew perfectly what he meant, given my efforts to puncture what I perceived as the façade-based culture of Toronto. I had only been in Toronto for a year and a half, but the media culture — the glossy magazines and billboards and slick radio and television — seemed so illusory and superficial. All newcomers and outsiders in a city probably feel this way — that they don't exist as there is no reflection of their presence in the media. For me it was a combination of craving some attention as a young artist, while knowing the media — and Toronto — were an elaborate house of cards in terms of image. I was looking for something substantial and real and contemporary in a city completely invested in the depiction of its own future.

§

I had moved to Toronto in October 1971. On the way to Toronto, I first stopped in London, Ontario. I packed up my red-and-white two-ton Ford pickup truck in Ypsilanti, Michigan, just west of Detroit, and drove to a campground on the outskirts of London. I had only a backpack full of clothes, a 35 mm Canon SLR that I had bought from a junkie for twenty-five bucks, and five hundred dollars cash. I was disillusioned with the culture of deceit and apathy in the States, and decided I'd try to establish myself in Canada. I headed into London and quickly met some people in the art scene around the University of Western Ontario (UWO). I was hanging around with a woman named Angie, who had a sister, a year younger, who had decorated their kitchen walls with body prints of her nude torso in Yves Klein blue. The kitchen paintings were a response to an assignment in one of Don Bonham's studio classes. It was hard to fathom how she managed to press her body into the wall so close to the ceiling. Angie wasn't quite as wild, but she knew her art history and took me to a visiting artist's presentation by Michael Snow at UWO. Snow showed "←→," his classroom film where a camera on a machine panned back and forth, first very slowly and then progressively faster

until it was whipping back and forth at such a rapid rate that several of the people in the front row had to leave during the most extreme section of the film, some of them actually vomiting. After torturing the audience with this horizontal pan for quite a stretch, the camera begins to roll vertically like a television. The transition is amazing, but there is this completely corny scene where a policeman looks at the camera and audience through a window during the vertical roll. During the Q & A, Snow was flippant and cocky and obviously pleased that his film had made people ill. I raised my hand and said that I thought the film was beautiful, except for the cornball scene with the cop. I thought the film was brilliant because he had stayed with the literalness of the camera motion, but that the cop was iconic and symbolic, and violated the aesthetic coherence of the film. Snow told me in no uncertain terms that I had missed the point and that the cop was akin to the stupid rigidity of educational institutions and that maybe if I'd get out of school for a few days, I might understand that the film was meant to violate institutional confinement. I was extremely pissed off because I wasn't a student at Western, or anywhere else. I was an artist and had been out of school for nearly two years.

Later that night Angie and I drank a couple of bottles of wine and smoked some dope, and after she had convinced me that I hadn't made a complete fool of myself by challenging Snow and being rebuked in front of nearly everyone that mattered in London, we headed for the bedroom. Things didn't go so well as she was tired and not feeling well. After talking about her feelings and how she wasn't looking for a serious relationship, we decided to get up and go over to Arthur Handy's studio, where there was supposed to be a big party. As we were rolling out of bed, Michael Snow suddenly appeared out of nowhere, being led into the bedroom by the agile, body-painter sister. Michael said hello and told me he enjoyed hearing my thoughts on his film. He thanked me, even. Michael and Angie's sister were making out as we were heading out the door. About a week later, Angie told me she thought London was too small for me, and that I needed to check out Toronto. I was still living at the campground, and it was getting too frosty to sleep outside in a sleeping bag any longer. Angie said she wanted to visit a friend in Toronto, and that her friend knew the city pretty well, and they could take me to a youth hostel where I could stay while I got my feet on the ground. I wouldn't see Michael again until Robin Collyer introduced us at Robin's first solo show at Carmen Lamanna's gallery.

So I gave Angie a ride to Toronto and that's the last time I ever saw her, as that night I found myself on a cot in a hostel on some street parallel to and east of Yonge and Dundas, surrounded by down-and-out hippies and the newly initiated members of various religious cults. The Scientologists were everywhere, mopping up the casualties of the sixties. I lasted three nights in the hostel, as on one fateful night a teenager down the hall slit her wrists with a razor blade. It's hard to get back to sleep after seeing something like that. On my fourth night in the big city, I was sleeping in my locked Ford pickup. I needed the privacy. When I wasn't

walking around seeing the sights, I'd duck into a movie theatre to catch a film and to warm up. I was excited to see *200 Motels*, the Frank Zappa film shot entirely in video and visually all dressed up with the special effects of analog video synthesizers. The video processing was supposed to be like being on an acid trip. The effects were interesting, and electric, like acid, but the film was terrible.

I was on the street about a week and a half and somehow ended up meeting and staying with some women I met, Wendy Banks and Marria Eermie, in an apartment building at Christie and Bloor, overlooking Christie Pits. I slept on their couch for a while, but soon was in a relationship with Marria. Marria liked to stay home and cook and knit. Wendy was a character, had a great Ontario accent, and had zero domestic inclinations. She liked to drink beer and chain-smoke Player's Light cigarettes and watch the Leafs and Argonauts play on TV. Neither woman was particularly interested in art, although Wendy and I made a wonderful series of photographs, where she modelled a white bra and panties over a black long-sleeved top and matching black tights. I shot stills of her writhing around on the couch and emoting her sexuality through her exaggerated facial contortions. Wendy seemed somewhat amused by my monologues about technological culture and art and told me I sounded a lot like Glenn Gould. I didn't know who Gould was but told her I did, all the while thinking she meant Robert Goulet, the schmaltzy Canadian crooner. I remember having my first American Thanksgiving abroad with Marria and Wendy and some of their friends, and watching the Argos lose the Grey Cup, televised from Vancouver, to the Calgary Stampeders, 14–11.

Marria and Wendy had day jobs, so I would wander the streets alone and one afternoon made a point of checking out the Art Gallery of Ontario (AGO), which was hosting a Tom Thomson show. I had never seen any paintings by the Group of Seven — so that was quite an eye-opener. The Group's modernism was so fresh and convincing. The Thomson show was designed to deliver the audience to the AGO's whole collection of paintings by the Group. I remember being particularly knocked out by some iceberg paintings by Lawren Harris. In the AGO bookstore, I found a copy of *Avalanche Magazine*, and as I stood there reading it I noticed a reference to A Space, with regard to video documents of performances by Dennis Oppenheim and Vito Acconci. I scribbled down the address — 85 St. Nicholas Street — and checking my map of Toronto, I immediately walked over to A Space.

85 St. Nicholas was right in the centre of downtown Toronto, just a shade south and west of Yonge and Bloor. A Space was a two-storey narrow brick building, painted white inside and out. The building had been a horse stable for the police back in the days when most of the force was patrolling the city on horseback, and you could easily imagine how scores of horses' rear ends once defined a corridor the length of the ground floor, half a block deep, like the architecture of the livestock building in any agricultural fair. The ground floor was pretty clean, but there were

ladders and wires hanging everywhere. The place was under construction. There was a freshly painted grey concrete floor and two rows of white pillars every ten feet or so for the entire length of the space. I heard some voices upstairs, and so I said hello like I was asking a question and was invited up by a woman's voice. At the top of the stairs I was greeted by Marien Lewis, who I would soon learn, was basically running the place.

Marien was one of the initial group that had founded A Space in 1970. The story was that Chris Youngs had started with family money a private gallery called the Nightingale Gallery in a building on St. Joseph Street. Youngs was losing his shirt because he made some bad business decisions, including showing interesting, but not very commercial, work. An American draft dodger named Robert Bowers, one of the artists showing at the Nightingale Gallery, had befriended Chris and was trying to save the gallery by setting up a non-profit organization called the Nightingale Arts Council. Robert had been in Toronto since 1969 and could see the potential for funding from the Canada Counci and the Ontario Arts Council. Robert had met Marien, a hairdresser involved in the theatre scene, at the Festival of Underground Theatre.

The Nightingale Gallery remained on St. Joseph Street while it became the Nightingale Arts Council. Then, just before the gallery failed financially, there was a fire. Youngs disappeared shortly afterwards, and Bowers and Lewis were left shopping around this non-profit charter without a space, when they met Stephen Cruise and Ian Carr-Harris, who had just graduated from the Ontario College of Art. Sculptor John McEwen was also in the mix early on. These were the people who started up A Space: Robert Bowers, Marien Lewis, Stephen Cruise, Ian Carr-Harris, and John McEwen. They found the space at 85 St. Nicholas, signed a lease, and began living the mission of fostering and delivering contemporary art to the public under the auspices of the Nightingale Arts Council. Pierre Trudeau was prime minister, and the great socialist cultural experiment was gaining momentum. Bowers, Lewis, and Cruise were there when the grants started rolling in. Ian Carr-Harris bailed very early because he just wasn't into the co-operative thing. John McEwen was quiet and not really suited for life in the city. He was converting a blacksmith's shop into a sculpture studio somewhere up north, and he, too, disappeared.

When I had wandered into A Space in the winter of 1971, Marien was very pleased to tell me they had just scored a Canada Council operations grant, and as she put it, the "master plan" was falling into place. Marien was basically one of the "boys." She was a big-busted woman with a small frame. She was warm and light-hearted and had the propensity for turning every mundane, ordinary day into an opera. She sang at the top of her lungs about everything: running out of staples, leaking pipes, love and war and heating bills. Robert Bowers was absolutely sure of himself, smoked cigarettes through a black cigarette holder, and always seemed like he was wearing a beret, even when his head was bare. Stephen Cruise was quiet

and walked around in slow motion. When he spoke it was always just a few words, followed by a little trailing laugh. Stephen and Marien were a couple. Not a happy couple, but a couple.

Marien *was* A Space, for all practical purposes, that winter and throughout the early years. She loved people and embraced every stranger who was attracted to the interdisciplinary idea of A Space. A Space was conceived as a cauldron for artists of all stripes to mix and collaborate and boil over. The energy from the sixties was still happening and we were all thinking cultural revolution. There were few rules and every day was crazier than the day before. Marien could read people quickly, and when she decided you were all right, she would do anything for you. She was warm and kind and would wax on about the potential of A Space and Toronto and Canada with great imagination. When she found out I had worked in video as an artist, back in Michigan, she told me they were going to need me at A Space, and she would then look you right in the eye and dramatize the part of the "master plan" you needed to hear to get you on board. She introduced me to everyone — writers and dancers, accountants, sword swallowers, government bureaucrats, you name it — and A Space was drawing volumes of creative people from everywhere. Marien loved A Space and everyone who wanted to be part of the dream.

By the new year, 1972, it was clear that A Space was about to expand as the Ontario Arts Council was beginning to come around, and there were these big grant programs, LIP (Local Initiatives Program) and OFY (Opportunities for Youth), being advertised by the federal government. There were hundreds of thousands of young people that were mostly unemployed and hitchhiking around in the early 1970s. The Canadian government, under Trudeau's leadership and vision, was seeking ways to harness what they saw as the unfocused, idealistic energy of Canada's youth. A Space was about to tap into some major funding streams. Being flat broke myself, I could hardly wait. I had moved into a room on Bloor Street, across from Varsity Stadium, the University of Toronto's football field. I was hanging out at A Space, picking up a little work with an expatriate (ex-patriot) American carpenter from San Francisco named Jay McGowan, who was in charge of building a café on the ground floor of A Space. Robert Bowers had garnered quite a bit of experience working in bars and restaurants in upstate New York before he had immigrated to Canada — he even knew how to keep the soap spots off glasses in a dishwasher — and wanted to use the income from a café at A Space to pay a good portion of the rent at 85 St. Nicholas. A friend of his from his days at Union College in upstate New York, a guy named Stephen Radlauer, had moved to Toronto, and was working with Robert on the planning and design of the café. Radz, as he preferred being called, was moving into the "inner circle" at A Space.

Marien told me I should get my shit together and get my landed-immigrant status, because she wouldn't be able to hire me unless I was legal. She liked Americans and had no problem

with helping me get landed in Toronto. She coached me on the process, found counsellors in Toronto to help me with the paperwork, and most importantly, she wrote me a letter stating that she would hire me as a "video technician" at A Space, and that as an employer, she needed my skilled labour. At that time, you could immigrate at the border if you had the promise of a job and you fit the description of a skilled worker needed in Canada. I drove back to Michigan, picked up all my worldly possessions, which weren't much — some tools and books and my vinyl record collection — and applied for landed-immigrant status from the cabin of my Ford pickup truck on the Canadian side of the Ambassador Bridge, the border crossing between Detroit and Windsor. I requested to immigrate to Canada, showed the Canadian customs' official my letter from Marien Lewis on A Space stationery, and he looked up "video technician" in his big thick book of desirable and not-so-desirable occupational skills. After totalling up my points for being young, college-educated, American, and accepting on faith that I was qualified to work in a video job waiting for me in Toronto, he smiled and welcomed me to Canada. He stamped my paperwork ("February 22, 1972"), gave me a temporary landed-immigrant card, and sent me on my way. As I drove across the rich, flat farmland of southern Ontario, the sun was setting behind me and cast an impressive rainbow through a light winter drizzle on the dark cloudy sky up ahead. With Richard Nixon's corrupt government and the hopeless culture of American's unjust war in Vietnam behind me, I was looking forward to my new life in Canada.

A Space landed an LIP (Local Initiatives Program) grant of $112,000, which was a ton of money in those days. And right after that, an OFY (Opportunities for Youth) grant also came in. The Café was up and running and I was on salary, putting up two-by-fours and plasterboard, building darkrooms and a video studio and improving the gallery upstairs with a lot of other people. Marien, Robert, Stephen Cruise, and Stephen Radlauer were running a revolving door of interviews and must have hired a dozen people on these grants. We all had different skills — I can't remember everyone, but I do remember Gary Marcuse, Bill Bradd, a couple of Michaels and Chris and Rob, etc. The grants involved a lot of interim reports and contributions in kind from the recipient organizations. For instance, A Space had to supply the materials, the lumber, plasterboard, and so on, if it were to hire a crew to renovate A Space. A Space didn't have any real money, so Robert called a meeting and explained that everyone on salary would have to kick back part of their weekly wages for materials. I would start out making $75 a week, be paid in cash every Thursday, and be asked to give back $25 to the kitty for building supplies. We all believed in the mission and went along with this scheme. Then after working for ten weeks we could be laid off and then be eligible for UI, unemployment insurance. We could work as volunteers at A Space while being supported on UI for up to six months, and then when our benefits would run out, we would be put on salary by A Space again. This went on for years. There were always scams like this at A Space, but we never felt guilty because we always worked our asses off and

honestly, great things were happening. We were building the model for artist-run centres across Canada and the US, and we were building our scene in Toronto.

There were casualties. Jay McGowan, our master carpenter and plumber, was still working for cash under the table because he kept balking at getting his landed-immigrant status. Meanwhile, Robert was hustling a retired advertising executive named Bill Graham, who was presenting himself as a wealthy patron of the arts, going to all the openings, and buying art. Graham lived in a luxury high-rise apartment and wore expensive clothes. He had given A Space $3,000 toward its rent before the grant money began flowing. Jay told me that Graham, who was gay, had come onto him and that he was rattled and undone by the incident. A couple of days later, I convinced Jay it was time to get landed-immigrant status so he would be less dependent on the various schemes that floated A Space. I drove him, with all his carpentry and sail repair tools down to Buffalo. We had no trouble getting into New York, but Jay was a wreck — he was so nervous as I coached him on how it would go as he applied for immigration to Canada from my truck. We crossed the Peace Bridge early in the evening, and when we got to Canadian customs, it was Jay's luck that he got the customs officer from hell. This power freak interrogated Jay and scoffed at the letter promising him a job at A Space. I wanted to tell this jerk that Jay really was a skilled carpenter and plumber (the rest of us were learning, painfully slowly, on the job), but the customs officer had already told me to mind my own business when I had tried to speak for Jay from the cab of my truck. He took Jay into a back room and when Jay came out I knew he wasn't going to make it. A security search had turned up a criminal offence on Jay's record in the US, and Jay was being refused entry to Canada. We turned around and went back to Buffalo. I told Jay we would try another bridge, and just get back to Toronto to regroup, but he was completely defeated by this time. He told me to keep his tools, as he really wanted to go back to San Francisco, and that this was meant to happen. I left him at the bus station in Buffalo, returning to Toronto without him, never to hear a word from him again.

Other far worse things were about to happen, but first there was more optimism and another round of hiring. Marien and Robert told me the video studio and a program of video screenings and production workshops were the next priority. Video was the new technology of the day, and it was a particularly sexy activity in the minds of those running grant-giving agencies. In late March and early April 1972, Isobel Harry, Lisa Steele, and Andrew Tuffin were brought on board. I remember Isobel and Lisa were interested in photography and writing, and Andrew was a writer who was interested in helping A Space start their press. Lisa, who wore a broad-brimmed farm-style straw hat, and I hit it off right away, and with Andrew and Gary Marcuse, we formed a small cadre of like-minded individuals within the chaos of A Space. We weren't in the inner circle, but we were becoming a force within the organization. We were mixing carpentry with the directed goals of providing photography and video

production resources for artists. Isobel was working more closely with Marien, writing grants and doing publicity. Marien convinced Robert and Stephen that Lisa and Gary and I should be given the autonomy to take A Space's involvement with video to another level.

As early as the spring of 1971, the original Nightingale group had formed a relationship with a Sony video dealer named Jack Paterson. Jack had provided the video equipment when Oppenheim and Acconci had done their performances at A Space, and Robert and Stephen had made video performances themselves around the same time. Jack gave A Space a Sony CV-2200 reel-to-reel studio deck and a camera. Paterson was trying to expand his market for portable video equipment beyond the universities and colleges and government studios in Toronto, and the non-profit arts sector seemed to him to have real potential. At that time there were only three places you could see video in the whole city of Toronto. Home VCRs, Betamax, and VHS were a full decade away from realization, and A Space, Trinity Square Video, and the Ontario Educational Communications Authority, later called TVOntario, were the only video centres in the city.

Jack Paterson's company was called Pat's Video, and it had a very modest space that smelled like warm plastic. Early video gear ran very hot and always smelled like it was about to catch fire. Pat's Video wasn't really a storefront operation but was a low-profile, second-storey, back-room kind of place with boxes of video equipment and a phone. I was surprised how small the place was, but in retrospect, there wasn't much of a market for video back then. Jack didn't seem to know much about video, but his assistant, Marty Dunn, seemed to know everything. Marty was tall and wore his long hair in a tight braid. Marty was the founding director of Trinity Square Video, which was getting started about this same time in the former Church of the Holy Trinity, an old stone church directly behind the Eaton Centre. Jack loaned us our first video equipment so we could get started at A Space. There wasn't any paperwork or anything. Marty brought us a grey half-inch reel-to-reel studio deck and a camera and a tripod and some cables and a monitor. Everything was dull grey. This was all from the "CV" series that Sony had launched in 1964. We were starting out with old gear.

I had worked a bit with this exact same equipment when I was in Ypsilanti. There was a new professor at Eastern Michigan University, a guy named John Orentlicher, who had just finished his MFA at the Art Institute of Chicago. I was already out of school and was just hanging around Ypsilanti, working at Ned's Student Bookstore, buying and selling textbooks. John and I met at a party and he said he heard I was interested in video. I told him I was, and the next thing I knew he had six of the same closed-circuit systems we would later use at A Space, and we were making tapes and patching systems together in Eastern's gallery space over the Christmas–New Year's break of 1970-1971. The first video work I ever made was a document of a performance where I stepped closer toward the camera in one-minute

intervals while I hyperventilated until I passed out. I fell out of the video frame and hit the floor in just under eight minutes.

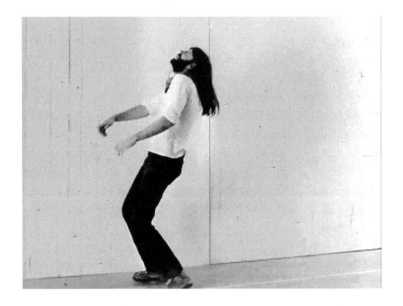

Still from Tom Sherman's third *Hyperventilation* performance, Ypsilanti, Michigan, 1971. From Andrew Lugg's 16 mm film *Trace*, shot in fall 1971 and released in 1972, 7 min. 40 sec.

Lisa Steele and I would begin teaching video workshops at A Space in the summer of 1972. Gary Marcuse and Lisa and I were inseparable for a time, but one day when Lisa was teaching me how to print photographs in A Space's deluxe new darkroom, we just started making out and couldn't stop for a couple of weeks. Gary moved to Vancouver soon after that. By June, Lisa and I were living together in her ex-boyfriend Kim Andrews's loft space on Temperance Street, just a few doors west of Yonge Street, directly across from Aikenhead's Hardware. Lisa and Andrews, a painter and professor at U of T, had just called it quits, and Andrews was travelling. The loft was raw and came complete with badminton rackets to swat the bats when they got out of control. There wasn't a breath of air in the loft when it was hot and Toronto's summers were gruesome and smoggy. I remember one night we were awakened by an alarm as someone had broken the front display window of Aikenhead's store and stole an electric fan, which was running with ribbons streaming in its breeze.

Lisa was into photography and novels and herbal teas. She had come to Toronto with a group of draft dodgers from Kansas City, Missouri. I think there were four couples, including Lisa and her husband. She had been married to a blues drummer named Cash Wall. They had split up shortly after they arrived in Toronto. Lisa had supported herself by working as a nude

model for drawing classes at the Ontario College of Art. I would later testify (in 1974) that she was living with me, common law, at her divorce proceedings. Cash was a great drummer with a lead-heavy beat, and a nice guy. He was playing in the Downchild Blues Band when I met him.

There were probably over a hundred thousand Americans living in Toronto during this period. The Vietnam War had caused a mass migration of "ex-patriot" Americans to Canada. From 1968 to 1971, there was wave after wave of deserters and draft dodgers, young men, and their loved ones, who had to leave the States or face imprisonment, or be forced to fight in a war they didn't believe in. And after the dodgers and deserters, a number of us immigrated to Canada simply because we couldn't stand to live in the States and its culture of war and deceit. We were pissed at the American political system. I personally couldn't bear the guilt and embarrassment of being part of a culture built on lies any longer. I had already beaten the draft before I decided to move to Canada. I had failed my draft physical due to a bad arthritic back, and because of some psychological issues, which I had concocted myself to make sure I didn't have to go to Nam. But guys like Joe Bodolai and Robert Bowers were in Canada because they had evaded the draft. They couldn't go back to the States without facing arrest. This mass migration of Americans was unprecedented in modern times. The exodus during the war in Vietnam had caused a brain drain in the States, and Canada was being enriched by a massive swarm of young, college-educated, English-speaking idealists. It must have been bewildering for Canadians to have all these young Americans moving into Canada. In places like Toronto, which was already full of immigrants downtown (you rarely met anyone who had grown up in the city), we felt we fitted right in. We formed our American ghettos, next to the Chinese, Portuguese, Italians, and Jamaicans. We were so grateful to be given a second chance to do something positive with our lives.

That summer we built the video studio at A Space, as we simultaneously conducted workshops on using Portapaks. I remember we had a visit from Michael Goldberg, a Canadian from Vancouver, who was on a mission to network all the developing media organizations in Canada (film, video, community radio . . .). He stopped by to find out what we were up to, and it was interesting to hear what was going on in Vancouver. Intermedia, the New Era Social Club, and the Image Bank were all happening (Al Razutis, Gary Lee-Nova, Ed Varney, Gerry Gilbert, Carole Itter, Glenn Lewis, Michael Morris, Vincent Trasov, Eric Metcalfe, and Kate Craig were then experimenting with video), and we were also beginning to get a sense of video activity in Montréal. Tom Dean had brought some tapes over from Véhicule, and we knew about the Vidéographe. Michael Goldberg was an earnest fellow. The day he arrived we were unloading a truckload of plywood and plasterboard. Michael, wearing bib overalls without a shirt, actually pitched in to help us carry the materials into the bowels of A Space. Handling half-inch gyprock and three-quarter-inch plywood isn't much fun, but he pitched right in

without a moment's hesitation. A few years later, in 1975, Goldberg would become the first video officer at the Canada Council. Networking was his game.

We were trying to build a studio with real studio lighting and decent acoustic properties. We were crazy about acoustic tiles and covered every surface we could find with sound-absorbing material. The concrete floor defeated most of these efforts, but the place was beginning to sound like a studio and not a bathtub. The lighting was more difficult, as the place had to be completely rewired. Fortunately, Robert and Marien had enlisted the services of an eccentric, nearly blind electrician (he wore really thick glasses) who went only by his first name, Michael. He was a big, gentle man who practised the Baha'i faith. The Baha'is, he told me, believe in loving the whole world and in serving the world in any way they can. Michael committed himself to getting A Space properly wired, even though he was being paid a tenth of what he was worth. He taught us as he worked, stressing the need to balance the circuits to ensure pure and unwavering illumination for our studio productions. The crazy thing about Michael was he never turned off the power when he was working. He would take a shot of 220 volts and literally get knocked off a ladder — but he would just get up and twist and stretch his neck from side to side and wring his hands with some determination, and then disappear for a few minutes to get a drink of water and compose himself. I saw this happen three times with my own eyes. Somehow he survived the job and designed and built these beautiful lighting grids. When the studio was done, he told us he was setting out on a pilgrimage to somewhere in the South Pacific, to take up another cause. The last time we saw him he was filing down the already radically chopped-off handle of his toothbrush, to reduce its total weight. He said when you are travelling with everything you own in a backpack, it is important to eliminate every little bit of extra weight.

We never used the studio to shoot much video. We shot some interview tapes late at night when the Café was closed and people weren't walking around in the gallery upstairs. We used the space mostly for editing and titling tapes we had shot with our Portapaks. Lisa and I had generated a little money for A Space by shooting a documentary on an archaeological dig near Penetanguishene, Ontario, on the rocky shores of the Georgian Bay of Lake Huron. The Royal Ontario Museum had commissioned a tape to show people what an archaeological dig was actually like. We had spent three or four days observing and interviewing a group of young archaeologists, and our Portapak-wielding presence had ended up spicing up what was probably a typically mundane dig, where day after day was spent on one's hands and knees digging through carefully measured and delineated squares of earth with spoons and what looked like dental tools. Our "documentary" ended with these self-conscious, media-savvy archaeologists performing a tobacco-smoking ritual, while overlooking an island said to be a giant, sleeping Indigenous man. As we watched through the eyepieces of our Portapaks, we saw people dedicating themselves to the task of recovering the material history of a frequently

used First Nations campsite, and as these archaeologists were identifying with the ghosts of these people, they were simply acting out the way they thought these deceased people must have acted. They didn't tell us much about who these Indigenous people actually were, but they wanted to dramatize how these people must have acted. It was quite bizarre how theatrical their performance was. It was the first time I realized that the mere presence of video gear could animate and transform behaviour to this degree.[1]

We made quite a few tapes throughout the summer and fall of 1972, but the shoot I will never forget was the one we did with the guys who started the animation studio Nelvana. Michael Hirsh, Patrick Loubert, and Clive Smith had contacted Marien because they wanted to make a videotape of Pascal, in drag, singing torch songs to World War I veterans at a Royal Canadian Legion Hall in downtown Toronto. Pascal was the dashing, female persona of Stuart Murray, a cousin of the famous Canadian vocalist, Anne Murray. Lisa and I set up the video, audio, and lighting one afternoon at the Legion Hall. Then early that evening, Pascal, dressed in a beautiful red evening gown, stood tall next to an upright piano being played assertively by a young woman brought in by the Nelvana crew, and sang her brains out, enthusiastically joined by Marien. The vets were very old but super stimulated, and completely inebriated, as the Nelvana boys had brought along a couple of cases of beer to get the vets in the mood. Lisa and I were the only people in the hall not singing after the first couple of songs, and the festivities went on for a couple of hours. There was so much joy and laughter, it was very hard to focus on the camerawork. Either the vets didn't know that Pascal was in drag, or more likely they didn't care. Pascal sang beautifully in her deep, rich voice. We gave the unedited video recordings to Michael, Patrick, and Clive, and edited our own version for the A Space archives.

The Nelvana boys were a lot of fun. Clive drove around in an old bread truck with a clear Plexiglas bubble-like dome protruding rather prominently out of the truck's roof. They were into animation and children's TV series programming and went on to make *The Adventures of Tintin*, *Babar*, and *Care Bears* for TV. They did scores of animated features and eventually produced animated versions of *Beetlejuice* and *Ace Ventura: Pet Detective* for the television. They also did the animated versions of the *Star Wars* TV spinoffs and even had a planet named after their company in the series. I always wondered what they were going to do with the video we called *Pascal Entertains the Troops*, but I don't think this material ever saw the light of day as a Nelvana project.

Marien was still singing and serving as A Space's ambassador, but she was crying a lot as well. Marien's daily opera was turning very dark in tone. She was doing most of the grant

1 Looking back today, it is recognized how problematic it was to present Indigenous life and culture as rooted solely in the past and to appropriate sacred ceremonies without express permission from the Wendat, Mississauga, Anishinaabeg, and Haudenosaunee on whose territory the film was made. There was not much consideration given to such issues then, nor were those involved likely aware at that time.

writing and generally seemed unhappy with the way things were going. A Space was getting more and more complicated and cumbersome from an organizational point of view, and artist-run centres are what they are: organizations run by artists. Everyone was playing in parallel, but there wasn't much co-operation. The inner circle called a meeting and announced that A Space was going to get out of the gallery business. Marien said she had had a dream where she was a nurse and the whole second floor of A Space was lined with hospital beds full of artists, broken and ailing artists, and she was caring for all of them, easing their pain and nursing them back to health. Marien wanted to be the Florence Nightingale of the Nightingale Arts Council. She was only half joking. She was talking about setting up a counselling centre for creative people — visual artists, poets, musicians, playwrights, and actors — to come together to express themselves and find support and learn about how others were facing the same problems. Basically, she was already functioning in this way, in her mind, but she wanted to close the gallery and install the beds. I didn't want to see the gallery close, so I volunteered to run the gallery that fall, to take care of the shows that were already scheduled, and then curate another season. Marien, Robert, Stephen, and Radz, checked with each other through a brief, silent sequence of glances, and a moment later Marien told me I could start on Monday.

One morning we learned that Michael Segal had hanged himself. Michael Segal had taken some video workshops at A Space and was working with Radz on a documentary tape on Alex the Holy, a famous homeless evangelist. I didn't know Michael very well. He was around but was always moving pretty fast, and we only spoke briefly a couple of times. He was an artist without much focus and just trying to get by, like many of us. He was intense and serious. He and his wife were sort of on the edge of the A Space scene. Michael had done a public art project out west involving billboards — Marien seemed to know him before he showed up and said he was okay — and now he was back in Toronto trying to get something going. I don't know what they were doing for money, but Michael's young wife worked at the Café. After finding Michael in their Cabbagetown apartment, I remember she came to A Space later that morning with their two little girls; they were probably three and four years old. They were wearing brightly coloured little cotton dresses. Their mother wasn't much more than a young girl herself, and her long, strawberry blond hair hung down over her face. Marien and Lisa were consoling her and walking her through what she had to do next. I just remember the sadness was so palpable, like we had all been punched in the gut.

Late that week Radz showed me the video recordings he and Michael had made with Alex the Holy. Alex was monologuing about force fields and electric currents inside of humans, and how these currents were positive and negative and, if short-circuited, could lead to universal displacement. Alex would stuff tissues into his ears so this energy wouldn't leak out, and he talked about wrapping himself in copper. Alex was old and decrepit, but his energy was good and he was very photogenic. He was a mountain of a man with his long

hair and beard and many layers of clothing. Michael's voice was scattered throughout the rough tapes, asking a series of questions, probing deeper and deeper into Alex's theories on the body electric. Michael's voice was kind and concerned and respectful. Alex was crazy, but he made a lot of sense.

The gallery at A Space was booked until mid-January. The first two shows I remember installing and sitting with were Bob Bozak's and Bill Jones's. Bozak had made these slick, brightly coloured ceramic hockey pieces, and it made me wonder why we were showing this kind of work at A Space. Personally I wasn't offended by "jock art," but sports and art rarely mix well. I was more concerned with the iconic, sculptural normality of the show. Some of the pieces were quite powerful: full-sized ceramic Montreal Canadiens hockey jerseys with numbers of historically significant players I didn't know, and hockey sticks and pucks, all made out of ceramics with beautiful shiny glazes. The saving grace of the show was there weren't that many objects, maybe half a dozen, and the blue-and-red-on-white colour scheme was pretty impressive throughout the huge, largely empty gallery's white walls and dark hardwood floor. It was clear to me that sparse was good. Our shows were only up for a week to ten days at a time, and Bob commuted in from London every day to sit with his work, and talk with visitors. I thought he would sell a few things, but he didn't. He carried a black metal lunch bucket and always ate cucumber sandwiches on buttered white bread.

Bill Jones was from Vancouver. He was a talker, had been in the US Army in New York City, and had deserted. Here was a guy who got drafted, but was lucky enough to end up running an Army motor pool in Manhattan, delivering cars to officers. He said the routine was driving him nuts, so he made a break for it. He ended up in Vancouver, married to a registered nurse, who he never saw because she worked nights. He was into conceptual photography, taking pictures of pictures of pictures. He had made these photo-card tables that embodied his personal history and all kinds of spatial jokes and visual narratives about gambling and migration, stuff like that. They were beautiful technically, but very busy and complicated and difficult to sell as ideas. They were fascinating on the surface, but too complicated and convoluted for viewers to unravel. Bill kept telling me he had done all of Michael Snow's best photo pieces before Snow, but that he was the victim of zero exposure because he was on the West Coast.

By this time I had gotten over my grudge against Snow. I had met him a second time in Toronto, when Robin Collyer introduced us at Robin's first solo show at Carmen Lamanna's gallery that past winter. The Lamanna Gallery was just a couple of blocks from A Space, on Yonge Street, north of Bloor, next to the Isaacs Gallery. Robin had made these elegant sculptural pieces out of ratty materials. He would do things like make a bowed arc out of a curtain rod-like strip of metal and pin the ends to the wall, a couple of feet up from and parallel to the floor, and then support the middle of the bowed strip of metal with a stiff

rectangle of corrugated cardboard standing straight up from the floor. Then he'd light the piece from below so the shadows would make a looping, bow-tie-like drawing at the base of the wall. Snow was kind and supportive as he ribbed Robin about being a cheapskate with his choice of materials. Snow was always joking around, and talked like he was playing music or making his art, improvising and pushing for new ideas with his quick wit and relentless energy. But under the competitive, jabbing, percussive, sometimes brutal critique of Collyer's show, delivered straight up, right in Robin's face, Michael was supportive and generous and sweet. Robin always enjoyed a good laugh, but I don't think I ever saw him enjoy himself more than on the night of his first solo show, with Snow going at him.

For whatever reason, Michael Snow didn't come to A Space very often. He didn't come to Bill Jones's show. This drove Bill up the wall. One of my main objectives was to get the same audience that Av Isaacs and Carmen Lamanna were getting. We did get some of their audience, especially on Saturdays, but the problem was we couldn't get any reviews in the city's major newspapers. A Space had spawned *Proof Only*, and later *Only Paper Today*, but these art tabloids were obscure, erratic, and confined to the limits of the scene. Toronto had always had the same problem: the lack of an art press. The *Globe and Mail* was the paper that people read for serious reviews. The *Toronto Star* was the other option, but it had always catered to an audience less likely to hit the galleries or know much about art.

Kay Kritzwiser was the critic at the *Globe and Mail* at the time. She had obviously completely missed the shift toward conceptual art and the crisis in modernism in the mid to late sixties, and still believed religiously in the primacy of painting and sculpture and printmaking, that wall art and discrete objects for sale in galleries were visual art's only legitimate forms. Kritzwiser supported Av Isaacs and his stable of artists, which included William Kurelek, Graham Coughtry, Gordon Rayner, Dennis Burton, Tony Urquhart, Walter Redinger, Mark Prent, Michael Snow, and Joyce Wieland. Coughtry and Rayner could paint, but to my eye it was nothing but lightweight painterly abstraction, loose and lyrical, but completely without urgency. Dennis Burton was a throwback to pop art, painting garter belts and other forms of women's underwear and abstractions based on genitalia. Mark Prent was stealing most of the attention with his exhibitions of mutilated, wax-museum-like figures. During Prent's first show at Isaacs Gallery in 1972, Av Isaacs was actually charged with exhibiting a disgusting object under an obscure section of the Criminal Code. Prent's work was heavy, dealing with issues like capital punishment and sadomasochism. Charges were later dropped, but the Prent show generated a lot of press. Kritzwiser would give Lamanna's artists an occasional nod. They were clearly the more cerebral, less expressionist counterpoint to Isaacs's stable. I couldn't even get Kritzwiser to answer my phone calls. We considered trying to buy reviews by advertising in the *Globe*, but we couldn't really afford to do so, and it wasn't our goal to become another sales outlet for object-based art. Nor were we cultivating another

fixed stable of artists. We were offering a beautiful space for contemporary, experimental, non-traditional art. We wanted to be recognized as an alternative, interdisciplinary arts space. The *Globe* remained invincible and exclusive.

The *Toronto Star*'s art critic was a man named Sol Littman. Littman didn't have an art background. He was an academic sociologist turned journalist. As a young Canadian, he had spent several years in the States, doing research into American radical right-wing organizations, such as the John Birch Society, and neo-Nazi groups, such as the American Nazi Party. He had joined the staff of the Anti-Defamation League and, through his analysis of white-collar anti-Jewish discrimination in the auto industry, had made his mark exposing racial and ethnic housing discrimination in the wealthy suburbs of Detroit. In 1971, he returned to Canada and was editing the *Canadian Jewish News* when he began writing a biweekly column on the arts for the *Star*. To his credit, Littman looked at everything being shown in Toronto, and he came to every show we did at A Space. I think he was honestly intrigued by a lot of the work we were showing, but he had this chip on his shoulder because he believed "modern art" was a sham. He took up the role as the defender of the general public and decided that anything he couldn't immediately understand was some form of conspiracy. I was patient as I could be with Sol and talked with him, at length, every time he came to A Space. The only person more needy than Littman was Roald Nasgaard, an art historian who came to every one of our shows and asked the weirdest questions about the intent of various artists. Nasgaard would take nothing for granted and take meticulous notes when I responded to his questions. An afternoon of Littman and Nasgaard combined would drive me right up the wall.

We had a particularly difficult series of shows in October and November 1973. Joe Bodolai installed a show of conceptual sculpture, mostly text, including some collaborations with Stephen Radlauer. Joe and Radz had founded an organization called the Cliché Guild of Canada, where they would claim they had originated any cliché they found attractive, and then they would accuse everyone else of copying their idea and therefore doing work derivative of theirs. They were having a field day with the way art and culture were a reflexive continuum, and were sending out letters asserting their ownership of a wide range of clichés. They printed up stationary and had rubber stamps made and were having a great time making mail art that was essentially critical of art that claimed specific ideas as discrete entities. Sol Littman didn't get Bodolai's elaborate jokes and for some reason, he became infuriated.

Right after Bodolai's show, we hosted a demonstration of the Paik/Abe video synthesizer. Walter and Jane Wright brought a couple of Paik/Abe synthesizers to A Space from the Experimental Television Center in Binghamton, New York. The Paik/Abe synthesizers were sophisticated, powerful instruments that permitted the manipulation of video at the abstract signal level. We ran a four-day workshop, letting visitors to A Space play with these

synthesizers. Right after that Ross Skoggard installed a piece called *paintings*, which was composed of thousands of Post-it notes, with their pastel pink, yellow, and blue squares covering every inch of our gallery's walls in an elaborate, all-encompassing minimalist grid. Ross worked for days getting the Post-it notes stuck to the walls in completely precise grids and working out the pink, yellow, and blue areas so each colour had areas that it dominated. It was a simple idea, but well executed.

When Skoggard's "paintings" came down, Lily Eng and Peter Dudar moved in. Eng and Dudar were becoming well known for their "movement presentations," a radical extension of Merce Cunningham's incorporation of everyday, routine human movement into performance. Eng was an amazing dancer, precise and athletic in her movement, often incorporating the martial arts and various forms of shadow kick fighting into her performances. I thought they were going to do a series of live performances, but they decided to exhibit the material residue of one of their performances, rather than focus on the performance itself. The night before the opening, they brought some lumber into the gallery and, with a circular saw, they cut three or four ten-foot two-by-fours into two-by-twos. They then took these and threw them through the small windows of the space, at the top of the walls, right under the ceiling, breaking all the windows and leaving the two-by-twos hanging partially in the gallery. They then swept up the sawdust and forced each other to swallow it, in turn vomiting this sawdust into a glass jar, which they left on the floor. I was horrified when I opened the space and found all the windows smashed, the two-by-twos sticking through the broken windows, hanging in the space, some of them resting on the floor. When I called them up to ask what the fuck had happened, Dudar assured me that they would replace the glass and fix all the damage after their show, and he explained their piece and asked me not to throw away the jar full of saw-dust-induced vomit, as it was a key element in their installation. I suggested they write up a description of their action, as the evidence left far too much to the imagination, and they did so.

As the curator and gallery director, it was my job to explain this kind of work to the visiting public. Sol Littman had become increasingly hostile. Although he wasn't writing about our shows and seemed pleased to be able to withhold his coverage, he had come to the conclusion that we were harming the public through our offensive, disrespectful work, and of course we were abusing the public trust by spending grant money on what he considered to be an elaborate, elitist scam. I was trying to convince Littman otherwise, somewhat naively believing he would someday be kind enough to actually review one of our shows. Robert Bowers wasn't much help, as he was by this time obsessed with playing "go," an ancient, completely open-ended, impossibly complicated version of Chinese checkers, and running continuous workshops on the merits of the game in the gallery's office space. Marien was singing while she was between phone calls about various things we shouldn't be sharing

with the public, like the Ontario Arts Council's impossibly convoluted criteria for sustaining operational funding.

Finally, Littman wrote us up in the *Star*, making fun of our fall season of shows, implying that we were criminals stealing from the public purse, and saying some pretty insulting things about me personally. The next time he came in, we were showing Colin Campbell's videotapes, *The Sackville Series*. Without even glancing at Campbell's tapes, Littman asked me what I thought of his article. I told him I thought he was a little, power-crazy prick who wouldn't recognize art if he had a mouth full of it — and not only didn't he get the point of most contemporary art, I had concluded he would never get it. We stood toe-to-toe and yelled at each other in front of a small audience of strangers, both red-faced, to the point where I wanted to hit him, but he made the first move. He took the brown leather gloves he was holding in his right hand and struck me in the chest, in a gesture that seemed from another time. It was as if he had challenged me to a duel. He then turned and clomped down the wooden stairs and out the door, never to darken our doorway again. Shortly after that he left his art post at the Star and joined CBC TV, doing documentaries on various social injustices. Eventually, he became one of Canada's most visible Nazi hunters and prison negotiators. The last time I saw him he was on TV, mediating the dispute between the Mohawks and the Quebec police, the RCMP, and the Canadian Army during the Oka Crisis in 1990.

The Experimental Television Center show that fall was important because it helped define the way Lisa Steele and I would approach video at A Space. In the early 1970s, Nam June Paik was making incredibly wild television programming at WGBH-TV in Boston, one of the flagship PBS stations in the States. Back then, PBS was actually funded generously by the US government, and stations like WGBH-TV and WNET-TV in New York had residencies for artists to experiment with television as a potential art form. Paik's groundbreaking television art programs, culminating with his broadcast classic *Global Groove* (1973), were a lot of fun to watch. Paik had an irreverent, eclectic, totally excessive style: more was better, and he always threw the kitchen sink at the audience. In the tradition of all neo-Dada art, Paik was obsessed with attacking bourgeois notions of fine art. Violins were smashed and pianos chopped up with axes. Paik would critique painting by simply automating the demolition with synthesized video. As early as 1965, Paik had declared, "The video camera is the paintbrush of the future." Paik had developed the Paik/Abe video synthesizer with Shuya Abe, a Japanese engineer, in 1969. The Paik/Abe synthesizer allowed artists to run straight, representational video or television programming through a series of analog circuits that distorted, colourized, and discombobulated the original material. The results were simply psychedelic, intoxicatively electronic. The Experimental Television Center show featured two Paik/Abe synthesizers, along with some video cameras, source decks, and decent monitors.

No matter what kind of video you used as input material for these synthesizers, and we were running everything we had into these synthesizers, including live camera feeds featuring the mirror images of our workshop participants, the end result was always a kind of electronic "painting." Walter and Jane Wright were promoting these synthesizers as cutting-edge instruments for making a beautiful, new kind of painting. They understood Paik's critique of painting, but wanted to go a step further by making serious electronic images — beautiful, electronic paintings that moved and evolved with the twist of a knob. The results were impressive. The Wrights were making a kinetic form of optical art. On the one hand, these screen experiments could be easily dismissed as "electronic wallpaper," but like any instrument, those who practise and perfect their playing get better results than rank amateurs, and the Wrights could really play the Paik/Abe machines.

After spending hours ourselves at the controls, and watching dozens of others processing video through these synthesizers in four jam-packed, intense days and nights at A Space, Lisa Steele and I were more convinced than ever that we wanted to reject the idea of tying video and drawing and painting together. We had been making our kind of video art, and both of us had several tapes under our belts by the time we were playing with these synthesizers. I had come to video through my academic background in sculpture, and was interested in systems, but convinced that video was best suited for documenting and extending performance. Lisa had come to video from her interest in photography. Both of us knew that video was a lot more than a frigging pencil or paintbrush and making paintings that moved was not one of our primary objectives. We were not interested in devolving video into an abstract form. One of the main problems with early video technology was its lack of resolution as a representational medium. Video already called more than enough attention to itself because it was such a crude electronic mirror. The image was fuzzy, especially after it had degenerated during the editing process, and video's audio was a nightmarish, monophonic disappointment. Why would anyone want to push the electronics of video into wildly oscillating colours and abstract forms when ideas and concepts were the name of the game, and when video as an instrument could be used to deliver people and the way they saw their particular world to other people? In our version of video aesthetics, we were going to emphasize content over form.

By the time the Wrights had brought these synthesizers to Toronto, Lisa and I had our own sense of video's potential and were beginning to see where we wanted to go with the medium. Throughout 1972 and 1973, we were making our own tapes, trying to make art with video, and at the same time we were making lots of tapes for others, exploring the power of video as a documentary tool. Video gives so much, instantly, through its real-time feedback, but when you turn video on, it sucks in the whole world around you. And while you are being intoxicated with its tremendous power to gather, the reasons you picked up the medium in the first place are likely to slip away. You have to live and breathe video for quite a while before you can get

on top of the medium. Lisa was struggling with the transition from photography and the still image to video's moving image with sound. She was also beginning to see the potential of video to tell stories, in the oral tradition. She was interested in theatre and the live stage. I dreaded going to the theatre and wasn't convinced video and drama would ever mix productively. Video amplified theatricality and turned the illusions of dramatic narratives inside out. Video was great for pumping up tiny, banal gestures. I was doing simple, minimal performances and recording them in video, and was playing around with editing structures to examine and expose the way performance was altered by video. While video was a common thread in our daily lives, we were going in different directions from the start.

We did both share an interest in literature. Lisa was a reading machine, and I was beginning to write. Sadly, I had managed to escape learning how to write in university, as art students often do. I was making sculptural installations, systems that gave material form to research and ideas, but I had little interest and poor instincts when it came to making things. I liked building things, experimental environments, speaker enclosures, and all manner of electric and electronic devices, but I was never very good at carpentry or soldering. I was too impatient with these processes. Craft never interested me, until I began to work directly with language to articulate my work. I needed to learn how to write and wanted to write well. I had been fascinated and liberated by the conceptualists that emerged in the 1960s. Sol LeWitt, Douglas Huebler, and Lawrence Weiner had laid down the groundwork. I wanted to extend their dry, formal, conceptual art language into a descriptive prose that could make vibrant images and flesh out the immaterial basis of the material world. I wanted to write about electromagnetic radiation and sex and love. I began my obsession with the written word. I started making texts composed of strings of deliberate declarative sentences. I would read fiction, and Lisa and I would talk a lot about books, but my taste for novels and the conventions of literature were falling by the wayside. I loved the linguistic acrobatics of Gertrude Stein and often wondered why literary prose hadn't developed into a more adventuresome discipline. I was always an advocate for more content and less emphasis on form, but twists in form were always necessary to explore new ideas. Alain Robbe-Grillet's books would soon grab me by the throat. The semantic nature of descriptive prose became my lifelong obsession.

Lisa was a serious film buff, and we began to go to a lot of movies. We went out and saw everything we could. We went to two or three films a week, often more, the whole time we were together. I had seen a lot of contemporary experimental film, and some classics, when I lived in Ypsilanti. Neighbouring Ann Arbor had good repertory cinemas and the Ann Arbor Film Festival. Toronto was simply an amazing city for seeing film. You could never catch up with the films you hadn't seen. Reg Hartt was showing the classics, and some contemporary film, all over the city. I remember we saw Jean Renoir's *Grand Illusion* and *Rules of the Game* back to back

on the same night at the Poor Alex Theatre on Brunswick Street. Renoir's films were incredible, profound, really, but a little slow. I was having difficulty focusing on Renoir's films as I was obsessed with building electronic devices from scratch. When I would look into the projected light of a movie screen I would see circuit diagrams and think through the problems I was confronting. I was building a tube-amplified Tesla coil that generated a three-foot, 50,000-volt spark in my studio in our apartment on Ross Street. Lisa thought it would be good for me to take a break (she thought I was going to electrocute myself), so we went out for some pasta covered with poppy seeds at our favourite Hungarian restaurant and then to the Poor Alex. My coil was powered by a hundred watts of tube technology, and I couldn't figure out how to keep the transmitter from overheating. I loved going to these classic foreign films because when the lights went out and the movie began I could literally superimpose the circuit diagram from my head onto the illuminated movie screen, and double-check the circuit, while I half watched the movie.

Movies to me were always stimulating because of the quality and intensity of the incandescent light reflected off the screen. No matter how boring the film, I loved to go to the movies because it always made me want to make things or write or talk a million miles an hour. It was the energy of the light, not the art of cinema, that turned me on. Instead of napping during art films, I used to work on my personal stuff. The cinema is ultimately a private space. I'd get enough out of a film to talk about it, and that night we stopped at the Brunswick Tavern, right on the corner of Brunswick and Bloor, to have a few drinks and talk about Renoir. I didn't tell Lisa I was pretty sure I had solved the problem with my Tesla coil. Instead, we talked about France and how wars change the course of history. We ended up drinking round after round of cheap draft beer with some people we met at the table we were sharing. At closing time, a handsome doorman, a dwarf who wore a tuxedo, would sing a rousing rendition of "Climb Ev'ry Mountain" (from *The Sound of Music*) and we would all toast him as we sang along. It was a tradition at the Brunswick to end a Saturday night with the little man inspiring the masses.

We were having a terrible time getting a decent straight-cut edit with the CV-series Sony video equipment at A Space. The only way we could edit was to patch a "slave" deck with the original material into a second "master" deck via video cable, and after getting both reel-to-reel machines cued up, rewound for pre-roll, and running, we would push the red record button decisively at the moment we wished the edit to occur and hope the edit would hold. Everything was done manually. We had to get both decks in motion because the first half-inch reel-to-reel studio decks didn't feature flying heads. You had to generate the proper speed for a successful edit by rewinding the tapes and making the edit while the tapes were on the fly. After the assemble edit was performed we would rewind the master tape and take a look. If we were lucky the edit would take place at exactly the right time (both tapes, on the slave and master machines, would have to be in the right place at exactly the same time) and wouldn't

be too noisy. This manual electronic editing technique was better than cutting and splicing videotape. Jack Paterson had actually supplied us with a splicing block, safety razor blades, and splicing tape when he delivered our first Sony equipment. If you physically cut tape with a razor blade (which was a common method for editing film and audio tape), the edit would make a horrible prolonged zzzzzzzzzzzzz sound, and the image would turn to video "snow" for a second or two.

I heard there was a video organization over in Rochdale, the high-rise tower that once housed Rochdale College, an experimental, student-run, free university created in 1968. This organization, called Rolling Thunder Video, was supposed to have a video-editing system that worked better than ours. Rochdale was associated with Innis College at the University of Toronto, but it didn't grant degrees. Rochdale was housed in an eighteen-storey high-rise at Bloor and Huron and was one of the largest co-operative learning environments ever created. A number of wonderful things happened at Rochdale, but the building and its residents fell victim to drug dealers. By the time I set foot in Rochdale, things had degenerated badly: the place was filthy and a little bit scary.

I cleared security, talking my way through a couple of hippie ranger types, and took an elevator up to the eighth floor. The hallways were long and dimly lit. Building maintenance had basically collapsed. Most of the ceiling lights were burned out or missing. There was a German shepherd taking a shit in the hallway between me and my destination. I waited for it to finish. The dog studied me, but remained passive. From the state of the carpet, people on this floor just let their dogs go out into the hall to do their business. A moment later, the dog's owner let his shepherd back into his apartment. I dodged the fresh mess and at the very end of the hall I found the door with the Rolling Thunder Video sticker on it; red San Francisco–rock poster letters outlined in white on a black background. I knocked lightly and was greeted by a young man wearing a T-shirt and blue jeans. Jim was skinny, barefoot, and had a ponytail. The apartment was clean enough but there was hardly any furniture. There was a stereo amp and turntable on the green-carpeted floor, and some books and papers, but not much else.

Jim wasn't interested in making small talk about Rochdale and led me into a bedroom set up as a video-editing suite. He had the same equipment we did. He told me the gear was on loan from the University of Toronto. He had a yardstick glued to the edge of a custom-made table, pretty high, made out of plywood, painted flat black. The video decks were counter-sunk into the table so the reels and record/playback heads were level with the table's surface and the yardstick. He put on a pair of white cotton gloves, and he showed me how quickly he could find the edit points on the tapes on both the slave and master decks, and then by manually rewinding the reels and pulling the slackened tape off the video heads, he would mark the edit points with a piece of chalk and then would measure the exact distance for a perfectly

timed pre-roll on both tapes using the yardstick. He'd then manually tighten the tapes on the reels of both decks, and using both hands he'd turn the control knobs to start both decks on their synchronized pre-roll. Video decks transported the tape through their heads at seven and a half inches per second, and he had simply figured out how to measure and conform the distance the tapes were in pre-roll. After probably five seconds, he would hit the record button just as we did, but his button didn't seem as stiff as ours, and he was right on the money. He had obviously done this hundreds of times before. His system worked. Lifting the head cover off the master deck, he showed me how to lubricate the record button, stressing that the button didn't have to be mechanically stiff to operate effectively electronically. After that, we talked a little bit about Rolling Thunder. I think he was documenting workshops for someone in Innis College, but he was vague. I thanked him, he gave me one of those crossed thumbs, "brother" handshakes, and I left.

On the ground floor of Rochdale there was a macrobiotic restaurant called Etheria, and a bookstore called the SCM Book Room. Etheria wasn't very interesting. Everything on the menu seemed to feature bean sprouts that were always a little too wet. The Book Room was another matter. They had a huge volume of the complete patents of Nikola Tesla and all of Wilhelm Reich's books on orgone energy. I had been reading Tesla and Reich in books I had found here and there in Ypsilanti and Ann Arbor, and then in Toronto, but they had the complete works by both of these fascinating outsiders at the Book Room. I was attracted to Tesla and Reich because they were brilliant and because they were both labelled kooks by the scientific communities of their days. They insisted on going against the conventions of their disciplines — they were true outsiders.

Tesla was the first scientist to understand and harness alternating current. He basically invented every component of our contemporary global electrical grid, envisioning most of it before the end of the nineteenth century. Thomas Edison, no slouch himself, had argued for an electrical infrastructure based on direct current. Tesla disagreed with Edison, as he comprehended the efficiencies and cost-effectiveness of alternating current, and ended up being largely responsible for authoring the science behind our contemporary electronic reality. In other words, Tesla kicked Edison's behind in the biggest engineering coup of the twentieth century. Tesla didn't stop there and insisted that it would be possible to transmit electrical power via radio transmission. He was absolutely convinced he could deliver wireless electrical power. He actually built a giant electric power transmission tower in Colorado and melted down half the state's electrical grid (talk about blowing a major fuse!) before the feds put a stop to his experiments. Near the end of his life in the early 1940s, Tesla, who had never married, fell madly in love with a white pigeon that hung out on the window ledge of his high-rise apartment in New York City.

Wilhelm Reich was another fascinating figure. Reich had studied with Sigmund Freud in Vienna, and practised psychotherapy both in Austria and then in the United States, but the Austrian-American psychiatrist and psychoanalyst did his most important work as an author. Reich believed he had discovered a physical life force called orgone energy, and wrote long theoretical texts that combined psychological theory with physics and human biology. His theories were global and comprehensive, linking human sexuality and mental health with weather patterns, precipitation, and drought. Reich's general theory focused heavily on healthy sexuality and the achievement of orgasm, defining orgasm as the release and exchange and flow of positive orgone energy. His theories were embraced during the sixties by the advocates of free love. I had been given my first Reich book when I was twenty-one by a hairy guy named Barry, the tireless trade-book manager at Ned's Student Bookstore in Ypsilanti. Barry had noticed my girlfriend at the time, Cindy Wolf, and he and his wife, who was apparently quite taken with me, invited us to one of their monthly orgies in Ann Arbor. They would get together half a dozen couples and go at it as a group with fruit plates, wine and cheese, and any drug you wanted to bring. As liberated as we were, we were never seriously tempted to attend. Reich's theories were being used to support the wonderful debauchery of pre-AIDS America. The volatile mix of the birth control pill and Reich's theoretical construct of "orgone energy" were at the heart of the sexual revolution. Reich also believed that a blockage in the release of orgone energy could lead to an accumulation of "bad" orgone energy (or DOR, deadly orgone radiation). He believed DOR was somehow responsible for cancer. Reich's main problem was that orgone energy, good or bad, couldn't be measured with existing scientific instruments, but he did believe it could be accumulated in devices called orgone boxes. The science establishment didn't buy Reich's theories, nor did the Federal Drug Administration. He was treating cancer victims in his orgone boxes when the feds busted him for being a quack in the 1950s. They smashed his orgone boxes with axes and put him in prison. I had to build an orgone box to see if it worked.

The same week I had visited Rochdale for my Rolling Thunder Video workshop, the Video Ring truck had rolled into A Space, and was literally parked in our video studio. The building at 85 St. Nicholas had big wooden garage doors, and it was possible to drive large vehicles into the bowels of A Space. Lisa and I were appalled, both by the opulence of the truck's technical set-up and because we didn't even know that A Space was part of this rather dubious venture. In the often-fake co-operative environment of A Space, decisions were not always made with the full participation of its membership. Marien and Robert told us they thought it was good politics to be involved with the Video Ring project, and they were very surprised it actually happened. Video Ring had been founded by Michael Hayden and Ed Fitzgerald and was supported by the Canada Council. The Council had put up $69,500 to outfit a mobile one-inch colour video production studio, basically a professional video studio in a truck, a high-tech vehicle that could travel around and meet the video needs of an assortment of artists based in

Toronto or London, Ontario. Hayden was a real operator and never did anything small. He had pulled together a lot of big names to land the grant, including Greg Curnoe, Jack Chambers, Murray Favro, Ron Martin, Ron Bowman, General Idea, Michael Snow, Joyce Wieland, Joe Bodolai, Gerry Zeldin, Ed Fitzgerald, and A Space.

Here Lisa and I were trying to make decent tapes with outdated half-inch, black-and-white video equipment, basically junk, and Hayden had used our organization and the names of a bunch of well-known artists who had absolutely zero interest in the medium to put together a Batmobile of a video studio for himself. We were given a technical workshop on the merits of the Video Ring truck, but in 1972 there were very few people technically sophisticated enough to run this kind of a mobile studio, and they certainly weren't working in non-profit, artist-run centres. I had no clue how we would ever manage to make tapes using this truck, despite being fairly adept with video equipment. After a run around the province for show and a few productions here and there, Hayden ended up parking the truck in his studio, collecting a few more years of funding for service and maintenance. I never saw a single tape that was produced using the Video Ring truck, except maybe the video document of Hayden getting his hair cut by a bevy of nude hairstylists?

Elke Hayden, later Elke Town, was then married to Michael Hayden, and she was the financial and logistical manager of the Video Ring project. Elke would eventually become a curator of contemporary art and an advocate of video, but in 1972 she had her hands full managing Michael's video truck and the bad vibe it was generating at A Space. Elke was never very diplomatic. She had a way of quickly dismissing anyone who didn't agree with her that wasn't very charming. On the truck's maiden voyage to A Space (and to my knowledge this was the only time the truck was at A Space, until it was parked inside it and stripped of all its video equipment in March 1976, and the truck's equipment was distributed among Trinity Square Video, 15 Dance Lab, and Centre for Experimental Art and Communication (CEAC). Greg Curnoe had come along to invite us to participate, beyond the use of our organization's name, in the project. I had become familiar with Curnoe's anti-American rants through *artscanada* and various newspaper articles, and while I could run an anti-American rap with the best of them, I was expecting the cold shoulder from Curnoe because of my background. The story was that Curnoe could have gone to New York and done very well selling his post-pop, conceptual paintings, but he chose not to. Michael Snow and Joyce Wieland had gone to New York in the sixties, and had returned to Toronto in 1972. Greg had never left London. Now, Greg, sitting in the open door of the video van, was fielding the damning questions we had about the practicality of the Video Ring van. He asked us to give the project a chance and stressed that any project that would link London with Toronto, and potentially other communities, was important. Greg found the mobility and networking potential of the Video Ring truck intriguing. He said there wasn't enough communication between the scenes in London and Toronto, let alone the rest of the

country. Greg also told us he thought Canada was benefiting from all the Americans, especially the artists, fleeing the States and landing in Toronto and everywhere else across Canada. I told him I was from Michigan, and he told me Ontario and Michigan had a lot in common, including landscape, music, and visual styles. He told me that the stretch of highway between Toronto, Detroit, and Chicago was the most powerful trucking corridor in North America. He had driven to Detroit on many occasions to hear live music, and we traded stories about Bob Seger, Ted Nugent, and Alice Cooper. He was a big fan of the MC5. He told me if I ever wanted to check out the London scene, to just give him a call. The Video Ring truck was gone in the morning.

Elke Hayden and Marien had cooked up this idea to have a Dominion Day party at A Space. Dominion Day was Canada's birthday. It was like the Fourth of July, except it happened on July 1st, and for us American expats it didn't seem to have all the bloody connotations of a nation formed by war.[2] On a warm summer night, we had a Dominion Day potluck supper on three tables running end to end in the empty gallery space. There were the usual suspects but several new people as well. Victor Coleman, the poet, and Rick Simon, the designer and artist, were there with a photographer named David Hlynsky, who was editing a photography quarterly called *Image Nation*. These three were working with Stan Bevington at Coach House Press, at the time a small but dynamic publishing house and custom print shop located in an alley behind Rochdale. Robert Bowers was fascinated with the idea of fine art printing, and Bevington and Simon were gurus when it came to state-of-the-art printing technologies. Robert, arm around his new girlfriend, Marlene Sober, a sweet, very young country fiddler with long flowing brownish-red hair and amazing green eyes who worked at the Café, told me that Coach House publications — books, posters, postcards — always had "Printed in Canada by mindless acid freaks" in microscopic, two-point Gideon light, their favourite typeface, somewhere in a margin just to prove they could print with an insane level of accuracy.

There was a nice crowd at this dinner. I didn't know many of the people. It seemed to be Robert and Marien's party. The food looked pretty good. I was sitting next to Victor Coleman. I had heard that he was a womanizing, old-style Casanova-type poet who went through a LOT of women, but he was alone that night and was soft-spoken and funny and not at all interested in the women at the table. Radz was beginning to cultivate a harem, hiring a handful of beautiful young women to work in the Café, and a few of them were at this party. Victor was a big man, but he was exceptionally light on his feet. He wore glasses and had hair just like Clark Gable's, dark and naturally greasy. Most people had the dry look at this time, so Victor's hair was different. Victor had grown up on Toronto Island, and he hadn't gone to university. He had just started to write poetry, and that was simply what he did. Victor seemed to know

2 Formerly known as Dominion Day, Canada Day commemorates the anniversary of Canadian Confederation which occurred on July 1, 1867. It is now understood that among some Indigenous Peoples and their allies, Canada Day carries negative connotations, as it is seen by them as a celebration which downplays the violent histories and lasting impacts of colonialism.

everybody and everything about them. He had lots of details. He was interesting. Lisa was talking to David Hlynsky. There was a photography gallery in town that was bringing in a series of high-powered photographers to talk about their work, people like Les Krims and Garry Winogrand. David and Lisa wondered if A Space would be interested in hosting these presentations. Robert seemed interested. The long table was abuzz with rumours and business was definitely going down. Just then, in the middle of the meal, Elke arrived with Michael Hayden, loudly apologizing for being late but carrying a big square white-frosted cake with a Canadian beaver, just like the one on the nickel, rendered in two or three shades of brown frosting. The beaver's coat was quite impressive, but it wasn't a great profile of a beaver, it was out of proportion and goofy and cartoony. There were at least two cases of beer fuelling this dinner and everyone was in the cups fairly quickly and for the full run of the evening. After spaghetti and meatballs, some Chinese vegetables, and some very interesting curried rice dishes, we divvied up Elke's cake. I remember getting a piece with part of the beaver's tail. Elke was circulating to collect compliments on her cake and I told her it was wonderful, but I said, playfully, but of course critically, that I wondered if the beaver on her cake really looked like a beaver in the wild. I admitted I had never seen a real Canadian beaver. I was quite surprised when she asked me if I wanted to see a real Canadian beaver and she stood back and unzipped her jeans and pulled her pants and underwear down rather decisively to show me her pubic hair. There were a few seconds of quiet and then the whole party exploded in laughter. Elke showed everyone her beaver, spinning this way and that, to give everyone a peak, posing for the full length of our laughter. Marien later told me she had seen Elke's beaver before, that this was a fairly standard routine when Elke would get drunk.

Lisa and I were enjoying our first year of living together on Ross Street. We didn't have much furniture and slept on a piece of foam on the floor. We built our kitchen table, had a ratty old couch from Crippled Civilians, and used wooden fruit packing boxes from Kensington Market for end tables. Lisa had two cats, Rose and Amy, and kept a couple of painted turtles, Juanita, a big male, and Hugo, a smaller female, in an aquarium. Rose, a fat bright-orange cat, was always a little grumpy. She didn't care much for Amy, a sleek Abyssinian, who monopolized Lisa and me for all the attention she could get, at Rose's expense. Amy would wander around the apartment talking cat talk and looking around for us, and Rose would get fed up and give Amy a little whack with a nasty hiss and claws bared almost every morning. Amy didn't get too stressed over these attacks, but always seemed quite surprised at Rose's hostility. We used one of the bedrooms in our flat for a workroom, and I used the workbench in this room to build my Tesla coil and various other electric and electronic apparatuses. I built the sound sculptures for my Electric Gallery exhibition in this space. I remember we watched the Munich massacre on an old Admiral black-and-white television on this bench. I had the back of the TV pulled off so I could hot-wire an audio patch into a phone-plug socket, turning the TV into a pink-noise generator. Jim McKay, the ABC Olympics reporter, tearfully told the

world that Palestinian terrorists had murdered all eleven kidnapped Israeli athletes at the 1972 summer Olympics in Munich. By the end of the day there were seventeen dead and the Olympic spirit was shattered.

Later that week I would fire a beautiful three-foot, lightning bolt–like purple spark onto the shiny white ceiling of this workroom. This spark crawled with plasma fingers trying to ground itself on the ceiling unsuccessfully. When I shut the coil down — the elements in the tubes were white hot and the voltmeter needle measuring the current feeding the amplifier was permanently jammed in the red zone, destroyed — the four-and-a-half-foot coil wound tight with about a mile of hair-thin copper wire was smoking hot. My Tesla coil was out of control and my jaw was tight and I was having trouble breathing and my arms ached, as the whole room had taken quite a charge. I had no idea what frequency the coil was transmitting on, but if aliens were out there listening, they would have wondered what the hell had just happened on Ross Street.

Lisa made some of her first tapes in our apartment on Ross Street. She was shooting herself in the bathtub with the turtles or making herself up like a mime performer and doing these magic-like tricks with eggs on camera. We did a jazzy improvisational tape with the cats and experimental music (*Ross Street Tapes*, 1972), and finally Lisa made a tape that felt finished and could hold its own through multiple screenings. *Juggling* was a narrative fantasy about juggling glass balls that floated through the air. At the end of the tape, Lisa confirmed the fact that she could juggle. Her images were getting stronger as she was falling in love with video. For me, video would have to wait. It didn't suit my interests at the time. I was making my idea-based sculpture and experimenting with all manner of electromagnetic radiation, and more and more of the time I was writing.

A Space was a constant source of amusement and aggravation. Robert Bowers had bought an offset press and was trying to figure out how to get it up the back stairs and into a small storage area we had built behind the gallery. I thought the idea of a press at A Space was a great idea, but I had installed an orgone box in this space, and a lot of the regulars at A Space and others from around the city were trying it out, so I was worried Bowers was going to try to get me to move the box. In the end there was room for both the press and my box, which sat right in the middle of the storage area. My orgone box looked like a cross between a gas chamber and a confessional. It was a steel-encased box, built around an infrastructure of two-by-fours; a vertical closet-sized enclosure with a steel door and a one-foot square grid of holes drilled for air. The walls, ceiling, floor, and door were four inches thick, and sheet steel on the inside as well. The orgone box was an imposing object to look at, but you had to sit in it, in the cold, metallic darkness to get the full effect. Basically, the idea was to surround a human subject with alternating layers of conducting and insulating materials. I had used

thin steel sheeting and fibreglass insulation, four layers of each. I hadn't thought much about how the box would look, but it ended up being very impressive. The interior dimensions needed to support a wooden chair and provide at least four inches of free space between the person's shoulders, head, back, knees, and feet and the interior walls. A Space had paid for the materials, because basically everyone was curious to see if the box would increase our sexual energy. I built this box well before my Faraday cage show, in November or December 1972, but it remained in the back room and was still frequented by many people by the time spring had rolled around.

I was serious about using the box, but honestly I didn't find it a very invigorating experience. I was twenty-five years old, in great shape, and was playing basketball for a couple of hours a day, four or five days a week. I was playing pick-up ball at the YMCA in the afternoons and in a citywide amateur league with a CBC-sponsored team in the evenings. Lisa and I were sexually active and I didn't have an ounce of fat on me. So I didn't notice any increase in my sexual energy. What I noticed was that I'd always shudder with a chill about five minutes into every sitting in the box, not from the cold, but similar to the way I'd have an involuntary shudder if someone tickled the back of my neck just right. I liked the ritual of sitting in the box. It was dark and calm as the box muffled and suppressed the noises in A Space and the distant traffic of the city, and it was a pleasure to relax and meditate daily, even though the box was kind of creepy inside. The latch was on the inside, to hold the door closed tight, but I always worried someone would lock me in the box. The other thing I noticed was I was always regular if I used the box. Several other people told me they'd also have bowel movements right after visiting the box. Everyone knew about the box and while you didn't need to make an appointment to sit in it, a lot of people were using it.

Andrew Tuffin was really into the orgone box. He was a smart, gentle man with a twinkle in his eye. He had immigrated to Canada from England with Sandy Stagg, and he had recently joined us on the staff of A Space. Sandy, who was brash and all business, had started up Amelia Earhart Originals, the first vintage clothing store in Toronto. Andrew was a writer, although he never showed me any of his writing. He had read all of Reich's books and was into everything from Madame Blavatsky to Ada Lovelace. He told me he knew a lot of people back in England who could see auras, and how Lovelace had invented the idea of computer programming during her intellectual affair with Charles Babbage, the inventor of the first calculating machines. He talked endlessly about Marcel Proust and James Joyce. I had read most of their books once, just to find out what all the fuss was about, but Andrew read this kind of literature every day, like it was the newspaper.

I remember being startled more than once when the door of the orgone box would swing open and Andrew would emerge. He was quiet as a mouse and he would use the box early in

the morning, before things got going at A Space. He would sit in the box for hours and come out spinning in a torrent of thoughts and images. He had a fantastic imagination and he would be so excited about connections he was making in his head. He talked about synapses and neurological activity like a scientist, and about the spine and the way it determined the way people walked. Andrew had a strong walk and a smooth stride, like a hiker who had traversed the whole of England. I loved to walk myself, and so did Lisa, and Andrew began to follow us around. He wanted to know what we were doing and was a very good listener when he wasn't telling us about what he was reading. I'll never forget the way he tore through the writing of William S. Burroughs.

General Idea was around Toronto, but our paths hadn't crossed much. I had seen their *Light On* show at Carmen Lamanna's. They had these big, beautiful hinged mirrors fabricated so they could direct rectangular patches of reflected sunlight onto buildings or landscapes, and they were making video documents of these, highlighting indexical gestures. They were working some other scene and didn't come around A Space in the early days. The Toronto scene was very small in the early seventies. There were the established artists who showed with Av Isaacs, and the cooler, more cerebral, mostly younger crowd who showed with Carmen Lamanna. There were a few other smaller scenes, associated with other galleries, and we would go to their shows if they paid us regular visits. There was this trade in reciprocal visits. I remember going to painting shows by Ric Evans, David Bolduc, and Jaan Poldaas around the city. Evans and Poldaas also showed paintings at A Space. Poldaas did these small Mondrian-like colour paintings. I always thought his work was very smart, so clean and economical. Shirley Wiitasalo was the best painter in the city. She showed with Lamanna, as did Ron Martin and Paterson Ewen. When I think back on those times, the city was pretty small. There weren't scores of galleries, nor hundreds of artists. There were three or four scenes and they didn't overlap much. Toronto was a decent-sized city, and it was complex with its ethnic ghettos. But the art scene was relatively small and incestuous.

Andrew was telling me all about General Idea and how they were really into Claude Lévi-Strauss and structuralism and myth. Michael Tims, aka AA Bronson of General Idea, was hanging around with Sandy Stagg and Carole Pope and her partner, Kevan Staples. Pope and Staples had a band called the Bullwhip Brothers, but they would evolve into Rough Trade in 1974. Andrew was impressed with Tims and the direction that General Idea was going. He gave me a copy of Roland Barthes's *Mythologies* and told me never to underestimate the power of the "Frenchies." He told me the French have a great intellectual tradition. I was impressed to hear this, coming from a Brit. General Idea was a threesome that all went by aliases: Michael Tims called himself AA Bronson; Ron Gabe was Felix Partz; and Slobodan Saia-Levy was Jorge Zontal. General Idea had a big space down on Yonge Street between Queen and Dundas, a third-floor walk-up above Mr. Arnold's, a body-rub parlour. If they lived there,

they lived in the back of the space, out of the public's eye. There wasn't a sign of domesticity in their public studio/office. They used the entrance and main space as a kind of showroom for various artifacts. This was General Idea's headquarters, following the corporate model they were emulating. The big mirrors they had shown at Carmen Lamanna's were there, as were life-sized photomural cut-outs of Miss General Idea, Marcel Idea (Michael Morris), and the windows at the front of the space sported custom-made mirror-surfaced venetian blinds.

All these mirrored surfaces were very dusty and the black tile floor was filthy with the dried salt that had been dragged in on hundreds of people's winter boots. They had quite a few large potted plants, which were not doing very well, but were still mostly green, in this showroom of slick silver framed glass and starkly black-and-white objects. Jorge was hustling around watering the plants while AA and Felix sat on their desks talking to me about what they were doing. They spoke at length in their own pretend-world jargon about Miss General Idea and the way you could see through these mirrored venetian blinds, while you were simultaneously seeing a reflection of yourself, and things like that. They played elaborate language games, but their puns and titles felt corny and it all seemed like a house of cards to me. But they were obviously serious about their game of art and they were going all out. The second time I was in their loft, I had dropped by to pick up a copy of *FILE Megazine*. I found the networking aspect of *FILE*, and its relationship with Image Bank in Vancouver, very interesting: the graphics were tough and direct. When I arrived to pick up the magazine, I found Felix and Jorge crawling around the floor searching frantically for their pet iguana. They just let this iguana roam around the loft, and it had disappeared. They couldn't remember the last time they saw it. I found it for them. It had crawled under one of the big cast iron radiators and had simply shrivelled up and died. It was quite a handsome object once Jorge had picked off the thick cloak of dust balls that covered the somewhat shrunken iguana's corpse from head to tail.

The winter had run its course and spring brought better weather, but A Space's Café was failing to bring in the revenue Robert thought was worth the effort, and the inner circle had decided to pull the plug. Robert hated the thought of losing the Café because it gave A Space security in terms of financing. He went to the Ontario Arts Council (OAC) and asked for a one-time influx of cash so he could get the Café licensed. He told them if he could serve beer and wine, they would never have to put another dollar into A Space. The OAC was not into establishing drinking establishments with public money. As the A Space Café was closing, Stephen Radlauer planned on opening a similar enterprise around the corner. He would open the Ritz Café on Charles Street that summer. Meanwhile, Bill Bradd informed Lisa and I that the Chinese landlord of our Ross Street house had decided to evict us in the fall, because he needed the house for some of his relatives. This was the last straw for Bill. Victor Coleman was moving in on the poetry scene at A Space, Marien wasn't being straight with Bill about this

transition, and Bill said he wanted to go back to California anyway. Bradd had spent some time in the Bay Area in the late sixties.

I had grown quite fond of Bill Bradd. He knew I was hungry to write and had decided to mentor me, to Lisa's dismay. Bill was a bit of a Neanderthal, especially when it came to women. One of his favourite poems was a short thing he wrote about an aging couple, probably modelled after his parents, who lived a silent, emotionally cold existence in a rural community in Northern Ontario. One day, while this fictional husband and wife were eating lunch together, the man, who hadn't spoken a word in a week, looked his wife in the eye, and said, "You ain't much, but you're better than a fried-egg sandwich." Bill seemed to have a slightly warmer relationship with his current girlfriend Cindy, a shy, quiet young woman originally from San Francisco. He told me Cindy's parents had a lot of money — that they had grand pianos in every room — but that they had cut Cindy off because she was living with him. It was hard to know if Bill was telling the truth because he was always writing poetry in his head, and when he spoke it was unnaturally deliberate, like he was testing the sound of his images and ideas. He was low to the ground and humble in his black rubber boots that he wore without socks, but he had an expansive, rather cosmic sense of the world.

Bill told me he once had a vision when he was on the shore of northern California, just north of Eureka. He said there were driftwood trees all over this beach, some of them seventy-five feet long and weathered white as the ivory of an elephant's tusk. It was timeless by the sea and Bill could imagine the "Indians" and their villages and all the wildlife coming and going like a time-lapse movie for thousands and then millions of years until there were dinosaurs and dragonflies the size of seagulls.[3] A stiff northerly wind was twisting the fog into ghost-like swirls. Bill was staggering around, face into the teeth of the wind, in this time machine of a landscape, following his dog, a mutt with some black Labrador retriever in it. His dog led him to the entrance of a cave. He realized his dog was the only creature in this cosmic episode that shared the same exact time and place with him. His dog was his guide and medium, his link with the natural and supernatural world — Bill and his dog were one. They both were exhausted from their time travel and lay down to rest on the sandy stone floor of that cave. The wind stopped howling and Bill and his dog curled up together to get warm. Bill couldn't believe how bad his dog smelled when his fur was wet. That stench had snapped Bill out of his grand hallucination. Bill smiled and told me never to try to describe the metaphysical unless I could ground the incomprehensible in the concrete banality of the day-to-day. If you're going to talk about God, make sure you do so through your dog.

3 Bill was likely unaware that Eureka lies on the Traditional Territory of the Wiyot Nation who still inhabit these lands to this day. This area has a well-attested Indigenous past and present. It is known as Jaroujiji for the Wiyot, and as do'-wi-lotl-ding for the Hupa (Natinixwe), and as uuth for the Karuk.

Bill wanted to do one more reading of his poetry at A Space before he left Toronto and
Canada for good. He asked me if I would do him a favour. He didn't know if I could help
him, but he wanted to use a recorded sound, the distant thunder-like sound of the thick,
snow-covered ice cracking on Lake Simcoe early in the spring, to punctuate his reading of
some prose poetry about his boyhood home in the country outside of Orillia. As a boy he
had loved this deep, mysterious sound, and he told me he could recall it in exquisite detail
as if it was embedded somehow in the stem of his brain. He had been told this sound was
so deep and haunting, it had never been successfully recorded, or at least he couldn't find
any recordings, and he wondered if this sound could be simulated electronically. I told him
if he could hear it, it was within the audible range of the human ear, and therefore it could
be reproduced or simulated electro-acoustically. I did some phone research and found a
graduate student working in the electro-acoustic music lab at the University of Toronto who
would help us. Jim Montgomery said he thought he could replicate the sound by recording
the snapping of a half-inch strip of wood, and then slowing it down and lowering its pitch.
He would do some experiments and then ask Bill and to come over to supervise the fine-
tuning of the fabricated rumble on the lake.

I took Bill over to the lab about a week later and Montgomery played the tape for Bill.
Bill looked out the window, seemingly transported to that distant space and time, but then
said it wasn't right, it was too much like an echo, and it should be more like the cracking
was travelling across the lake through the ice itself. The simulation wasn't grounded enough
in the deep cold of the frozen lake and the black water below. Montgomery was generous
and patient and we spent the whole afternoon trying different degrees of attack and decay
and adding multiple tracks and filters, and finally, I watched Bill intently as the three
of us listened to a version that sounded very convincing. Bill nodded affirmatively and
Montgomery made us a dub to audiocassette, and after a round of enthusiastic handshakes
Bill and I headed back to A Space, cassette in hand. As soon as we got outside Bill told me
the tape was okay, but he realized during the exercise that the sound he recalled couldn't
be captured. He didn't want to disappoint the kid with the thick glasses who was so intent
on getting it right, but this whole exercise had been a waste of time. Bill ended up doing his
final Toronto poetry reading to a small audience of A Spacers without the electro-acoustic
simulation of the ice cracking, and then he packed up and took Cindy and his smelly dog to
California. The last time I heard from him, he and Cindy were living in a converted chicken
coop in an artists' commune north of San Francisco.

A few years later I would experience first-hand the sound of ice breaking up on a big
northern lake, and would understand why Bill had decided it couldn't be recreated on tape.
Robin Collyer and Shirley Wiitasalo had met a man they called Mr. Kase, who had a wilderness
retreat in Algonquin Park. Ed Kase had set up a camp called Pringrove on Brule Lake in the

Park in 1939. Kase had a string of degrees from Princeton, including a PhD from the Princeton Theological Seminary. He had been a pastor at Grove City College in Pennsylvania (hence the name Pringrove). The lodge had served as a base camp for the Grove City Outing Club for years.

When Robin and Shirley introduced Lisa and me to Mr. Kase and the Pringrove experience in February 1975, Kase, then retired, was staying in the Park year-round. Pringrove was modest but wonderful. Everyone had private bedrooms, and there was a cast-iron woodstove in the centre of the lodge where Kase would place saucepans on its black top with hot cereals cooking slowly every morning. It was my introduction to Red River Cereal and a few other Scottish whole grain porridges.

Algonquin Park was amazing, a vista of fresh white snow and magnificent firs, pines, and hardwoods, teeming with wildlife. Raccoons, coyotes, and foxes would mess around with the bird feeders at night. Mr. Kase asked Lisa and me if we would like to feed strips of bacon fat to the Canada jays out back. He draped the strips over our outstretched palms and we stood there quietly while the grey jays, a little bigger than blue jays, landed and fed vigorously while sitting in our hands. Pringrove was a magical place.

The third day of our visit was a Sunday, and it was a brilliant, sunny day. Robin, Shirley, Lisa, and I decided, at the suggestion of Mr. Kase, to go snowshoeing. The snowshoes hanging on the walls of Pringrove were the genuine article, with long ash frames and rawhide lacing. We needed snowshoes to walk in the woods, as the snow was nearly three feet deep in places. The snowshoes, although difficult to control at first, made it possible to move relatively quickly along the paths splitting the stands of fir. We walked across a few small lakes, following paths across wooded land, enjoying the flat white expanses of a series of snow-covered lakes for their luxuriant silent space and easygoing surfaces.

Around noon it was getting warm and the snow was getting sticky and heavy. We had our coats open and we were getting tired. We were circling back toward the lodge, traversing a large lake, when the lake's surface appeared to drop slightly and we heard a roar that seemed to circle us, echoing for several seconds. The lake was hundreds of metres across and maybe a thousand metres long, and we were right in the middle. The ice beneath the heavy wet snow was probably two feet thick, but it was cracking with a roar the scale of which I had never experienced. We all froze. Lisa started screaming in panic. The three of us tried to reassure Lisa that there was plenty of solid ice and we weren't in danger. She wasn't buying it, and was shrieking that we had to get off the lake. If we continued down the lake toward the lodge, we'd be off the lake in half an hour. Lisa insisted we get off the lake to head back through the woods. We couldn't calm her down or reason with her, so we reluctantly headed for the nearest shore. When we were on land, she stopped sobbing and hyperventilating, but the going was rough

through the woods around the lake (there were no paths), and it took us a couple of hours to
get back to Pringrove. We had badly underestimated the level of physical exertion involved in
snowshoeing and the muscles on the inside of our thighs were on fire. We were all exhausted
and sore by the time we made it back to the lodge. Robin and Shirley were annoyed that we
had abandoned the direct path back across the lake. The next morning we thanked Mr. Kase
and headed back to Toronto, all of us very sore and with a bad feeling in the car.

Back in the summer of 1974, Lisa and I were evicted from the house on Ross Street after
our landlord told us he needed the house for his relatives. We then found an apartment above
the Cinema Lumiere on College Street, across from the mouth of the Kensington Market. It
was bigger than our place on Ross Street, with high ceilings and a large window facing south.
The light in the front room was brilliant. Behind the front room, through a set of French
doors, was a good-sized bedroom, and behind this bedroom was a spare room we used for
a studio. The kitchen was in the back of the apartment and the back door opened out onto a
flat, gravelled half roof that served as a patio, and eventually a vegetable garden. We grew
tomatoes and herbs in wooden planters. We were basically in the same neighbourhood but
had moved to the west side of Spadina and College. As far as we were concerned, this was the
best neighbourhood in Toronto. We had a decent repertory cinema literally at the bottom of
our stairs, and we had the energy and bustling mercantile activity of the Chinese, Italian, and
Portuguese communities, plus the rock, blues, and country music and completely different
drinking scenes of the El Mocambo, Silver Dollar, and Grossman's Tavern, all within a few
city blocks. Kensington Market had the best fresh meat, fish, and fruit and vegetables in the
city, and there was a funny little candy store run by a heavy-set elderly Italian man named
Mr. Sorrento. He sold cigarettes, penny candy, and canned goods. The store was full of little
kids after school, buying candy in a frenzy. If you would trouble him for a pack of matches, he
would smile and give you change for your nickel. As he often said, even a penny is business.

Milton Acorn, the People's Poet, used to buy his cigarettes from Mr. Sorrento. Acorn was
always present on the street, and I remember how he always turned the corner of Spadina and
College kind of wide, coming uphill from somewhere on Spadina and swinging out with the
momentum of his strong gait onto the shaded side of College, heading west. He always wore a
heavy red-and-black-checked lumberjack shirt, tucked inside his dark cotton slacks, which he
wore without a belt, kind of high. He had an emotionless, almost paralyzed face of chronically
dry skin that seemed to say he had seen way too much life. His hair was unkempt and he
often sported scabs on the side of his face, like he had fallen or been in a fight. I finally met
him when I went to hear him read a year or two later at A Space, in 1974 or '75. He read his
powerful and very funny poem, "The Natural History of Elephants." Every stanza would begin
with the same opening line, "In the elephant's five-pound brain," and Milton would shout
out this phrase with a shotgun of a voice and roll into the substance of the poem repeatedly

following the momentum of this image. The audience adored him, laughing like they couldn't get enough and listening to every single word of his vocal explosions of wisdom and pain.

Andrew Tuffin was trying to keep up with everyone, but he was having a hard time of it. There was so much going on. Lisa and I were getting our feet on the ground as artists, and there were shows and readings and screenings by people we knew almost every night. The scene was really beginning to heat up as the emotional energy of the late sixties was suddenly being transformed into a polyphony of articulate experimental voices. Things were really happening. Andrew was plugged into this energy but was having trouble finding his voice. He was researching and reading and thinking, but he couldn't find his own thing. He said he was writing, and I offered to take a look a number of times. But he always declined, saying he wasn't ready to show his writing to anyone, even his friends. Sandy Stagg and Andrew had parted ways and he was living alone. He was confused about his sexuality and was reading everything that William Burroughs had ever written. He was still always smiling, but we were beginning to worry about him.

Word got back to us that Andrew was exposing himself on the corner of Queen and Bathurst. Some friends of ours had tried to talk to him but he appeared zombielike, his eyes glassed over. When I asked Andrew what he had been up to, he told me he was experimenting freely with his sexuality. Coming out is one thing, but Andrew was obviously in some kind of psychological free fall. He wasn't sleeping and wasn't taking care of himself. He was completely disoriented. Lisa spent a day with him and managed to get him to check himself into the Clarke Institute for help, but it was voluntary and he checked himself out. I hadn't seen him for several days when one evening I was home alone reading. Lisa was attending some acting workshops in the evenings. I had just smoked a joint when there was a knock at the door. I went to the door and could see the shape of a large man through the stained glass window of our kitchen door. I asked who was there through the glass and the man said he was a police officer. The apartment reeked of marijuana and I was reluctant to open the door. The officer asked me if Lisa Steele was home. I told him no, still talking with him through the glass, thinking I was going to get busted. He asked me if I knew Andrew Tuffin. I told him I did. He told me Andrew had killed himself. I opened the door. The man was wearing a trench coat. He showed me his badge. He was a detective. He asked me to give Lisa his card, for her to give him a call. She had given the people at the Clarke our address, and the police had found their way to our door. They don't use the telephone for this kind of news. I asked the officer how Andrew had taken his life, and he told me he had "blown his head off with a shotgun."

I told Lisa the bad news when she came home later that evening. I remember sitting in our kitchen in a silence that seemed to ring with the vacuum following that shotgun blast. Over the next couple of days I heard lots of gory details, about the scene in his apartment,

the floor covered with books and clothing, and about the way he had been conducting his life for a couple of weeks before the end. His body was shipped back to England, but there was some kind of memorial service in Toronto. I couldn't deal with the shock of Andrew's death and my loss of a friend. I couldn't bring myself to go to the memorial service. For a passively aggressive, indecisive character like Andrew to get a hold of a shotgun was one thing. But for him to actually follow through with such a violent, movie-like suicide was another. I should have gone to the memorial service and sought some kind of conclusion to his life for my own good. With his life torn away so suddenly, I would end up seeing Andrew on the streets of Toronto for years after that. Whenever someone resembled him even a tiny bit, or there would be a certain kind of motion on a crowded street, I'd see Andrew walking toward me, as if this fantasy of a suicide had never happened.

Andrew was missed at A Space, but the institution had its own momentum, and someone else took his place. A Space was a revolving door of characters trying to find their voices. This was serious, important work. After something tragic like this happens, you notice people going at their work with more resolve. People were a little more sensitive when there were various emotional meltdowns, although this increased sensitivity was short-lived. The place and the times were crazy. Robert Bowers had had enough with A Space. He was increasingly disappointed with the way things were heading. Marien and Victor were interested in shifting A Space's aesthetic, already impossibly eclectic, toward a more theatrical direction and were interested in bringing in Eric Metcalfe, Kate Craig, Glenn Lewis, and Anna Banana from Vancouver to do a series of their neo-Dada performances. Bowers, who had always stressed the importance of diversity — he had even argued we should show wall works when the quality was there — was staying away from A Space during the days and restricting his involvement to working with the press in the evenings. Eventually Robert decided to take a hiatus from A Space, heading off to Germany in search of Joseph Beuys, hoping to bring a wave of progressive Europeans back to A Space. He ended up hanging around with Lawrence Weiner in Amsterdam for a couple of months. By the time he returned to Toronto, A Space was not about to embrace the cool and conceptual. I was part of the problem, as my early curatorial career was sometimes a painful learning experience, and the A Space aesthetic was hardly cool and clean and lean anymore.

I had given in, against my better judgment, to a persistent, wholesome, impossibly earnest couple named Tom and Martha Henrickson. They were photographers who lived on a farm somewhere outside of Toronto. They were somehow affiliated, maybe as part-time faculty, with Ryerson Polytechnical. The Henricksons wanted to do a zucchini show, telling me that all the Italians in Toronto were growing zucchini in their gardens, and that zucchini was about to break as the next great vegetable in North America. They told me zucchini was like a cross between a cucumber and a squash, good hot or cold, and that it grew like a weed.

They wanted to give every artist in Toronto a packet of zucchini seeds at the beginning of the summer, and then assemble the results in the fall, challenging the artists to make images and sculptural objects out of the zucchini they grew. It was kind of like balloon art, only using zucchinis. The Henricksons kept bugging me and told me all they needed was a day to do the installation, and then they wanted a Saturday night to have their zucchini festival in the gallery, including a zucchini feast of salads and soups. I relented and the date was set, and the seeds dispersed. The irony was they generated a big pre-opening story in the *Toronto Star*, and I found myself happily answering a lot of calls from the general public. It seemed we had a hit show on our hands.

Tom and Martha began installing their show, a bunch of sausage-like dogs and horses and airplanes made up of zucchinis held together with nails. Before I knew it, there were about twenty-five people sticking these horribly crafted vegetable sculptures all over the walls and throughout the gallery. Of course, several artists had noticed that the zucchini was phallic with its smooth, shiny, slightly curved green sausage form. So there were several erect zucchinis, some carved to look like they were circumcised, with gourds hanging for testicles, protruding from the walls and the pillars throughout the space. I was not as perplexed as Tom and Martha were when the show's opening filled with gays. Somehow the word had gotten out that this was a "cock show" and every gay man in Toronto had shown up. It was an amazing turnout. The gallery was so crowded the zucchini sculptures were being unintentionally knocked off the walls and subsequently mashed into the floor. The Henricksons were putting up a good front, despite the fact that their country kitchen had been overwhelmed by Toronto's bathhouse scene, but were now dismayed that there wasn't enough food for the overflowing crowd. This was a short-lived anxiety as the crowd's energy peaked around ten o'clock and then things began to wind down, and the crowd was thinning out when I noticed a tall, extremely thin man with shoulder-length, jet-black hair, wearing a little white patent-leather jacket, matching hot pants and boots, and clutching a coordinated handbag with a gold chain. Standing dead centre in the gallery, his long, slightly bowed bleach-white legs were adorned with thick black leg hair. It was Alice Cooper, in town after playing at Maple Leaf Gardens the previous night. Alice was wearing heavy makeup and looking for a conversation. Not a soul spoke to him. I think everyone was intimidated by his fame, not to mention his outfit. Since he had appeared as the crowd had begun to wane, it was as if he had cleared the room. Alice looked around for a few minutes at the zucchini show wreckage and then departed without saying a word.

The aesthetic of A Space was changing from white-walled conceptual and experimental to something more eclectic and colourful. Toronto was still relatively conservative in the early 1970s, and Marien and Victor were determined to change things for the better. The people we were bringing in from the West Coast were definitely loosening the place up. I couldn't believe

it the night that Al Neil nearly destroyed the piano we rented for his performance. Neil was a free jazz legend from Vancouver, and an artist and poet. I knew him through his mail art — he made surreal collages with decapitated mannequins. Neil was a weathered, diminutive fifty-year-old artist with a doctor's bag full of collages and poems. He wore dirty glasses and had long greasy hair and a bushy graying beard. He looked like someone who would live in a dumpster. He got drunk and high before his performance. He made the audience wait. We had a nice house. All the chairs were full and a lot of people were sitting on the floor. The gallery lights were turned down low and the space had this eerie, dusk-like incandescent glow. Neil charged into the space with a determined gait wearing a World War I–vintage football helmet (or was it an aviator's cap?). The earflaps were frayed, the leather rotten. He attacked the "88" as he called her. He played in streams of notes that seemed to spread out in all directions. He'd abruptly stop playing and shout poetry, still seated at the keyboard, with his back to the audience. He recalled being in England during World War II. Then he'd launch another attack on the keyboard with a torrent of energy. He was beautiful, really. He played without stopping for over an hour. I was with him most of the time. Toward the end he had the piano rocking with a storm of keyboard noise as he was playing standing, slamming his head repeatedly into the soundboard of the upright. He was going up and down the octaves, rocketing back and forth until finally he fell off the stool with a swing to the right, and as he rose to his knee and finally up to his feet, he took a lean to the left and veered through the crowd, which scattered, until he slammed headfirst into the brick wall. Audience members rushed to his crumpled body only to be pushed away. He marched off and disappeared behind the back wall. There was a weak round of applause from a confused audience, and finally a standing ovation. Neil didn't return for an encore. The next day I gave him an envelope Marien had left for him with a couple of hundred bucks in it, and he disappeared into the streets of Toronto. Victor Coleman found him three days later, no worse for wear, I was told.

Dr. Brute graced the same space at the height of his powers. Dr. Brute was the persona of Eric Metcalfe, an artist from Vancouver. A number of artists on the West Coast seemed to be embodying a fantasy through a persona. Metcalfe had developed the character of Dr. Brute, the epitome of lechery and masculine self-indulgence. Dr. Brute loved everything leopard skin and cohabitated with Lady Brute, who was played by Kate Craig. Craig dressed in all the leopard-skin fixings, the pillbox hats and furs and spotted underwear. Metcalf and Craig were actually married in real life, but their romantic relationship was over by the time Dr. and Lady Brute hit A Space. Eric was really into his Dr. Brute lifestyle and had this creepy laugh. He was a sweet guy, but he loved acting out the clichés. In the lingo of Marcel Idea (Michael Morris), Dr. Brute was the victim of "image-bondage." He had the leopard-skin fetish really bad. Eric had made these prints of himself chained nude to the pillars of A Space, and he hung these prints in our gallery, and of course the pillars in his prints had leopard-skin spots. His other fetish was jazz, bebop, so of course there was a saxophone decorated with the

leopard-skin motif. Eric never tired of showing off his slick, enamelled, leopard-skin-painted, red-cedar tenor saxophone. He handled the wooden sculpture of a sax like a dildo.

Eric had booked A Space to do a Dr. Brute performance on the weekend. He set up a beautiful stage with a leopard skin backdrop. A Space's gallery was transformed into a nightclub in *Brutopia*, with small tables with candles scattered throughout. In the dim light behind and to the sides of the tables, it was standing room only. A big part of the show was a piano player named Maury Kaye: a real pro. Kaye played melodically in a light groove to open the performance. The audience was patient, awaiting the anticipated arrival of Dr. Brute. With a dramatic burst of spotlight, Dr. Brute made his confident entrance in a top hat and tails, a leopard-skin collar, and white gloves. His teeth gleamed whiter than his dress shirt as he clearly relished the attention. His makeup was a little heavy. He was wearing eyeliner and lipstick, and his cheeks were powder white. This was cheesy vaudeville. The audience offered an enthusiastic welcoming round of applause. Dr. Brute methodically removed his gloves, threw them backhanded into the corner, and picked up a brand new pair, cutting the string that tied the gloves together with a penknife from his pocket. He was acting like a magician with a drum roll in his head. He slowly donned the new gloves like a surgeon and proceeded to open the leopard skin case that held his beloved spotted saxophone. He took the horn out and fondled it. The build-up to Dr. Brute's sax solo took forever, and I couldn't imagine what he would do with a wooden sax to take this performance anywhere beyond the image he had created. He turned his back and appeared to be adjusting the reed and, with a sharp change of tempo on the piano, he spun and, sax to his mouth, began to wail like Charlie Parker. He was using a kazoo as a mouthpiece and, amplified, it sounded nasal and funny like a kazoo but closer than you would think to a real warbling, drilling riff on a saxophone. The audience roared with laughter and Dr. Brute grooved and pushed his sax toward the ceiling, finishing this opening number and interrupting the applause with a few other short tunes, just to show he had a bit of range. Eric really believed he was making beautiful jazz, and if you closed your eyes the kazoo riffs were enthusiastic and strong and coherent. You could also hear how good Kaye was on piano. Dr. Brute was horny and sick and believable with leopard spots behind him, all over his wooden horn, and in his mind's eye.

Lisa and I were going to movie after movie after movie. I couldn't get enough of the films of Claude Chabrol, France's answer to Alfred Hitchcock. I remember seeing *The Unfaithful Wife* (1968), *This Man Must Die* (1969), and *The Breach* (1970) in the same week in 1973. We were spending most evenings at the Revue Cinema in the West End, on Roncesvalles. The Revue had just begun its fabulous run as an independent repertory cinema, and we were loyal patrons. The Cinema Lumiere, right below our apartment, was showing a lot of schlock in 1973, movies like *Night of the Living Dead* (1968), but also some serious material, like *Weekend* (1967) and *One Plus One* (1968) by Jean-Luc Godard. But honestly, we would watch anything

that would move. Our third-floor walk-up apartment on College Street was often unbearably hot throughout the summer and fall, and we would find relief in the air-conditioned movie theatres throughout the city. Lisa had bought our first decent video monitor, a small Sony Trinitron TV, at Bay Bloor Radio. We also had cable television for the first time with all of twenty-three channels, using a tethered, nearly remote control unit supplied by Rogers Cable. We particularly enjoyed watching Tricky Dick Nixon resign and leave the White House in the summer of 1974. Lisa was shooting videotapes, but not showing them to many people. Besides me, she would show her tapes to Lynne Cohen and Andrew Lugg, when they would visit. I had become friends with Lynne and Andrew when I was going to university in Michigan. I had taken a printmaking class with Lynne when I was at Eastern Michigan. She was a TA and making etchings before she became a photographer. She made these images of technological landscapes with a blue cast, and used pearl essence, a sparkling powder, to give her prints lustre. She also showed me an aluminum casting she had done of one of her favourite denim work shirts. Andrew was doing his PhD in philosophy at the University of Michigan and writing film and art reviews, including a very nice text on Andy Warhol's transition from painting and printmaking into film. Andrew knew Robert Ashley, Bob Sheff, George Manupelli, Anne Wehrer, and Pat Oleski, the key members of Ann Arbor's ONCE Group. Andrew was making films himself in 16 mm: documents of performance art works, with exaggerated formal angles, and short films that mixed still photography with cinematic movement. We showed his films at A Space. Lynne and Andrew visited us frequently and gave Lisa feedback on her early tapes. Andrew took a teaching job in the philosophy of science at the University of Ottawa, and Lynne and Andrew followed my lead by immigrating to Canada.

I would often run into Norman White on College Street, close to our place. Norman lived on St. Andrew Street in the Kensington Market. He had a place in a brick building above a vegetable store. At street level there was a dark-green wooden door with a small window. Inside the glass there was a small sign that said White Noise. When you went in there was a long straight set of stairs up to his apartment. The hallway wreaked of cat smell. An old, retired fellow on the ground floor had fourteen cats. Norman told me that every week Mr. Wood would buy a half-dozen cans of cat food and Irish stew; he'd eat the cat food and feed the Irish stew to his cats. Norman would walk his ten-speed racing bike out of the market and onto College to the point where I'd usually run into him. He rode a bright-orange Jeunet with really skinny wheels. We would stand and talk for long stretches if the weather was good. I remember Norman told me that Mr. Wood had burned his thigh on a hot cup of coffee, and he had asked Norman to take care of his cats. Norman got a scratch from one of the cats and developed cat-scratch fever. He showed me the lump he had on the inside of his right biceps. Norman seemed to know a lot about viruses and electronic circuits. I'd ask him questions about circuits I was working on, and he would be very helpful, suggesting I try various things. He could explain things very clearly, and he was patient and incredibly generous with his

information. He helped me build a simple electronic rheostat for regulating the temperature of the water in Lisa's turtle tank. Norman had gotten into electronics through a job as an electrical assistant in a naval shipyard in San Francisco. He had thought he wanted to be a research biologist, but after getting a degree in biology from Harvard, he found himself in a basement lab inoculating baby ducks with deadly infections day after depressing day. So he took an occupational detour and ended up taking art classes at the San Francisco Art Institute. After travelling around the Middle East, India, and Europe, he moved to Toronto in 1967. He ended up working as a graphic designer at Erindale College (part of the University of Toronto), working a day and a half every week out in Mississauga. He drove an old '53 Chevy bread truck. In 1972 he quit his job at Erindale and tried to make it as an artist. He showed a few times with Carmen Lamanna, but had moved over to the Electric Gallery by the time I met him.

Around this same time, I met John Watt. John was coming back to Toronto frequently while he was in university. He would come into A Space, and we had some great conversations over my *Faraday Cage* show. John had grown up in Toronto and had gone to Mount Allison University in Sackville, New Brunswick, to study art. He was at Mount A for two years, from 1970 through '71. There he met Colin Campbell and Chris Youngs, two new hires who really shook the place up. Mount A was a traditional art school where you would learn about colour theory and hone your drawing skills by completing endless still lifes. Campbell, a Canadian from Manitoba, had gone to California to do his MFA and was doing some radical photo silkscreen printing. Chris Youngs had come from his failed Nightingale Gallery in Toronto and was running the university's art gallery and collection and was buying a ton of prints by Jim Dine. John decided to move on to the Nova Scotia College of Art and Design (NSCAD) in Halifax to finish his BFA in 1972/73. This was the period when NSCAD was on fire with conceptual art activity. The young Garry Neill Kennedy was president and had pushed aside the seascape painters for the likes of Sol LeWitt, Dennis Oppenheim, Lawrence Weiner, and company. NSCAD was on the cutting edge of a revolution, and there was no place more open to pedagogical experimentation. John became good friends with Kasper König, who was starting up the NSCAD Press. John also began hanging around with David Askevold in the wide-open studios of NSCAD.

After getting his BFA, John moved to New York City in the summer of 1973, first crashing at NSCAD's New York loft, but then getting an apartment in the East Village. He hadn't been in the city very long when Colin Campbell came down and stayed with him in his apartment. Colin told John his marriage was breaking up and that he was unlikely to be granted tenure at Mount Allison; his first priority was making art. Colin had been married to a painter, Janis Hoogstraten. John was a great admirer of Colin. Colin had been one of his most important mentors, and John was happy to have Colin around. They both shared a love for video and wanted to make art more than anything. Colin and John bought some video equipment

together, a Sony AV-3650 reel-to-reel studio deck, a video camera, and a tripod, and they began to help each other make tapes. John's apartment had a light and air shaft that ran right through the middle of the apartment, so someone could look out a bedroom window and see someone in the kitchen, or vice versa. This was great architecture for making tapes about voyeurism and intrigue, and Colin was beside himself. John and Colin were getting a lot of work done and enjoying each other's company, when things unravelled. John was completely unaware that Colin's marriage had split up because Colin was in love with John. John was straight, and was quite taken aback when Colin admitted he was obsessed sexually with John. John told Colin he cared a lot, but he couldn't go there. They parted as friends, but their collaborations in video had ended.

John moved back to Toronto after living in New York for a year. Colin had bought out John's share in the equipment they had purchased together, so John needed access to video equipment when he returned to Toronto. Equipment access was a big issue in video in 1974, as this was well before the consumer-video era. John started hanging around Trinity Square Video (TSV) when it was in the basement of the Church of the Holy Trinity, behind the block where the Eaton Centre was built. TSV was being run by Marty Dunn, one of the founders of TSV. Marty was working part-time with Pat's Video, and he was doing some of his own performance video, but his heart was in community access, and in working with First Nations in particular. He introduced John to the Chiefs of Ontario, an affiliation of chiefs of First Nations who wished to develop the media literacy of their respective communities. John was hired to work with them. He would videotape them in mock interviews, and they would watch these tapes over and over, practising how to use the media in order to get their message across. This was John's first real job. In 1974, Trinity was doing a lot of vital, practical work in the community. Terry McGlade and Paul Castleman were making tapes in support of homeowners on one of the Toronto Islands. The government was trying to expropriate families from their homes in the interest of developers. John did more contract work with Trinity, sometimes for money, sometimes in exchange for equipment access. John managed Trinity for a short time, when it moved to another basement location in a building on Duncan Street, at the corner of Pearl. The building had been purchased with grant money by Amerigo Marras, the founder of the Centre for Experimental Art and Communication (CEAC). Other tenants included *The Body Politic*, the first magazine covering the LGBT community. John brought in Ian Murray to work at Trinity. John and Ian had met when they were both students at NSCAD. By the time I really got to know John, he was spending most of his time in a loft on Queen Street East, over by the Don Valley Parkway.

In 1974, Lisa began to make her breakthrough tapes. She had been hammering away at the medium for a couple of years, and finally things were beginning to happen. She was shooting in our apartment on College, which had great natural light, and with the front window closed, wasn't too noisy. She was working directly to video alone, appearing before

a fixed camera on a tripod and addressing the eventual audience with her monologues, capitalizing on the inherent intimacy of the medium. Lisa and I had had endless conversations about personal voice and working in the first person. Colin Campbell was now in Toronto, as was John Watt. They were fresh off their video work in New York. Colin had been denied tenure at Mount Allison and had moved to Toronto. Janis Hoogstratten had been hired by the University of Toronto's Scarborough campus. With their marriage on the rocks, Colin was mainly concerned with staying in contact with his son, Neil. He was working in a copy centre, running a photocopy machine nine to five, and crashing at General Idea's place. He was doing video performances directly to camera, as was John Watt. You could feel the scene building. Eric Cameron and Noel Harding were getting involved with video, and were frequently in Toronto showing us the work they were producing at the University of Guelph. Peggy Gale had just left a full-time job as art education officer at the Art Gallery of Ontario (AGO), and she was working on a contract with Marty Dunn on a video survey show at the AGO. Peggy had been in contact with Colin and John when they were in New York, and she was doing a bit of travelling and research and told us about the video activity she knew about from coast to coast. It was clear that things were beginning to happen and the video-art craze was about to break.

Lisa made *Birthday Suit — with scars and defects* in 1974. I remember coming home from A Space and watching it with her. We had talked a lot about ways of combining image and spoken narrative before that tape, and it was beautiful the way she expanded her visual narrative with voice-over information with *Birthday Suit...*, alluding to things that had happened years ago, while she was examining the absolute explicit present of her scars and defects with the video instrument. Basically, the *Birthday Suit* tape consisted of Lisa beginning to tell her life story through the mnemonic device of her body. Shortly after that, she made *Outlaws*, breaking away from the real-time continuum and the strategy of simultaneous, parallel narratives she had been developing. *Outlaws* was an experimental treatment of a handful of people around her. Lisa was beginning to understand the way video could be used to transform the familiar into the exotic. She was also beginning to create a mythology of her own relationships, her ex-husband, her friends, and yours truly. Our conversations over these tapes were animated and energetic. The work was good and the philosophy and aesthetics were falling into place. I was curious to see what she would do next.

I was sideswiped by *A Very Personal Story*. Lisa had set up a video camera on a tripod and had sat tight peeking out through her hands in a close-up frame for twenty minutes, telling an anonymous audience the story of coming home and finding her mother dead when she was fifteen years old. I remember watching the tape with Lisa and feeling the tension in the room, which was palpable and embarrassing to me. After living and breathing in what I thought was a very intimate relationship with Lisa for a year and a half, here I was watching Lisa telling a video camera something she had never shared with me. I knew her mother had died when she

was a teenager, but she always seemed reluctant to talk about her mother's death. She would paint a very positive image of her mother as an independent, intelligent woman, but would share nothing about her decline and passing. Now she was "broadcasting" something she couldn't talk about with me to the general public. Being at a loss for words, I told her I found it a bit weird to make art out of something so personal, and for her to tell me something through a video recording that she had never told me in person. Lisa told me she never felt I really wanted to hear this story, and rationalized that only the neutrality of the video equipment's audience had allowed her to recount her mother's death. I was hurt and angry. Things were cool and awkward between us for a few weeks.

Lisa and I talked about collaborating on making art together, but we never clicked. Lisa, in particular, thought two artists living together couldn't really be together unless they were making art as a couple. We were very supportive of each other's work, but were never on the same page. I was obsessed with systems and acoustics and electronics while Lisa was fascinated with stories about King Arthur and the Knights of the Round Table, or the inner voice of Marcel Proust. We shared an interest in literature, cinema, and in the potential of video, but in the end our art never merged. However, Lisa was responsive to my writing, and I was 100 per cent behind most of her video work. After my initial problems with *A Very Personal Story*, I began to see how radical and powerful the tape really was. We had talked so much about authoring video works in the first person — about the importance of telling our own stories as the substance of our work — and Lisa had definitely stuck her neck out by recording the most personal story she could tell. Watching the tape again and again, I could see the power in the naked truth of that recording. Colin Campbell saw the tape and thought it was brilliant. Peggy Gale, by this time, had already made her selections for the *Videoscape* show, the first major survey of Canadian video art at the AGO, and Lisa, Colin, John Watt, Ian Murray, David Askevold, Noel Harding, Eric Cameron, Stephen Cruise, Walter and Jane Wright, and a lot of other people were in the show. Peggy had seen my tapes, but was mostly interested in my writing, so I wasn't going to be in the *Videoscape* show, except for my hand in *The Ross Street Tapes*, an improvisational video music thing I had co-authored with Lisa. My own tapes at that time weren't very accomplished. I hadn't put the time in my own video work. By this point my sculptural work, dealing with experiments in acoustics and electronics, were beginning to transmute into text. I found I was interested primarily in the ideas and phenomena at the core of the sculptural pieces. I also realized that images rendered in written texts could be very strong and succinct — an image could be decoded to perfection in the mind of the reader. I was writing and beginning to "publish" my texts in photocopy editions. I would finish a text, make a hundred copies, and send it out by mail to a targeted audience of friends and potential readers. I was happy to eliminate the time between making the work and reaching an audience (and getting feedback).

Marien Lewis was obsessed with time capsules. She talked a lot about the inevitability of a nuclear holocaust. Her father was a nuclear scientist in Chalk River, Ontario, and Marien often said if anybody really knew what was going on with Canada's nuclear energy program, they would be horrified. Marien told me all the time about capsules people were burying around the University of Toronto. An organization called Pollution Probe had collected vials of smoggy air and polluted waters and tapes of noise and microfilm of printed matter about the sorry state of the environment and buried this material in a time capsule somewhere on the grounds of U of T. Marien loved the idea of time capsules and told me the U of T people were doing it right. Their time capsules were beautiful objects consisting of glass cylinders filled with inert argon gas to protect the goods from radiation, heat, and vibration. These glass cylinders were housed in thick, impact-resistant outer-brass cylinders, buried deep in the ground, and covered with concrete yards deep.

One day Marien told me we were charged with the responsibility of putting together a bundle of mail art for documentation, as there was another important time capsule in the making. We spent a couple of days filling a plastic laundry basket with a representative selection of a full spectrum of mail art that A Space was receiving on a regular basis. There would be no multiple works by artists, just a single piece of mail art by each of over two hundred artists. I was surprised when we noted the works were postmarked from twenty-one countries. It felt good to do something positive with this material, as we had been throwing away bushels of mail art every month. Marien said this time capsule would be big, like a giant coffin, so the actual mail art, not microfilm documentation, would be sealed in its own plastic box. Virtual time capsules were space-efficient (another one had been buried in 1973, marking the 175th anniversary of U of T's founding), but we were contributing to a big capsule of original material objects. Stephen Radlauer was also involved and had neatly boxed about a dozen cans of various brands of aerosol cheeses. I couldn't go to the official burial, but Marien said it was very moving. This time capsule would be exhumed and examined in seventy-five years (if the world wasn't destroyed by a nuclear disaster). Marien told me our stuff was either buried at the foot of the Thomas Fisher Rare Book Library, the odd sphinxlike protrusion of U of T's Robarts Library, or under the wheelchair ramp at the entrance of the Medical Sciences Building. She was involved in contributing to more than one time capsule at the time.

After feeling centred and committed for the first couple of years at A Space, I was going through a confusing period where I decided there were just too many loose ends. I never doubted my decision to leave the United States, but it was quite a struggle negotiating Toronto. Beside the escalating cost of living, the art scene was small and becoming complicated with its weave of alliances and petty politics. I was part of a scene but often didn't want to be. I wasn't very good at playing the game. I was antisocial by nature and happy staying home working on my texts. A Space gave me all the social exposure I could

stand. In 1974, I was still largely overseeing the gallery at A Space, and we were showing films and hosting jazz concerts and poetry readings as well as showing art. Artists were moving in and out and doing their thing at a hysterical pace that resembled the compression of time in a time-lapse film. In these initial days of the artist-run centre movement, we would do more in a month than most cultural institutions were doing in a year. It was hard work, but we were learning so much so fast. It was exhilarating.

One night jazz legend Dollar Brand would be blowing our minds at a keyboard, and the next we'd have a full house for a poetry reading by Ed Dorn. Dorn's writing was lean and incredibly precise, and his reading voice was the best I had ever heard. He read from his *Gunslinger* poems. His timing was impeccable. Dorn would end a stanza with a line like: "I'll be right back, if I come back at all." Our installation shows would be booked for one out-of-breath week at a time, so we could pack in more shows and keep things fresh. Show after show graced our space. John Orentlicher, who had introduced me to video back in Ypsilanti in 1971, did this beautiful installation called *Yard*. It was enclosed by a ranch-style fence made entirely of fluorescent tube lights which, in their glow, made the shredded packing material that stood in for grass seem to float above the gallery floor. Most of our shows were not so sensual. Tom Adair, another artist I had befriended in Ypsilanti, had simply installed a telescope in the gallery pointing up into the void of an open patch of sky. Adair removed the gallery's skylight to puncture the ceiling and had a statement on the wall about macro and micro space. The Saturday afternoon of a late September opening, we were thrilled to see a major migration of monarch butterflies passing through the sky above A Space. I had never seen this many monarchs. There were thousands, tens of thousands of them moving northwest to southeast, layers of them sailing through the air as high as you could see.

One of the most intriguing shows we ever had was when Jay Jaroslav premiered his *Extended Credentials* work at A Space. Jaroslav was from Boston, and he had assumed the identities of thirty-one individuals who had died as infants the year he was born. He had obtained social security cards, driver's licences, and passports for each of these identities and was developing personal histories for each of his extended personas. Jaroslav was a paranoid guy and talked about the FBI's interest in his work with some dread. Why wouldn't the FBI be interested in his work? Basically, he was running a workshop for criminals or people who just wanted to hop from identity to identity via government documents. Jay was teaching at the School of the Museum of Fine Arts, Boston, and had been a member of the Artificial Intelligence group at MIT in the late sixties, and told stories about flaunting his experiments in identity theft from behind the shield of his professorial role. Jay also told me he had been a successful criminal, a cat burglar, when he was younger. All told he was a fascinating, complex personality.

Jaroslav's show was beautifully designed with photo enlargements of white blocks of text on slate-grey panels. The mental images of these fabricated individuals were constructed from statistical information like eye and hair colour, height and weight, but talking to Jay you could see he had taken things much further. He was living in each of these identities for long periods of time and had thirty-one very complex stories more or less straight in his head. He was writing from a structure and there was a lot of freedom in his process. I identified strongly with Jaroslav and his work because I wanted to escape from my own fixed identity, from my American persona and my working-class background. I was enjoying writing in the first person because I realized I could shift my identity in my texts through the things I would see and the way I would see them. The crazy, intense week spent with Jay Jaroslav was very helpful. He really was a professor, in the best sense. He showed me a way out of my confusion over writing and its relationship to conventional literary forms. What he and I were doing was different than poetry and short stories and novels. Writing was a visual art and it could take conceptual art a step further into the perceptual, sensual realm.

Writing and sitting around in the gallery at A Space was taking its toll, and I really needed to do something physical. I had played basketball in college and missed the competition. I took out a membership at the YMCA downtown and started playing pickup ball in the afternoons three or four times a week. My shooting touch came back quickly and I was surprised by how much stronger I was at twenty-seven than I had been at nineteen. The first week on the court, I ran into Danny Finkleman, whom I had met through Joe Bodolai. Finkleman was a nice, quirky guy, but not much of a basketball player. He was very left-handed and dribbled with his head down, always going to his left and was very easy to defend. He had a nice little jump shot and could hit it if he wasn't guarded. He was funny and a great talker. He loved classic pop music and had a program on CBC Radio called *Finkleman's 45s*. It turned out that about half the guys playing at the Y were with the CBC, most of them executives. I was a couple of steps above the competition but found the regular workouts wonderful. Finkleman asked me if I would consider playing in a senior league for a CBC-sponsored team. I told him I didn't work for the CBC. He said he would see what he could do about that. The next thing I knew, I was doing monologues on *This Country in the Morning* with Peter Gzowski. I would go to the library and do research on a subject of my choice, say, the hibernation and early emergence of brush-footed butterflies, like mourning cloaks and red-and-white admirals, or I'd talk about electromagnetic pollution in Canadian cities and the potential health risks of radiofrequency energy. I even did a piece on Wilhelm Reich and orgone boxes. I was paid a hundred dollars per piece before taxes.

Everyone listened to Gzowski's show. He had a huge national audience, and I'd get quite a bit of mail. One day Finkleman brought me a letter fiercely critical of my discussion of Reich and orgone energy in such a public forum. Basically, it was a death threat. Gzowski was fond

of telling me that I didn't know shit about Canada; that I was a Yank and my experience in Canada could be summed up in about ten square blocks in downtown Toronto. We'd often meet to drink beer in some dive near the CBC Radio studios on Church Street. Gzowski would order a dozen drafts at a pop for the three of us. He could really drink. I never saw him without a cigarette in his mouth, even in the studio. On the court I thought he was going to die every time he played. He had zero skills and horrible hands, but he would exert himself until he was beet-red. He certainly had desire and he loved basketball and every other sport you could name. He would literally start smoking before he showered up. Bruce Kidd, once a world-class long-distance runner famous for sustaining a career-ending injury prior to the 1964 Tokyo Olympics, and Don Shebib, the filmmaker who made *Goin' Down the Road*, were also regular participants in our afternoon sessions at the Y. Kidd saw himself as a playmaker. Shebib always shot the ball as soon as he touched it and had this terrible turn-around, line-drive, no-arch "jumpshot." He couldn't jump an inch. He always tried to bank his shots hard off the backboard, even when he was shooting straight on from the middle of the key. Surprisingly he could hit his shots, when he managed to get them off, but wasn't very tall and had them blocked most of the time.

Finkleman and I became good friends. He was very generous and took me out for dinner often after we played. He always paid. Danny would take me to Switzer's delicatessen on Spadina, where I learned to appreciate the corned beef and knishes, or the Swiss Chalet on Bloor, a family-style restaurant that featured massive roasted chicken and rib dinners. I could always eat a horse after playing ball for a couple of hours and found I was unable to maintain my weight while playing so much basketball. I was always starving in more ways than one. Canadian Manpower was making it more and more difficult to stay on unemployment insurance, so the freelance work with the CBC was important to me. Danny got me a gig on CBL-740, a flagship CBC AM station, doing morning rush-hour reports on NBA games at the Gardens. The Buffalo Braves were playing half a dozen games at Maple Leaf Gardens, an NBA strategy for testing Toronto as the site of a future NBA franchise. The Buffalo franchise was failing and they were considering moving it to Toronto. I got to sit with the press on the floor, centre court, in front of the best seats in the house, which cost $8 each at the time. I remember marvelling at the seven-foot-two Kareem Abdul-Jabbar as he methodically destroyed the Braves with his sky-hook when he was in his prime with the Milwaukee Bucks. The morning after the games I would do a live three-minute report on the game on CBL, going on the air at 7:27 a.m., just before the 7:30 a.m. news. I was paid $21.60 for each report, but the free games and great seats were quite a treat. This mix of basketball and CBC work continued through the winter and the CBC team did fairly well in the city-wide senior league.

One night in February I played the best basketball of my life. I scored 41 points, making 20 of 26 shots, in an 82–56 win. I would have had 43 points, but was given a technical foul for slam-

dunking a rebound and hanging on the rim. Dunking was illegal in the early 1970s. A week later we lost to a team led by Ken Dryden, the brilliant goalie of the Montreal Canadiens. Dryden had decided to interrupt his hockey career by articling at the law offices of Osler, Hoskin & Harcourt in 1974. He had played basketball at Cornell University and was playing in our senior league to stay in shape. I held my own with him, but he had the quickest hands and got to every loose ball. He was extremely competitive. At the end of the game the backs of both my hands were swollen and nicked up from his fingernails jabbing at me every time I went for the ball.

Joe Bodolai was also working for the CBC, doing book reviews and quirky bits on consumer culture. He was living in a house on Huron Street across from the massive, recently constructed bunker that was Robarts Library. I had a community library card and used to take out books from the Robarts and then stop and look at them and talk about them at Bodolai's place. Stephen Radlauer also lived in this house, as did three members of a band that sounded just like the Eagles. The musicians slept most of the day away, so I seldom saw them, and Radz was in the restaurant business, so he was scarce as well. Bodolai's door was always open, and the kitchen was a social centre for a wide range of people. I liked hanging out there because you didn't have to talk about art. In fact we talked about just about everything but art. Joe loved science-fiction imagery, and we used to talk about Judith Merril's collection quite a bit. Judith Merril was an accomplished author and editor of science fiction, and she had reached an agreement with the Toronto Public Library to transform their Palmerston branch into the Spaced Out Library. Merril donated her collection of over five thousand science-fiction, fantasy, and related non-fiction books to the library. I had talked with Merril about the literary designation of speculative fiction and she helped me position some of my own writing as "conceptually experimental, future-oriented work." She helped me get comfortable with what I was doing. Joe was fascinated with the images of science fiction, the visions of the future, the way the future was projected in drawing and paintings, and how we had failed to grow into so many of these models. How come nobody was commuting to work on jet-powered hovercrafts?

Joe Bodolai, like me, was a generalist and interested in practically everything. There was another Joe that used to hang out in that kitchen. His name was Joe Wright, he had been born and raised in Mississauga, and he worked the graveyard shift at a canning factory. Joe Wright, who had been raised as a Christian Scientist, was into research. We'd talk about something and end up with some good questions on a Tuesday, and by Thursday he would have the answers. Another person who was a large part of that kitchen scene was Jeremiah Chechik, a photographer, entrepreneur, and conversational provocateur. An English Canadian from Montreal with a degree from McGill, Jeremiah was aggressive and intense. He had no sense of personal space and would stand on your feet when he'd talk to you. The four of us had the best time talking and learning. We would bring our respective worlds into that kitchen two or three times a week and the place would explode with ideas and energy and laughter.

Scott Didlake lived a couple of doors down from Bodolai's place on Huron. Scott didn't hang out with Joe, or anyone else I knew. He was a bit of a loner. I had met Scott at A Space. He was a draft dodger from Crystal Springs, Mississippi, and he had the accent to prove it. I loved to listen to him talk. He'd run these amazing monologues with unusual rhythms (his voice seemed to go up and down in pitch at the same time, as if there were two voices), a lilt that would usually end in a question. He had been a child preacher and could sell an idea with a gentle, circular, never heavy-handed argument. He worked in film the same way, making free-form documentaries to persuade by simply offering evidence. Scott carried a Super 8 film camera mounted on a monopod everywhere he went. He always swore by his monopod, saying it was better than a tripod because of its mobility. He was always shooting things on the street and when there were crowds, you couldn't beat a monopod. He had been part of the civil rights movement in Mississippi, and he said when the police would move in on the crowd and start beating the shit out of people, with a monopod you could get moving quick enough to get away. Scott lived the simplest life imaginable. He lived in an attic space above a corner grocery store with a cot and a chair and nothing else except his banjo and his books. I don't know where he bathed. His hair was always unkempt.

Scott loved Toronto but he just couldn't catch a break in terms of work, or finding his place. By 1974, there was a backlash against all of us Americans. We hadn't helped matters by being anti-American ourselves. We were all expatriates no matter what our draft status had been when we came to Canada, and we could run down the States with more venom than any Canadian ever could. Now that there were so many of us and we were seen to be more aggressive and confident and filling too many jobs, the Canadians had begun turning on us, throwing the anti-American rhetoric we had brought with us back in our face. I was from Michigan and had a fairly neutral, Midwestern accent, so I could more or less pass for a central Canadian. Scott, with his southern drawl, had American stamped all over him, and it was never easy for him in Toronto. Scott had struggled in Toronto since 1969, and he was tired and becoming cynical. He was finding work as a technical writer here and there, and sometimes worked on people's films. He wanted to go back to Mississippi and pined for the old country, but was still illegal. I'd see him a couple of times a month and we'd spend a day together. Scott and I talked mostly about the difference between independent, decentralized media and the mass media. He was well read in mass-media theory and could rattle off the contents of scores of books. He would often recite Harold Lasswell's model of communication: "Who? Says What? In Which Channel? To Whom? With What Effect?" (from a 1948 article titled "The Structure and Function of Communication in Society"). He knew the classics and could mix in George Orwell or Harold Innis or Marshall McLuhan, whatever suited his mission. I told him I had some problems with McLuhan, specifically McLuhan's ideas on what he termed hot and cool media. McLuhan had been very important to me when I was in art school. In fact, McLuhan's *Understanding Media* was the first relevant book on making art that I had ever read.

I remember the frustration of looking for something useful and finding nothing but books on how to build armatures for clay modelling or how to mix pigments or make rabbit's foot glue. McLuhan wrote about the effects of media, about the speed of electricity and light, and about the written word and cinema and television. He acted like an artist. Being a young artist, it was so liberating to find McLuhan. But I had some problems with his categorization of media and his poetic, obscure approach to structuralism. Scott and I argued about McLuhan all the time.

Scott Didlake said we were crazy not to go and meet Marshall McLuhan. It was common knowledge that McLuhan was holding a weekly seminar at the Coach House on Queen's Park Crescent, and someone had told Scott that if there were room, McLuhan would let anyone attend. We went early to make sure we would get a seat, and as we entered the Coach House we were surprised to be greeted by McLuhan himself. He was standing there, tall and thin, in a brown, double-breasted tweed suit. He offered Scott a handshake and they exchanged names. McLuhan, noticing Scott's accent, asked Scott where he was from. He then asked Scott what he did, and Scott said he was a filmmaker. Then he turned to me and got my name. When he asked me what I did, I blurted out that I was a video artist. McLuhan laughed and said, "Now that's an oxymoron if I ever heard one!" "Oxymoron" wasn't part of my vocabulary at the time, but I sensed McLuhan was being derogatory. Repeating our names, he welcomed us to take a seat. It wasn't a big space, but we were early and took a couple of seats against the far wall. As I watched the room fill, I kicked myself for saying I was a video artist. No one knew what a video artist was in those days.

McLuhan greeted about thirty or forty people until the place was full. Students filled all the space on the floor. The place was absolutely packed. At 7:00 p.m. sharp McLuhan called the seminar to order, welcoming everyone and introducing Peter Drucker, another older man wearing a suit, as the featured guest for the evening. McLuhan said Drucker was his dear old friend and that he was indisputably the world's top thinker on management. McLuhan and Drucker went way back, and McLuhan's introduction was as playful as it was bombastic. He said Drucker was the unlicensed psychiatrist of modern business, and that Peter had, like fellow Austrian Sigmund Freud, figured out that people would pay a lot of money to anyone who would listen to their problems.

Drucker started his speech by thanking Marshall for inviting him to read passages from "A Descent into the Maelstrom" by Edgar Allan Poe. Poe would be the medium for this evening's seminar. Seated in a crumpled blue business suit, Drucker began reading from the "Maelstrom" while Marshall sat close by his side, arms folded, listening intently with his eyes closed. After probably five minutes, McLuhan, eyes still shut, raised his left hand, interrupting Drucker, and after a few seconds of silence, began reciting bits of Poe's "Raven" from memory. After a few stanzas, McLuhan fell silent, as if he was savouring the trail of the verse, and Drucker

started up "Maelstrom" again. This odd duet went on for forty minutes: prose and poetry, poetry and prose. Two of Poe's texts, as different as day and night, were divided further by their contrasting reading styles. Drucker's dry rendition of a sailor's attempt to avoid being swallowed up by a giant whirlpool was broken repeatedly, at McLuhan's discretion, by the haunting verse of Poe's most famous poem. I wasn't getting much out of the duality of Poe, except the almost comic clash of Drucker and McLuhan's reading styles, but the audience remained still and attentive. Finally, mercifully, Drucker seemed to be finished. He closed his book, and there was a welcome silence, and then McLuhan, in the same rhythm and tone of poetic voice, opened his eyes and began a monologue about the importance of studying the nature and effects of the currents of chaos. He straightened up in his chair, recrossed his legs, and likened the act of reciting a poem with the logic of retracing the steps of a criminal in a detective story. He said that Sherlock Holmes loved reciting poetry like it was a crime scene and stressed that retracing our steps was fundamental to learning how to comprehend any old or new happenstance. None of this made any sense to me, but McLuhan's speech was gaining momentum as his eyes swept through the Coach House for any twitch or nod. A few of the older, professor types in the front row were nodding affirmatively. Drucker, wearing a crooked smile, didn't seem very convinced himself. But McLuhan was stimulated and looking for something from the audience.

McLuhan looked us all in the eye and asked if anyone had something to offer his guest. The readings from Poe had done little to stimulate interaction, and there was nothing but shrugs. McLuhan unfolded his legs and was now standing and demanding that someone offer a question or a comment to get the ball rolling. Finally, a young man with long black curly hair, rose from the floor and began to make a fiery speech directed at Drucker, stating that Marx and Poe may have written around the same time, but that unlike Poe, who offered escapist literature, Marx had tried to make the proletariat aware of the pitfalls of capitalism. This kid wondered why Drucker had spent his entire career trying to revitalize capitalism, when it was clear that the knowledge sector that Drucker had been championing since the 1950s was imprisoning workers and driving a wedge between the classes throughout the world. Drucker seemed prepared to answer, but McLuhan stepped forward and, glaring at the kid, he said: "As you're probably aware, Karl Marx was one of the Marx Brothers. The other three were in the movies. Karl made speeches and started revolutions. The others worked hard. Someone in the family had to have a job, I guess." And further he said that everybody knew that Karl couldn't hold a candle to Chico, Harpo, and Groucho. The audience was laughing by this time, drowning out the kid's retort while McLuhan asked him where he got off comparing Marx and Poe, as they were clearly in different leagues. If Poe had worried about making a fair wage for his writing he wouldn't have written in his completely original style. Poe was the revolutionary. Marx was an ordinary hack. McLuhan was standing in front of Drucker, looking and acting like a gunslinger with both guns drawn. McLuhan was a cowboy.

The young Marxist and two of his friends were fit to be tied, but left the Coach House in a huff, and things quieted down. McLuhan mumbled on about respect and manners and the preponderance of regressive, exhausted arguments as he returned to his seat and asked, in a subdued, disinterested voice, if there were any more questions or comments for Peter Drucker. After another long silence, Drucker spoke about Poe's "Maelstrom" and stated that for him the whirlpool represented the massive change brought about by the Industrial Revolution. When confronted with massive change, it would be up to us to sink or swim. Capitalism and the division of labour had been one solution. He went on to admit that capitalism was hardly perfect and knowing full well that economics and politics were akin to studying the weather, it was clear that capitalism was going to evolve into something else. What this would be was still a question mark. Then McLuhan went on a long monologue about chiasmi. There were no more interjections from the audience that night. Drucker and McLuhan talked for another half-hour, and then the audience was dismissed. Scott and I had met Marshall McLuhan. Neither of us ever returned to the Coach House.

Back in the spring of 1974, the Art Gallery of Ontario had hired a new curator of contemporary art. His name was Alvin Balkind. He had parachuted into Toronto from Vancouver. The AGO was expanding and there was a chance it might do something to reflect the vitality of Toronto's contemporary art scene. The AGO was constructing a new wing to house a massive, unbelievably redundant collection of Henry Moore's sculpture and works on paper. Moore had basically dumped every plaster he had ever made on the AGO. There were hundreds of dinosaur-sized pelvic-bone sculptures and abstract female forms with tiny breasts and elongated pinheads, but for a major institution in the centre of the colonies, this sculpture dump by a modern British genius was reason enough to expand the AGO. Alvin Balkind was determined to do something positive with the opportunity of the AGO's expansion and announced there would be a large survey show of Toronto's contemporary scene to complement the opening of the Henry Moore Sculpture Centre. I wasn't so sure about Balkind because he had already introduced himself to Toronto through his preliminary work on a giant thematic exhibition to be called *The Chair Show*. Balkind was asking artists to make their dream chairs, any kind of chair, and he was predicting the result would be a fun, accessible show for the masses — in other words, a predictably playful and stupid show. I suspected Balkind was a lightweight.

Meanwhile we received a press release from the AGO announcing that Balkind would do a contemporary Toronto show and the studio visits commenced. Alvin Balkind was working his way through the Toronto scene like a bulldozer. He was looking at everything and talking to everyone. We had never seen anyone with this kind of energy or commitment. Peggy Gale had left the AGO because the bureaucracy would kill anyone with a brain in his or her head. Alvin was telling everyone he wasn't interested in paperwork. Being a curator wasn't a desk job to

him. He came over and looked at my text works and Lisa's tapes. He asked a lot of questions and, although he was non-committal, he seemed interested in what we were doing. He didn't seem grounded in object-based art. He understood that art was about ideas and stories and personal obsessions, and if you told him what interested you, he would listen. He didn't talk too much about what he was thinking, but rather he would talk about things artists were doing in other places. I still wasn't sure about Alvin, but he was a breath of fresh air. He wasn't pretentious and cool. He was a little awkward in his manner of speaking. He was too loud and then he'd mutter under his breath, and then explode in laughter. His laughter was startling. And then he would be quite sober. He wasn't sure about Toronto. Alvin missed Vancouver from the day he arrived in Toronto, and he wasn't afraid to say he wasn't sure about Toronto.

It wasn't too long before the letters arrived. The show would be called *In Pursuit of Contemporary Art*, and Lisa and I were invited to show specific works, as were Colin Campbell and General Idea and Rodney Werden, Robert Bowers, Stephen Cruise, Robin Collyer, Shirley Wiitasalo, Ian Carr-Harris, and just about everyone else who had it together. I would learn later that the show would include around twenty-five artists, quite a diverse group, although the show did end up being fairly cool and decidedly black and white. Lisa and I were excited as the AGO was a big deal. It was exclusive and stuffy, but we were being invited into the upper echelon of Canadian art. This show was a breakthrough for us. It was only a Toronto show, but we were blind to anything else going on beyond the outskirts of Metropolitan Toronto. Cities are fiercely regional entities in their own way. In any case, Alvin invited everyone to bring the works he had chosen to the gallery for a pre-installation meeting a little more than a week before the show was to open. We were going to be allowed to install our own works, or at least to position the works for the AGO's staff to mount them. Alvin had chosen one of my text pieces, *This Message Is about the Condition of Your Body*, written in the summer of 1974. **(1)*** I had the typewritten text, a series of simple declarative sentences about the vulnerability and mortality of the human body, photo-enlarged onto two text panels that, when mounted on a wall, looked like a very large open book. I had spent a month nursing a nasty open wound on the inside of my left biceps and had done a lot of thinking about the frailty of the body. I damned near lost my arm from an infection no drugs could deter. The text reflected the anxiety and paranoia of a person betrayed by their body. The text closed with an image of a man lying face down on the top fold of a roof, head turned to one side or the other, with the arms and legs split bilaterally by the peak of the roof. I had played around with jumping from first to second person to take my own self-consciousness and vulnerability and transfer it to the viewer of the work. I took my two photo-enlarged text panels to this meeting with a box of pins. I was confident about the work and looking forward to its installation.

*Bold numbers appearing in parentheses refer to the texts that appear at the end of this essay. See p. 113.

Alvin was clearly very nervous when we arrived. He assembled all of us in an upstairs foyer, and then led us down a granite staircase, walking sort of sideways as he was telling us what he hoped to accomplish that afternoon. He was a stocky, solid-looking man, low to the ground but with questionable balance in the best of circumstances. He leaned forward when he walked and in this case seemed to be tilting sideways as he got his foot caught in the edge of the stairway and fell and rolled like a stuntman down six or seven stairs, only to pop up on his feet on the first landing as if nothing had happened. A few people moved to help him but he simply brushed off the sleeves of his sport coat and continued his spiel. I thought he must be dying with pain, but everyone pretended this dramatic spill hadn't happened in sympathy with this man responsible for inviting us to show in the big house. Things would get worse.

It turned out the space allotted for our show was a glorified hallway on the way to the Henry Moore Sculpture Centre. The ceiling was fairly low and it was hard to imagine how all of us would fit in such A Space. Some of the sculptural objects for Alvin's show were already in the space, including a large jukebox kind of object, made out of plywood, in the middle of the floor. We all gazed around the space, looking for the best possible place to install our own work. Standing there like a group getting ready for a tour, Alvin explained that he had already designated a specific area for each of our pieces, but there had been a few misunderstandings and there wasn't enough room for a few people he had invited to be in the show. It turned out that Alvin was telling Eldon Garnet and others that there was not enough room in the gallery for their work. Relieved as I was that he wasn't asking me to take my texts and leave, I couldn't believe that a curator would screw up and invite too many artists to be in a show, and then would tell the unlucky ones that they had to leave in front of a couple dozen of their peers. Eldon Garnet wasn't going to take this lying down and went into a rant about Alvin's complete and utter incompetence. I felt sorry for Eldon, but noticed he was standing next to his "poetry machine," the jukebox-like object, as he continued his understandable tirade. Alvin just stood there and took it, but finally muttered something that led me to believe the poetry machine wasn't the object he had asked Eldon to deliver. Both rejected artists left after this exchange and the rest of us, a bit rattled by the bad vibes, were led to our respective areas and began to get a sense of the way the show might look. The ceiling was low, and the floor was carpeted, but the walls were freshly painted white, and the track lighting was adequate.

A few days later, and only a week before the show was to open, we got the word that Rodney Werden's piece was being removed from the show because the administration of the AGO thought his piece might offend the public, or more specifically the trustees of the gallery. Werden's piece was a large photograph modelled after a movie poster, showing a rather androgynous figure coming up behind a standing man, suggesting the somewhat blurry figures might be engaged in anal sex. The artfully executed, handsome black-and-white photograph had a block of red-and-white text at the bottom that said "Coming Attraction." You couldn't miss

the orgasmic implication of the image, but it was hardly explicit. There were no visible genitalia and unless you were in complete denial about the possibility of anal intercourse, the piece was hardly offensive. It turned out that William Withrow, the director of the AGO, had noticed Rodney's photograph on the way to the Henry Moore Centre and had asked Alvin to get rid of it. Alvin had called Rodney up and asked for another work and Rodney had refused, so Alvin was being forced to pull the work from the show. Lisa, Colin, and I mounted a telephone campaign telling everyone in the show that the AGO was censoring the Werden piece, and announcing that the three of us were withdrawing from the show in protest and asking them to join us.

Rodney was one of our contemporaries and, while he was already developing a reputation as a bad boy, this was outright censorship, and it was wrong. Rodney had grown up in Toronto and was scratching out a living as a bookkeeper, typesetter, and photographer. He was attracted to sexual activity of all kinds and used his cameras to work his way into a wide range of interesting situations. He loved to watch and was frequently asked to shoot documentation of couples having sex on their wedding nights. His business evolved through word of mouth and the quality of his images. Rodney lived with a writer named Susan "ASA" Harrison. Harrison was a large woman, big-boned and heavy set, almost a head taller than Rodney. She liked to talk about sex and laugh. She edited a book called *Orgasms*, published in 1974 by Coach House Press, a series of interviews where women talked frankly about their sexual activity. They were a fascinating couple. Rodney had a smile like a Cheshire cat. He was naughty, but nice. We were determined to come to Rodney's rescue. We asked everyone in the show to join us by pulling out of the show in protest. While everyone was sympathetic with Rodney's plight, no one else was willing to pull out of the show in defence of Rodney. Lisa, Colin, and I delivered our intention to withdraw from the show in writing and began to make some calls to get the story into the press. Alvin was between a rock and a hard place.

Rodney was of course buoyed by our support, but in the days that ensued we all felt betrayed by Alvin and the rest of the artists who decided not to join our boycott. Here we were, withdrawing from our first big show and, worse, finding out that principles didn't mean squat in our "community." As far as the other artists were concerned there was more space for them. The embarrassment for Alvin must have been profound. It was a very depressing situation. Three days into this gloomy silence we got a call asking us to meet with William Withrow in his office. We figured he was going to try to convince us to show minus Rodney, and we reaffirmed our decision to withdraw before we went to the meeting. Alvin was already in William Withrow's office when the four of us were asked to take a seat at this round table over coffee or tea with the director. Bill Withrow was straightforward and immediately apologized to Rodney and Alvin, and admitted he had overreacted. He wanted us to know that Rodney's work was now properly hung and lit and would be part of the show, as Alvin had intended, and that he hoped Lisa and Colin and I would also remain in the show. We coolly expressed

our wish to be part of this important exhibition and, making eye contact with Alvin, we thanked Withrow for reversing his decision to exclude Rodney from the show. Withrow was gracious and we finished our meeting by making small talk about our work and our belief in the vitality and importance of our scene. Once outside the gallery, we laughed and hugged and celebrated our victory. While we never discussed the meeting and Withrow's change of heart with Alvin, he obviously made his own stand against the AGO's administration and won. We were pleased with ourselves and Rodney was relieved and moved by our support.

Our show opened the night of the gala for the AGO's new galleries. Our work looked pretty good, but was lost in the excitement surrounding the Henry Moore Sculpture Centre. We stood in the vicinity of our work and watched streams of strangers in evening gowns and tuxedos rush past our work on the way to the Moore collection. There were a few people watching Lisa and Colin's video, sitting on the benches in front of monitors in the little alcove under the stairway, but they couldn't hear what was being said on the tapes because of the din of the Moore enthusiasts. I had dressed down for the occasion, wearing my jeans and a clean plain-white T-shirt. Back in the rotunda, a woman I had never seen before, probably in her mid-thirties, wearing a low-cut iridescent-blue gown, looked me up and down rather deliberately and asked me if I was an artist. This woman and I were having a polite conversation by the punch bowl next to the large, iced-butter sculpture of a unicorn, when I noticed Adolf Hitler milling around by the hors d'oeuvre. I found out this spitting image of Hitler was created by Glenn Lewis, the ceramicist turned performance artist from Vancouver. Lewis had dressed up as Hitler, uniform and all, and the likeness was incredible. Introducing himself as Flakey Rosehips, he had even clipped his moustache in Hitler fashion. He wandered around for quite a while without causing much of a stir, despite his disturbing appearance. Eventually a bouncer, dressed like a partygoer in a tux, tried to throw him out when Lewis ventured too close to the main entrance. There was a scuffle, but Flakey escaped and rejoined the crowd. General Idea was busy giving mock interviews in the snarl of the crowd, answering questions posed by a shotgun-microphone-wielding Whitney Smith, using the crowd as a backdrop for a photo and video shoot. I felt completely out of place and wandered around, had a few too many drinks and got caught by Lisa flirting with a young, nearly naked British tart dressed in a full-body nylon stocking with only a few feathers covering her breasts and pubic area. She had taken off her bird mask to reveal her identity and to give me her number and a kiss on the cheek when Lisa arrived. That was the end of the evening.

Later when the *Videoscape* show opened in November 1974 at the AGO, I went through the motions of going to the opening, but I was distracted with preparations for a solo show of my latest text works at A Space that would open a few days later. Lisa and Colin and John Watt and General Idea and scores of other artists were featured in the *Videoscape* survey, but the problems of exhibiting video in a museum were never more apparent. The work in

Breathing Apparatus, 1974, wearable negative-ion generator
exhibited by Tom Sherman in *Text Works*, A Space, Toronto, November 1974.

Videoscape was installed in a series of viewing stations surrounding the museum's sculpture
court. The idea was to provide intimate viewing areas for seated viewers to watch tapes on
monitors, listening through headphones. In other words, audiences were asked to engage in
an intimate, private viewing of the tapes in a public space. In a curious way, the audience was
on display watching this new medium of video. The glow of the monitors seemed odd at the
edges of the sculpture court, but if you would take away the *Videoscape* banner, you might
miss the show entirely. Nonetheless, *Videoscape* was well attended over its long run (it ran
until April 1975) and definitely energized the video scene by officially recognizing the medium
and demonstrating the extent and range of video activity throughout Canada and New York
City. Peggy Gale had started out intending to curate a full-blown international survey, but there
was so much good Canadian work, only a handful of artists from New York were included.
Lisa, Colin, John, General Idea, Noel Harding, and Eric Cameron's work looked great beside
tapes by Nam June Paik, Richard Serra, Robert Morris, and William Wegman. The balance of
the Canadian work was unmemorable. The medium was in its infancy and process was still
emphasized over product. Peggy had found the work early, conducting her research while
working for the AGO as education officer, travelling and looking at a lot of work and forming
her unique overview. The work for *Videoscape* had been selected back in 1973, and Lisa had
already made better work than *Sleep/Dream Vigil* and *Juggling*, but Colin and John's tapes in
Videoscape were very impressive. John's *Peepers* and Colin's *This Is the Way I Really Am* and
Sackville, I'm Yours were stunning.

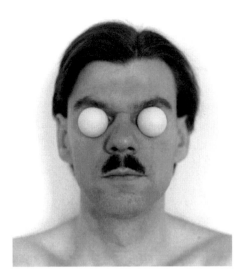

Self-portrait of the artist advertising the exhibition *Tom Sherman
at Art Metropole*, Toronto, May 18-31, 1975. The poster included the text:
"The city is attractive and intelligent conversation is often heard. A nice size.
The ordinary ping-pong ball, cut in half, provides a source of even white light."

Peggy Gale was doing the legwork toward understanding the contemporary art scene in Canada. She had studied art history at the University of Toronto and seemed a bit academic when I first talked with her. As formal as she was (she dressed professionally, like an adult, even though she was only a few years older than us), she always had a good vibe and ended most of her studied, careful, somewhat halting critiques with a warm smile that revealed this amazing little space between her two front teeth. Peggy was married to this very nice but impossibly boring man named Peter Gale, who was doing an advanced degree in art history. When her husband took a position at the National Gallery of Canada in 1974, Peggy left the AGO and moved to Ottawa where she worked on the *Videoscape* catalogue essay, her first contract as an independent curator, while Marty Dunn was dealing with tech decisions in Toronto. She had an appointment with Penni Jacques at the Canada Council to ask her about video-production-distribution details when Penni offered her a job as her assistant. As assistant film and video officer at the Canada Council, Peggy would expand her knowledge of the developing media arts scene in Canada. There was a lot happening across the country, but very few people had a handle on the whole national scene.

Peggy had been in contact with Garry Neill Kennedy and he had turned her on to the conceptual works of David Askevold and Doug Waterman and the NSCAD scene in Halifax. Peggy also told me she had heard the people at Le Vidéographe in Montréal had figured out how to link two Sony AV-3650s electronically, thereby automating the editing process. She couldn't tell me anything about the electronics, but she said she had seen recent Vidéographe

tapes and said the edits were really clean. She travelled to Vancouver, where she experienced the radical, vibrant experimental-video scene, including the technical virtuosity of Al Razutis and the zany neo-Dada activity that was pouring out of a disintegrating *Intermedia*. I knew about Fluxus and Claes Oldenburg's store and Nam June Paik and Yoko Ono's early performances, but Peggy had a better handle on how to explain this activity and hundreds of similar actions historically. Peggy outlined the connections between Michael Morris and Image Bank and General Idea, and this gave me a better idea how Dr. and Lady Brute, Mr. Peanut, Flakey Rosehips, and Anna Banana had evolved.

We were getting bushels of mail or correspondence art every week at A Space and we were just looking through it and throwing it out. The volume of mail art we were receiving was incredible. Marien Lewis reminded me there were real people doing real things behind all this mail art, but we were getting so much every day, it was becoming simply another form of junk mail. Don Mabie, aka Chuck Stake, from Calgary, and Ray Johnson, founder of the New York Correspondence School and the hand behind countless bunny-head portraits coming out of New York, were especially prolific. Marien, like Peggy, was talking a lot about neo-Dada, but not from a historical point of view. Marien was intrigued with the theatricality and political irreverence of the activity. The idea of networking communities of interest was cooking before computers were personal, and the postal system, then a real bargain, was providing long-distance links between sources and a concrete alternative to galleries and museums. Peggy was very high on General Idea and their magazine *FILE*. The magazine was functioning as a sourcebook for ideas and image exchange as it was simultaneously constructing a concrete scene out of a smattering of ethereal activity. Peggy seemed conservative in dress and manner, with her institutional experience and art-historical perspective, but she was a conductor for a national and international crossfire of new ideas.

Meanwhile I was getting my texts photo-enlarged for my solo show at A Space. I wanted to see if it was possible to involve an art-gallery audience in a reading experience more demanding than a text or two. I photo-enlarged nine typewritten, short text works, some consisting of multiple panels, and hung them throughout much of A Space's gallery, lighting them like photographs. The text panels were not very large, eighteen by twenty-four inches, so viewers could settle into a comfortable reading distance, standing a little more than three feet from the wall. The texts themselves were full of written images: some of them more conceptual than others, some pure descriptive prose, and some verging on cinematic narratives. One wall had a dozen panels, sampling a piece I had written called *11 of 50 Car Crashes with Fires*. **(2)** I had found a book of matter-of-fact police-style records of car crashes resulting in fires, and with Andy Warhol's *Death and Disaster* series in mind, I had rewritten fifty of these accident descriptions to flow as a gory, percussive, serial string of high-impact flaming disasters. In the sixties and early seventies, many American cars had gas tanks hanging precariously under

their trunks, literally anchored to the rear bumper. If any of these vehicles were rear-ended the gas tank would explode, engulfing the rear-ended vehicles in flames. A reader at A Space would scan these texts and see things like a dark-blue 1968 Buick Skylark travelling at forty-five miles an hour hitting the brakes but slamming into the rear of a safety-orange 1969 Ford Pinto, with the resulting explosion engulfing the Pinto in flames and resulting in the death of three teenagers and a boy.

On another wall there would be a series of descriptions of insect-related incidents, like my first tape recorder being infested with cockroaches or a formal examination of the helical shape of a tomato worm (in metamorphosis, all larvae embody the form of the helix). **(3, 4)** People would predictably decide to look at the panels from left to right, walking from panel to panel and stopping to read each one with their eyes scanning left to right, top to bottom, while they stood transfixed in the images contained in each text. **(5)**

There was also a two-panel text called *The Art Style Computer Processing System* that served as the initial work of this show (there were no text panels to its left). **(6)** I had written this text after playing around with the Paik/Abe video synthesizer at A Space, realizing that most people would look for order in the abstraction of a scrambled video picture and find it in the history of painting. Synthesized video was either impressionistic or expressionistic electronic painting, depending largely on colour saturation and contrast. My text made the analogy between scrambling a video picture and various aesthetic strategies of painting. It was a critique of this new tool, which ironically and regressively transfigured video, a powerful photo-electronic, representational medium, into an electronic, rather unsubtle form of abstract painting, and of painting as a creative act in itself. Painters, since photography, had little choice but to emphasize form over content. This was one of the basic tenants of Clement Greenberg's modernism.

I placed the *ASCPS* text at the beginning of this show for a couple of reasons. First, it signalled a transition in my work from text as concept to the use of descriptive prose as a way to form sensual, virtual objects. I realized that images could only be perfect for a viewer if they were formed in their mind's eye. I would initialize an image through descriptive prose, but the viewer would have to meet me halfway and create the image in their mind. The second reason this text was up front was because I was very proud of this text. *The Art Style Computer Processing System* was the first writing of mine that had ever been published. I had sent out a hundred photocopies of it as soon as I had finished it, sending it to friends and acquaintances and targeted venues like university departments and technology journals. I had received good feedback from people in Toronto, but nothing from a distance, until one day when I received a package from England. There were ten copies of the *Journal for the Communication of Advanced Television Studies*, a serious journal coming out of London, with

a note apologizing for not asking permission, but they had taken the liberty of publishing *The Art Style Computer Processing System* in this current issue, and that they thought the text was fantastic. Of course, I didn't care that they had jumped the gun and published my text without asking permission. I was thrilled. They seemed to have interpreted my text as the description of a new form of television and through publication had given weight to my critique. This publication fuelled my writing and marked my sense of progress. The solo show of my texts at A Space was another accomplishment. These were small steps that didn't make much difference in a city the size of Toronto, but I was beginning to get a sense of what the future would hold. I wanted to be an artist and to work with written language.

The cover of the *Journal of the Centre for Advanced Television Studies*, London, England, 1974, Tom Sherman's second adjudicated publication.

Around this time I had a run of bad health. One morning I noticed a lump on the inside of my left biceps. I didn't have a regular doctor so I went to a clinic, the kind of place you would go with a venereal disease. The doctor I saw was nice but had no idea what to make of a lump this size. It didn't hurt when he pressed his thumb in and around my muscles, but there was a distinct lump about the size of a walnut. He referred me to a surgeon named Haraki. Dr. Haraki didn't know what it was either but said it might be cancer and recommended a biopsy right away. I had a rather unpleasant biopsy under local anaesthetic and after he

removed the lump and sewed me up, he sent me home to await the test results. That evening my arm swelled up to three times its original size and I headed over to Women's College Hospital, where another doctor began treating me with antibiotics. I was running a fever and my arm was killing me. After a couple of days with no reduction in swelling, Dr. Haraki had me under general anaesthetic and was opening up the wound, debriding the infection. I was sent home with an open wound, as a wound this deep would have to heal from the inside out. I was on Percodan for pain and generally pretty out of it for a week. Within a day or two, I had managed to leave my wallet on a streetcar and realized I couldn't function on Percodan, but it did ease the pain. Lisa would help me change my bandages and we would look at this open, runny, mouth-sized wound and wonder how in the hell it was ever going to heal. The multiple courses of antibiotics were doing nothing and Haraki admitted he didn't know what to do next. The biopsy had revealed nothing. He said it could have been a viral infection, but that now my problem was bacterial, an infection sustained during surgery. The good sign was I was holding my own. Most of the swelling had gone down below the elbow. He told me if things turned for the worst he would have to amputate my arm. Basically, I was on my own.

I was collecting unemployment insurance and spent nearly six weeks pretty close to home, reading and writing and waiting for the wound to heal. From our third-floor College Street apartment, I watched the CN Tower emerge in silhouette against the glimmering surface of Lake Ontario. The twin black towers of the Toronto Dominion Bank were already in place. Toronto was growing into a big city before my eyes. Its population was now over two million and all the Canadian banks were building their world headquarters in Toronto. Skyscrapers were sprouting up in a spirited competition to dominate the skyline. The CN Tower had been hyped up in the press for over a year before its shaft actually began to emerge. It would be the world's tallest free-standing structure. Essentially, it would be a television and microwave antenna cluster with an observation tower and restaurant, but it would be very tall. Construction workers laboured twenty-four hours a day, pouring massive volumes of concrete from an enclosed slip form, a construction hoarding that capped the lengthening shaft as it rose almost two thousand feet into the sky. By the time the giant Sikorsky helicopter began placing the forty-four sections of the antenna into place, my arm was healing and I was getting back on my feet. I had learned to increase blood flow through my upper arm through meditation and could make the healing wound heat up and tingle by staring at it for half an hour. I literally willed that wound to close.

People were very kind while I was laid up. Robin Collyer and John Watt would visit me a lot. Robin was seeing a lot of films and would describe every scene in meticulous detail, never noticing how tedious his descriptions would become after the first few minutes. It was particularly bad during his Jerry Lewis phase. Robin loved Jerry Lewis films and would laugh out loud while he would tell me about all his favourite scenes. Robin would talk about movies

as if they were real flesh-and-blood experiences, as if the cinematic world and the real world were one and the same. I couldn't remember if I had seen half the movies he was telling me about — anyway, I just couldn't go there. If Robin asked me if I had seen a particular Lewis film, I'd say yes, hoping it would end there. But then Robin would describe the whole film, generously wanting to share its joy. I had seen most of Jerry Lewis's movies when I was a kid but had never liked them and couldn't remember them. Robin thought Jerry Lewis was a genius. John Watt, on the other hand, was always bringing me audiocassette dubs of new music, mostly rough-and-ready reggae from Jamaica. John was into Jimmy Cliff a couple of years before he became famous as the gun-toting, drug-selling rude boy in *The Harder They Come*, Perry Henzell's hit movie. John promoted "world music" before there was a category for it and was on top of the musical currents running through Toronto at the time. John always had great music and magazines and he could talk the language of the street. He had a great ear for slang. He was hanging out in Toronto's "Black Bottom" neighbourhood, eating hot patties and stewed ox-tail dinners, and buying lots of vinyl.

One day I got a call out of the blue from AA Bronson of General Idea. He said he had a book he wanted me to check out and asked if he could pay me a visit. I didn't know AA very well. Whenever I made small talk with him, AA always seemed to be "on" with his glib sense of humour. GI was always practising their corporate lingo. It was hard to have a real conversation with AA, Felix, or Jorge. AA came over for a visit that afternoon and we had a nice talk over coffee. He told me he was glad to hear I was getting better and asked me about my writing. He listened. He was soft-spoken and didn't ham it up the way he did when he was speaking on behalf of GI. He was very bright and well-read and rattled off a string of titles he thought I would enjoy. We talked a bit about the scene and publishing and typography and design. As our conversation began to lose form he pulled a book out of his bag and handed it to me. It was a hard copy of John Brockman's *By the Late John Brockman*. It had a plain-looking brown cover, but inside it was composed of page after page of short texts, from a few typeset lines (in Times New Roman) to a page-long paragraph in length. There was a lot of empty pages showing throughout, like a poetry book, but this book was prose, a philosophical, but clear, bare-bones prose. There were asterisks throughout the text with an extensive set of references at the back of the book. I skimmed through it, fascinated. AA told me John Brockman was from New York and that he had published another book called *Afterwords: Explorations of the Mystical Limits of Contemporary Reality* (Anchor Books, 1973), a book much like this one, republishing a revised version of *By The Late John Brockman*, but expanding it into three sections. AA then said he had to go to another meeting and that it had been a pleasure. As we stood I told him I'd check out Brockman's book and get it back to him when I was done. He told me not to worry. It was a gift. He said my writing had led him to believe I might find Brockman interesting. I thanked him, we shook hands, and he left.

That week I read Brockman's book three times straight through without taking a break. I stopped writing and did nothing but read Brockman day and night. It turned out that each page framed an idea, clear and beautiful ideas initialized by great thinkers like Bertrand Russell, George Kubler, Alfred North Whitehead, René Descartes, Ludwig Wittgenstein, Carlos Castaneda, Samuel Beckett, Buckminster Fuller, Alain Robbe-Grillet, Marshall McLuhan, and scores of others. These great writers were referenced, but Brockman had written these beautiful passages that framed the ideas with remarkable precision. Brockman constructed a reductionist philosophical collage that shattered belief systems and eliminated self-consciousness, to the point where you had no choice but to be right on the page, in a present so full there was no room for the past. Brockman wrote with such economy, one of his paragraphs was like a whole book by someone else. If a book could be a bomb, then Brockman had torn my head off and handed it to me. After I felt I understood what he was doing, I returned to my writing with a sense of purpose. My arm had completely healed. I attacked my writing in sessions six and seven hours long. I was trying to find the absolute moment in the present, the loaded present that Brockman managed to deliver at the end of so many of his lines.

After days of writing where I couldn't eat or sleep, I had to get out of my head and back into my body. I had returned to my regular basketball routine at the Y, playing harder than I had ever played. The pick-up games at the Y had intensified. A lot of the guys were executives and under a lot of pressure at work, and they played hard. There weren't many laughs, just a lot of hard-headed banging. By the end of the first week, I got into an elbow-throwing contest with a six-foot-seven, three-hundred-pound asshole. I could take him outside and make mincemeat out of him with a crossover, but I took pleasure in backing him into the key for little jump hooks off the board. I would use a little stutter of head fakes to get my shots off. I was holding my own on defence. He would back me into the lane with his back end as big as a house, setting himself up for a hook shot. He always faked to the right and turned to the left. I could feel his weight shift and would reach around and strip the ball before he went up with his hook. I was torturing him with frustration until he decided he had had enough and levelled me with an elbow to the mouth. I found myself on my ass, half unconscious, ears ringing, holding my mouth. I was bleeding like a pig. He had shattered a posted, capped tooth in my upper jaw. Basically, he had knocked one of my front upper teeth into my throat. I was so pissed I wanted another shot at him. Danny Finkleman gave me a hand and helped me stand up and told me that was it for the afternoon. He took me to an oral surgeon he knew, and the dentist went in and extracted the metal post from the bone and stitched my gum up. The swelling went down over the weekend and I played without a front tooth for a week until my regular dentist got me a partial plate, a flipper that wasn't too much trouble and looked better than the cap I lost.

I continued to play even harder. The afternoon sessions at the Y were nasty and bloody and full of injuries and fights and swearing. We played like we wanted to kill each other. I was losing weight and was eating like a horse and was horny all the time. Lisa didn't know what to do with my energy. We had developed this finesse-based sexuality together, but now I just wanted to break on through to the other side. My writing process was very intense and I seemed to be feeding off the mental energy when I moved into the physical domain. With my newly developed meditative powers, I was able to use my mind to suppress any and all ambient sound until I would find myself in the silent white space of the empty page. I could clear my mind in no time and showers of ideas would flow once I kicked the day-to-day nonsense aside. I loved the way my IBM Selectric would strike the paper. I could write for hours, seemingly without breathing. When I'd lose my focus, I would find the energy in my thighs and shoulders, and then I'd have to bang, to slam myself hard and long into the core of my physical existence. I had tapped into something. I had unlimited energy.

I was making progress on my mission, but the unemployment insurance had run out and I didn't have any prospects except A Space again, and I couldn't face that place every afternoon. I enjoyed going to shows and screenings there, and still was there a fair bit of the time, but I felt I couldn't work there full-time again. Finkleman was engaged to marry a librarian from the Toronto system. He told me they might need someone to work in a branch library called the Evelyn Gregory Library, a small library in an Italian neighbourhood in North York. The money was pretty good, so I got cleaned up and went for an interview. The head librarian was a woman named Diane and she was having a nervous breakdown because the neighbourhood kids were terrorizing her after school, throwing footballs through windows and putting cherry bombs in the toilets, cracking the bowls and flooding the washrooms. Diane was a redhead and had bloodshot eyes that bulged out of her head. Beside her frayed nervous system, she had a serious thyroid problem. Basically, Diane wanted a male assistant librarian to function as a bouncer, to control the kids. I was big and hairy and serious looking and would do just fine. They made an offer and I took it. It was a long commute, but excluding the chaos that ensued in the hours after school and before supper, the job was laid-back and it had its perks. The inter-library loan system was efficient and I could do my own research while collecting a salary. I requested a couple of hundred titles and kept the books as long as I needed them.

It took me a month to get the kids under control. I banned the worst ones and worked with the parents to calm down the rest. In the meantime Diane went on an extended medical leave, so I was basically running the place. I conquered my fear of little kids by learning to entertain them with story time every Saturday morning. The library was a fascinating place with a collection of weirdos. There was a guy who worked in the meat department at Loblaws; he was into space exploration. He would come in every noon hour to read a giant, one-volume outer-space encyclopedia in the reference section. I think he was trying to memorize all

twelve hundred pages. He would scream out the names of his favourite astronauts, scaring the hell out of me and the other patrons. "SHEPARD!" I talked with him a couple of times about his yelling, but he told me he couldn't help it. "ARMSTRONG!" There were housewives that read twenty-five books a week and always brought them back on time. They loved large-print westerns. Go figure.

There was a kid about twenty years old with thick glasses taped together with shiny black electrical tape. He smelled real bad. His clothes were filthy. His father shovelled coal and obviously beat this kid and his older brother on a regular basis. He would bring a thick red spiral-bound scribbler with him and sit by the window in the back of the library, writing like there was no tomorrow. He wrote with tremendous velocity. I asked him what he was writing and he'd ask me if I had ever read *The Canterbury Tales* by Chaucer. He wanted to write like Chaucer, only it would be about the people in Toronto today. He would write on the bus, describing everyone and listening to everything they would say and then continue through the streets and into stores and his house. He told me that people were all different from one another, if you looked closely. One day his father, more agitated than usual, came in to get him, grabbed him by the ear, drug him out, and threw him in the cab of his truck. The kid left his red scribbler in his regular spot and never returned to pick it up. I couldn't resist taking a peek at what he was writing. The red-covered scribbler was full of one continuous seismographic line tracing his thoughts through a hundred pages without forming a single word. I could imagine the things he might have seen, but this book was an abstract drawing, not a text. I could see the points where he'd pick up the wiggle of this line from day to day, where the blue ballpoint pen would skip when it was starting out and where it would die before he would go home.

So this was the routine: the library during the day, and then movies and A Space in the evenings, and writing deep into the night. Lisa had begun volunteering at a crisis centre for women called Interval House. I was playing basketball a few nights a week. Often, late at night, I'd look at the red blinking lights on the nearly completed CN Tower and think about electromagnetic radiation. We were plagued by RF (radio frequency) interference whenever we tried to use an external microphone with video gear. The microphone cable acted like an antenna and you could hear radio programs in the background hiss of all our tapes. I experimented with scarf-length "blankets" of grounded wire mesh, but there was so much electronic smog in Toronto, it was nearly impossible to eliminate the RF noise through grounded screens. I was reading Soviet scientific literature on microwave transmission. Some Soviet scientists thought there were connections between microwave propagation and cellular abnormalities like lymphatic cancers. I wondered if the initial lump in my arm had resulted from my experiments with Tesla coils. I thought about turning the whole College Street apartment into a Faraday cage, but Lisa wasn't sure she wanted to live day and night in a laboratory. I thought this was funny because no matter how we tried to reach out to a

broader public, our scene was so isolated — it was like we were already living in a laboratory. We had our own culture, our own art. We found popular culture simplistic and repulsive. We were already living in a cultural isolation chamber.

Around this time Norman White and Lisa and I had spent an evening together, first seeing *The Conversation*, one of Francis Ford Coppola's most brilliant films, downstairs at the Cinema Lumiere, and later talking for hours in our living room about bugging phones and parabolic microphones and the way insects hear. Norman could really extend a conversation into interesting territory. He told us he might be moving out to Vancouver shortly. Stan Bevington at Coach House told him about a sculpture competition for an electronic mural for CBC's headquarters in Vancouver. Norman had submitted a proposal and it looked like it was going to happen.

I had built a darkroom for Lisa in our spare room. It was a little free-standing shack, not that different than the *Faraday Cage* I built at A Space, although I skipped the metal shielding and focused on improving the light lock. Lisa had continued to work in photography while she was developing her video work. She enjoyed having her own darkroom and spent a lot of time trying to get her prints just right. She was hand-tinting photos and making some interesting, subtle images. The photography scene in Toronto was conservative and exclusive. Photography was a separate, discrete practice and had its own galleries and scene. There were not many venues. Photography was exhibited as framed, matted, small black-and-white prints. Colour photography was seen as commercial. It was difficult to break in as a young artist. Lisa had been fairly active with the Baldwin Street Photographers' Co-Op. Michel Lambeth and John Phillips were the movers at the Co-Op. They had brought in Garry Winogrand and Les Krims and others to present their work in a co-production with A Space. They had done a great job doing publicity and the turn out for Winogrand and Krims was impressive. Outside of an incredible crowd we had for William S. Burroughs, where we sold out every inch of A Space and had to turn a lot of people away, the presentations by Winogrand and Krims were the biggest crowds we had ever had at A Space. Lambeth and Phillips had tapped into Ryerson and the Ontario College of Art for a sizable, paying audience. Winogrand and Krims were accomplished, well-known artists, but pretty full of themselves and clearly sexist. They put down women in their work and in the Q & A. Some of Krims's work was designed to provoke through exploitation (naked women with bags over their heads, etc.). Lisa and Marien did video interviews with both of them for the A Space archives. The interviews were combative and interesting only as a clash of generations and genders. Lisa and Marien loaded every question with a feminist critique, and Winogrand and Krims stood their ground in very unattractive ways. People got knots in their stomachs watching these interviews.

Lisa was preparing a solo show of her photography at A Space. I was nervous about the show because her photographs were about our domestic situation, including my genitals. Lisa had done a series of pictures of me in bed, sleeping with the morning light highlighting strawberries she had placed around my figure. The pictures were black and white, but she had hand-tinted the strawberries red. She had done a whole series of my penis and testicles, isolated in close-up, surrounded by orbiting pink-red strawberries. There was a nice comparison between the head of my circumcised cock and the berries. I liked the pictures but I wasn't sure I could deal with the exposure. These pictures could be read as anonymous male genitalia, as they were cropped to completely isolate the pubic area, but we were a monogamous couple and this was going to be a show featuring my privates. I was flattered, embarrassed, and reluctant. I was confused about the whole exercise.

Lisa had very specific ideas about presentation and had asked me to construct floating display panels, hinged at the top (they were shaped like pup tents) that would hang from the ceiling, positioning small clusters of these pictures in natural light, at just the right angle to avoid glare and fairly low so viewers would look down on the pictures. The prints were small and delicate and pinned like specimens to the flat white surface of the panels. Hanging the panels presented difficulties, but we succeeded in getting things level and in the right light. There were three hanging, two-sided panels, and twenty-four pictures in groupings of four each. There were plants tinted green and cups and saucers and brooms tinted yellow, and the cats and I sleeping and six pictures that zoomed in on my strawberry cock. The opening was on a Saturday afternoon and although the audience wasn't huge, all of our friends showed up and the response to the show was warm and enthusiastic. I stood around drinking punch and eating strawberries and cheese and crackers like everyone else. Lisa was exhausted but was basking in the attention, enjoying round after round of congratulatory remarks. People were nice enough to me and only a few made jokes about my unusual habit of sleeping with strawberries. One woman, a friend of Lisa I had never met before, told me one of the penis pictures was like a clock, with a strawberry at noon and three o'clock and so on. Cleaning up after the opening, I realized how good the show looked overall. The show ran for a week and I was able to take a look without anyone around a couple of times, trying to figure out what it meant to have my genitals floating around on display like this. These images were too close for comfort. In the end, I was relieved when the show came down.

The A Space scene was crazier than ever. Marien Lewis and Victor Coleman were under fire for abusing their autonomy as curators, and Marien got fed up and resigned. She said she was tired of working for a board of directors that didn't understand the mission of A Space. Everyone talked a good line about A Space the collective, but in reality a place like A Space was only as good as the motivated individuals who ran it. Marien and Victor were doing their thing, being creative and making things happen. They were the heart and soul of the place, but the

board wanted control. Some people didn't like the way things were going. They saw A Space as Marien and Victor's playpen. So A Space was becoming a bureaucracy in the service of the "community." I had never been interested in the politics of the place and couldn't believe the way the scene was factionalizing. There were power plays and betrayals and a series of insane meetings. Marien was completely burned out but, while being crucified, seemed to be enjoying the drama immensely. Things were absurdly complicated. The same night that Marien resigned, she was elected to the same board of directors that accepted her resignation. It was clear that A Space was becoming dysfunctional.

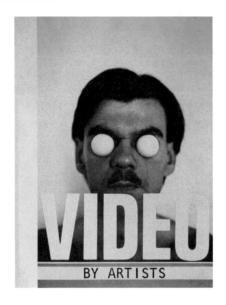

Cover of *Video by Artists*, edited by Peggy Gale, Art Metropole, Toronto, 1976.
Designed by AA Bronson.

I began spending more time at Art Metropole (AM), which was the distribution organization for General Idea's *FILE Megazine*, but AA Bronson was building an organization that archived and distributed artists' books and artists' multiples of all kinds. AM wasn't tied up in the same conflicts that plagued A Space. The fact that AM was dominated by GI's concerns didn't bother me: that was a given. General Idea was publishing and marketing itself through multiples. I enjoyed going to Art Metropole because there were beautiful limited-edition books and records, and there were people there who could talk about an international scene that intrigued me. AM had a lot of multiples from Europe, including things by Joseph Beuys and Robert Filliou, and a number of other Fluxus multiples. These were the drawing card for me, but AA clearly understood GI could only flourish if there was a strong local scene, and Art Metropole was designed to build this scene. AA always emphasized the positive, and there were always new people to meet at AM. AA introduced me to Dianne Lawrence, an actress and

vocalist who was interested in surrealism. Not the melting clocks' or headless mannequins' kind of surrealism, but more about the idea of the conscious mind without sensual stimulation. We talked about retracing the trail of the day in a semi-conscious sleep. I told her about my interest in sensory deprivation and how I had learned to read my subconscious mind by taking naps on my back, elbows tucked tight to my ribs, with my forearms and hands straight up into the air. As I would fall asleep my arms would want to fall to my sides, but if I kept them upright I could ride the narrow edge of waking sleep and examine the vivid dreamscape of my naps. Dianne smiled and said she would try this herself. She was involved in the performance art scene and had done some smoky, scantily clad jazz vocals with Dr. Brute. She was very beautiful and even when she was dressed down in a long winter coat and jeans, you could sense the way she would move in the most intimate way imaginable.

I was stumbling through my days with Dianne and a few other women on my mind constantly. Lisa knew my mind was wandering and could sense my attraction to other women like she was psychic. I was being faithful, but I needed to break the seal of our monogamy. We talked openly about our desires, in particular the way I was overtly flirting with various women. I thought Lisa was exaggerating, but maybe she was right. Lisa and I frequented a tavern called the Morrissey, not far from A Space. It was a traditional beverage room with separate entrances for men and women and a formal lobby with a gold-framed, beautifully lit painting of a horse that had won the Queen's Plate in between the mixed and men-only lounges. Late one afternoon we sat and drank a few beers as Lisa was probing me about my need to be with other women. Lisa and I had been together for nearly three years, thick as thieves and strictly monogamous. I admitted I was having trouble controlling my attraction to other women, but there was no way we were going to open up our relationship to having sex with others. I agreed that would be too weird. We were getting drunk enough to be fairly frank and I was inebriated enough to think the conversation was healthy. I wasn't feeling too guilty to admit the details of my wandering desires. Our conversation was intense and we were letting it all hang out. After a couple of hours and many beers, the bar had filled around us and it was strange because we noticed there was a lot of moaning in the otherwise strangely subdued crowd. A man staggered into our table and stood back looking across the tavern, rubbing his chest like he was fondling a woman's breasts. Then he reached down and grabbed his crotch and licked his lips, signalling to a woman seated with three of her friends. The young woman signalled back by spreading her legs and rubbing her crotch through her jeans. We looked around and realized that everyone but us was deaf and the moaning was the uninhibited vocalization of desire by a room full of people who couldn't talk. Thursday night was "Deaf-Mute Night" at the Morrisey. Our honest, down-to-earth conversation paled in the midst of this non-verbal display of animal magnetism.

Peggy Gale and her husband Peter had moved back to Toronto from Ottawa. He had just landed a position with the Art Gallery of Ontario in their education division. They invited us over to their place for dinner. Their place was nice. They had real furniture and art on the wall. The table had a certain formality about it. Peter Gale was extremely frail, skinny as a rail, and quite neurotic. Pale and gaunt, he was dark under his eyes. He talked a lot. Nervous talk. Peggy and Peter were an odd couple. Peter would wax on about his interest in involving audiences with art, describing the AGO as a huge delivery system, almost equivalent to a television station, a mechanism for injecting art into the lives of the masses. Peter said the AGO had so much potential. The big house and the fancy address would funnel people into the AGO's galleries. The power was there to make a difference. Peggy would contradict him, saying that the AGO was a massive bureaucracy and reminding him how she had realized the organization would always have different goals than artists and those interested in art. She said the AGO was always compromised by the political instability of the institution, its money problems, and the conflicts between the museum's function as a repository for art history and its role as a showplace for contemporary art. The weight of the collection would always stymie contemporary concerns. As Peggy and Peter went back and forth, it was clear that Peter wanted in and Peggy wanted out. She said her experience as an independent curator during the *Videoscape* project was more to her liking. They could screw up her show whether she was in the organization or not, but she wanted to work more directly with artists and audiences.

We talked about Alvin Balkind's difficulties and William Withrow's leadership. I didn't know that Withrow had been with the AGO forever. We told them about our experiences with the gallery over Balkind's Toronto show. Peggy said she heard Alvin had resigned. He hadn't lasted a year. Peggy told us about Ottawa and the Canada Council. There was work to be done there, but again it was another big machine with a momentum of its own. I found her descriptions of Ottawa fascinating. Individuals were making decisions and, with a signature, they could make or break a scene. We talked about David Silcox and how he had single-handedly given Intermedia a $50,000 push. Peggy said it was called discretionary funding. I was of course interested in finding support for my work as an individual. I pumped her for information on how the grant system worked. Who was on the juries? Who chose the juries? How much money could you get and for what kinds of things? I loved systems and launched into a monologue about the mainstream media and the blanket it cast over independent, grassroots media. I told her I had one foot in the CBC and the other in the art scene. I skipped the part about my day job in the library. I had Peggy's attention as I went through my spiel about systems aesthetics and how I thought form and content had to resonate through systems that were transparent and structured in the most obvious ways. I told her about the *Faraday Cage* and Wilhelm Reich. Peggy had the most beautiful brown eyes. She asked a lot of questions. She was precise and wouldn't accept fuzzy language. She wanted the real story. I

talked about my belief in language, in the essential role of descriptive prose. She told me she wanted to find the time to write herself. She smiled. We had connected.

One day at the library I got a call from a producer at the CBC, asking me if I would be interested in doing some work with Barbara Frum on *As It Happens*. Frum was a great interviewer, and *As It Happens* was one of the best shows on the CBC. Several of the radio monologues I had done with Peter Gzowski had been science pieces on topics like "electromagnetic smog," or brush-footed butterflies, and this producer had heard of my work. He invited me to propose some topics and during this initial call we quickly agreed I would work up a piece on infrasound pollution and resulting emotional duress for *As It Happens*. The *New Scientist*, a popular British science journal, had run a series of articles about how high winds could generate vibrations in long power lines at frequencies below the audible frequencies of human hearing, between 7 and 10 Hz. These infrasonic vibrations were gnawing away at people living near these power lines, affecting their sleep patterns and generally irritating people with subliminal noise. It was an interesting story because everyone could potentially fall victim to this kind of subsonic sound pollution. I would also talk about how the French were using infrasonic "guns" for disrupting unruly protesters. The French police would use these sound canons to shake the inner ears and stomachs of the protesters until they induced vomiting. I had built some large infinite baffle woofers for generating subsonic standing waves when I was preparing my audio work for the Electric Gallery show, but I had decided not to work with infrasound because the vibe was awful. People did not respond well to audio they could feel in their gut but couldn't hear. I think this anxiety is caused as people sense they are absorbing acoustic energy into their bodies, but there is no apparent source.

I was introduced to Barbara Frum in the second-floor hallway of the CBC's Church Street studio. She was dressed in a long Indian shirt and blue jeans and had short, jet-black hair. She was warm and talkative and as we proceeded down the hall she stopped to say hi to a couple, asking me if I had met Gord. Gordon Lightfoot shook my hand and said he was glad to meet me. I told him I loved his writing. He smiled and thanked me for the compliment. He had a young woman with tattoos on her ankles hanging all over him. Lightfoot didn't introduce his companion. Barbara took me into a studio where we joined Harry Brown, her co-host. She said we would work "live" to tape, so I should just follow her lead and we would tape fifteen minutes and they would cut it and use six or seven minutes that evening. She was well prepared and set me up beautifully. Barbara could direct your speech, requesting elaboration or signalling for you to wrap it up, with her eyes. I did my thing and described the sounds that couldn't be heard that were driving people crazy. She had introduced me as an independent researcher of acoustic phenomena and the piece had a nice feel to it. I was talking about something I knew a lot about, and she was giving me the air of authority. After two or three questions and probably ten minutes of talk, she turned to Harry Brown and asked him

if he had any questions. Brown asked me if these power lines were playing songs only aliens could hear. I paused, hesitating to say something stupid that would be used to undermine my piece in a humorous way. I asked him what he meant by his question. He asked if creatures from outer space could hear these dreadful sounds, and if they in fact might enjoy this kind of repulsive music. I looked Frum in the eye and she smiled and nodded. I said I didn't know. She said that was a good answer and that they had what they needed. The piece was aired that night without Brown's questions.

I was walking home, deep in thought, when I saw Andrew Tuffin walking straight toward me. There was a young man who was a dead ringer for Andrew. He had the same exact gait and he responded to my recognition by smiling as he walked by. His eyes were Andrew's eyes, bright inquisitive eyes with heavy lids. That was a couple of years after Andrew had died and I was still seeing him on the street. As I walked I thought about the way Andrew had suffered, trying to keep up with the rest of us. He had wanted to make a contribution, to join our scene as a player, but he couldn't find his voice until he pulled the trigger. I thought about the time I was wasting at the library. I was sick of the commuting and the routine. I wasn't spending enough time on my own work. It was time to take some chances. I decided to quit my job at the library. I would go back on unemployment insurance, and after that I'd find something else. It was dishonourable going at things in a half-assed way. It was time to make a full-time commitment to my work as an artist and writer. That Monday I gave the library two weeks' notice. Shortly after, I stopped going to the Y to play ball. I would continue to do the occasional piece for the CBC, but I had to focus most of my energy on my own work.

Colin Campbell was intense and serious and hungry to make art. I was spending some time with him, meeting him for lunch, having him over for a coffee and long conversations about video and writing and fiction and fact. He and Lisa had become friends. Lisa told me I should get to know Colin. Colin was all over me about my writing. He was courting me, telling me how much he loved my writing, offering positive feedback, and asking to see everything I was writing. Colin was courting everyone. He was a social animal who excelled in intimate, one-on-one conversations. He was charming and witty, hungry to know about others and very serious about his own work. And he was very excited about the Toronto scene. He said we could do things in Toronto that weren't possible in New York. He had this stellar attitude about the importance of making vital, honest work. He said there was so much bad art around. Empty art. It made him sick to see people going through the motions. He couldn't figure out why they bothered. He was living hand to mouth, working on the front line of a photocopy centre and always talking about making work and having a dialogue and collaborating on building something big. He wanted to know what I thought of his tapes, for me to be honest. I dug most of his work. He wanted to make tapes with me. We talked about writing a lot. He told me he admired me and wished he could write like I did. He was also very funny. He could run great

routines on A Space and Marien and Art Metropole and AA and all the dreadful painters and sculptors in Toronto that mimicked the Americans in New York. His humour was martini dry and he'd deliver his best lines with the straightest face. When you spent time with Colin you became intoxicated with him. You talked like him. You found yourself holding your coffee cup and flicking your hair like him. His greatest strength was his empathy. He would listen and was genuinely interested in what you were thinking. He would burrow into your mind and help you understand what you were doing. I wanted to be the artist and writer that Colin told me I was.

My last act at the Evelyn Gregory Library was to serve a Trinidadian gentleman named Benjamin Paris. Paris was a Black Canadian, a landed immigrant. He had come into the library a couple of times and had talked to me about the Caribbean culture of Toronto and my work with the CBC. He would stand at the desk and talk to me for hours in the evenings when the library was quiet. He actually had heard me speak on the radio about Wilhelm Reich and he was knowledgeable of Reich's philosophy. He told me he was sure I knew that Reich had believed in the free exchange of ideas and resources (besides open sex and free love), and we laughed and joked about how librarians were often reluctant to share their wealth. Librarians were always worried about books being lost or damaged, often forgetting that the value of any book was its meaningful circulation. I was helping Paris use the city's inter-library loan system. He said he wanted to start his own community library dedicated to cultures of the African diaspora someday, but at this point he was just interested in seeing what was out there. We ordered every book we could find in the system dealing with African history, doing the paperwork for over a hundred titles. I had called Paris to tell him we had received about forty books in less than a week, but the phone number he had given me had been disconnected. He showed up about a week later and was thrilled with the two heavy cardboard boxes of books I had managed to scare up for him. We did the paperwork to get him a library card and he said he wanted to take out both boxes of books. I told him we had a rule that limited people to twelve books at a time. He said he was so excited he wanted to look through all the books. He said many of the books looked brand new, and he bet nobody had ever taken them out. I told him this was true of the books we had on our shelves on African history. They seldom, if ever, went out. Ben said he would like to take these books out as well. Did I have another box or a plastic bag? He waited patiently while I gathered the eight additional in-house titles and checked out all forty-six books on his card, telling him all the books were due back in three weeks. I told him I was bending the rules because he was so enthusiastic about learning. He was very pleased with himself and took two trips to load the books into his used white Ford van. He came back in and shook my hand and told me I was the best librarian in the city of Toronto and it was an honour for him to be my friend. He looked back and waved as the glass doors closed. Turns out he never set foot in the library again.

One Saturday afternoon Lisa and I were forced to evacuate our apartment by fire escape. The projector lamp at the Cinema Lumiere had ignited the cinema's balcony during a matinee and the fire department was all over the place. We heard the sirens and opened our kitchen door to shouts for us to get out through the back door. If the Kensington Fire Station had been more than a block away, we would have been homeless, or maybe worse, but they had doused the burning projector and there was nothing more than a lot of smoke. Stephen Baker, the new owner, was freaked out. Fires in movie theatres were bad for business. I felt sorry for him because he was so earnest and serious about returning the Cinema Lumiere to its glory days, plus he wanted to turn the cinema into a resource for artists. We had talked to him about exhibiting work in his lobby and about having performance art events late at night or in the afternoons. It was a comfortable 260-seat house with a small proscenium stage, a good clean sound system, and a metal pipe railing for mounting and directing theatrical spotlighting from the balcony. Baker didn't have any money, but he was open to practically anything we might want to do there.

Lisa was busy with her work at Interval House and was taking acting lessons with a woman named Mari. Lisa was learning how to breathe properly, using her diaphragm in unnatural ways, so she would never run out of air when she was delivering her lines. I was spending more time with John Watt, drinking, and smoking a lot of dope with him and Robin Collyer and Ian Murray. Murray had moved to Toronto from Halifax with his girlfriend Cyne Cobb. Murray and Cobb had a second-floor loft on Queen Street, just west of Bathurst. Murray was into audio art, had done some very good work, but mostly he was into getting high. John's girlfriend Pam liked to drink. John and Pam used to hang out a lot with David Askevold, who had also just moved to Toronto from Halifax. Askevold was infamous for his work in conceptual photography and video. He had been teaching at NSCAD when John and Ian and Cyne were students there. When David would get drunk, he would talk about ghosts and the supernatural, and if you said you weren't a believer he would get real ugly and start speaking in tongues as if he was possessed by the devil. Askevold was a very convincing Satan. There was a venomous snake lurking in his brainstem. Alcohol was the ticket to his dark side. One night I saw him go after Ian Murray, not physically, but with his viper tongue, and it wasn't pretty. He would find his victim's weakness (Murray had a habit of stretching the truth) and drill in like the prosecution for the kill. It would take months for Murray to recover. I made it a point to stay clear of David Askevold when he was drinking.

The city was full of interesting artists and there was a ton of good work being made, but there was a tragic shortage of venues. The AGO had taken a step backwards, in my opinion, hiring Roald Nasgaard to replace Alvin Balkind as their curator of contemporary art. Nasgaard would take years to formulate and execute an exhibition, and he was really only interested in minimalism. Rodney Werden made a pretty hot tape called *Call Roger (1-800-PhoneSex)*,

but there was nowhere to show it. To get a screening at A Space, you now had to go through a programming committee, which slowed things down considerably. Everything was getting so political and petty. The exhibition centres throughout the city were looking to broaden their audiences to justify their grants of public money, and curators only seemed interested in work accessible to a general audience. Meanwhile, the work we were making was getting more and more extreme, more refined, but often difficult. I was anticipating the way audiences would likely view particular objects, beginning to think about exhibiting text works that represented the visual reception of photographic images. I had the form worked out in my head and my search for magnetic content continually led me to Rodney Werden. Rodney often teased me, telling me about things he was working on that involved anomalous sexual activity. Rodney was fascinated with dangerous territory and loved to make people uncomfortable. He showed me pictures of things I had never seen before.

AA Bronson encouraged me to do something at Art Metropole. He invited me to be part of that scene. Lisa and Colin and I would do a performance based on my writing. The three of us met and talked and decided on a script and developed the performance. The main text was a thing I had written in five parts called *Promise Me Warmer Weather, ABCDE.* **(7)** The text began with the examination of a woolly bear caterpillar, the larval form of the Isabella tiger moth. As myth would have it, you could predict the severity of the winter ahead by studying the black and brown bands of the woolly bear's furry coat. The shorter the central brown band, the longer and harsher the winter.

The text began with a description of a woolly bear curled up in the palm of my hand. I was reading from the page, playing the role of the author. There were about fifty people crammed into Art Metropole. AM was basically a bookstore, so the audience was standing next to and behind tables, wherever they could find a spot. We had cleared a spot in the centre of the space and were spaced about seven feet apart in a triangular formation. Lisa and Colin followed my opening passage as they recited their parts of the text from memory and emphasized the descriptive prose in a series of literal gestures. Lisa, down on her hands and knees, did this very nice yoga exercise, arching her back like a cat, inside out, stretching in slow motion while she read. Her newly perfected breathing techniques allowed her to read with a strong, unwavering voice while contorting her body. Colin did this robotic, spooky routine where he looked blankly at the audience while discussing the distance between hindsight and insight. He concluded his segment by baring his throat to the audience. His long neck was stretched open and uncomfortably taut.

Then I took control again, reading from a related text about voices and the embodiment of other peoples' thoughts. You could have heard a pin drop as I began to describe the groupthink of mediated experience, exchanging my paper text for a silver

transistor radio. I turned on the smallish radio and its harsh, scratchy talk-radio voices cut through the dramatic space we had created. I held this obnoxious squawking radio absolutely still over a bucket of water for probably a minute. Not a soul in the audience moved a muscle, as they followed the lead of Colin and Lisa and I as we focused our strict attention on the blaring radio, with Colin standing opposite me and Lisa still on her hands and knees. Time stopped. With a direct thrust, I instantly silenced the radio by submerging it in the bucket of water. The silence was impressive. I held the radio under water for probably ten seconds. There was a wonderful commotion of relief as I lifted the dripping-wet, dead-silent radio out of the bucket, and some people laughed, and the audience clapped. Lisa and Colin and I looked at each other and awkwardly acknowledged the audience, which seemed to have found the performance interesting enough to give us a warm round of applause.

This performance at Art Metropole had firmed up my presence in the city. AA and Art Metropole, and Colin and Lisa had conferred a certain status on me as an artist and writer. The buzz around town was very positive. AA wanted to publish my writing. I was having showers of ideas and was filling journals with the form and content of new works. Lisa and Colin and I were developing a philosophy about taking personal disclosure into a whole new realm of formal innovation. We had decided earlier that we would tap directly into our personal lives for the content of our work. Toronto was an impossibly superficial, façade-based environment. We decided to cut through this artificial stiffness with bold-faced truth. People could decide we were ordinary and boring and pointless navel-gazers, but we were determined to represent ourselves, our lives, in our work. Lisa and Colin had already transformed their personal disclosures into art through their video. Lisa's *A Very Personal Story* and Colin's *This Is the Way I Really Am* were groundbreaking works. I had done similar things with my texts. **(8, 9, 10)** We talked often about first-person narratives and how things could be twisted to extend our bare-bones, painfully honest disclosures into objects of thought that could stand on their own. It wasn't that we thought we were fascinating — we simply didn't accept the notion that we were ordinary. It was possible that mass celebrity culture had reduced the broadest public to a society of self-effacing, anonymous voyeurs, but we were intent on building honest personas as artists, and we had to start from scratch. The formality of live performance offered a mechanism for transforming the personal into the public domain in a different way. Performance was a different link to audience than the interface of electronic mediation. Personal disclosure and video were ultimately confused with vanity and publicity. Video, although different than television, would always be associated with television. Lisa and Colin had faced a tremendous critical backlash as their personal video work was labelled narcissistic. Live performance, oddly enough, demanded more distance between the personal and public. We decided to blend personal disclosure with layers of literal gestures, setting up layers of analogies and multiple points of entry for audiences. As performance artists, we had to avoid the conventional artifice of theatrical drama.

Our next performance would be a more complicated blend of voice and gesture. I had befriended Peter Melnick, a playwright and musical composer, and we had come up with an idea for a feature-length performance called *Liquid Thresholds*. Melnick had seen our performance at Art Metropole and connected with our aesthetic. He was frustrated by the lack of innovation in the theatre scene. He had just finished a play called *Monomania* at Theatre Passe Muraille. *Monomania* had gone largely unnoticed, and Peter was feeling like an odd duck in the theatre scene. I felt we would benefit from a dose of Melnick's theatricality. Peter used music and lighting in crazy, intriguing ways, and he was a charismatic performer. He was dry and stoic and funny in a quirky way, reminding me of Peter Sellers. Peter and I would mix our writing interests, and there would be a brief monologue thrown in here and there (we agreed there would be little dialogue), but the main emphasis would be on visual image, the creation of a series of images created by people interacting in a series of scripted gestures. The overriding form of the piece would be a continuous transformation of figure/ground relationships. A couple would meet and talk, trading parallel monologues, and just as the audience was adjusting to listening in on their quiet, low-key, improvised "conversation," someone else would crawl onto the set on their hands and knees looking for something they had dropped and lost on the floor. Then someone would walk in front of the stage and direct the audience to consider the temperature of the theatre and the scent of the person sitting in the seat next to them. We wanted to continuously redirect the attention of the audience from event to event in a seamless experiment in controlling their attention. We would stick to literal, non-symbolic relationships, and meaning would be constructed through layers of unfolding events. Peter, Colin, Lisa, and I would develop *Liquid Thresholds* through a series of workshops. We would bring in other performers as needed and planned on using a dozen or so people in a thirty-to-forty-minute piece.

Stephen Baker enthusiastically agreed to let us present *Liquid Thresholds* at the Cinema Lumiere. He offered us a schedule of times we could use the theatre when movies were not being screened. Colin was the only one with a day job at this point and his hours were flexible. Baker wanted us to make a big splash as he wanted to feature performance art on a regular basis, and he saw us as a means of getting the word out about his plans for transforming his repertory cinema into a centre for experimental, interdisciplinary work. Peter and I agreed to start writing, and Lisa and Colin would join us in our first workshop in the space in about a week. Lisa and Colin were participating in some video art conference in New Brunswick. I wasn't paying much attention to Lisa's schedule. I was enjoying writing day and night. It was just me and the cats in the apartment for a few days.

Lisa arrived home from the airport, and we were having a cup of chamomile tea in the living room, when she told me that something unexpected had happened, and she and Colin were involved in a different way. I asked her what she meant, and she said that she

and Colin were involved sexually. I thought this was strange, because Colin was so obviously gay. Lisa said Colin was confused about his sexuality, but that they had slept together in New Brunswick, and that she too was very confused about their attraction. I was wiped out and too stunned to act pissed. I couldn't believe that Colin was still into women, and that Lisa would find him attractive sexually. The balance of our threesome had definitely shifted. As this news was sinking in, I was trying to convince myself this wasn't really happening. Lisa was looking at me with this worried look; acting like she was afraid she was hurting me. We sat around and digested the quiet, empty vibe in our apartment. I was devastated. Lisa said she had to go to do a shift at Interval House, and that we could talk more later. She didn't come home that night. She had left me for Colin. They wanted to live together and make tapes together. They were repulsively romantic. We tried to talk over the next few days. She called to see how I was doing. I was angry. I was beginning to hear from other people who had heard. Rodney Werden was the first. He had heard from AA. Not only was I living alone with Lisa's cats and turtles, I was now the featured victim in Toronto's gossip scene.

I remained in the apartment for the balance of the lease, which was only a little more than a month. Lisa came and got her animals and stuff. She left me the bed and the table I wrote on. She wanted to be friends. I told her that would have to wait, if it was possible at all. I went to the meeting at the Cinema Lumiere on the day we were to begin work on *Liquid Thresholds*. Peter Melnick was blindsided when I pulled out. I simply said I couldn't continue for personal reasons. Lisa and Colin kept their mouths shut. I couldn't even look at the two of them. After the brief meeting where we disbanded the group, I told Peter that Lisa and Colin were now a couple and, as much as I wanted to be professional about the whole thing, I preferred not to work with them. Peter didn't know what to say, other than it was a missed opportunity. Over the next couple of weeks, some people were nice to me, especially Marien Lewis and Peggy Gale. Marien gave me a big hug whenever she saw me and told me to stay focused on the big picture. There would be setbacks, but she assured me that the master plan was still in place. She now said "master plan" with a German accent. She had these wild ideas about video cabaret and wanted to talk about media and performance and power. She was kind to me, but she was done playing nurse. Marien was sick of taking care of broken artists. She needed to move on to bigger and better things and told me to keep my head up and look forward. Peggy Gale, who had just herself left her husband and was now running Art Metropole, was supportive and encouraging me to focus on my writing, which she told me she thought was important. I needed to hear that at the time, as my self-discipline was blown to pieces. I hadn't written a paragraph in weeks. I now had all the time in the world. No day job. No relationship. Peggy told me my writing was important and she offered to write me a letter of reference for a Canada Council grant.

I didn't know what I was going to do when the lease ran out on the College Street apartment. I couldn't make the rent by myself. I remember standing in the empty living room,

looking out the window at the blinking lights of the completed CN Tower, thinking about being alone in the city. Toronto was growing with its major bank towers going up. The expanding skyline was as impressive as it was distant and cool. Someday this city was going to grow into itself. Someday the culture of this city would be as impressive as the architecture. Maybe this would happen in the twenty-first century? I had been in Toronto for almost four years, and yet I was still living hand to mouth. I had only a few hundred dollars in the bank. I was back on unemployment insurance. The CBC hadn't called in over a month. The freelance work had dried up since I quit playing basketball. Out of sight, out of mind. A Space was turning into a useless bureaucracy, and there was nothing there for me any longer. I did have good friends however, like Joe Bodolai and John Watt and Robin Collyer and hundreds of acquaintances in the art scene and beyond. I felt like I belonged.

But at the same time Toronto was cold and tough and unyielding, and I felt so insignificant. You could go at it every day and accomplish a lot, but the city itself was so indifferent. I still felt like an outsider. I began to write about Michigan, the past, where I had come from. **(11, 12, 13)** I had been back in Michigan to see my parents and some friends in Ypsilanti after the Art Metropole performance. I couldn't go back there. There wasn't anywhere to go, really. I was collapsing inside and losing all sense of time. I wrote all night without satisfaction and would hit the street mid-afternoon, eating my big meal of the day at the Mars, a restaurant just west on College. I would keep coffee and cream and a bag of almonds and Oreo cookies in my fridge.

When my lease ran out, I moved into Ian Murray and Cyne Cobb's place on Queen Street. They were spending the summer in Nova Scotia and Connecticut and asked me to watch their place while they were gone. I didn't have much stuff: a couple of boxes of books and records, a turntable and amp and speakers. I ran into Norman White and he told me his commission for the CBC mural in Vancouver was finally happening and he was moving to Vancouver. Joe Bodolai said he thought there was going to be a general amnesty for the draft dodgers and if this was going to happen, he was thinking about going back to the States, at least for a while. Scott Didlake was thinking the same thing. When Ian and Cyne returned, I stayed with them for a week or so, but they didn't have that big a place and it was clear I'd have to find another place to crash. I was just trying to hold on for another month or so. I was pretty sure I would get a Canada Council grant I had applied for, and with that money I'd do some travelling and see if I could figure out what to do next. I asked Robin Collyer if I could stay with him and Shirley Wiitasalo. They had a big loft space on Yonge Street, not far from Art Metropole. I had watched their place and fed their cat while they were out of town a couple of times. Robin got back to me after a few days and told me he had discussed the situation with Shirley, but the answer was no. Shirley didn't think it would be "appropriate" for me to stay with them. That's the word Robin used. I was basically out on the street, in the same situation I had been in when I first drove into Toronto in late 1971. Things were unravelling.

Joe Bodolai let me stay at his house on Huron. There was an extra room. It was cold at night. It was autumn and there was no heat in this tiny room. I slept in a sleeping bag. Joe and I talked a lot about going back to the States. I began writing a long text called *The Last Days of Fahrenheit*. **(14)** Canada was preparing to go metric. I was asked to put a text in a show at the University of Guelph called *The Narrative in Contemporary Art*. Eric Cameron called me up and told me he liked what I was doing with perceptual narratives. I began writing a series of descriptions of photographic portraits done by Jeremiah Chechik. **(15)** We pitched a show to A Space for the following summer. I received a rejection letter from the Canada Council. It was disappointing, as I needed the money, but it didn't matter. I was writing again and things were flowing. I painted a couple of houses with Robin Collyer and his father. I got a job through an office overload firm, a strange job where I was colouring maps of forests in Northern Ontario at Ontario Hydro. I would sit at a round table with half a dozen Jamaican landed immigrant women, colouring maps with coloured pencils. The topographic maps featured thirty-one numbers designating thirty-one species of trees. The number seven was maple; twenty-one was white pine. Maple would be coloured yellow. White pine was purple, and so on. We were colour-coding these maps by hand so a computer could read them. Ontario Hydro was cutting corridors for power lines and needed to know what had to be cleared if they went in one direction or another. I loved talking all day with these Jamaican women. They were sweet and funny. The supervisor loved my maps. I was fast and accurate. After three weeks we were done and our colouring group was disbanded. The cheque was pretty nice.

I decided I needed a change in scenery. I wasn't done with Toronto, but I needed a break. I stored my books and records and reduced my personal belongings to a single backpack. I went down to the bus station and bought a ticket to Cincinnati. I had shown a conceptual work at the University of Cincinnati a couple of years before, and Andrea Joseph, an old friend of mine from Michigan, said she had an extra room and I could stay with her for a while. I said goodbye to Joe and Peggy and Marien and Toronto. I would be on the road for nearly a year, writing every morning, filling notebooks wherever I'd go. Eventually I would follow my nose back to Toronto and radio and video and my obsession with writing all manner of texts. The bus left for Chicago at 7:00 p.m. It was already dark and the temperature was falling. I was alone and hungry as I watched the lights of Toronto disappear. I took out my journal, turned on the overhead lamp, and began to write.

Previously unpublished, "The Faraday Cage" was written in 2006 and later edited by Sherman in January 2014 and again in December 2018.

(1) *THIS MESSAGE IS ABOUT THE CONDITION OF YOUR BODY* (1974)

This message is about the condition of your body.
You need to know how to win. Loss of life.
I want to know when I am attractive.
I want to look at myself in as many ways as I can.
It is important that I see my breathing. I want to die naturally.
My things take on me after a while.
It is good to open up when I go outside.
I feel attractive outside.
My arms tell me by the way they look.
My hands are afraid just like the rest.
Those loose connections around my legs.
Moving outside I get my power picture.
People know me when they can see me.
If they look they will see how different I am.
Train your eyes to see more.
My shoulders are wider than my waist.
The muscles in my arms are like tight balls of meat.
My breathing doesn't seem right.
In the morning I taste my throat and wonder if it is right.
Tightness in my back takes colour from my face.
I want to be more comfortable.
Let the machine show me what my force field looks like.
When I am relaxed I feel honest.
My skin is cool and I am easy inside.
I look so much like my family.
Sometimes I can just sit back and display myself.
By moving around I mix up my display.
It is important to place yourself in front of the right background.
Sometimes I cannot stop the secretion of my story.
I can appreciate your interest in yourself.
You are looking for something normal people cannot see.
I want to be comfortable all the time.
I do not believe this is what I really look like.
I cannot believe you look like that.
I treat my eyes to make them more sensitive.
I only see those I want to see.
I want to see so I will know those with a bright display.

I feel so tight. I know I am infected.

The infection inside my upper left arm.

The infection inside my lower right leg.

My force field and my skeleton.

I look to try to see my skeleton.

I look at other people and try to see.

I sit and look in the mirror to see my insides.

My blood and lungs.

Something is the matter with me.

It is a personal matter.

I lie face down on the fold of a roof structure.

My head turns either right or left.

I can see the marks disease has left on me.

You are the picture of health.

I have always thought you were.

This Message Is about the Condition of Your Body was included in the exhibition *In Pursuit of Contemporary Art*, AGO, Toronto, September 1974; and published in *FILE*, "Glamour" Issue (Winter 1975); *Detroit Artists Monthly*, 2, no. 8 (October 1977); *Tom Sherman: Cultural Engineering*, ed. Willard Holmes (Ottawa: National Gallery of Canada, 1983); and *Tom Sherman: Ingénierie culturelle*, ed. Willard Holmes, trans. Hélène Papineau (Ottawa: National Gallery of Canada, 1983).

(2) *11 OF 50 CAR CRASHES WITH FIRES* (1974)

1964 Mercury convertible overrun by Mack truck in 13 vehicle rear-ender at 6:30pm, July 6, in a dust storm with high winds. The convertible traveling at 25+mph, the truck closing at 30+mph, the impact resulting in extreme crushing of the rear and side of the car, the passenger compartment demolished, the truck saddle tank ruptured, 5 burn fatalities, 8 killed.

1962 Corvair sedan traveling at 30+mph in offset head-collision with 1958 Buick HT moving 60–75mph resulting in extreme front-end damage to both vehicles, Corvair's fuel system disrupted, 3 persons killed, 2 died of 3rd degree burns, 1 from other injuries; December 24, 7pm, the street wet, visibility impaired by slight mist.

1955 Buick is hit from behind by 1966 Mustang. The Mustang closes at 50–60mph, the Buick is traveling 21–26mph. Severe rear damage resulting in massive gas tank rupture, 2 burn fatalities in the Buick; clear, dry, 9:30pm, January 19.

1969 Chrysler 2-door hard top in rear-ender with 1968 XKE Jaguar roadster; the XKE was running 23–28mph when the Chrysler came up from behind at 37–43mph, severe rear damage, the fuel tank ruptured, 2 persons sustained severe burn injuries, clear dry, no wind, 1:10am, June 7.

1965 Peterbilt truck in rear-ender with 1964 Cadillac sedan. Cadillac traveling 8–12mph is hit from behind by the truck, closing speed 20–30mph, the impact results in extreme rear damage to sedan with the overriding truck cab crush! Cadillac gas tank, severe pavement scraping, 3 trauma/burn deaths including truck driver, July 30, clear and dry evening, 8:52pm.

1963 Ford Fairlane in head-on collision with Greyhound bus, Fairlane moving at 50+mph, closing speed of bus 80+mph, extreme front impact at 9:50am, a clear and dry day, June 28, the gas tank ruptured from extreme inertial bulge, both vehicles caught fire, 4 deaths by trauma and burns.

1964 Triumph in off-road rollover at 12:20am, August 3. Weather conditions clear and dry. Moderate damage from rollover, vehicle caught fire after upset, 2 burn deaths, fuel cap popped open.

1966 Oldsmobile wagon in head-on collision with 1969 Ford station wagon; the Oldsmobile at 25+mph, the Ford at 65+mph; severe extreme front impact; weather clear, dry, 7:42pm (daylight), June 13, gas tank strap failure, filler disruption, 5 deaths, at least 1 by burns.

1970 Challenger closing at 40–45mph hits 1970 Barracuda from behind, the Barracuda traveling 18–23mph. Mode impact, severe damage to rear of Barracuda, tank intact, filler disrupted, 2 burn fatalities in struck vehicle, July 22, 10:15pm the weather clear and dry.

1962 Kenworth truck in rear-ender, a multiple oblique rear-ender with 1967 Oldsmobile. The Oldsmobile traveling at 20–25mph, the truck's closing speed 25+mph, crashing into Oldsmobile from behind resulting in extreme, total damage. Tank punctured, 2 trauma/burn deaths, June 12, 1:45pm, cloudy, dry.

A clear and dry July 2, 2:37pm. 1963 Chevrolet truck caught fire underway, burn damage only, sudden fire in cab before driver could stop, 2 burn deaths and 1 severely burned, no cap on gas tank.

11 of 50 Car Crashes with Fires was included in the exhibition *Text Works*, A Space, Toronto, November 1974; and sections of this text were published in "The Trouble with Psychosurgery, Advertising Photographs with Words," *Criteria* 4. no. 1 (Spring 1978).

(3) *THE SPIRAL LINE* (1974)

I believe I am using the word "spiral" incorrectly. I should be identifying a helix. A spiral is the path of a line travelling around and along a cone. A helix is the path of a line travelling around and along a cylinder. True, many folks use the word "spiral" colloquially to identify such lines.

One thing for sure, I have become very sensitive to my vine. I have a big passion fruit vine growing right between my two windows. The vine grows up and out of its plastic garbage pail and climbs up the cylindrical trellis I have made out of chicken wire. The trellis is about ten feet high. The vine climbed over the top of the wire support and is hanging down from the ceiling. Passion fruit vines grow outdoors in Brazil. They can reach over thirty feet in length. They climb by means of long spiral tendrils. I don't think my vine will bear fruit; growing indoors with such short periods of daylight. It is an attractive vine, with three-lobed leaves from three to five inches long with fine, saw-toothed edges.

This room I've rented is on the second floor of an old three-storey building. The room is not very big, but it has the two nice windows. Beautiful natural light. Most of the wall space is taken up by my books and magazines. A small sink, flanked by tall piles of magazines, is on the wall across from the windows. The old copies are on the bottom of these piles, the most recent issues are on top. My books are stacked in the same way, their titles facing out. I put the sink in so I could have running water. I need drinking water, coffee water, and water for the vines. My coffee pot and other provisions are on the small metal table next to the sink. I heat water on a single-burner gas stove.

The sink was no trouble to put in, but the drain pipe seems to sweat constantly. I've tried wrapping rags around the pipe to keep water from dripping on the floor. It hasn't hurt the floor too much, but the dampness has ruined several old magazines. I suspect the dampness is behind my booklice problem. Booklice are tiny, pale, wingless insects, less than 1/12th of an inch long. They are yellowish, grey or brownish, with soft bodies and relatively large heads. They breed continuously and irregularly; all stages can be found at any time during the year. Booklice can do a lot of damage. They may he found between the pages of books and papers that have lain undisturbed for some time. They apparently damage the glue, paste, and paper backing and bindings of books by feeding on the tiny moulds that grow on moist surfaces in damp locations. They are sometimes abundant during the summer and fall

in poorly lighted, warm, damp rooms, or in new buildings that are not yet completely dried out. Residual sprays are useful.

The place doesn't get fresh air because the windows were permanently painted shut years before I got the place. I like having them shut because very little street noise comes into the room. The temperature inside is just about perfect. It is a small room, though, and sometimes I feel cooped up.

I make a living operating machinery. I work with a number of different machines with efficiency and safety. My fear of machinery keeps me from becoming careless on the job. You can become quite sensitive to the demands of powerful motors. The machine sounds are thick and straining. The sounds are sharp in attack and unnaturally long. I never get used to the smashing, ripping, pounding, and cutting. I feel so good coming home from work. My flesh shows not a single scar left by machinery I have tended or directed.

The Spiral Line was included in the November 1974 exhibition *Text Works,* and published in *Sherman: Cultural Engineering,* and *Sherman: Ingénierie culturelle.*

(4) *THE HORNWORM* (1974)

The talk always took place in the front yard. I'd push off with my bare feet, leaning back until the chair rested on the front of the porch. There I was, suspended out over the lawn.

The fellow next door was playing in the driveway again. Towards the end of the afternoon he would set up for his fish-line game. Action would begin when he'd come across a hornworm eating his tomato plants. He'd carefully remove the worm and the damaged stem of leaves it was feeding on. Placement of the worm on the pavement would start me wondering. The worm began to recover from its transplant in the shade of the garage. Then the black fish-line was tied around the stem of tomato leaves. This disengaged, fragrant bundle was set on the edge of the shade, less than a foot from the worm. The man would walk out over his concrete driveway and settle into a lawn chair placed at the intersection of his drive and the public traffic. As the hornworm advanced the man would pull the vegetable bait along the cement towards the street, the worm predictably following at a steady pace. I would check the time on my watch the moment he sat down. He never broke two hours getting that worm to chase the bait out into the street. The finish was the curb line. This character has a phenomenally long attention span. He didn't mind people watching either. In fact, when there were spectators, he would let the worm get very near the bait before he would retreat, sometimes with a little jerk. I've sat through hundreds of hours, being a neighbour and a person who admires a sharp focus. In all the play I have seen, not one person has criticized the man while he was locked in his concentration. People talk behind his back, but I guess most folks admire his composure.

After the bait and the hornworm crossed the curb line he would actually jump up out of the chair, completely extend himself on his tip-toes, and let out this hoarse, scratchy blast of air. The softness of this eruption impressed me so much. You couldn't hear it if you weren't listening intently. Detection would be impossible if you weren't precisely tuned to the point of commotion.

The Hornworm was included in the November 1974 exhibition *Text Works,* and published in *Sherman: Cultural Engineering*, and *Sherman: Ingénierie culturelle*.

(5) *LOOK WITH THE EYES SO CLOSELY* (1975)

Look with the eyes so closely that you can't hear the room. You cannot hear the sound of the room. Just what you see. Sweeping over the surface. Focus. Motion in changing directions staggering through reflection and shadow. Jerk away from point-blank, the off-centre vision pouring over that point of focus, in travel, occupation in the flow toward that attraction, under pull, a velocity apparently unburdened by the heavy head bones — the fleshy face. The eye muscles stretch then lock in one constant dimension: the organs of sight spread out to the walls, pushing out the skin away from the flesh. This extended skin makes a face that disintegrates in the air.

Look With The Eyes So Closely **was included in the November 1974 exhibition** *Text Works*.

(6) *THE ART STYLE COMPUTER PROCESSING SYSTEM* (1974)

"As it is, our perception of things is a circuit unable to admit a great variety of new sensations all at once. Human perception is best suited to slow modifications of routine behavior."

— George Kubler, *The Shape of Time: Remarks on the History of Things*

A communication system is for sending and receiving messages. A communication system consists of two transceivers: two components that transmit and receive messages. A communication system is limited when the message is sent in only one direction, transmitter to receiver. This limited system can be expanded by integrating a processing system at the receiver end to provide access to the message. A processing system permits special treatment of the message at the receiver end of the communications system. The computer-processing system described in this text is specifically designed to manipulate the message transmitted to the two-dimensional surface of the video screen. The message source is a commercial television broadcast. The message is limited to display on the flat surface of the video screen. An analogy is formed between processing the video message and the act of painting. This processing system provides personal choice of how the message source is viewed, in the same way the painter chooses to view the environment through his or her method or style of painting. This system is labeled the ASCPS.

Style is a phenomenon of perception governed by the coincidence of certain physical conditions. The ASCPS is constructed of information obtained from every major historically innovative treatment of the two-dimensional surface. The system contains the concise history of painting. By block encoding historically successful modes of sensing, the system contains a set of period visions. These period visions are methods of seeing the environment. They are rule-governed styles for processing messages. The rules are those instituted by schools of painting dominating particular periods of history. At this time, period visions contained by the system are: Abstract Expressionism, Abstract Impressionism, Action Painting, Arabesque, Art Nouveau, Automatism, Barbizon School, Baroque, Bio-Morphic, Cartoon, Classic, Colour-Field, Cubism, Dada, Danube School, Divisionism, Expressionism, Fauvism, Futurism, Gothic (Late and International), Group of Seven, History Painting, Hudson River School, Impressionism, London Group, Mannerism, Neo-Classic, Neo-Impressionism, Optical, Orphic Cubism, Painterly Abstraction, Photo-Realism, Pointillism, Post-Impressionism, Primitive, Rayonism, Realism, Renaissance, Rococo, Romanist, Romantic, Social Realism, Super-Realism, Suprematism, Surrealism, Synthetism, Tenebrism, and Vorticism.

The vision circuit for each period contains additional processing characteristics. These simulate decisions of individual artists contained by schools of painting or period visions. The capacity of each period vision-processing circuit depends on sensitive patterning of physical conditions marking the consistent vision. Fine adjustment control of contrast, brightness, colour, and form open the end of each processing channel. The viewer fine-tunes a wide band of processed message, attaining authorship of the message. The commercial cable television system provides structure for immediate integration of the ASCPS in the home viewing system. The ASCPS consists of a centrally located computer with remote control units functioning as switching devices which afford access to the processing circuits of the system. Passing the message through a chosen period vision is accomplished by switching in the desired circuit by push-button selection on the remote control unit.

Application of the ASCPS: The message is the broadcast of a network news program. The information is in colour with low interference. The viewer decides to process the message with the period vision labeled Rayonism. Rayonism was an abstract Russian movement stylistically between Futurism and Abstract Expressionism. Mikhail Larionov, an instructor at the University of Moscow, published the Rayonist manifesto in 1913. This selection is made on the remote-control unit. While passing through the processing circuit, the message form is disintegrated to simulate the radiation of lines of force emanating from the objects in the news program. Important artists having this period vision are Mikhail Larionov and Natalia Goncharova. The viewer chooses to understand Rayonism through Larionov's vision. This processing circuit is switched in through a selection made on the control unit. Larionov's vision is nonobjective. Visually, the news program is processed into a pure abstraction, with objects becoming new forms as they disintegrate into radiating colours. Fine-tuning controls permit control of colour and contrast with Larionov's radiations.

The ASCPS is introduced to provide the best possible system for the study of the history of painting. The system provides a previously unattained view of the artist's systematic attempts to attain efficient communication through the two-dimensional channel. The system simulates the collective visual experience of recorded history and offers choice of vision to the one-way communication system of commercial broadcast television. The viewer, in implementing historically incoherent methods of sensing on a contemporary message, can introduce message equivocation; that is, uncertain knowledge about the transmitted message when the received message is known. Uncertainty of message increases with degrees of image latency, the time interval between image and response or understanding. Message latency is abstraction.

The ASCPS is a stochastic system. That is, its output is in part dependent on random or unpredictable events. Total randomness of message produces monotony, a sense of sameness. Period vision-processing circuits pattern and structure the message. The structure

provides a familiar visual language allowing new sensations to be perceived through contrast. By processing an available random message, broadcast television, the two-dimensional output of this communication system becomes a highly structured moving image with a degree of unpredictability.

The completion and integration of the ASCPS into the existing cable television system effectively surrounds (contains) the history of painting. Expansion of the methods of communication depends on technological invention. Components of this video-processing computer system are being designed and tested by technological artists in scattered communities around the globe.

The Art Style Computer Processing System was included in the November 1974 exhibition *Text Works* and served as the content of Sherman's video *Theoretical Television*, 1977 (colour, sound, 28 min.) which was broadcast on Rogers Cable 10, Toronto, April 1977. This text was published in *Journal for the Communication of Advanced Television Studies* (London) 2, no. 2 (Fall 1974); *Videation* (Richmond: Virginia Commonwealth University, 1977); *Sherman: Cultural Engineering*; and *Sherman: Ingénierie culturelle.*

(7) *PROMISE ME WARMER WEATHER, ABCDE* (1975)

A. The worm-like animal curled up in the palm of the right hand. A caterpillar named the Woolly Bear, the larva of the Isabella Moth. The long slender body is completely covered with bands of black and brown fur. Found crawling across the sand, grasped between the thumb and index finger of the left hand, the finger and thumb tightening around the tiny body, careful not to crush the mid-section of this Woolly Bear. Down on one knee, the left, with the elbow of the right arm resting on the thigh behind the right knee. The muscles of the left breast jerk as the left arm bends at the elbow, the forearm raising the hand, slowly positioning the insect over the open right hand. Rolling into a tight ball of black and brown fur, the Woolly Bear plays dead.

B. On the hands and knees, the face down, the head in front of the body. The heels of the hands push against the ground, the knees press into the ground, the toes rest on the ground. The eyes see the ground below the head, in front of the hands. On the ground below is the caterpillar. The hands move, positioning the head over the worm-like animal. The arms bend at the elbows, lowering the body; the trunk, the shoulders, the neck, and the head. Closing in on the insect larva. The head is pulled back as the nose is positioned directly over the caterpillar. The nose almost touches the larva as air is inhaled for smelling. The arms bend again, the body shifts, the toes lift, the mouth opens, the head drops, the mouth closes over the larva.

C. The palm of the hand cupped in front of the mouth. The thumb placed outside the left nostril, the index finger placed outside the right nostril. The hand is steady holding the nose. Exhaled air from the left nostril strikes the web of skin stretched between the base of the thumb and the base of the index finger. Exhaled air from the right nostril passes the palm striking the tip of the little finger of the left hand.

D. The mechanical movement of the invented person. Turning the eyes back far enough to see behind the face. Finding that I know things I don't believe. Forcing air through the voice box, forming talk with the tongue, the teeth, the lips. Pulling back the lips, exposing the teeth. It happens that we believe only what has occurred before. Finding that I believe in things I know nothing about.

E. The arms, the legs, the cock, the balls, the breasts, and the neck. The neck does resemble the other appendages of the body. At the front of the neck is the throat. Prominently displayed on the male throat is the Adam's Apple. Both men and women possess the Adam's Apple. The Adam's Apple is the voice box. This box is composed of muscle and cartilage at the upper end of the windpipe. The voice box houses the vocal cords and produces the raw sound of human

speech. Talking through the back of the neck is talking nonsense. Lifting the chin up high, rolling the head back as far as it goes; pose the throat for biting. The lids are pulled down tight over the eyeballs. The power to picture without eyesight. You must have eyes in the back of your head. Insight is part of your vision.

Promise Me Warmer Weather, ABCDE was included in the November 1974 exhibition *Text Works* at A Space, May 1975 at Art Metropole, with Colin Campbell and Lisa Steele, Toronto, and *Bookness: An Exhibition of Unique Books*, Centre for Experimental Art and Communication, Toronto, November 1977. This text was published in *Art Communication Edition* (Toronto), no. 5 (Spring 1977); *Sherman: Cultural Engineering*, and *Sherman: Ingénierie culturelle.*

(8) *OFF-CENTRE IN SIGHT-SEEING* (1975)

Off-centre in sight-seeing. A plot of window screen, the frame of white pine with shellac.
The aluminum screen supports a mass of housefly larva — maggots, legless, pale, a white
island of young flies. Just centimetres away adult flies land. These flies walk then stand
still. Compound eyes protrude from the head. A sharp cut, shift to mid-air, the sphinx moth
approaches — attaches itself to screen, the feather antennae stirring the air in irregular
circular patterns, feelers to the nerve clusters. Large patches of screen with no animal motion.
Sight pulled off a bare spot of screen, placed on the underside of the moth's thick abdomen.
Back across the screen into this white island, the fly eggs laid on a wire mesh. The motion of
hatching, falling out of the eggshell, rolling into humid air, dropping hard on the white pine,
all the weight on the board. The eyesight shoots off the board up into the screen, the eye
penetrates the screen, picking up the body a few inches off the surface, flying the moth pulls
away backwards. Trace a light mark absorbed by the dark.

Off-Centre in Sight-Seeing was included in the November 1974 exhibition *Text Works*.

(9) *THE MAN SITS PLAYING WITH THE BABY* (1975)

The man is seated, playing with the baby. The adult's feet are on the floor. Bending at the waist, the top of his body leans forward. Holding the weight of the chest with the back muscles, the elbows held in tight against the ribs, the forearms extend the hands that hold the baby's feet. A circle of thumb and first finger wrap around each ankle. Holding the kicking legs, looking into the child's eyes. The man pulls the little foot up to his face. The child jerking the legs with a strong kick — attention is directed to the sole of the foot. The tongue moves out of the mouth and drags across the skin just behind the largest toe of the foot held in the left hand. Looking into the man's eyes, just holding back the kick long enough for the tongue to travel across the pad of tender skin. Each stroke starts out wet with spit and winds up dry and rough. As the tongue lifts off the surface and leaves the patch of skin to cool by the evaporation of water, the struggle resumes. My head turns to the right to draw the mouth near the next foot. The child's leg straightens at the knee as the foot rises in the right hand. The heel of the foot is pressed tight against the smooth skin of the bottom lip. With a sudden-smooth motion, the head rolls back to pull the chin up across the heel. This motion leaves a line of sensation running from the bottom lip down to a point under the chin at the throat. Still at the throat for a moment, then the stroke is reversed and the scratching of the heel is repeated. On this portion of the face the skin is rough with the stubble of the beard. The heel has passed back and forth across the sharp curve of the chin for some time now. My head is pulled back. The heel is held against the taut skin at the front of the throat. Both the legs hang motionless in my hands. Our eyes look to different spots on the ceiling, above and behind our heads. Inside, my mouth is filling with water. Those little feet are both resting at the base of my throat. The legs rest with all their weight on the webbed skin between my thumbs and forefingers. The hands slide the feet up the neck, around the jaw-bone, until I feel the feet touch the lobes of my ears. Cool to the touch at the ears. The toes pretend to be walking across my cheeks towards the open mouth. The man takes the foot in a bite, not hard enough to hurt.

The Man Sits Playing with the Baby was included in a May 1975 exhibition at Art Metropole, with Colin Campbell and Lisa Steele, and in November 1977 in the context of *Bookness: An Exhibition of Unique Books.* This text was published in *Sherman: Cultural Engineering*, and *Sherman: Ingénierie culturelle.*

(10) *THE VIEW THROUGH THE WINDSHIELD IS DETERMINED* (1975)

Driving with the headlights on, at dusk, heading north. Light from the sunset coming in through the driver's side window. The car is directed by the left hand on the steering wheel. Fingers of the right hand stroke the hair at the back of the head. The palm of this hand rubs an area at the top of the head. The hand then rises off the head and taps on the ceiling of the car with the tips of the index and middle fingers. Both hands on the wheel, making song with a voice, singing at the top of the lungs. A companion, riding shotgun, looks out the passenger's side window into the dark roadside forest. There is plenty of leg-room with the seat back all the way. The highway cuts through pine forest, a winding road through rolling hills. The view through the windshield is determined. The privacy of darkness, driving at night. The window is rolled down; the driver's left arm is outside resting on the top of the car door. Cool, dry air streams over the forearm, the arm hairs drag through the air; feeling the high-frequency whipping of the skin. Smashing animals on the windshield. Bodies popping open, becoming liquid circles of yellow and white on the glass: this liquid spreading up several inches in slow-motion before running off onto the roof. A thin black line of insect shows before each crash. Dark particles, once legs and feelers, appear at the edge of the now dry, creamy circles. Disintegrated insects cover the windshield. The car is stopped, the engine still runs. Scraping the windshield clean. The scraping sound comes in clearly over the smooth-running internal combustion engine. Finished, the windshield is clean enough to see through. Crushed bodies form a border around the clean glass. Pushing the gas pedal down to the floor, accelerating back on the highway, picking up speed. The edge of the road shows through the clear glass, just above the bottom strip of insect-white. A bird thumps off and over the windshield. This thump is loud and very close. As near as can be seen, there is nothing of the bird left behind on the glass. The bird has bounced hard off the windshield straight up into the air. The shattered neck bone still vibrates from the collision; the head hangs on only by the flesh. The sound of the dead bird hitting the pavement is covered by a blanket of (car disappearing down the road) sound. At rest on the pavement, just left of the centre-line, the dead bird has a ring of blood-stained feathers around the neck. Sight and sound of the car is gone. 1. Much later, a gust of wind slides the body over to the side of the road. 2. Much later, two adult humans of the opposite sex ask if the kid would like to go for a ride in the car. The kid is sitting on a pillow in the back seat of the car; full thought is given to the task of setting up the dolls: the placement of three dolls so they sit just like the kid on different spots across the back seat. The adult voices demand that attention be shifted outside the car to a grass-fire. Pick this fire out of the roadside view. This selection of viewpoint has to be made through the open side window. The right or left side window? Notice that the direction is given by the position of the heads of the adults in the front seat. There, out to the right side, smoke marks the place of the grass-fire. Without warning the object changes from grass-fire to spider. The spider is quick to run across the car seat, entering a folded powder-blue blanket. Inside

this blanket, the Brown Recluse Spider stands still at the arch of a baby's foot. The spider's body is a pale, yellowish-brown colour. A medium brown surface marked by a spot of dark brown on the back — just behind the head. This mark is very near black in colour and in the shape of a frying pan, or a fiddle or a violin. On this spider's face, just above the fangs, six eyes are arranged in a semi-circle. There is no reason to believe that this spider cannot see through all six at once. Six eyes and eight legs. A couple of claws at the end of each leg enable the spider to walk upside down. These legs are long and capable of high speed. Remove the brown spider from the dark, dry cellar; or the attics, sheds, closets and garages. Walking across the coarse, irregular, scanty web. Uncomfortable in the daylight, the spider hides in the folds of clothes or bedding. Bite to eat. Bite to defend. Bites of sleepers by spiders trapped in the sheets or blankets. Spider bites inside infrequently worn clothing. The fangs break the skin. The initial pain of the brown spider bite is less intense than that of a bee, but this pain becomes progressively more severe and may be agonizing for eight hours or so. A spider is quick to run across the car seat, entering the powder-blue blanket. The automobile is in motion. Looking out the side window, the head locked in one position, water is coming from the kid's mouth, spit is forced into "blebs" between the lips. These chains of bubbles buzz as they are made; a sound just below the tip of the nose.

The View Through the Windshield Is Determined was included in a May 1975 exhibition at Art Metropole, with Colin Campbell and Lisa Steele, and in November 1977 in the context of *Bookness: An Exhibition of Unique Books.* This text was published in *Sherman: Cultural Engineering*, and *Sherman: Ingénierie culturelle.*

(11) *ADJUSTING A COLOUR TELEVISION* (1975)

We sat there in our respective chairs waiting for the colour television to warm up. A few minutes before the network news broadcast, right after dinner, with a glass of beer or a cup of coffee. Light flashes and rolls onto the screen with a voice track coming in distorted, then clear; a commercial we memorized weeks ago. The automatic colour control is operating, but as usual, the tint is wrong on the people's faces. We'll wait until the news to adjust the picture. There's that familiar face. I know the colour of his skin, and the set isn't coming close to delivering the correct flesh tone. I'll wait a second and maybe she'll get up and adjust the colour. He even looks worse against that new background, a slide of an airline crash. That brought her out of her chair. She set her cup down and she is standing over the television, leaning over the picture tube as she works the controls. She is going to the contrast and brightness first. By the time she gets to the colour mixing, the picture is messed up beyond belief, a dull and muddy picture. I can't understand what she thinks she is doing. She has altered the colour through her manipulation of the controls, but that newsman is farther than he's ever been from coming right into our living room. I can't believe she's sitting down. She's going to watch that picture. She's going to sit there and watch the picture she's destroyed, as if there is nothing wrong. I can't accept what I'm looking at. There is still twenty minutes of news I could be watching. I get up out of my chair and kneel down on one knee in front of the control centre. It is going to take some tuning. This set is capable of a sharp, accurate picture if you just look at the screen and think about what you are doing. His skin is coming in, too pink, a little yellow, little yellow, there. . . .

Adjusting a Colour Television was published in *Video by Artists* (Toronto: Art Metropole, 1976), *Sherman: Cultural Engineering*, and *Sherman: Ingénierie culturelle.*

(12) *PICTURE WINDOW VIEW* (1974)

I centered my "picture window" in the front wall of my house. I took out a smaller window and cut a rough hole 5 feet 3¾ inches high by 8 feet 3¾ inches wide. The picture unit fit right in the first time. The sill is only 24 inches from the floor because I want a full picture view.

My front room is simple. I have a big davenport that converts into a bed when I have guests. It sits across from my new window, facing west. I have one comfortable chair with a reading light next to it. Next to the north wall is a small table and chair. I write my letters and pay my bills at this table.

The walls are painted with a high gloss enamel so they are easy to keep clean and bright. The only thing I have on the wall is a painting above the davenport. It is a print of painting done by Frank Czeszak. The title is on the frame: Freedom from pain, disease, isolation, and fear.

There is no date on the print I own. It is hard to remember to clean under the chair. The dust really builds up fast. Plenty of things get kicked under the chair by accident. I mean things like cookies and apple cores and ashtrays. Another problem area is the corner where I stack my newspapers. After they are piled high they begin to get warm down towards the bottom. I try to take them out before they heat up too much.

Every evening I read the paper in my comfortable chair. I usually make some cornbread and eat it in the front room. I take the cornbread directly from the oven and smother it with butter. On this steaming cornbread I pour cold milk. I have to be careful eating it because the cold milk makes my teeth hurt, especially on the left side. I eat it so fast that it goes down the wrong pipe. My eyes water as I gag on my food.

The sheet of glass in the frame measures 60 by 96 inches. This is a sashless pane of glass set in a vinyl-coated wooden frame. Nothing but a glass panel, a window with beauty. The beauty, reliability, and insulating properties of wood windows are taken to a new dimension of durability. A rugged vinyl sheath wraps the wood core in timeless protection so it will not rot. warp, rust, corrode, swell, or shrink. This window never needs painting, yet it costs the same as a regular window plus what you would expect to pay for one paint job. The weather never touches the wood so it maintains a permanently snug fit. Wood is a natural insulator, assuring comfort, warmth, and fuel savings. The insulating glass, the thermopane, reduces heat loss, eliminates misting and frosting. Only two surfaces to clean. No storm windows. A glazing bead of soft vinyl seals the glass so there is no putty to crack away. This 60 by 96 inch pane of glass virtually gives you a "picture window" that will last a lifetime.

Picture Window View **was included in the November 1974 exhibition** *Text Works,* **and served as the text for** *Exceptional Moment A* **(1976), a 16 mm film made in collaboration with Andrew Lugg. This text was published in** *Sherman: Cultural Engineering*, **and** *Sherman: Ingénierie culturelle.*

(13) *VOLUNTARY HANDCUFFS* (1975)

When Russ bought the house it needed plenty of work. He did things for his family, but every time he walked into that out-building he imagined how that space would look when it was fixed up. When he and Teresa first looked at the house and yard, it was definitely the building he wanted. Now, years later, Russ was in his own world out there in his building. The small out-building had captured his imagination.

There was a dirt floor the first time he looked inside. Grey-black dirt with pieces of broken glass from those old storm windows leaning up against the back wall. He mixed the concrete inside, splashing water on the dirt he was covering. As the cement floor dried light and clean he could see the rest of the room taking shape. Working from drawings he placed his table saw and drill press, the new table tops and that whole wall of work bench. Fiberglass insulation tightened up the walls and ceiling. Its silver foil intensified the hanging lights. Incandescent lamps. There were only two windows, one in front and one in back. That was enough because of the heat loss and Russ didn't plan on spending that much daytime out there anyway.

He could go out there and make a fire in the space heater, straighten up the tools or just sit and listen to some music. He could read his books in his own good time. He had finally collected all his tools under one roof. No one else could lose them or leave them scattered around on the floor. It was hard all those years, watching other people misusing his tools, making a mess out of perfectly good materials. Things were different now. He could go out there and work without having to first clean up after someone else. Set up and ready to go.

The routine was so beautiful. Russ could walk into his building and flick on the lights, take a few more steps to the radio pre-tuned to the station he wanted to hear, the volume was set just right. He liked his Country Western music down low in the background until he heard something he wanted to give his full attention to — then he would turn it up. If the radio was up too loud, it would break his concentration. It would take him away from his work. One night in particular, when he felt real good about the way his work was going, he understood that part of the reason his night was going well was that the radio was on just loud enough. He had been humming along all night and neither the DJ or the commercials had cluttered his mind.

Russ used a magic marker to put a mark just where the line on that knob showed how loud the set was playing. He left the knob right there and cut the power cord and put in a line switch. After he hit the lights upon entering his building, the second move he made was to click on that line switch. He knew that in less than twenty seconds those tubes would be warm and that radio would come on so nice. It would come in kind of natural, like the music

was part of the air. Then he would walk across the work area and ignite the space heater. That little unit sure threw the heat.

There was a telephone out there with a buzzer that Teresa could use to signal Russ when there was a call for him. One buzz for a phone call. Two buzzes for dinner. He didn't answer the phone when she was home. Most of the time it was ringing for her. Wires ran from the house, hanging across the yard in clothesline fashion, tied down high on the out-building wall with those old-style clear glass insulators. Those black wires are the telephone and power lines. That orange stranded wire is the buzzer line.

The first piece of work Russ set out to do this year was to make up a set of voluntary handcuffs. These so-called voluntary handcuffs would be a device that would remind a man, when he is unable to say how he feels, when he is shackled by something too strong to overcome, that he simply has to let go, thereby breaking the binding force of his own mind.

Since Russ has worked with tools as far back as he can remember, it was natural that the device he made up was a physical object that resembled a tool. The voluntary handcuffs were two hardwood handles coupled by a heavy steel chain. Russ would take the handles, one in the firm grip of each hand, and he would try to free his arms, pulling as hard as he could in an effort to break that chain. After he had tried steady pulling, after twisting, after snapping tight the slack chain, after failing to pull out of this binding device, he could lay the voluntary handcuffs down on the table and his arms would relax and he would be free.

Russ hung his voluntary handcuffs over a ten-penny nail on the wall above his reading table, across the room from his other tools. That nail reminded him of something a friend once said. Ideas are ten a penny.

Voluntary Handcuffs was published in *Video by Artists*; *Sherman: Cultural Engineering*, and *Sherman: Ingénierie culturelle.*

(14) *AUTUMN, THE LAST DAYS OF FAHRENHEIT* (1975)

[Twenty-one of forty-three numbered paragraphs — prose descriptions of the Great Lakes Region of the US and Canada]

1. Autumn, the last days of Fahrenheit.
2. A satellite picture is backdrop for my thoughts. The North American landform is immense! Only a handful of men have seen the outline of the American continent from directly above, viewing the continental body with the naked eyes, earth not covered by ocean water. Eyes wide open look closely on the surface. An area is magnified: the Great Lakes Region, the giant freshwater lakes located in the heart of the continental landmass.
3. Isolation in the Great Lakes Basin; living in the cities; Duluth, Green Bay, Milwaukee, Chicago, Grand Rapids, Fort Wayne, Detroit, Windsor, Cleveland, London, Buffalo, Toronto, Rochester, Syracuse, Trenton, North Bay, Sault Ste. Marie, Thunder Bay. Trace a line of concrete highway from city to city, tie a cord around the lakes, connect the cities into the outline of the Region; beyond this enclosure of highways, the shape of the Great Lakes Basin continues to spread out into the land.
4. The Great Lakes Region seems like a dream to me now. A ghost of a climate of thought contained by red clay cliffs; the walls of dry land overlooking the lake. The surface movement of the liquid, the force that raises up the top and spreads it, then the surface drops as though there is nothing underneath. Forced movement with no sign of resistance. A smooth delivery of power, the surface responds in gliding undulations, fluid driven in waves, sloshing in the Basin, fast moving air drags across the surface, pulled by areas of low pressure.
5. At the shoreline: the edge of land and water undulates, a winding twisting line as the lake comes up and recedes, water seeping into sand, sand pulled into the lake with the undertow. Development inshore consisting of sand beach with pockets of lake debris. This debris builds up on the lakeside edge of sprawling beds of cutgrass and low brush.
6. The weather changes constantly. Weather fronts with sharp edges. Significant change inside an hour. Full days of change. Mornings completely different than afternoon. Not everyday . . .
7. The spine of the Region: the Industrial Corridor, 500 miles of freeway connecting Chicago with Toronto through the Detroit-Windsor mix. Toronto to Windsor on 401, the 4-lane divided highway, 94 from Detroit to Chicago. Toronto to London, 122 miles, 2¼ hours of driving; London to Windsor, 122 miles, 2½ hours; cross the Detroit River; Detroit to Chicago, 275 miles, 5¼ hours; let's say 500 miles from Toronto to Chicago non-stop in 10 hours flat. All distances approximate in the last days of Fahrenheit.

11. Ontario and Michigan, face to face; Canada and the United States; the Region's nation to nation border line. She said she always thought of Michigan as being just another part of Ontario.

12. Commercial Radio on the Industrial Corridor. Motor City Radio rhythm blues soul country western jazz. An automobile commercial at high volume breaks the music.

15. That pickup, how much does it weigh? Check the brake fluid, the distilled water in the battery, the air filter element; put in new points and plugs and change the oil, the oil filter; set the timing; grease the universal; drain the radiator; take a glance at the fan belt. A neutral transmission, the key turned all the way to the right — ignition — the engine fires; antifreeze and water poured in the radiator, a squeeze of the radiator hose; have a look at the automatic transmission fluid while the engine is running. Spin the wing nut, remove the air cleaner, a finger tip held screwdriver adjusts the carburetor, a faster idle, a richer fuel mixture, the precise hand tuning, the automatic choke sticks, a tug on the throttle, the revving engine strains on its mounts, air is sucked loud down the throat of the four barrel carb.

16. Going to the cottage over the weekend. The modest cabin with lake frontage. A picture of a small cabin jammed with supplies mounted on the dashboard just above the AM-FM radio. Scanning the dial for the traffic report, the nature of freeway congestion by recreational vehicles. Fridays and Sundays, North and South, freeway traffic crawls.

17. Rapid transit from the city to the outskirts; the abstraction, the concept of country: trees, grass, weeds, wildflowers, rolling hills, swamps, insects, lakes, rivers, mountains, cliffs, waterfalls, rapids, muddy banks, wild animals.

18. The four wheel drive vehicle invades the interior. Machines with high bodies on huge tires that can roll across any terrain, rocky or wet. Heavy duty shocks and roll bar; inertia straps hold the riders. The wild-grass covered sandy soil is pressed into 2-track road. Turn off the highway, the dense traffic, the speed traps, the restrictive law, the radar equipped police. Four wheel drive vehicles with eight cylinder engines and custom built 50 gallon gas tanks. A length of 4 inch steel pipe is welded on as the front bumper; protection against possible radiator damage during collision with small trees. A good floating compass mounted under the rear view mirror. Beside the AM-FM radio and 8-track cassette machine install a citizen's band transceiver and the police band radio. The guns under the seat with lengths of chain and rope, tool boxes and rags, a 12 gauge shotgun and a 30.06 deer hunting rifle. The firearm collection is completed as a high caliber revolver wrapped in a soft cloth is placed in the glove compartment with the county maps and the liquor flask.

21. There's another way to go to the cottage. Cabin cruiser. Riding the water at night; the only visible light comes from a freighter a mile or so off. Cabin cruiser freedom to piss off the bow while fishing for transplanted salmon.

22. The squall comes up fast. Afternoon. The storm rolls in with strong winds that whip the waves up. A rough lake eases back into smooth swelling surface contortions. Rain falls for twenty minutes. The waves have been up on the beach. They have left deposits of plants and animals, most of them dead. Surviving insects crawl on solid ground again. Most of the beetles

have floated in on their backs and some still lay with their legs stirring the air. The corpse of a young black bird lies throat up, the feathers wet and matted, the sand sticks making the black bird grey, the two feet curled up close to the belly. A Monarch is flying, bucking the Southern wind. Bouncing in the air over pockets of rotting fish. Dropping down to feed on the meat. The Monarch butterfly zigzags down the shoreline, alternately feeding on moist animal flesh and the nectar of the flowering milkweeds.

26. Sit on the breakwater, the line in the water; fishing off the pier. The fog lifts and the wind dies down. The lake choppy, green. Close the eyes: without the sound of the water moving against the pier, the smell comes up off the lake.

27. The lake trout stay on the bottom this time of year. A small outboard motor propelling an aluminum boat at the constant recreational pace, the troll; fishing with a moving line, the revolving lure in cold, deep water.

28. A small-town radio man gives the temperature, the frequency of migratory low pressure systems and promise of cold artic air masses to come in winter. Switch to a truck radio with live play of the Tigers-Orioles night game in Detroit. The Detroit ball club has an announcer with an Arkansas accent.

29. The dress suit, shirt and tie, shining shoes, umbrella and briefcase; the purse, the skirt, high heels, jacket and blouse, the makeup; hair styles. Carrying the bag, the free arm swings with the brisk walk. Equipped with pen and paper, telephone numbers and addresses, names, a pocket calculator; the wallet, proper identification, the cards, bills and change; Kleenex, sunglasses, sugarless gum. The arm swings, the hand stretches out; fingers straight, the nails clean, the ring; the wrist watch covered and uncovered by the cuff. Decisions, phone calls to make, interviews, lunches, drinks, the taste in the mouth; a glass of water, please. A Mack truck pulls a stainless steel tank of homogenized milk; the silver image moves across the plate glass window at the front of the restaurant.

30. The pedestrians were all sleepwalkers. They'd turn without signaling first. A black wingtip shoe stamps on a dime that has rolled out of the crowd. People changing directions, jerking to stop 'n start. Outside a restaurant on the sidewalk; I used to meet her in there. Arms up, the hands hold the hats on the heads as a gust of wind blows around the corner. Dust and pieces of white paper whistle through the air.

36. It's beautiful to hear the sound of your voice. The idea that you were talking about planets and stars the first time we ate supper together. I had no idea what you were talking about at first. The last meal of the day finished with a coffee. We watched the sky after supper.

37. Alone in the observatory, this person isn't into astrology of astronomy. This person is simply paying attention for the pleasure of observation. The understanding of the amateur. The feeling I get looking into the night sky. My shack of an observatory is placed on level ground. Just four 4 × 4's for corner posts, 1 × 10's fill in the walls of the box, a rectangular

enclosure 8 feet high, no floor, no ceiling: a 4 × 7 foot piece of the sky, completely unobstructed. One of the short walls is on hinges and serves as the entrance; the wall-door is hung beautifully, it opens and closes without a light-leak; a fine piece of work. I shellacked every inch of the observatory and painted the outside a Blue-Spruce green, the inside flat black. The short sides of the observatory face Northeast and Southwest; not that it matters much, I didn't give it much thought when I sunk the posts. The door is the Northeast end: I enter, close the door behind me, bend over to help my body down with my hands, to soft-land on the left side, rolling over on my back, lying on a bed of pine needles, my head opposite the door, the feeling I get looking into the night sky, squirming around on my back, at night, the inside is so dark that only the patch of sky floats above.

41. The voice just a sentence long turns the woods into highway; run the freeway right through that stand of Douglas fir. Interior penetration; the four-wheel vehicle moves off the highway into the forest. Clouds move through the field of vision. Fog fills the space between high-rise building: The weather changes before me.

Autumn, the Last Days of Fahrenheit was previously unpublished in its entirety. Paragraphs 36 and 37 were published under the title "Is Scientific Thought Outrunning Common Sense?," *Only Paper Today* 4, no. 8 (October 1977).

(15) *WRITING FOR PHOTOGRAPHIC PORTRAITS BY JEREMIAH CHECHIK* (1976)

[Ten of twenty-four written portraits . . .]

Eyeglasses with wire frames in the shape of guitar picks, these glasses frame the eyes, his eyes
soft in the shadow of his brow. Directly over the nose, on the forehead, an area of light shining.
In this highlight indentations shadow, nicks in the tight flesh of the forehead. Off to the sides,
skull lines at the flesh of the temples, high forehead back to the dark hair thinning, running
down into sideburns, long transparent tufts the full length of the jaw, the skin form of the ears
emerging, the chin clean shaven, the mouth dressed with a double shadow under the bottom
lip and the light smooth skin line above the dark upper lip extended by two shadows at the
mouth's corners anchoring the lips into the cheeks. The nose twisted just off center. Most of
the neck dark under the chin. The top of a dark vest shows under the collar of a plaid shirt, his
large glasses rest on pads pinching the bridge of the nose. His glasses frame his eyes soft in the
shadow of his brow.

———

At the neck white flesh is contrasted by the neck of a sweater and her black shining hair
waving full and long. Her hair combed, parted at the top falling into thick tangle sitting on
each shoulder, hair parted just off center, thick hair forming a soft hairline, hair frames her
face as her dark lids frame her eyes, the top lids lie heavy on the eyeballs, the dark lower lid
skin creases under her eye whites clouded, white flecks of light at 10 o'clock in the iris circle
of the eye. Black eyebrows arch over these eyes set in dark-skinned heavy lids.

———

Large head flat face tight skin, the man's ears have grown back tight against his thin hair
waving out, a fringe of dark hair forming in the light bright behind the neck. Little stars of
light reflecting off the pupils of dark eyes, eyebrows long, merging through a light growth of
hair over the bridge of the nose. Straight across mouth line closed, strong jaw, the chin cleft in
soft shadow, no visible facial hair.

———

Young woman in glasses, steel rims circle blue eyes underlined by red marks close to the colour
of her lips. Her eyes open wide in an off-centre stare; off to the same side, tape is holding
together the broken frame of the eyeglasses. Ear-length fine brown hair flips out over a pierced
ear ringed with gold, around her neck a gold chain above the neck of the white sweater. The

jaw line running around her chin up the cheek to bend indented by the lens's distortion. The lines of the nose shadow up into the forehead inside the brown of the eyebrows.

———

A man with a beard in a T-shirt. Straight hair parted on the side and falling to cover most of the ears. Lines in the flesh of the neck rounding the Adam's apple, a spot of light on the stubble gray, the thick black beard growing out over the trimmed neck. Inside the facial hair the line of the mouth. His curving nose ended by the horizontal crease cutting across the bridge, a continuous fold in the skin underlining the eyes as it loops over the central nose.

———

The head of a man tilted to one side, half the face taken out by black shadow, one eye shows through tortoise shell framed eyeglass. Lips closed, the mouth turns down. On the neck a mole, on the cheek a side burn, the ear shaded with hair endings. A dark eye through an invisible lens, crow's feet spread from under this eye. Sharp line of light and shadow, the nose pointed. A light shirt, collar open.

———

Black shadow takes out one side, the head of a man tipped to one side, one eye shows through tortoise shell frame glasses. Mole on the neck, side burn, lips closed, the light on the nose pointed, the mouth turns down, crow's feet under the eye, the ear shaded with ending hair. A dark eye through invisible lens. Collar open a light shirt.

———

Black hair waving back from the temples, hair standing high, a forehead with a few light lines topped by the straight-across hairline. A relaxed face soft, eyelids heavy, blue eyes. Leather coat, silk scarf. Face dotted with moles. Soft lines of the nose underscored by the red mustache spreading, the top lip practically hidden, blue eyes at the personal level of the face.

———

Projecting through the eyes the inside of the girl, strong. Her complexion, red lips, auburn hair, steady eyes, lids firm. The vertical shadow on the chin. The eyebrow a fine hair drawing. Clothes patterned. A necklace. Skin yellows, reds, whites. A nostril and the curve of the closed mouth line, both ends of the line in shadow. The roundness of the top of her

head, the arch of her skull. From the dark side the eye shows blue-gray black, speck of white. Highlights spotting the hair curling, sticking high on the cheek. The sharp crease running from the corner of the mouth to the nose.

———

A puff of cigarette smoke, long ash hanging from the filter in his lips. Eyelids squint to screen the smoke, nose hidden. Traveling through the black hair a line of gray smoke. Beard short hair, chest hair coming up the neck, the open collar of a plaid shirt inside the sweater.

Writing for Photographic Portraits by Jeremiah Chechik, an exhibition at A Space, Toronto, June 1–12, 1976.

PART II

UNDERSTANDING MEDIA WAS OUR FIRST BIG MISTAKE

Miami. Here I am. Sitting on the fifth storey sunroof of the Wandlyn Motor Hotel. Taking in the (squint-eyed) panoramically framed view of the quiet, mid-afternoon light. Laid back in a chaise lounge, drinking a gin and tonic, interviewing Maria Del Mar, greater Miami artist and successful media entrepreneur. I'm the one who is staying in this hotel. I'm living it up on the magazine's expense account (*Centerfold*). Maria preferred to come to meet me. She said she was looking for a reason to get out of the house. As well as being the eleventh wonder of the world, Maria is a very active artist who works directly with the highest forms of available technology in a potentially full, creative sense. She loves her equipment, and the machinery she designs really puts out for her. Skip Olson, a flashy programmer from Boca Raton (educated at Caltech under Harold Proctor), does most of Maria's super tech. It was actually Olson who put the final touches on Maria's "Spinal Ray Gun." The "SRG" is an electro-acoustic transducer that makes the body, as Maria says, "speak in tongues from head to toe." This "fun gun" is based on Olson's patented (1975) digitally focused transductive floating head assembly. Make no mistake, the "SRG" was Maria's own invention, and still is.

She has been working with various electro-acoustic transduction techniques since emigrating from Caracas to the United States in 1974. Maria explained that she had felt stifled by the total lack of activity in the experimental technological arts in her native Venezuela. She originally landed in New York where she found work with Pan American airlines (on the ground) while she looked for the access she needed to continue her creative work in the States. It took only six months for Maria to decide New York was not for her. Her move to Miami in the winter of 1975 was based on the weather, and as it turned out it was a stroke of good luck. She ran into Skip at a computer conference that same winter. He was lecturing on his developing digital focusing mechanisms. His floating head assembly proved to be the missing interface between Maria's transductive ideas and the spine of the general public . . .

As she has just taken the real thing out of her purse, Maria Del Mar's "Spinal Ray Gun" looks like a cross between an electric finishing sander and a Princess phone at this reading. Ivory. Although they have taken the idea quite a ways, the machine is obviously still at the prototype stage. What the "SRG" is, in plain English, is a very articulate and powerful vibrator held firmly in place at the base of the spine by a thick nylon belt around the waist. A smaller control unit, looking a lot like a miniature cassette player, is connected by cable to the "SRG."

When I say the "SRG" is articulate, I mean it is capable of "injecting" a wide frequency of vibrations into the central nervous system with a sophisticated articulation of power far beyond the actual surface transduction. I am not talking about fancy massage. As I have said, this floating head assembly, developed by Olson, without practical application before Maria figured out the way, bestows the "SRG" with its awesome potential. Olson's "head" enables vibrations to be injected into the sensitive base of the spinal column with just about all the depth and power you can imagine. The physical interface of the transducer itself is a four-by-seven-inch soft rubber pad, perfectly smooth on the surface. Underneath this pliable pad, which fits any lower back perfectly, is over an inch-thick layer of liquid crystal membranes. These "membranes" undulate under directive electrical stimulation to form concentrations of pressure "locally" by frequency.

This "locality by frequency" is the key to the "SRG." It is as if this floating head is an electrostatic body of liquid pressure. Behind this floating head is the power transducer, which is an electromechanical vibrator set to a control frequency of approximately 15,000 cycles per second. Maria wouldn't tell me the exact frequency of her control vibration. These "localities of frequency" set up in the head assembly are directed by digital computer according to the program Maria chooses to insert in the cable-connected remote control unit. Maria creates her own programs for the "Spinal Ray Gun" to play back in anyone's body. As I thought out as much as she would tell me about the specifics of the "SRG," I came up with a hitch in her sketchy elucidation. She wanted to strap the thing on me — I just wanted to talk it through a bit more before I committed myself. I told her I thought the rubber interface pad would transfer with restrictive uniformity any such diversity of said-to-be "local frequencies" underneath it. Why? Because of the absorbent qualities of the rubber interface itself. It was at least a quarter of an inch thick. So that makes the "SRG" just a vibrator. So "thanks, but no thanks, Maria."

She told me I did not understand how the machine worked and unfortunately she could tell me no more. I did get her to admit that the control frequency functioned as some sort of bottom-end for a deep shaping of these various "frequency locales." I can only speculate that the device induces a sympathetic flow of bioelectrical current through the fluid channel of the spinal cord. As resonance is achieved, the initial charge is in all probability reissued (fed

back) on the neuro-microscopic level of the ganglia and below. But in order to make only the smallest areas move independently, this would have to take us into the radio spectrum. And the fact that the thing is called a "Ray Gun" . . . I don't know.

We move from the interview to the demo, from the rooftop to my room. The first time I was under the "gun," I was lying face down on my bed with only my swimsuit on. Maria sat in a chair by the open balcony window. She held the control unit in her lap as she talked me into her first program. As gentle as her voice was, I was apprehensive. "Ataques de amor" (my translation, "needles of love") was just another mini-cassette until she ran it though the "SRG" and into my entire body. It was the first recording she had ever made for the "SRG." She explained how rough it was as she turned up the volume. It was all I could do to keep from inhaling the sheet I was lying on! "Oh my God," was what I would have said, had I been able to exhale. I can't begin to tell you what she was doing to me. "Ataques de amor," she told me after, was just under four minutes long. I had no sense of time, as I had never been on top of the sensation. I asked her why the world "love" was in the title. She said there was "love" because of the "hug of the chest" affected by the "needles" penetration. From the smile on her face I knew I should get up, but this was the most interesting position I had been in for quite a while.

I asked her what was next. She seemed to lower her voice for "un hombre que esta muriendo nunca se equivoca" ("a dying man is never wrong"). It was only two minutes long, but all I can remember coming out of it was that my hands . . . wait, my arms were straight out to my sides and my legs were also straight with my feet resting slightly apart. All I can remember is that my hands and feet seemed to press themselves into the mattress and I felt like I was rising from my centre as if my ass was being lifted by a crane. After I had come down, I checked the bed. I could tell from the lack of wrinkles on the sheet that I hadn't moved an inch.

Then she took me through a piece called "El ultimo suspiro" ("swan drive"). It made me cry. It was very beautiful. On the way out of "El ultimo suspiro" I could remember being briefly conscious of a plateau of pleasurable sensation before the plunge I had to forget. She was explaining to me that these things she did to me (through me, actually) did not have compositional form in a normal sense, but that time was simply filled until it passed away. I never even considered getting up from the bed. I wanted "El ultimo suspiro" again. The second time through I found myself dancing — at least I thought I was dancing. My eyes felt as if they were opened, but I could not see. I remembered — actually I heard her voice playfully chanting "Me divierte ver el gringo bailar" ("I love to see the stranger dance"). How was I to know "El ultimo suspiro" was a comedy?

It was over. Maria was sitting with her eyes closed, her lips cracking a smile as she laughed with her arms and legs crossed. I rolled over to my side. I could feel the power cord of the "SRG" twist between my thighs as I undid the belt and removed the heavy "Gun." All I could think to say was to ask her what did she do before she did this?

She told me to support herself as an artist she had worked as a crime reporter for a newspaper in Caracas.

Excerpt from "Understanding Media Was Our First Big Mistake," published in *Centerfold* magazine (1979).

PRIMARY DEVICES: ARTISTS' STRATEGIC USE OF VIDEO, COMPUTERS AND TELECOMMUNICATIONS NETWORKS

The purpose of this writing is to examine one fundamental question: Why do artists choose to work in today's predominant communications technologies?

The predominant communications technologies of our time are video, computers and telecommunications networks. These key interrelated communications technologies supply speed-of-light, electronic power to a much more visible media environment comprised of print, photography and cinema. These media of greater visibility have attained their considerable profile in part because they have given birth to vast histories of artistic accomplishment. Print, photography and cinema are the "smokestack media" of the cultural industries. By comparison, video, computers and telecommunications networks are, from an arts perspective, relatively uncharted territories. That is, while there is a recent art history for each, an arts perspective of these communications technologies is still an unestablished, minority point of view.[1]

Being on the margin fails to discourage some artists. This kind of defiant attitude has been exhibited by significant artists throughout Western art history. Today many of these artists are more interested in managing information than they are in formulating unique forms of individual expression.[2] Problems inherent in the management of information, working with and against the hierarchies which dominate information and communications technologies, are difficult problems which intrigue and challenge many contemporary artists. Video, computers and telecommunications networks are the technological infrastructure of

1 From the broadest perspective, there is no general societal acceptance of communications technologies as legitimate art media. Video, the most highly developed of the three predominant communications technologies cited, embodies scarcely more than twenty years of artistic practice, if television is not considered.
2 This point of view was expressed repeatedly at an intensive, two-day meeting sponsored by the Canadian Commission for UNESCO in Ottawa, December 1984. American and Canadian specialists on art and new technology were brought together to discuss specific themes and problems related to this developing field. For a detailed summary of this meeting, see *Art and New Media: Report* 53 (Ottawa: Canadian Commission for UNESCO, 1986).

the late twentieth-century information economy. It is not surprising that many artists choose to work directly with these predominant communications technologies.

The primary devices of these communications artists differ from those working with traditional fine art media, just as widespread attitudes and values associated with the use of communications technologies differ substantially from traditional art concerns. An intellectually acceptable methodology for using communications technologies does not include a behavioural lexicon of theatrical gestures or anti-communications techniques. Methodologies of information gathering, processing and diffusion are unlikely to be conceived for the purpose of defining or establishing one's creative identity. Communications art strategies are usually devised for their utility and effectiveness. Other, more convoluted, traditional approaches to the art making process will tend to render the artist ineffective or incompetent. The primary devices used by communications artists are specific pieces of equipment designed to perform assigned functions or serve particular purposes — such as video tape recorders and personal computers.

In many cases these primary devices are format-technologies, technological devices taken off the shelf and used without modification. The artist forms a relationship with a particular class of machine for the purpose of confronting the problems and opportunities these machines were designed to address.[3] Teams of engineers, working in most cases without knowledge or concern for artists or the art-making process, design these primary devices, assigning functions with consumer or industrial applications in mind. Market realities determine the performance specifications and degree of utility of these devices. A specific piece of equipment therefore constitutes a particular work environment or site. Factors of compatibility, or more significantly incompatibility, with other machines go a long way towards defining the context or place within which one must act.

While the actual working context or environment may be extremely limited in reality, many artists using contemporary communications technologies see an unlimited future potential of these chosen media. In other words, extremely rigid machine environments are accepted, because, in theory, existing restrictions will fall as these technologies advance on their own momentum. Artists working with today's powerful but challenging technologies believe they are at the frontier. In the face of unavoidable, unnerving change, these artists want the same things they have always wanted, and more: to work directly, without restriction, with images and sounds.

Artists do not relish art making which is distanced by cumbersome levels of technique. Artists want to control motion precisely. They long to harness computers and robotic techniques for cultural and artistic purposes. Everyone would probably agree that screens of all sizes must

3 An alternative to working with format-technologies is to build custom devices as part of the art-making process. In many cases artists choose to design and build their own hardware, write their own software, etc.

eventually go. Virtual environments of unprecedented complexity must be designed to exist without the constrictive influence of frame and aspect ratio.

Communications technologies may be restrictive today, but one has only to look contemplatively at the actual pace of development to become intoxicated with the potential of these integrated technological devices. If television, which can be seen to be the history of video,[4] breaks up the way radio has into a spectrum of mobile, wireless personal telecommunications technologies, what will the temporal and spatial implications of fully interactive video be if it is transmitted at the speed of light on a global scale? A question like this will stimulate some artists more than others, because some will believe they can play an active role in the process of technological change. There are individuals in all sectors of society who feel they must take part in psychological and societal change brought about by advancing technologies. Certain educators, scientists, economists, bureaucrats and politicians all find themselves advocating technological change from their particular perspectives. Informed artists are likely to communicate with professionals in other sectors sharing similar goals. Thus we witness the development of cross-disciplinary, collaborative work that transcends strict professional jurisdictions in efforts to reach common goals.

It may be difficult to form productive, working relationships across disciplinary lines, but artists inclined to work in non-traditional media also face limited opportunities in their own interdisciplinary sector. The arts community in any nation with an advanced technological infrastructure seems to find comfort in the fact that the arts are a physical and spiritual link with the past. In the visual arts, painting and sculpture continue to reign as the mature forms of apparently everlasting value. The endless examination and manipulation of these mature, material-based forms seem to continue to satisfy most artists, patrons, curators, critics, dealers, publishers, bureaucrats and psychologists.

Related visual media like film and video are marginally accepted as legitimate art forms but make things complicated from both an aesthetic and economic perspective. For one thing, film and video invite viewers to think about sound and music and performance. To complicate things further, the visual arts community has also generously accepted photography, the written text, audio, performance and installation. In some circles even holography is an acceptable medium for artistic purposes.[5]

4 If it is true that television is devolving into video, a mass medium into desktop video and picture-phones, then television, as we know it today, will end up being the history of the video medium.

5 Holography is at present one of the least acceptable of visual art media. Its production and display limitations, plus its totally unique look tend to overpower and diminish every artist who comes into contact with the medium. This unfortunate situation will subside as the medium advances technically and as the technology becomes transparent through more frequent use.

The choice an artist often must make is whether to work in a well-developed or completely undeveloped territory. If one wants to make a painting, the problems have been addressed over and over by countless numbers of very capable individuals. On the other hand, if one wants to work in video, computers or telecommunications networks, relatively few have looked at the territory from an art-making perspective.

When looking at well-worn work environments or unusual places where few artists have dared to go before, is it really possible to use the same criteria to evaluate the way art making problems are solved in such extremely different domains?

As well as an underdeveloped critical environment, communications artists have the additional problem of working in the professional territory of another group, namely engineers and scientists. From a traditional arts perspective, the painting problem is a challenging, ongoing proposition of merit. From a science and engineering perspective, the act of painting is fascinating as an abstract exercise. The viewpoint of the engineer is considered here because the artist must wear the other professional's hat whenever he or she enters the communications environment in an art-making mode.

From an arts perspective, the terrain of video, computers, and telecommunications networks presents an unstructured work environment, with no clearly established range of techniques and relatively little art history. There are neither behavioural expectations nor performance standards. From an audience perspective, there is scant knowledge of the terrain, and curators and critics rarely exhibit the willpower necessary to gain an informed, privileged point of view. To make matters worse, from a science and engineering point of view, video, computers and telecommunications networks offer a work environment suitable for just about everything but the art-making process. Many hard-science professionals think only of Escher and Bach when they do think of art and culture.[6]

There are scientists and engineers who think of themselves as artists in the mold of Leonardo da Vinci or as intellectual humanists quite well equipped to view art. But the reality of the situation has been rendered in black and white to the point of hopelessness. A gray-scale of ideas of any complexity would necessarily involve the multiple perspectives of an interdisciplinary group or recorded conversations between individuals transcending professional over-specialization and seemingly inescapable segregation and isolation. The fundamental problem is that there is no business ($) to speak of in the interdisciplinary zones where artists currently exchange information with professionals from other disciplines.

6 This horrible cliché, that scientists, technologists and engineers always think of Escher and Bach when they think of art and culture was set in cement when *Gödel, Escher, Bach: an Eternal Golden Braid* by Douglas R. Hofstadter (New York: Vintage Books, 1980) was published.

Money talks and video, computers and telecommunications networks simply do not serve the interests of interdisciplinary groups as well as they serve multinational corporations.

To go back to a comparison of traditional art practice and activity designed for the new technologies, it is apparent that there are substantial differences between the two options. Artists who choose to work with traditional media completely control the production of their art with their own hands. Artists who opt for manipulation of information must rely on others to control the processes of enormously complex systems. Work that involves the artist with communications systems dictates the artist must work collaboratively. When this collaborative work demands formal relationships with people in other cultural sectors, things may become extremely interesting — often to the point of complete dysfunction. Successful collaboration and, even more importantly, productive collaboration, becomes the measure of professionalism in the communications art field.[7]

Unfortunately, co-operative work habits cannot be sustained by goodwill alone. Mutual benefits must also result, for example, the acquisition of previously unattainable information. Maybe this new information will actually lead to business ($) opportunities. At this time there isn't much business ($) for the unaffiliated individual in and around these complex global systems. It is likely to happen soon, but for now personal satisfaction is all that is available — the terrific feeling one has after collaborating and co-operating transculturally. Many of these emotional benefits arrive via the keyboards and other devices of interactivity. Interacting directly in co-operative professional communication is a remarkable experience, even when it is not perceived to be part of the art-making process.

The main objective of all interactive works is to reduce the response time for everyone concerned. The artist wants to know what the audience thinks and will in some cases share authorship of the work with others to find out. The spontaneity of natural conversation is sought. Improvisation, a desirable ingredient in all creative communication processes, is fundamental to the evolution of a dynamic aesthetic of communications art.

A structural approach to communications art may involve the artist in the creation of serial analogies. Analogous models of particularly interesting aspects or applications of systems are constructed for the purpose of introducing these modes into larger, more comprehensive systems. A series of analogous systems are constructed in an attempt to shift meaning in a system to suit personal objectives. Thus the basic natures of the larger systems are redefined, step-by-step, over time.

7 Roy Ascott, a former president of the Ontario College of Art, now holding professorships concurrently in schools of telecommunications art in the UK, France, and Austria, publishes widely on these concepts of contemporary practice in the arts. See his "Art, Technology and Computer Science," in the 1986 Venice Biennale catalogue.

Artists form relationships with systems with the goal of becoming the managing agents of the systems employed. An artist, when confronting the reality of a general system that is underdeveloped as an art-making environment, will naturally seek out and interact with the system's like-minded agents, who may or may not work within large organizations. These like-minded agents will be other artists or professionals from other disciplines inclined to exchange information with artists.

In this way artists manage to control an aspect or application of a system, rather than finding themselves powerless, non-productive and completely alienated, like a majority of members of their society.

Another matter that should be considered is the inherent value of membership. The artist enters an association with a particular community that is using the same system, or at least the same routing and addresses in a system. The "nerdy" view of this is that membership translates into being a "node" in the system. For instance, the artist might want to be an active partner in a group hoping to influence national and international societal trends (i.e., an environmental group). In such cases the national and international societies are managed by a critical mass of optimistic people who want to see an aspect of a system, or a whole system, work. For this to happen, the behaviour of the group has to be studied so that information may be extracted and transferred in an unobtrusive, controlled manner. The system managers must refrain from asking too much of potential collaborators while still finding the way to prime the pump.

Whenever anyone manipulates information or an audience that is interested in consuming and contributing information there is bound to be a political reaction. The management of interactivity depends on a practical understanding of how members of a participating audience are going to react. If an interactive system is controlled intelligently through the process of anticipating the behaviour of the participants, then the system may not differ much from vertical information hierarchies like television and other classical mass media. Vertical hierarchies are top-down, one-way information diffusion systems that do not feature equal status between the artist, the system designer and programmer, and the audience — the potentially responsive participants.

Hierarchical relationships do not have to be vertical in nature — they can be horizontal.[8] Many artists working with communications technologies are obsessed with the idea of eliminating vertical hierarchies in favour of formal relationships that feature lateral,

8 Revealing comparisons can be made between the adverse conditions facing independent media artists in North America and the struggle by all Latin Americans for control of their own media environments. One of the most influential Latin American communications theorists is the Bolivian, Luis Ramiro Beltrán. See his *Farewell to Aristotle: Horizontal Communication*, prepared for the International Commission for the Study of Communication Problems, adopted by the General Conference of UNESCO, 19th session, Paris. Source: Canadian Commission for UNESCO, Ottawa.

equivalent levels of information exchange. To this end, communications artists are constantly trying to build ladders between have-nots and those who possess or appear to possess greater skills and resources. In some cases this quest for a "level playing field" becomes petty. Success is often resented and every attempt is made to subvert emerging power in individuals or the organizations they manage. Those who appear to make extraordinary gains are thus criticized for unfair practices or disappointing performance, given the advantage they seem to hold. Rumour and innuendo are the conventional weapons of such destructive, negative levelling tactics.

More optimistically, not everyone equates higher levels of technology and vertical hierarchies exclusively with military research, behaviourist domination of the media-illiterate, corporate profit acceleration, or California-born special-effects movies.[9] Not everyone insists that low-tech is the only way to be politically correct. What is the value of maintaining pathetically low levels of image and sound fidelity in the interest of assuring one's competitive position on the bottom? What is so attractive about dressing in the commonplace images and sounds of gutter-end technology?

Thankfully, the microchip revolution has transferred tremendous power to the bottom-end. The basic Macintosh computer resting on today's junk-pile due to factors of obsolescence is still a machine of incredible power and utility. Such a piece of equipment is simply the price of admission to a universe of opportunities and problems. Personal economic realities aside, the artist who is interested in managing information must have the psychological and social freedom to work with whatever level of technology he or she needs or wants.

The artist must be concerned about the accessibility of specific machines, the primary devices of his or her profession. The artist must also be able to cope with the politics that come with the territory of these communications technologies. The politics in the traditional art milieu are fairly straightforward and easy to understand. Reactions to art based on these new technologies will range from indifference to paranoia, which may result in active attempts to oppress such machine-focused activity.[10] But within the communications art community itself, the artist may face ruthless competition as everyone struggles for resources and security in this undeveloped, hostile environment. The corporate sector which controls the evolution

9 A depressing picture of the confusion, anxiety, and general competitiveness surrounding the issue of technological development in the arts is to be found in a publication prepared by ANNPAC/RACA following their 1984 conference, "Artists Talk About Technology," held in Halifax, June 1984. The publication, *Artists Talk About Technology/Interface: Artistes/Techniques* (Toronto: ANNPAC/RACA, 1985) in its best light appears to document a well-balanced dialogue having taken place between opposing factions. In fact, the Halifax conference was a black hole of paranoia and irrationality, a nightmare of misunderstandings, where opportunities were thrown away and a good deal of momentum was lost, perhaps never to be regained.
10 For an introduction to these professional vagaries, see Tom Sherman, "Message to ElectroCulture," in *Video by Artists 2*, ed. Elke Town (Toronto: Art Metropole, 1986).

of the primary technological devices and the actual channels of communication will likely remain unimpressed with real innovation and creativity until it can be demonstrated that there is business ($) in the affairs of communications artists.

As it stands, many people give lip service to the importance of interdisciplinary activity. Actual financial support comes exclusively from informed individuals at agencies within governments of no more than a handful of nation states. Universities, like all bureaucracies, know the theoretical value of interdisciplinary exchange, but face insurmountable resistance from tenured faculty content to stay over-specialized. With respect to the private sector, the artist may find access to sophisticated technologies in exchange for services in kind. In light of this grim synopsis, why do artists choose to work in today's predominant communications technologies? Clearly, they are simply not interested in the traditional problems associated with art making. They seek relationships with technological systems that are not conventionally perceived as media environments conducive to creative activity. There are freedoms associated with the absence of firm behavioural expectations or standards of performance. There are few rules to break.

The individual who chooses to work in communications technology must be able to transcend reality in an attempt to anticipate the potential problems and opportunities presented by rapidly advancing technologies. These problems and opportunities separate those who can actually participate actively in the development of a technologically based culture from those who will have to contribute to the broader culture in other ways. Technology moves ahead progressively. It is driven by business ($). It waits for no one. If artists wish to determine its course they must project themselves into a future they can manage on their own.

If some artists are really interested in managing information, rather than formulating unique forms of individual expression, then they must have the tools, the skills and they must begin to think of their work as business ($). If their business is the exchange of information with professionals from other disciplines, then they must convince their peers, patrons, curators, critics, dealers, publishers, bureaucrats and psychologists that their particular form of art/business has value. While this will be difficult, it is not impossible. Time is on their side because of the growing — in some cases technologically generated — need for interdisciplinary groups.

The exchange of information in interdisciplinary zones must be well documented, and all such activity should be thought of as information transactions. All such transactions should be compiled in detail and then released when appropriate to open-minded people in other interdisciplinary zones. If artists construct rather than edit these information

packages, a common management problem will soon arise. The volume of information formed by the documented history of transactions will demand adequate storage and indexing strategies for information retrieval and manipulation. Sooner or later, someone is going to need this information, and at that point the information provider, the communications artist, is going to be in business ($).

This text was first published as "PRIMARY DEVICES" in *Siting Technology* (Banff: Walter Phillips Gallery, Banff Centre, 1987); and then as "Primary Devices: Artists' Strategic Use of Video, Computers and Telecommunications Networks," in *Connectivity: Art and Interactive Telecommunications*, a special issue of *Leonardo* 24, no. 2 (Cambridge: The MIT Press, 1991).

ON SHORE

Every year when I arrive in Nova Scotia, I rush down to the ocean to experience the luxury of space and the sweet cleansing sound. If it is clear and the sky is full of light, the visual dimension is really too much. I blush at the beauty of the sea. My eyes fail to meet the challenge of the whole incredible vista. You can look for as long as you can stand at the water's edge, but you'll never feel worthy of the full display. This is a landscape dominated by liquid and ether, of light playing at the very top of its game. This is a vista as old as the beginning of time. And yet there is no evidence that yesterday ever happened. There is only this day's particular ocean and sky and sound. Looking down I hear the sound of the water meeting the land. The water's air fills my ear canal. I begin to walk, to move while breathing in the ocean until I become one with its expanse. This surrender can take weeks.

I don't know what it is, but you can sense the past when you look out to sea. It happens the first time you see it. I don't mean you can see wooden ships with tall masts and full sails leaning toward the surface. I'd say there is a sense of the past in that the water tells you where you came from, that you've crossed it, and swam in it, and drowned enough times to have no fear of the nearly infinite space between you and the horizon line. That borderline where the sky hisses as it meets the liquid sea. Everything has happened more times in the sea than you can count or imagine. Its memory operates in a different time zone. Its space is second only to the sky.

I walk back and forth along the shore. Pacing like an animal at the boundary between a solid earth and forbidden pleasure. I could swim if it wasn't so cold and dark. I can, and do, swim in the sound that enters my body and mixes with my breathing and convenes with the rhythm of my walk. My feet slap the hard sand at low tide. My legs make real gains while my hips keep time. The ocean fills me with its breathing patterns of waves breaking. The music is broken by a glance out toward Port Mouton Island. It's still there. A fog bank hangs farther out. I drop my head as my feet splash and the wind tones begin again in my ear canal. The sea comes into my body through my ears and my skin. I pace up and down the edge of the shore.

Previously unpublished, "On Shore" was written in summer 2002 on the South Shore of Nova Scotia.

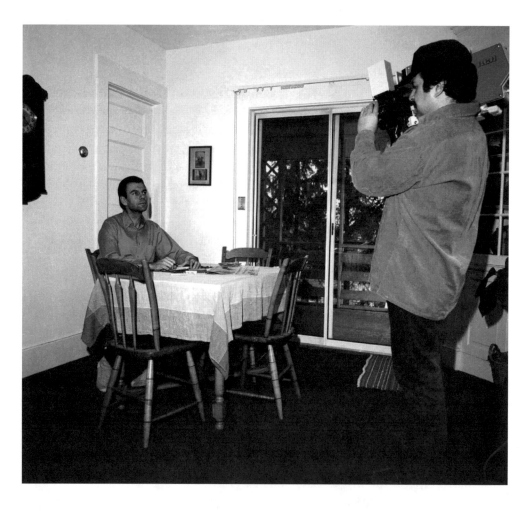

Production still from *TVideo*, Syracuse, New York, 1980.
John Orentlicher is pictured as the video camera person. Photo: Lucinda Devlin.

THE APPEARANCE OF VOICE

In the beginning I used the video medium as a place to "publish" my written texts. Although I was operating with the intent of a visual artist, I aspired to be a writer, of essays and prose, and found it natural to read and record, and exhibit my texts in the time-base of video. I made a videotape, *Theoretical Television*, in 1977, in which I contextualized one of my early texts called "The Art Style Computer Processing System." I formatted the ASCPS as an advancing character generator display, asking viewers to read my text on television. Cable access channels commonly feature community message boards, formatted as white text advancing, usually vertically, up and off an electric blue background. Instead of using upbeat muzak, I used some dark, modern violin and cello music, injecting a little mystery. Theoretical Television inhabited the spot on cable reserved for job listings, and current events, and had a more or less constant, six-month play on the community access channel of Rogers Cable in Toronto.

I began writing as an artist in 1973. My first texts were strings of simple declarative sentences. Bare bones, economical sentences, the prose equivalent to lines of computer code. I wrote intuitively in a generative manner, following my nose from one statement to the next, later cutting and stringing my sentences into compositions. Although I had been working and exhibiting as a sculptor working with sound and other invisible phenomena prior to beginning writing, I saw text as a purely visual phenomenon for the first few years. There was no oral voice in my text. The prose was absolutely silent. I was still making visual art when I wrote.

I started displaying my texts as enlarged photostat objects in public spaces and galleries in 1974. By 1975 I was experimenting with reading my texts out loud, using the narratives to direct performers (Colin Campbell, Lisa Steele, and I did such a performance at Art Metropole in Toronto, each of us reading a text passage while another executed minimal actions). Although it was awkward reading these voicelessly conceived texts, I liked the formality spawned by reading my dry visual texts out loud. During this time I became fascinated with the way the "talking head" functioned as the physical site for the emission of narrative. To

emphasize the ideas of my texts, I would alter or twist the physical site of emission. In Television's Human Nature (1977), another video recording conceived for cable television release, I had two performers, Susan Harrison and Peter Melnick, sit absolutely still under hot studio lights, looking straight into the camera, while their pre-recorded voices described them watching television in the privacy of their own homes. Their faces, lips unmoving, are perversely passive, as their voice-overs become their "inner voices," their private thoughts reflecting on the nature of the television viewing process. Over the next few years I made a number of works that situated spoken narratives on peculiarly inanimate humans. I used the head-and-shoulders frame common to television, the human motif of the close-up, to ground and position my voice-over texts as inner voices, the internal manifestation of thinking.

This early work was clearly structural, and was intentionally overstated as such. There were distinct, discrete elements operating in parallel. The video or television studio context (unnaturally hot lighting), the physical appearance of the body (the head-and-shoulders frame, usually shot straight on), and the off-camera, spoken narrative (which filled the frame and attached itself to the body) — these elements were combined to construct an "object of thought." To provide conceptual integrity, I often described the situation the human subject found her- or himself in, in the work. The 1970s, for me, were a time where arid conceptual, structural constructions could be made to live and breathe. Earlier conceptual art had been so tightly scripted and dry. With structural constructs emphasizing the spoken word, ideas could be fleshed out, without employing the conventions of character and narrative common to drama. I was particularly interested in internal monologues because they appeared to be unselfconscious articulations of thought. Context and ideas were emphasized, not character development or story. Subtle nuances in image and voice were exploited to provide warmth and tone missing in earlier manifestations of minimal, conceptual art.

My work of the 1970s and 1980s was a series of experiments with voice. I use the term "voice" to describe the essential carrier of my unique, individual self. My thoughts become manifest in my speech and writing, both centred by my voice, that primary mechanism of response and authorship. The spoken word is thinking off the top of the head, as verbal expressions of thought are formed to bridge the distance between people in a room, or through a communications medium, such as the telephone, radio, or television. Writing is where the mind hits the pavement, the place where thoughts are marked on the environment itself. Drawing, and other records of movement, including the recordings of presence formed by cameras, are additional varieties of documented "voice."

When I was younger, I realized I didn't have a voice. This was a very painful realization. I was part of the world, but I didn't know how to participate, how to hold up my end of the bargain. Living involves certain responsibilities. We must learn how to listen, to look

around, to survey the environment, and to contribute by responding, rearranging, or adding something. Our voice, not our mere bodies, is our presence in the world.

Recordings of a spoken voice are similar to the records of how one sees or hears, in that a recorded voice represents a point of view. A voice recording is like a picture of a place. The voice is contextualized in an acoustic circumstance. I'm not talking about what a voice is saying. The voice itself denotes the presence of an individual. The characteristics of the voice, its pitch and rhythm, and its position in an acoustic space, determine the nature of this presence. This presence establishes point of view (POV).

Video technology, because it can describe multiple dimensions of space and time simultaneously, offers a wonderful channel for finding one's voice, and for examining different types of voices and their effects. A basic, unaltered video recording offers a visual and acoustic space that can frame a number of types of voices in time. Pointing a camcorder's lens and microphone down a hallway immediately creates a literal, explicit point of view of that hallway. Shooting video is a fundamental, initial exercise in establishing point of view, in expressing "voice." The act of recording the hallway adds a description of the hallway to the world. This description is determined by the eye and the hand, and by the ear, in concert with the camcorder. Video facilitates the instant, precise exchange of POV. The broadest number of people can share video's visual and acoustic space. As a perceptual instrument, video has the power to manufacture broadly exchangeable POV. This literal, explicit, easily grasped, electronic description of the hallway, appears to be very real. Raw, real-time video recordings are the closest description of reality our species has come up with so far.

Hundreds of millions of people have had the experience of feeling the fundamental nature of a video-induced voice, the kind of voice expressed by pointing a video camcorder and guiding it with their eyes, hands, and ears, as they make an electronic description of the exact time and space they live and breathe in, in the exact same time they inhabit this space. Real time.

Let's add another type of voice to this muse. At the end of the hallway, a door opens and a woman's face takes control of the frame. She speaks to the camcorder, and thus the cameraperson (and viewer of the recording), asking her or him to come in. The middle-aged woman has a raspy voice. Her lips, darkly outlined by lipstick, are in sync with her words. Sync-sound spoken voice. She turns and we walk into her space following her, still listening to her speech, as the camera pans to check out her apartment. She has birds. There must be fifteen or twenty birdcages, all sizes. There are parrots. Love birds. Parakeets. Black birds. We hear her ask us (off camera) how our day is going, and if we would like a cup of coffee or tea. The camera continues to survey the cages. There must be a hundred birds. The

menagerie begins to get noisy. A new voice, the voice of the cameraperson, springs from behind the camcorder. A child's voice, probably a boy's high-pitched voice, says "Yes, coffee, black . . . thank you."

In the scene above, I've emphasized how the video image influences the expectations for audio and spoken voice, and how the spoken voice and audio, in this case, the acoustic information of the apartment, influences the visual information. There is a profound symbiotic relationship between audio and visual information in video, just as there is in real, unmediated life. If we recognize that video technology evolved from audio tape recorders, not film technology (where image and sound are recorded separately, in parallel, using two discrete technologies, photochemical and magnetic), it may go a long way towards explaining the video-base at the heart of so-called "reality television." The camcorder records video and audio on the same surface, videotape, adding visual information to a magnetic tape recording process that was once only capable of recording sound. Eventually this "surface," where the visual and acoustic reality is inscribed, will be a disk, or something resembling a computer memory chip. Regardless of the exact physical memory base of the medium, video and audio will be encoded as one, interdependent reality. This interdependence is why it is so interesting to pull video and audio apart when working with video.

Still from Tom Sherman's *Envisioner*, 1978, video, 3 min.
Produced at the Western Front, Vancouver, 1978.

Through the late 1970s and early 1980s I worked a lot with voice-overs and juxtapositions of disorienting, contradictory acoustic information. Voice-overs are out-of-body expressions used to include internal muses, or information added after the fact. In *Envisioner, Individual Release*, and *East on the 401* (all 1978), and in *Transvideo* (1981),

I worked with voice-over, and when I used sync-sound video, I floated incongruous acoustic environments throughout my sound mixes (this is especially apparent in *East on the 401* and *Transvideo*). There is a prepared-piano improvisation inside the drone of the Dodge Aspen speeding down the highway in *East on the 401*. And I replace the sync-sound of the highway in *Transvideo* with noisy, spatially illogical recordings of radiotelephony. In these videotapes the visual information leads and pushes the spoken narrative content through the time and space constructed by the video and audio relationships. The video image in these tapes is intentionally banal, unchanging and constant. Incongruous information is introduced through the audio. By substituting one acoustic environment for another, I accentuate my spoken narratives, which are theoretical constructions based on analogies (transportation to communication — the highway of cars and trucks becomes the information highway). In *TVideo* (1980), the only videotape where I perform on camera during this era, I speak directly to the camera, voicing my narrative in visual lip-sync, while I use incongruous acoustic environments (bus station sound in my kitchen, etc.), to both complement what I am saying ("when I'm home I feel like I'm on the bus"), but also to give structural integrity to my spoken words. The figure of the voice continues true to form in one space and time, while the ground, the environment, shifts from time to time, from space to space.

Still from Tom Sherman's *TVideo* (1980), colour video, 28 min.

Still from *Exclusive Memory*, the video performance, segment no. 19,
recorded by Tom Sherman at the Western Front, Vancouver, 1987.
Cameras and stereo audio by Kate Craig.

I continued to talk to video cameras throughout the 1980s, examining the space
between the technology and myself. As I've said many times, machines are the last good
listeners. There is no shame in admitting anything to a machine. In 1987 I made *Exclusive
Memory*, a work based on eighteen twenty-minute monologues (six hours of talking) to
video cameras. I decided to go public with three hours, leaving half the monologues on the
shelf (monologues remaining exclusive between the machine and I). In *Exclusive Memory*
I operated under the premise that the video cameras and microphones were the sensory
input of an artificially intelligent robot. This was a productive exercise, not only because I
could effectively anthropomorphize video/computer technology, but also because I ended up
treating my eventual human audience like a machine. Viewing this tape involved the audience
in some unusual role playing: literally becoming one with video and computer technology. This
construction yielded unexpected levels of intimacy. Instead of talking through the technology
to reach an audience, I was talking directly to the technology. The audience, by sitting in for
the technology, finds me unusually close. But because I'm treating them like a machine, I am
not too close for comfort.

In the 1990s I began working with composers of music, and working exclusively with
video and its ambient, sync-sound. I was interested in establishing point of view (and voice)
with the visual and spatial language of video, devoid of written or spoken word. I made tapes
with Jean Piché, the Montréal-based composer. I would cut video "scores," video compositions
without spoken words, and Piché would compose music to complete these video-music works.
In other words, we were not making music videos, but the inverse. In 1990 we released *Planes,
Spiders, and Motion Pictures at English Bay*, and *The Atlantic Twice Removed* in 1991. In Motion
Pictures . . . Piché used my voice as an "instrument," mixing my voice talking under his music,

establishing my presence and tone, and accentuating my camcorder-articulated "voice," but not permitting my words to surface and become foreground information. I found this collaboration with Piché extremely liberating. I loved just working visually again.

During this time I was writing theoretical texts, and enjoying communication and online publishing opportunities brought about by the development of the internet, and the world wide web. I had worked in radio over the years, and had always been attracted to the idea of making art exclusively with audio and acoustic information. There is something beautiful about creating spaces and images with sound. Spaces and images rendered perfectly in the mind's eye of the creative listener. Audio streaming on the web was knocking down doors, internet radio was exploding, and international, collaborative radio art was reaching significant audiences, especially in Europe. Heidi Grundmann, the producer/curator of *Kunstradio*, the remarkable radio art program of the ORF, the Austrian Broadcasting System, asked me to contribute my theoretical texts via spoken word to *Kunstradio*. I did a series of monologues on the effects of new media on artists, and society, for *Kunstradio*. The monologues needed a sonic environment, and sound signature. Heidi asked Bernhard Loibner, an Austrian composer, to work with my voice recordings, to give my monologues a musical signature. Loibner and I have been working together ever since, in radio, in live performance (as the duo, Nerve Theory), and most recently in video, and DVD.

Through my work with *Kunstradio*, I found myself collaborating with musicians and composers from all over Europe, operating with my voice as an instrument. Sometimes I would tell stories and inhabit the role of the lyricist. But a lot of times I would simply talk, contributing phrases in the time and space of the composition. Often I would contribute to networked, global compositions through my telephone. Working exclusively with voice in its sonic dimensions is liberating, especially after being confined by the logic-governed frame of camera-image and screen display. Audio, and its acoustic, spatial reality, is so beautifully wide-open and transrational. It is fascinating to witness a structured voice narrative, a string of linguistically coherent spoken words, as they are pushed around in a sonic field where beat tracks collide with walls of noise washing over musical tones and sounds literally running faster and slower at the same time.

Representational language and semantic meaning dissolve into abstraction differently in an exclusively sonic domain. Our conscious understanding of form in a sonic domain emerges from a deep well of perception and experience. A sonic field of events is hard to describe in our heads in the moments it is unfolding. Description is the basis of consciousness and memory, when our experience takes on a linguistic character. Concepts emerge from perceptual experience only when there is certain form or logic. For me, a person with a visual bias when gathering information, a purely sonic space is refreshing, intriguingly

non-hierarchical, difficult to get a sense of, and impossible to get back from enough to describe what is happening when it is happening. Someone once told me that the eye needs distance in order to be able to judge, while with sound, being closer is always better.

Throughout the 1990s I sought opportunities to work as an artist with audio exclusively. As I look back to my very early work, I was also making sound installations in darkened spaces back in the late 1960s and early 1970s. Working with video for the past thirty-plus years, a technology that evolved from audio tape recorders, and from day one has simultaneously recorded audio and visual information on the same medium (a polyester tape with metal oxide particles bound to its surface with a polyurethane-based binder), I always found it interesting (and irresistible) to pull the audio and visual components of video apart. Thus I worked with silent video, video with voiceover, unrelated (simultaneous) depictions of visual and acoustic space, rich audio over arid visual fields, and audio projected acoustically in installations to extend and distance itself from the video image confined to the screens of monitors or projectors.

This disassembly of the components of the video medium is consistent with the strategies of multimedia, where information is offered as a simultaneous field of often disparate, fragmented sensual triggers. Multimedia is usually thought of as a holistic approach to constructing a message or environment. We usually think of inclusion and immersion when describing the strategies of multimedia (and installation). But in fact multimedia displays engineer a disintegration of sensual perception. Audiences are put in the position of having to bridge the gaps between a fragmented display, being forced to navigate through a disorienting experience. The concept of voice is spotlighted in such an environment, whether it is a spoken voice, or text, or the clearly defined position of a microphone or a camera lens (show me, don't tell me . . .). The "voice" is the message of a fellow traveller, sort of like a guide, in an environment based on relatively high levels of uncertainty.

Toward the end of the 1990s and into the millennium's first decade, I did a series of live performances with Bernhard Loibner, under the name of Nerve Theory. *Shades of Catatonia* (1999) and *The Disconnection Machine* (2001) are good examples of this live performance work. We used silent video tracks like a clock. With *Shades of Catatonia* we used two video tracks projected side by side; with *The Disconnection Machine* (The DM) we used three. These silent video channels run the duration of our performances, providing a visual time-base, and transforming the architecture of the space we are working in. Our audiences are asked to link two or three streams of projected video, images that often seem incongruous or unrelated. Bernhard and I stand between the audience and these video projections. Bernhard works with his laptop, articulating a sonic environment that surrounds, exceeds the space defined by the video. Although his sound design is simultaneously an acoustic examination of the video

tracks and the actual space we are working in, our audience is comforted by their recognition of his contribution as being music. There is this dichotomy, where the video, images captured optically and electronically with a camera, is so explicit — but the sound and music (without recognizable sources or lyrics) are so abstract. I stand in the space with a microphone, and I talk, sometimes telling stories, sometimes describing the things happening in the video, sometimes addressing the audience.

After years of pulling the audio and video apart in recorded media, it is such a great experience just talking in the presence of an audience framed by sound and image separated by distance, both physically, and in terms of disassociation. We prefer being in the exact same light with the audience, so they can see us in our operations, and we can see them. It is important that they know we can see them. With Nerve Theory, Bernhard and I are creating an array of visual and acoustic information, co-operating with each other, and with the audience, to construct a field of information with plenty of room for interpretation. If anything, we are building a schematic context for perceptual reconstruction. We rehearse many times before we involve an audience in a work like *Shades* . . . or The DM. Bernhard comes to the performances with a set of audio files, and I know pretty much what I'm going to talk about. But during our performances we do share the space and time with the audience, and improvise and respond to, and weave in as much of the audience's vibe as we can into the performances.

For me, these performances are similar to making a work in video, but very different at the same time. First, let me state the similarities. Talking to a camera, and improvising with an audience in mind, involves the same level of attention to detail, and to the situation on a whole. When on camera, and issuing a monologue, the words spill out of the mouth, and there is the logocentric power of speech, the reality that speech is more direct and effective than the written word, even when a text is read out loud. With video performance to the camera, lip-sync amplifies the imperfections of speech off the top of the head. In the video frame, the smallest inconsistency is blown way out of proportion. It is a well-known fact that acting on video demands a subtlety of performance that would appear flat and lifeless on film. I love to play verbally within the intense space of a straight-to-camera video performance, but it does restrict the kind of work one can do.

Now let me spell out the differences between live performance for an audience, and a performance for a recording. Live, multimedia performances in the presence of an audience are situations where I'm having the experience of the performance, from the perspective of the audience, while I'm guiding the audience through the experience, through my performance. The spoken word, its character shaped by having a microphone in the presence of a performing musician, is certainly perceived differently in a live Nerve Theory

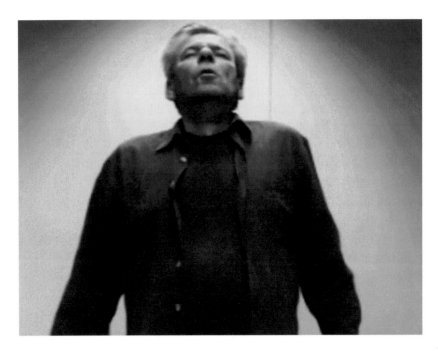

Still from Tom Sherman's fourth *Hyperventilation* performance, Syracuse, New York, 2011.
Documented in Sherman's *Hyperventilation 2011*, 2011, video, 9 min.

performance. My speech verges on singing, as Bernhard's music seduces the audience, and me, the straight-talking intermediary between the music, the multiple video tracks, and the audience. My voice must touch on the video tracks in terms of content, functioning like a voiceover in a recording (as in video, and television, and cinema), while it simultaneously surrenders to the influence of Bernhard's music. The voice must conform to the time and space of the music, and the video tracks. And the audience has its needs, its ideas . . . its presence. The audience demands a kind of "voice-under," reflecting its own tone of experience. My talking must somehow touch on the audience's unstated inner thoughts. I've also got to know when to completely get out of the way, when to stop talking so Bernhard can take over the role of the "voice-under" with his music.

When I describe our pre-structured live improvisations, we are making a space for us to incorporate the presence of the audience into our authoring processes. We prepare a "script" of multiple, silent video projections, and then fill the entire architecture with music, and talk. We construct a very particular, complex environment, and we build this environment for (and with) an audience. I'm watching the video tracks with the audience, talking about what I see, and stating what I think the audience would like to know, while I'm listening, and shaping my voice to become part of Bernhard's music. Bernhard is listening to me talk, mixing to coax and

push me, while everyone in the space, including him, is watching the video. He is describing the video, my voice, and the audience. We're incorporating the audience's presence into every single twist and turn. We leave a big space for the audience.

What an absolutely fantastic space for writing with the tongue, framed in "real time" by the explicit video images, and the audience's expectations for narrative, for story. What a time for the music to forge connections between the spoken word and the continuously advancing video tracks. And ultimately, what a perfect opportunity to saturate the audience with an all-pervasive acoustic totality, an overwhelming musical reality, that sweeps away a person's spoken words, and subverts the dominant power of relentless streams of video, to give the audience the strongest possible sense of its whole body, down to each individual living and breathing speck of flickering, introspective self-consciousness.

What an absolutely fantastic space for writing . . .

"The Appearance of Voice" was written in 2003 and published in Nicole Gingras, ed., *Sound in Contemporary Canadian Art* (Montréal: Éditions Artexte, 2004).

ARTISTS' BEHAVIOUR IN THE FIRST DECADE

Someone asked me what I thought of the idea of cultural citizenship.[11] The first thing I thought of was whether or not I belonged to a specific culture. I guess I could claim my birthright. If I were born and raised in a specific locale, I would have the right to participate culturally without inhibition, and hopefully with some sophistication, in the culture I was born into. If I inhabited that locale for a sustained length of time, my citizenship would undoubtedly be strengthened. If I decided to move or I was uprooted for some reason I would still carry the sensibility of my original culture forever.

If by chance I landed somewhere worthwhile and decided to invest in a new culture, I suppose I'd have to work harder than the locals to earn my new cultural citizenship. But I would already have an idea of what it's like to belong somewhere. I could apply my previous experience to my new context. I would be that much richer having two cultural identities. Eventually I would learn to blend my duality into something special. When I would travel the world I would have a choice of expressing the sensibilities of my first or second culture. Depending on my day to day position in transit, it would be interesting to see which citizenship made more sense in this place or that, with different kinds of people, or when I was alone in a foreign landscape. Even a couple of cultural citizenships can be confusing. Where would my allegiances lie?

In the first decade of the new millennium people are conflicted about a lot of things. Distances separate children from parents, workers from offices and co-workers, people from the landscapes they belong to. Everyone I know is networked in a profound way. The glue isn't a familiar place where everyone knows the rules and shares a water cooler or a whiteboard or a vegan menu. Telecommunications devices facilitate the connections that people make today. People connect through devices like telephones and computers, and speakers and screens, with the goal of eliminating the distance between each other.

11 Colin Mercer, *Towards Cultural Citizenship: Tools for Cultural Policy and Development* (Hedemora, Sweden: Bank of Sweden Tercentenary Foundation and Gidlunds Forlag, 2002).

Sure people still meet and press the flesh. Meeting people in person is great as long as you wash your hands frequently. There is still something to be said for a sense of smell and our rusty instincts. But in such unusually intimate circumstances people find it reassuring to be augmented by cameras, recording devices, and surrounded by all kinds of supplementary memory.

Flipping back to my thoughts on cultural citizenship, I suppose I have an opinion on such an abstract, slippery concept because I'm an artist. Artists are usually oblivious to the fact that they are out of their depth. Artists are very comfortable with the notion of cultural environments because they are obsessive, compulsive consumers of information. My eyes bleed and ears ring every third day. I'm a voyeur and I can't get enough of the things people say, and the way they dress and act and display their relationships with machines. That's my particular fetish: person-machine relationships.

As an artist, as a general rule, I never trust a sociologist,[12] or anyone who poses as one. I buy into the idea of cultural citizenship because as an artist I contribute to the cultures I am living in through my work. I'll even go so far as to claim special status as I participate far more than the average citizen. I take pride in my work, although most of the people who appreciate my efforts do so from a distance. I meet almost total indifference in my immediate physical environment. In fact, when I display my work locally it seems to make my associates very uncomfortable. They pretend I don't exist. Sometimes I'm happy to hear that most theorists agree that the meat body is disappearing in the digital age. I'm certainly uncomfortable in mine when people don't know how to respond to the things I make. Thankfully I'm networked to a string of kindred spirits residing in other jurisdictions.

I think the root of this indifference bordering on hostility has to do with my inability to accept thanks or the gift of art in return. I'm learning how to give and receive art, but I've been conditioned by the culture at large to be competitive. As an artist I go to great lengths to try to give back to a culture that steadfastly refuses my gifts. I vomit in the face of a culture dominated by industrial crap: the waves of violent, titillating cinema; the wasteland of totally banal formulaic music; the blanket of broadcast propaganda, state-issued or private. Our media environment is structured as a one-way, top-down, irreversible flow of manufactured instruction sets on how to act and look and feel and consume. Our radio, television and newspapers invite our response, our participation in call-in, talkback forums, or letters to the editor, or through text messaging or audience polls via the World Wide Web. This formal reversibility of the media, the apparent "interactivity" of the culture, couched as

12 Art and Language [Art & Language]: an English group of conceptual artists founded in 1968 by Terry Atkinson, Michael Baldwin, David Bainbridge, and Harold Hurrell. In May 1969, they established the journal *Art–Language*, and began issuing multiples in various media, including a phonograph record, where one of them issued the warning: "never trust a sociologist."

a utopian fantasy of true reciprocity, is nothing more than a repeated exercise in controlled feedback, a spectacle of cybernetic manipulation. The power always resides with the one who can give and cannot be repaid.[13]

But surely we can vote with our dollars, our consumer power, or ultimately through our indifference. After our letters to the editor are rejected or our calls put on hold — after our submissions by email are acknowledged by avalanches of spam — we tend to pull back and withdraw. Who needs the rejection and subsequent harassment? Everyone knows the only feedback the media will accept is that which demonstrates obedience. Talk back to the media critically and you will face public humiliation. The audience is thus trained to accept a culture designed to be received by a polite, compliant populous conditioned to accept programming determined by the lowest common denominator. Pabulum for the pabulum eaters.[14]

As an artist I am left stranded with all those rejected by the predominant culture. Misery loves company. There are a great number of us. I understand that power always resides with those who can give and cannot be repaid, and admit that I am suspicious when people identify with and tell me they appreciate my work. My first instinct is to mistrust and reject positive feedback. If people can identify with and embrace what I'm doing, I fear it must be too close to standard fare. It is hard to be a good citizen when one is locked in such a double bind. I beg for attention and space in the culture, and yet when I get some respect I tend to want to bite the hand that feeds me.[15] This double bind used to inevitably shorten my relationships with curators and producers, but since I've shifted my work from objects and installations and the kind of things that make sense in relation to bricks-and-mortar architecture, institutions like museums and galleries have stopped being interested. I have made concept-based video and audio and performance art for over thirty years.

13 Jean Baudrillard, in response to Hans Magnus Enzensberger's "Constituents of a Theory of the Media," a discussion of a concept that might be called interaction. See Hans Magnus Enzensberger, "Constituents of a Theory of the Media," *New Left Review*, 64 (Nov/Dec 1970): 13–16. Reprinted in *The Consciousness Industry*, trans. Stuart Hood (New York: Seabury Press, 1974); and Jean Baudrillard, *For a Critique of the Political Economy of the Sign*, trans. Charles Levin (Saint Louis, MO: Telos Press, 1981), 164–84. From the French *Pour une critique de l'économie politique du signe* (Paris: Gallimard, 1972). Baudrillard states: "On a more practical level, the media are quite aware how to set up formal 'reversibility' of circuits (letters to the editor, phone-in programs, polls, etc.), without conceding any response or abandoning in any way the discrimination of roles. This is the social and political form of feedback. Thus Enzensberger's 'dialectization' of communication is oddly related to cybernetic regulation. Ultimately, he is the victim, though in a more subtle fashion, of the ideological model we have been discussing."

14 This phrase was issued by the group General Idea (AA Bronson, Felix Partz, Jorge Zontal) in the 1970s. I don't know where they picked it up, but it was used to describe a culture based on the lowest common denominator. Source: AA Bronson, "Pablum for the Pablum Eaters," in *Video by Artists*, ed. Peggy Gale (Toronto: Art Metropole, 1976), 196–200.

15 *Cultural Engineering* was the title of a solo exhibition of my video and text-based installations at the National Gallery of Canada, Ottawa, May 19–July 10, 1983. *Cultural Engineering* was an existential portrait of the artist (Tom Sherman) as product of the combined cultural policy of the federal government of Canada. The exhibition featured a series of photo/text works featuring configurations of the logos of Canadian agencies in 1983: the National Film Board, the Canada Council, the Canadian Broadcasting Corporation, the Science Council of Canada, and the Department of Communication (the split-Canadian flag logo covered many additional departments).

I have found institutions, most of the museums and galleries and broadcast media, to be dreadfully slow to evolve. I used to be ahead of my time. Now I'm smack dab in the middle of a burgeoning media culture supported by a decentralized infrastructure of networked personal computers. These computers are connecting people through opportunities to exchange art. Sometimes the screens are big. Sometimes they're small. Opportunities to display to audiences are suddenly everywhere. I'm finding it a lot easier to give and receive in this new environment.

Let me describe the media-saturated world I'm living in. First, let me say I hesitate to use the phrase "new media" because it is a business term being used deviously to extend the reach of converging broadcast, publishing, communications, and security industries into our communities, our homes, and our personal gear. Saturation is the name of the game. There are only so many hours in the day. The "new media" bridge the gaps between movies, live performances, and recordings while in transit. Content is diluted so everything can be overlapped. We surf the web while we talk on the phone. We listen to recorded music while we converse over ambient television. If we're not talking, we're doing something else with our mouths, like eating or drinking or smoking. Talking across distances is very popular. Talking while doing something else is as big as it gets. The more things we can do at the same time the better. High-density overlaps are a generational thing. Multi-tasking is the primary skill set of youth.

Camcorders, notebooks, downloading players, and personal digital assistants help us manage our information flow. All of these devices are getting smarter and have even begun "talking" to each other. People are getting so stressed out managing their personal information; they have to take a break from time to time. Video games offer an escape. Video games are immersive. They demand our complete attention. That's the limiting factor with the interactive forms; you can't do anything else at the same time. Camcorders are different. They transform live experience into opportunities for documentation. Your immediate world is cloned in real time, appearing in the camcorder's LCD screen while it is being recorded. We can save our experiences for later on. With our computers we can organize our recordings, mixing and matching downloads and streams, and shuffling files to make something new out of ordinary experience. When you double your experience, you can end up with a lot of unmanageable time. These information appliances are turning us into very stylish librarians![16]

Today's personal media environment is the hot turf of contemporary art. The idea of the pro-sumer, the complete synthesis of the producer and consumer of information, fostered by Japanese consumer technology firms in the 1980s, is now fully realized. Well-equipped individuals are producing and moving information around at unprecedented rates. Artists are bypassing anachronistic institutions such as museums, galleries, broadcasters and publishers.

16 For a full description of the contemporary media environment, see Tom Sherman, *Before and After the I-Bomb: An Artist in the Information Environment*, ed. Peggy Gale (Banff, AB: Banff Centre Press, 2002).

Individual artists manage to compress pre-production (research), production, distribution, and exhibition, once discrete and specialized time-consuming functions, into the same week. Middlemen and middlewomen everywhere are being cut out of the loop. Artists are aligning themselves strategically into co-operative groups. Co-operation replaces collaboration in an effort to conserve and enhance personal autonomy. Playing in parallel beats compromise.

There is little money involved at ground zero in the twenty-first century information economy. The rush is in the open exchange of information. Art, like science before it, is now functioning as a gift economy.[17] One's status among peers is based on giving away things that are useful to the community. Science has been a gift economy of ideas for a long time. Scientists give papers and openly share research findings, hoping to make significant, lasting contributions with their "gifts." The scientist who contributes the most to his or her field is held in the highest esteem. Scientists have been able to sustain their gift economy because institutions like universities and research institutes have supported them.

Artists have been supported by different kinds of institutions. Museums, galleries, and publishers commodify art by being selective and exclusive. There is a collective, open-source mission in every art scene, but these institutions force so much redundant, unattractive, competitive behaviour. Arts councils have been better at supporting art as a gift economy. Governments have tended to spread their funding across a wider spectrum of activity, mainly because public officials tend to get in trouble when they interfere with businesses trying to make a buck. The number of practicing artists has exploded over the past three decades, and the proliferation of digital media art (video, photography, animation, interactive installation, net.art) has increased the volume and circulation of contemporary art to a whole other level. Institutions still trying to function as gatekeepers are moving too slowly and will never catch up with the excellent work swirling through regional and international gift economies.[18]

Universities have been busy credentialing artists with MFA degrees and most recently through PhD studio/theory programs. The art gift economy is now composed of a mix of university-based artists and independent, institutionally unaffiliated artists working day jobs as designers, technicians, computer programmers, cooks, waiters, carpenters, models, etcetera, etcetera. Young artists have always done whatever they needed to do to support their art habit. Digital media art scenes are transgenerational. The unknown mingle freely with the notorious. What you've done in the past doesn't matter as much as what you're doing now. The technology and media are ubiquitous and inclusive. International work is freely exchanged in shows, screenings, and festivals. Local scenes make use of artist-run spaces, ad hoc-quick hit galleries, vacant storefronts, music clubs, community centres, cafés, restaurants and bars

17 Lewis Hyde, *The Gift: The Erotic Life of Property* (New York: Vintage Books, 1983).
18 Tom Sherman, "Museums of Tomorrow," in *Parachute* (Montréal), no. 46 (March, April, May, 1987).

(any "third place" between work and home). Online shows link any variety of third places with homes, libraries, schools, and wireless laptops.

Despite the efforts of universities, museums, and publishers to privilege a select group of professional artists, in fact the speed of change and complexity of activity in the digital media arts sector is having a levelling effect on all active participants. Reputations are hard to maintain when the technology is evolving quickly and the territories and jurisdictions are fluctuating between popular culture, underground art, technosocialism and the expansive hybridity of recombinant aesthetics. Cultural citizenship today must be established through local commitment and presence, along with simultaneous international initiatives and recognition abroad, technical competency, increasingly refined media literacy, punctuated by occasional successes in expanding audience by crossing-over into the spotlight of pop culture.

A university education will definitely help one stay afloat in such a complex world, but degrees in themselves will not ensure professional status. Everything rests with accomplishment in the arts, and with the digital media arts you are only as good as your latest work. Media art history is sketchy and poorly known. The DIY culture holds the sophisticated amateur in the highest esteem. As sexy trends and the sheer velocity of change undermine the notion of professionalism, young artists emerge very quickly, self-taught, self-promoted, self-screened, and self-streamed. Information on how to be a digital media artist is abundant. The tools of the trade are everywhere. Is it really possible to be a folk artist in the information age?

This elevation of the amateur and the devaluation of professional status are in line with relentless attacks on the elitist status quo launched repeatedly by the avant-garde throughout the twentieth century. Marcel Duchamp's initial attack on retinal art, Dada's spirited critique of the bourgeoisie, the ridicule of abstract painting by the nouveaux réalistes, the anti-establishment message of Fluxus, and conceptual art's assault on object-based art have taken their toll on the status of the individual creative genius and the institutions that perpetuate this myth. Andy Warhol and Joseph Beuys, extremely prominent artists in the 1960s, both proclaimed that everyone is an artist and that anything can be art. Warhol went so far as to state that he wished he was a machine (and not an artist). Beuys, in his sermons on social responsibility, said everyone, in all walks of life, was obliged to be creative. Art could no longer be separate from life. This rhetorical bravado signalled the dawn of a postmodern chaos that has now spanned five decades and shows no sign of abating. Artists have enthusiastically embraced this black hole of freedom (absolutely anything goes) and have recently dumped the whole delicious mess into a transcontinental blender called the digital revolution. Total fragmentation doesn't begin to describe the current state of affairs.

To close I would like to touch on the idea of cultural citizenship in this era when institutional, economic and aesthetic order in the arts continues to collapse. Artists will lead their societies into a future where the consumption of art and culture is balanced with real creative output by a majority (not a minority) of its citizens. Artists will be respected as skilled managers of information, not individual creative geniuses, and art will be seen and valued as information. Artists will no longer be defined by medium or discipline. They will work with media appropriate to the task at hand. Practically everyone works with a computer these days. When the problems or opportunities call for different technologies or media, artists will adapt and alter their approach accordingly. National borders will continue to fade, but exact geophysical positions will be as crucial as dates and times in defining point of view and intent. GPS, global positioning systems, and GIS, geographic information systems, will anchor psychological, social and spiritual exposures physically and statistically. Artists will continue to think locally and globally. Regionalism will be redefined as microregionalism. Contemporary art history will be tracked like the weather is today, by information scientists, using computer models to predict the near future. Museums, galleries, publishers and broadcasters will keep trying to ride out the storms.

The gap between personal and industrial culture will continue to widen. Corporate and government media will hammer away at social and psychological anomalies, attempting to control perception and ideology cybernetically.[19] Artists, in the broadest sense of the profession, will respond with combinatorial play, playing in parallel, improvising with recombinant strategies. Power will reside with the one who gives and receives in equal measure. Initially these human "transceivers" will be heavily mediated, simulated and virtual, but registered and tracked by microregion. Security issues will slow real social change. Mediated behaviour can be tagged with less risk. The psychologists, sociologists and economists will get their data. Corporations and governments will attempt to maintain their gag orders on artists through the enforcement of copyright law. Gordon B. Thompson, the renowned engineer and theorist at Bell-Northern Research, once told me "copyright is theft."[20] He knew that intellectual property law would be used to sew up the media environment, restricting the two-way flow of information by preventing reciprocity of manipulation (i.e., talking back to the media using the actual media environment as the subject and substance of discourse). Consumer rights advocates ultimately defending the rights to personal autonomy, free speech, and privacy will protect the personal media domain.

19 Tom Sherman, "Artificial Perception as Reality Check: Thinking about MIT's Tangible Bits," in *Horizon Zero* no. 3 (Banff, AB: Invent, 2002), horizonzero.ca/textsite/invent.php?is=3&art=0&file=14&tlang=0, (site discontinued).

20 Gordon B. Thompson, "Memo from Mercury: Information Technology is Different" (Montréal: Institute for Research on Public Policy, Occasional Paper #10, June 1979). Besides being a senior engineer at Bell-Northern Research, Gordon B. Thompson speculated in music copyrights. Having discovered that the rights of the Canadian national anthem had lapsed and were available, he purchased them. He then informed the federal government of Canada that they were violating his copyright. After making his point, Thompson sold the anthem's original score (back) to the Government of Canada for one dollar.

Collage, in visual art, and montage in cinema, set the stage for sampling and the remix in music. Video, the supreme reproductive technology of the twentieth century, has been incorporated into the twenty-first century's maturing digital media forms whose principle advantage is endless reproducibility without loss of quality. Digital, non-linear editing has engineered the increasing use of repeat structures in audio and video. "Phrases" of images and sound are recombined to establish the form and substance of video compositions. The analogies for all digital media are minimalist musical structures, or more profoundly genetic recombination, where the building blocks of DNA are reassembled in seemingly endless combinations to yield the diversity of life. The recombinant aesthetic strategy is environmentally friendly in that it permits the recycling of used mediated content into fresh new permutations of message.[21] The finished work of art is a thing of the past.[22]

Artists' behaviour in the first decade of the twenty-first century is characterized by a desire to interact in tight local communities, rubbing shoulders through exchanges in gift economies, in two-way, back-and-forth exchanges, whether these exposures are comfortable or not.[23] The analogy of collective, open-source programming is transformed into a prescription for social change. These exposures, live and mediated in degrees, or mediated across distances through networks, will be most effective in the long run if registered by microregional origins (GPS, GIS data: exact time and place). Tracking and measuring the volume and describing the nature of the flow will yield important insights into the psychology and behaviour of artists. The practice of recombinant aesthetics will permit a direct, critical discourse with a toxic industrial media culture, and foster a healthy disregard for corporations and governments attempting to repress this discourse.

The concept of cultural citizenship will only be useful if the public understands and embraces it. The first question artists will ask is whether or not they belong to a specific culture. Time and place, in this era of dematerialization, dislocation, and alienation, are extremely important. Being able to get and keep one's hands on the actual substance of the media environment, to probe, reconfigure, and cleanse the ether of this place, is crucial.

"Artists' Behaviour in the First Decade" was written in November 2003 and published in Caroline Andrew, Monica Gattinger, M. Sharon Jeannotte, and Will Straw, eds., *Accounting for Culture: Thinking Through Cultural Citizenship* (Ottawa: University of Ottawa Press, 2005).

21 Tom Sherman, "An Addiction to Memory [and the Desire to Annihilate Images]," in *Noema Lab, Tecnologia e società* (Universita di Bologna, Italy, 2002), noemalab.com/sections/ideas/ideas_articles/sherman_memory.html (site discontinued).
22 Tom Sherman, "The Finished Work of Art is a Thing of the Past," in *C Magazine*, no. 45 (Spring 1995); and as "L'œuvre d'art 'achevée' est un concept du passé," in *Où va l'histoire de l'art contemporain?* (L'Image et l'École nationale superieure des beaux-arts de Paris, 1997).
23 Cary Peppermint, a performance artist, calls his performances (and web-based photo/text works) "exposures," a compression of the idea of personal, psychological disclosures with the act of exposing photographic film to the light of day.

RARE SPECIES ARE COMMON

Every day, in the early afternoon, I like to take a walk down the beach, to get a little exercise and to see if there are birds migrating through the area. At the end of the summer we normally have quite a few semipalmated plovers migrating through, feeding right at the edge of the water, and this year is no exception. These plovers move with great agility, tight-roping along the undulating shoreline, with their skinny little legs laying down a sewing machine–tight rhythm while their bodies court the water's edge with the abdominal control of a step dancer. Their bodies are propelled along without the slightest wiggle. Their upper body control is amazing. There are maybe thirty or forty semipalmated plovers on the beach at any one time, in two groups, one large bevy halfway down the beach, the other smaller group at the very end of the beach at the river. These bevies are mixed with a handful of sanderlings. You have to get right on top of them to pick out the sanderlings, as they mix in beautifully. If you look closely you'll see they run along the edge of the surf a little differently, they wobble a little in the tail-end as they peck at the wet sand with a greater urgency than the plovers. I suppose they're all feeding on sand fleas, but you can't see the fleas except at low tide when there is a big hatch at the end of the afternoon, and they're big and fat and white and hopping around like crazy.

As the semipalmated plovers, sanderlings, and other mixed shorebirds are crowded by beachcombers looking for shells or walking and talking or jogging, they take flight and circle back in a tight formation low to the surface of the water in perfect 180-degree arcs delivering the flock back to a stretch of shore without people, where they pull up and land with light feet and resume feeding immediately. They are not skittish but have a business-like way of avoiding people when they're preoccupied with feeding. They feed constantly, all day, every day. At the end of the afternoon the plovers stand perfectly still, often on one leg, near clumps of dark, dead seaweed at the end of the beach. They blend in and it's easy to walk right by them without noticing them. They become part of the inanimate landscape. They disappear.

There were just a few piping plovers this year, three adults for a few days, no nesting pairs. There were no signs of any willets. Perhaps the fox that wiped out the piping plovers

got the willet eggs as well? Ground nesters don't have a hope in hell when there are fox in the neighbourhood.

There are only a few herring gulls on any given afternoon. There's been plenty over the years, but now there's just a few. There's a lot of crab this year, and the gulls are having an easy time finding a wild meal of crab and sea urchin at the first low tide. Despite their good fortune in the seafood department they're never too full to steal a bag of chips from a beach blanket as soon as the people head out into the ocean for a swim.

There are always a few crows around. They stick to the back-beach, or the sand at the edge of the high grass. They also frequent the clam-flats at the base of the lagoon. The crows and herring gulls can be seen hanging out together on the clam-flats at low tide.

I haven't seen or heard any kingfishers this summer. When they're around you usually hear their rattle-like call when they are in flight. But there has been a lone osprey circling the sky out over the ocean off the mouth of the river, and that's the first fish hawk we've had around these parts in probably five years.

When I think of it there are a few members of a number of species that dot the beach. From year to year these species may or may not be represented. Hopefully the missing species will reappear, although from what I hear it is unlikely the piping plover will return to nest in our lifetime. My wife, Jan, told me she once had a professor at Syracuse University who used to frequently say, "Rare species are common and common species are rare." The professor's name was Sam McNaughton, and he was a professor of biology. He specialized in grassland ecosystems and the ecology of large mammalian herbivores in the Serengeti National Park in Tanzania. Professor McNaughton was a pioneer in ecological studies, and he was stating a key ecological paradigm that points out that considerable diversity is needed to support nature's biggest success stories, and that large populations of any species in any given place are rare. The big success story on our beach this summer is that the semipalmated plovers are migrating through in decent numbers. This is a modest success story, but when you think about it we generally dislike very successful, common species like crows, seagulls, pigeons, and sparrows, whereas we are thrilled to see a rare bird. It is hard to appreciate any species' success when it becomes too common and its hoards are literally shitting all over everyone and everything. Think of what it must be like to be another species and to be crowded out by that success story of success stories, that extremely common mammal, the human being.

Rare species are common and common species are rare. For every big, high-profiled success, there are hundreds of thousands, maybe millions of little stories that comprise an

environment stable and rich enough to sustain rare outbreaks of humongous commonality. To make a cultural analogy, for every blockbuster motion picture that eats up thousands of peoples' lives through its life cycle of script development, pre-production, production, post-production, distribution, theatrical exhibition, and finally the prolonged exploitation of rental and television and foreign markets, there are hundreds of thousands of low and no-budget films and videos that involve relatively few people in tiny, by comparison, concentrations and expenditures of resources. The big studios on the top of the food chain expend hundreds of millions of dollars in the hope of sucking half a billion in profits out of the entertainment sector of the global economy. Think of the time and money burned by the purveyors of, and audiences for, these cultural tsunamis. Cities compete with tax breaks and skilled labour pools, hoping to be scorched by these flame-throwers of quick cash. When a movie is in production, money is poured into a chosen city at obscenely high volume in short bursts. All the merchants benefit, although a stable, diverse urban economy is temporarily disrupted and sometimes altered for long periods of time. Audiences everywhere are then bilked of their pocket money in an effort to recoup the costs. Massive advertising campaigns generate desire, usually through sex and violence and/or escapist humour. The peer pressure for common experience is almost impossible to resist. When all is said and done, audiences are only too happy to stand in line to be part of something so common and rare as the blockbuster hit. It is human nature to choose to associate with the big successes. As a species we are thrilled to be part of a big crowd, the almost unnaturally large congregations of human commonality.

Think of the time and energy and talent each blockbuster devours. They're not called blockbusters for nothing. These explosions of "productivity" consume the efforts of thousands of people, locking them in the mission of creating a cultural artifact that simply appeals to the broadest possible audience. Thankfully common species are rare and only a few blockbuster hits are possible every season. The impact of a blockbuster is devastating. Not only is there zero time and scant resources left for making different kinds of statements in film and video after a blockbuster rips through town, but even more tragically the audience far beyond this scorched earth is once again conditioned into thinking that experiencing mediocrity on a grand scale is important and enjoyable. Cultural success based on the lowest common denominator results in a totally compromised, dumbed-down culture that engineers a taste and hunger for widely shared stupidity. Is it any wonder that audiences conditioned to embrace the "big common" find intelligent, anomalous culture offensive and pretentious? Audiences brainwashed by industrial culture do not appreciate the rare attempts to reflect intelligence in the media. In fact, audiences groomed by industrial culture are indifferent, if not hostile toward the efforts of individuals operating on their own. Amateurism is just what it is. It's not slick. It's not professional. It doesn't draw big audiences. Amateurism is, in its own way, common.

Rare species are common. Not everyone is eccentric, but if we would study any cross-section of people carefully, we would find there is diversity in the multitudes. If we would look hard enough, we will find there are people making film and video that doesn't aspire to emulate the mainstream, hit-based, industrial culture. I wouldn't call these people "independents," because independent producers generally emulate the formulae of the mainstream. They are trying to produce movies that attract and satisfy large audiences. So-called independents may be operating at a disadvantage in terms of resources (they operate with relatively poor budgets, employing unknown actors and unemployed technicians who will work on spec), but they target the common audience, designing their mediated narratives to exploit the industrially conditioned mindset.

Further outside the independent sensibility, we will find individuals and groups working to satisfy the needs of microcultures, pockets of small audiences looking for a reflection of their identities. For instance there is a movement called handmade film. People are using 8mm and Super 8 cameras and even pinhole cameras to expose film, and then developing their own film stock, splashing bleach and acids on raw celluloid in sinks and bathtubs, in order to come up with rich, highly textured, abstract, experimental, personal films. The results are primitive but successful in developing a small, tribal audience. Video is being used by all kinds of subcultures. Skateboarders document their tricks with digital camcorders. Skater video has its own conventions of extreme motion capture. Video is also being mixed and blended by computer in live improvisations by VJs, video disk jockeys, in clubs and art spaces. Movies and television are being chopped up and superimposed and recombined with computer graphics and animated film into streams of data and energy that merge effectively with techno and trance music. This is an example of recombinant culture. Digital technologies take collage and montage into hyper-bricolage.

The scope and range of the personal and niche media culture is remarkable. There are thousands of small scenes across all continents where projectors display film and video to audiences of twenty, thirty, fifty, or a hundred people at a time. The audiences are aggregate, in that these scenes are inclusive forums for being different. These small, vital, local audiences know and love (and hate) what they see. These are authentic, edgy scenes defined by raw, often problematic displays of media. The media has character and presents unbalanced, oftentimes imperfect and offensive arguments. The street is full of hot, problematic conversations, not governed by slick, predictable public addresses. Control of these small scenes is under contention night after night after night, video after film after video, as each screening unfolds. The work in film and video impacts the audience directly at the moment of experience. Meaning is not predetermined by advertising or other forms of pre-publicity. In these small media scenes your film or video work must speak for itself during the moments it commands the screen. Individuals and groups author media in their

own languages and dialects. They tell their own stories. They share their singular point of view. The rare message is common. This kind of a scene breeds incoherency and contention. These scenes have edge and their audiences continuously break up and stay small. The messages keep on coming, relentlessly reinforcing competing microcultures, building and reforming group identities, highlighting individual voice. The rare species is common.

One day last week, I was pleased to see a great blue heron flying over the dunes running the length of the beach. The heron's wings were beating slowly, methodically, but the big bird was gliding at an unusually good clip due to a pretty stiff tailwind. There haven't been many herons this year. Usually the lagoon is home to three or four herons at a time, but this year I've seen only one, and mostly on the rocks on the ocean-side of the beach.

There have been a number of spiders on the beach at low tide. I don't remember ever seeing this species. They are a large spider, as big as a Canadian two-dollar coin. They have a range of earth-colours marking their bodies and legs: earthy reds and browns and tans. When you stop to look down at them they walk toward you like they are hoping to climb up your legs to escape from the sea. They move toward vertical figures for obvious reasons. When you back away, they stand absolutely still and blend into the colour of the sand. I always think they will make a nice meal for any bird that comes along, but the shorebirds, the plovers and sanderlings, wouldn't know what to do with a morsel this size, and the crows don't usually come down to the wet sand this close to the water. They're very shy of people and prefer to hunt for food back in the dunes or up in the dry sand by the high grass.

Jan and I did get a kick out of a young raven that was walking its silly, geeky walk and alternately hopping with its wings partly open along the shoreline one day. The baby ravens haven't developed a fear of people, because the people in our village have been feeding them stale bread and other forms of organic garbage (they'll eat anything), so they're not shy yet like the crows. We saw this young raven walking along pecking at and ingesting small pieces of shells and maybe the odd insect on the shoreline. This bird was having such a wonderful time at the beach. His walk was so funny and he seemed so proud of himself, collecting shells and sharing the beach with the humans. Jan and I shared a joke about the raven going home to tell his family about this wonderful place called the beach.

The cormorants have been very busy diving for fish about fifty metres off shore. There must be herring running as the cormorant are concentrated in groups of seven or eight, fishing in a frenzy. Most of the time I'll notice them flying upriver toward the ocean. Their flight is a no-nonsense, determined flight at one speed as frantic wing movement propels the long-necked bird to its next patch of water. Cormorants give me the feeling that they fly out of necessity, but it isn't really their thing. Diving and swimming underwater is their forte.

I usually hear the Arctic terns before I spot them. Their high-pitched chatter cuts right through the wind and the white noise of the sea. Terns are the ultimate flyers. They command the sky with their speed and agility as they climb and swoop and flutter and dive. Terns look completely out of their element on the ground. Their legs are too short and their wings don't fold up easily.

Early one evening we spotted a nighthawk swooping and looping through the air over the dunes, feeding on airborne insects. It struck me how similar the nighthawk's flight is to that of the tern, but they are dark and a little heavier in the air. In minutes there were half a dozen nighthawks, then ten, as they always move across the cooling earth in loosely organized feeding flocks. Nighthawks maraud at dusk, where terns knife through the bright of daylight.

There are various sparrows and assorted small songbirds throughout the brush lining the back-beach road. I tend not to pay too much attention to the little brown birds. It is hard to tell them apart. All I know is they are numerous and have beautiful songs. Sparrows do not seem as abundant in the country as they do in the city, where they are remarkably, obnoxiously common, like the crows, pigeons, and seagulls.

This summer's survey of the beach wouldn't be complete without mentioning a crazy little black bird with a long narrow tail that seemed to be flying erratically along the edge of the grass at the top of the beach. This delicate little black bird seemed to be learning to fly for weeks at a time, launching itself into half-loops and crashing repeatedly into the sand. It would hug the grass with its flight and occasionally make some quick progress down the beach in a beeline, straight-arrow-low over the sand, but then it would crash land, and flip back up into a looping pattern like it was attacking the grass or trying to shake off a bug or something. It all seemed like it was hallucinating or maybe it was simply a casualty of misaligned tail feathers. I never got a close look at it, as it always seemed to be flopping around in the background behind someone I was talking to. It disappeared by the time August rolled around.

And finally there are the horseflies. We normally have green-eyed flies, I think they are called deerflies, that bite and generally torment us when we're down by the river. In late August, these green-eyed flies disappear, only to be replaced by giant, black horseflies. Once they get your scent they'll follow you all the way down the beach, and if you don't watch it, they'll land and after a few seconds they'll bite. We just let them land and then smack them and then we give them a heel-twist into the sand for good measure. When we're swimming in the ocean they'll come right out for us in the water. They'll land on your back or in your hair and the only way to escape is to duck under.

There is a range of behaviour in each species that is governed by the time of day or season, or by opportunities for feeding or threats of danger. Environments and local conditions govern behaviour, although individuals are different in all species. Common species, like the constant and robust presence of migrating semipalmated plovers this summer, are rare. Rare species, like the small numbers of all the other species dotting the beach this summer, are common. I also made note of the missing species with the hope that they'll return next year or sometime soon after that. All the members of all the species mentioned seem to have great appetites. Come to think of it, wild creatures always have great appetites. Eating disorders in nature are very uncommon.

Previously unpublished, "Rare Species Are Common" was written in summer 2005 on the South Shore of Nova Scotia.

VERNACULAR VIDEO

Video as a technology is a little over forty years old. It is an offshoot of television, developed in the 1930s and a technology that has been in our homes for sixty years. Television began as a centralized, one-to-many broadcast medium. Television's centrality was splintered as cable and satellite distribution systems and vertical, specialized programming sources fragmented television's audience. As video technology spun off from television, the mission was clearly one of complete decentralization. Forty years later, video technology is everywhere. Video is now a medium unto itself, a completely decentralized digital, electronic audio-visual technology of tremendous utility and power. Video gear is portable, increasingly impressive in its performance, and it still packs the wallop of instant replay. As Marshall McLuhan said, the instant replay was the greatest invention of the twentieth century.

Video in 2008 is not the exclusive medium of technicians or specialists or journalists or artists — it is the people's medium. The potential of video as a decentralized communications tool for the masses has been realized, and the twenty-first century will be remembered as the video age. Surveillance and counter-surveillance aside, video is the vernacular form of the era — it is the common and everyday way that people communicate. Video is the way people place themselves at events and describe what happened. In existential terms, video has become every person's POV (point of view). It is an instrument for framing existence and identity.

There are currently camcorders in 20 per cent of households in North America. As digital still cameras and camera-phones are engineered to shoot better video, video will become completely ubiquitous. People have stories to tell, and images and sounds to capture in video. Television journalism is far too narrow in its perspective. We desperately need more POVs. Webcams and videophones, video-blogs (vlogs) and video-podcasting will fuel a twenty-first-century tidal wave of vernacular video.

WHAT ARE THE CURRENT CHARACTERISTICS OF VERNACULAR VIDEO?

Displayed recordings will continue to diminish in duration, as television time, compressed by the demands of advertising, has socially engineered shorter and shorter attention spans. Videophone transmissions, initially limited by bandwidth, will radically shorten video clips. The use of canned music will prevail. Look at advertising. Short, efficient messages, post-conceptual campaigns, are sold on the back of hit music. Recombinant work will be more and more common. Sampling and the repeat structures of pop music will be emulated in the repetitive "deconstruction" of popular culture. Collage, montage and the quick-and-dirty efficiency of recombinant forms are driven by the romantic, Robin Hood–like efforts of the copyleft movement. Real-time, on-the-fly voiceovers will replace scripted narratives. Personal, on-site journalism and video diaries will proliferate. On-screen text will be visually dynamic, but semantically crude. Language will be altered quickly through misuse and slippage. People will say things like "I work in several mediums [*sic*]." "Media" is plural. "Medium" is singular. What's next: "I am a multi-mediums artist"? Will someone introduce spell-check to video text generators? Crude animation will be mixed with crude behaviour. Slick animation takes time and money. Crude is cool, as opposed to slick. Slow motion and accelerated image streams will be overused, ironically breaking the real-time-and-space edge of straight, unaltered video. Digital effects will be used to glue disconnected scenes together; paint programs and negative filters will be used to denote psychological terrain. Notions of the sub- or unconscious will be objectified and obscured as "quick and dirty" surrealism dominates the "creative use" of video. Travelogues will prosper, as road "films" and video tourism proliferate. Have palm-corder will travel. Extreme sports, sex, self-mutilation and drug overdoses will mix with disaster culture; terrorist attacks, plane crashes, hurricanes and tornadoes will be translated into mediated horror through vernacular video.

FROM AVANT-GARDE TO REAR GUARD

Meanwhile, in the face of the phenomena of vernacular video, institutionally sanctioned video art necessarily attaches itself even more firmly to traditional visual art media and cinematic history. Video art distinguishes itself from the broader media culture by its predictable associations with visual art history (sculpture, painting, photography) and cinematic history (slo-mo distortions of cinematic classics, endless homages to Eisenstein and Brakhage, etc.).

Video art continues to turn its back on its potential as a communications medium, ignoring its cybernetic strengths (video alters behaviour and steers social movement through feedback). Video artists, seeking institutional support and professional status, will continue to be retrospective and conservative. Video installations provide museums with the window-dressing of contemporary media art. Video art that emulates the strategies of traditional media — video sculpture and installations or video painting — reinforces the value of an

institution's collection, its material manifestation of history. Video art as limited edition or unique physical object does not challenge the museum's raison d'être. Video artists content with making video a physical object are operating as a rear guard, as a force protecting the museum from claims of total irrelevance. In an information age, where value is determined by immaterial forces, the speed-of-light movement of data, information and knowledge, fetishizing material objects is an anachronistic exercise. Of course, it is not surprising that museum audiences find the material objectification of video at trade-show scale impressive on a sensual level.

As vernacular video culture spins toward disaster and chaos, artists working with video will have to choose between the safe harbour of the museum and gallery, or become storm chasers. If artists choose to chase the energy and relative chaos and death wish of vernacular video, there will be challenges and high degrees of risk.

AESTHETICS WILL CONTINUE TO SEPARATE ARTISTS FROM THE PUBLIC AT LARGE

If artists choose to embrace video culture in the wilds (on the street or online) where vernacular video is burgeoning in a massive storm of quickly evolving short message forms, they will face the same problems that artists always face. How will they describe the world they see, and if they are disgusted by what they see, how will they compose a new world? And then how will they find an audience for their work? The advantages for artists showing in museums and galleries are simple. The art audience knows it is going to see art when it visits a museum or gallery. Art audiences bring their education and literacy to these art institutions. But art audiences have narrow expectations. They seek material sensuality packaged as refined objects attached to the history of art. When artists present art in a public space dominated by vernacular use, video messages by all kinds of people with different kinds of voices and goals, aesthetic decisions are perhaps even more important, and even more complex, than when art is being crafted to be experienced in an art museum.

Aesthetics are a branch of philosophy dealing with the nature of beauty. For the purpose of this text, aesthetics are simply an internal logic or set of rules for making art. This logic and its rules are used to determine the balance between form and content. As a general rule, the vernacular use of a medium pushes content over form. If a message is going to have any weight in a chaotic environment — where notions of beauty are perhaps secondary to impact and effectiveness — then content becomes very important. Does the author of the message have anything to show or say?

Vernacular video exhibits its own consistencies of form. As previously elaborated, the people's video is influenced by advertising, shorter and shorter attention spans, the excessive use of digital effects, the seductiveness of slo-mo and accelerated image streams, a fascination

with crude animation and crude behaviour, quick-and-dirty voice-overs and bold graphics that highlight a declining appreciation of written language. To characterize the formal "aesthetics" of vernacular video, it might be better to speak of anaesthetics. The term "anaesthetic" is an antonym of aesthetic. An anaesthetic is without aesthetic awareness. An anaesthetic numbs or subdues perceptions. Vernacular video culture, although vital, will function largely anaesthetically.

The challenge for artists working outside the comfort zone of museums and galleries will be to find and hold onto an audience, and to attain professional status as an individual in a collective, pro-am (professional amateur) environment. Let's face it, for every artist that makes the choice to take his or her chances in the domain of vernacular video, there are thousands of serious, interesting artists who find themselves locked out of art institutions by curators that necessarily limit the membership of the master class. Value in the museum is determined by exclusivity. With this harsh reality spelled out, there should be no doubt about where the action is and where innovation will occur.

The technology of video is now as common as a pencil for the middle classes. People who never even considered working seriously in video find themselves with digital camcorders and non-linear video-editing software on their personal computers. They can set up their own "television stations" with video streaming via the Web without much trouble. The revolution in video-display technologies is creating massive, under-utilized screen space and time, as virtually all architecture and surfaces become potential screens. Videophones will expand video's ubiquity exponentially. These video tools are incredibly powerful and are nowhere near their zenith. If one wishes to be part of the twenty-first-century, media-saturated world and wants to communicate effectively with others or express one's position on current affairs in considerable detail, with which technology would one chose to do so, digital video or a pencil?

Artists must embrace, but move beyond, the vernacular forms of video. Artists must identify, categorize and sort through the layers of vernacular video, using appropriate video language to interact with the world effectively and with a degree of elegance. Video artists must recognize that they are part of a global, collective enterprise. They are part of a gift economy in an economy of abundance. Video artists must have something to say and be able to say it in sophisticated, innovative, attractive ways. Video artists must introduce their brand of video aesthetics into the vernacular torrents. They must earn their audiences through content-driven messages.

The mission is a difficult one. The vernacular domain is a noisy torrent of immense proportions. Video artists will be a dime a dozen. De-professionalized artists working in video, many sporting MFA degrees, will be joined by music-video-crazed digital co-operatives and by hordes of Sunday video artists. The only thing these varied artists won't have to worry about

is the death of video art. Video art has been pronounced dead so many times; its continual resurrection should not surprise anyone. This is a natural cycle in techno-cultural evolution. The robust life force of vernacular video will be something for artists to ride, and something to twist and turn, and something formidable to resist and work against. The challenge will be Herculean and irresistible.

VENTURING INTO THE BROADER CULTURE OF MESSAGING

The culture of messaging is transforming art into a much more extensive social and political activity. The role of the individual artist is changing radically as complex finished works of art are no longer widely embraced enthusiastically by audiences. Attention spans have shrunk and audiences want to interact with the culture they embrace. Audiences are consumed by the compulsion to trade messages. Today, messaging is all that matters. Instant messaging, voice messaging, texting, email, file sharing, social networking, video streaming and all manner of interactive synchronous and asynchronous communication are the order of the day.

The speed and pervasiveness of electronic, digital culture is erasing the function of art as we knew it. The world of top-down, expert-authored one-to-many forms of communication have given way to the buzz of the hive. The broadcast and auteur models, where control of content remains firmly in the hands of a few, have disintegrated. Speaking horizontally, one-to-one or many-to-many, now dominates our time. Our cultures are no longer bound together by the reception and appreciation of singular objects of thought, but by the vibrations and oscillations of millions of networked transceivers. Transceivers, those devices for receiving and authoring messages, the video-enabled cell phones and laptop computers and PDAs with webcams, are erasing the differences between artists and audiences as both move toward a culture of messaging.

In the early 1960s, the communications revolution, satellite-based telecommunications, made it impossible to maintain an art separate and distinct from the culture at large. Boundaries between art and the broader culture simply broke down due to increased communication. Abstract expressionism, the zenith of Clement Greenberg's high modernism (art for art's sake) was crushed by a deluge of advertising imagery. Pop art marked the beginning of the postmodern era. Postmodernism resulted from a technologically determined collapse of the boundaries segregating and protecting the art world from a broader culture dominated by advertising. Chaos has characterized Western art ever since, as for five decades we have experienced the relative freedom of an "anything goes" philosophy of expanding pluralism. Feminism and many previously unheralded Others (and content in general — the counterpoint to abstraction and formalism) took their turns in the spotlight of a postmodern era churned by the broad, alternating strokes of minimalism and the ornate. The formal properties of postmodern art and culture swing back and forth between the classic simplicity

of natural forms (minimalism) and the playfully complicated synthetic hodgepodge of bricolage (neo-rococo).

If pop art essentially signified the big bang that commenced postmodernity, an era characterized by cultural diversity and hybridity, then we can imagine fragments of art mixed with culture flying away from the centre of a cataclysmic implosion. The postmodern implosion of the early 1960s resulted in an expanding universe where art and culture mixed haphazardly. Art remained as a concept at the centre of the postmodern implosion, recognizable only through art historical references. Art was pure and identifiable only if it quoted or repeated its past, an art history crowned by its highest order: abstraction — the zenith of modernism.

THE SECOND IMPLOSION: POSTMODERNITY ITSELF COLLAPSES

We have now undergone a second, even more violent and gargantuan implosion. The second postmodern implosion took place early in the millennial decade: 2002–2005. The cultural debris of the expanding postmodern cultural mix, the delightfully insane levels of diversity, hybridity and horizontality characterizing late twentieth-century culture and its fragmented, disintegrated pockets of contemporary art, had reached a density and weight so disproportionate to the vacuum at the centre of "art" that a second complete collapse was unavoidable. In other words, after five decades of relative chaos, postmodernity itself has collapsed and imploded with such intensity that we now occupy a vast cloud of cultural disorientation.

If this exercise in cultural cosmology seems unreal and strangely rooted in a philosophical premise that art has an important function in creating, remaking and even maintaining order in our increasingly turbulent cultures, be warned that this text was written by an artist, a believer in the value of art. Artists believe strongly that it is their role to push cultures to change as a result of the imposition of their art. Art is extreme, twisted, marginal culture, a minority report. Artists believe they are agents of change and act accordingly. Artists ask embarrassing questions. Artists are ahead of their time. By simply embracing the present, thereby glimpsing the future, artists lead audiences reluctant to let go of the past. The principle tenets of the belief system of art are that art refreshes culture and somewhat paradoxically that the history of art can anchor culture during stormy times of disorder. We live in such stormy times.

Art is a belief system in crisis. At the centre of this belief system we find art chained to art history, to times before the dominance of computers and the emergence of networks and vastly distributed authorship. We find contemporary art that finds security in looking like art from the early to mid-twentieth century (modern art). While these historical references have been stretched to the breaking point by time and techno-cultural change, the broadest public persists in embracing an idea of art that remains antithetical to television, radio, cinema, design, advertising and the web. The web of course encompasses all the media before it and

stirs the pot to the boiling point with a large dose of interactivity. Art at the centre necessarily acquiesces to the parameters of art as have been defined by the history of art, refusing to be corrupted by interactivity, but for more and more thinking people art historical references are unconvincing and useless in the face of our collapsing cultural order. These anachronisms are security blankets with diminishing returns.

One thing for sure is that levels of uncertainty are up big time. The speed and volume of cultural exchange is undermining the lasting impact of "original" ideas, images and sounds, and the economics of both culture and art are undergoing radical change. In the millennial period, everyone is looking for a foothold. Artists are just as uncomfortable with instability as everyone else, but the prevailing myth has it that artists seek and thrive on uncertainty. But there has to be some order before artists can break the rules. Seeking order and security, artists have been moving back and forth between two pillars of thought throughout the five decades of postmodernity: 1) the history of art is a source of order and content in a post-historical era, and 2) culture in the broadest sense (television, cinema, radio, newspapers, magazines, music, the web), has its own mind-numbing conventions in formulaic programming, but provides access to broader audiences. Artists inhabit and straddle these opposing, negligibly conjoined islands of form and order and gaze at the turbulent universe swirling around, under and over them.

THE IMMEDIATE ENVIRONMENT FOLLOWING THE COLLAPSE OF POSTMODERNISM

The immediate environment is a cloud-like swirl of fragmented particles and perforated strips of culture and art. The second implosion has been devastating, delightfully so if one is selling telecommunications transceivers. Isolation and alienation must be countered by real and potential social opportunities. MySpace, Facebook and YouTube come to mind. Digital, electronic networks provide the only perceivable order and stability in the immediate environment. Digital telecom is the lifeline. This is ironic as digital telecom and the horizontal, decentralized nature of internet communication has been the major factor in eroding institutional authority and order. Museums, universities, the press, religions and the family have all taken major hits. Internet communication, while having tremendous advantages in terms of range and asynchronous time, has serious shortcomings in depth, especially relative to a physical social world. On the other hand, a physical and social grounding through links with a virtual world are better than nothing. Nature, we are told, is on its deathbed. The autonomy of the individual has eroded psychologically to the extent that the body has become a fleshy temple. We savour our food, go to the gym, have sex and otherwise push ourselves physically, to the point of exhaustion, in order to feel our bodies.

The current environment favours messaging, the propagation of short, direct, functional messages. The characteristics of poetic art, ambiguity and abstraction, are not particularly

useful in a messaging culture. We desperately seek concrete correspondences between our world of messages and the physical realities of our bodies and what remains of nature. While messaging can extend beyond our immediate physical environment, the body must remain in contact with the earth. Global telecom, the breakdown of space and time, is balanced by the emergence of microregionalism. Cities are redefined as manageable neighbourhoods. Nature is attainable in specific places; say a clearing in a wooded area behind a graveyard. Messaging often coordinates physical meetings in particular spots at specific times.

Messaging differs from industrial culture (cinema, television, radio, newspapers, and the synthesis of these smokestack media through the Web) in its pragmatic referencing of the body and specific locales. The body is the last autonomous, "original," non-mediated physical object, at least until it is cloned, and its geographical position can be tracked and noted. A person, a body, may issue voice or text messages, but the body is referenced physically by photography or video to create a sense of the site of authorship. Messaging is tied down, given weight and actuality through references to the emanating body. Disclosures of place are also key to message functionality. "I'm having a coffee at Starbucks on Marshall Street. (Here's my image to prove it.) Where are you?" This message from Starbucks differs from art and industrial culture such as commercial cinema in its brevity and simple goal of placing the body. Obsessive messaging interrupts longer, more complex objects of thought like cinema. Movies, television and certainly literature are perforated as audiences and readers are sending and receiving messages instead of paying total attention, thus breaking the continuity of narratives. Cultural objects are perforated by messaging, compounding their state of fragmentation at the hands of advertising. Longer, more demanding narratives are being blown full of holes by the apparent necessity of messaging.

Ambiguity and abstraction fare poorly under the siege of constant interruption. Explicit, pragmatic short message forms, repeated for clarity and effectiveness, may survive the perforation effect. This perforation analogy can be used to describe consciousness itself in the millennial decade. There is no such thing as an interruption anymore because attention is defined through the heavily perforated veil of our consciousness. We give away our attention by the split-second to incoming traffic on our cell phones, PDAs and laptops. Our observational skills have suffered as we have mastered multitasking. We now commonly send messages while we are in the act of receiving information.

The millennial environment is strangely similar to a premodern environment in that accurate description and literal representation tend to rule. The authors of messages (texting, voice, email, webcam, clips for video file sharing networks . . .) have short-term, clearly defined goals. In this period after the collapse of postmodern industrial culture and art the environment is "stable" only in the sense that it is unrelenting in its turbulence and incoherence. There is no room for small talk in this kind of environment. The behaviour of

other species in environments and ecologies with high levels of uncertainty offers insights into our current situation. For instance, scientists think that birds only say two things, no matter how elaborate their songs at dawn and dusk. The birds say, "I have a really good tree," and "Why don't you come over and have some sex?" Human messaging follows similar patterns in terms of directness. I have a body and I am in a particular place. Use your imagination to figure out why I am contacting you.

The medium of video, and in particular live, real-time video, is the heir apparent to the summit of messaging. No medium establishes presence and fixes position as well as video. The development and application of communications technologies forced the initial collapse of modernism in the early 1960s. The coming of age of digital telecom in the millennial decade has created the conditions for an even more complete breakdown of the meaning of industrial culture and art. We now navigate within a thick cloud of shifting cultural debris, anchored by networks permitting us to interact. Most of the messages insist that we exist and insure that we can sustain ourselves (the business of water, food, companionship, amusement, sex, shelter within the broader concerns of economics and politics).

Given the reality and inevitable growth of such a culture of messaging, there are questions we have to ask about the future of culture and art. When will poetic work emerge again in a network-anchored culture dominated by straightforward pragmatic exchanges? And if ambiguous and abstract messages once again emerge, will there be anyone left with the strength of attention to read them? And finally if artists cling to a belief system that includes the potential for transforming culture through autonomous, strategic interventions, then how will they do so effectively in a culture of messaging that continues to diffuse the power of individual messages in favour of an increasingly scattered, distributed, collective authorship?

Acknowledgment is due to the art historian Arthur C. Danto for the clarity and utility of his analysis of postmodernity. Danto's After the End of Art: Contemporary Art and the Pale of History *(Princeton University Press, 1996) served as a springboard for my scan of the post-postmodern culture of messaging in 2008.*

"Vernacular Video" was written in 2007/2008 and published in Geert Lovink and Sabine Niederer, eds., *Video Vortex Reader: Responses to YouTube* (Amsterdam: Institute of Network Cultures, 2008).

PART III

Not all wildflowers are delicate. On the coast they have to be tough to stand up to the wind. This one seems to be two plants in one. The deep-green leafy scaffolding anchors the yellow blossoms at the extremities. Yellows are hard for all my cameras.

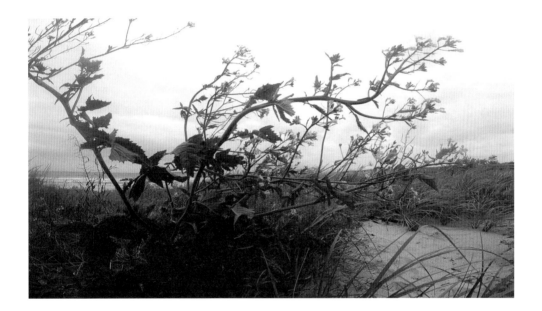

Set: August 23, 2018

Unless otherwise noted, the text-image works comprising Part III were previously unpublished.

First angel of the year. The wing of this seagull is remarkably intact. Don't know whether the rest was eaten after death or what. This is how the ocean positioned it. I turned it over but this was its best side.

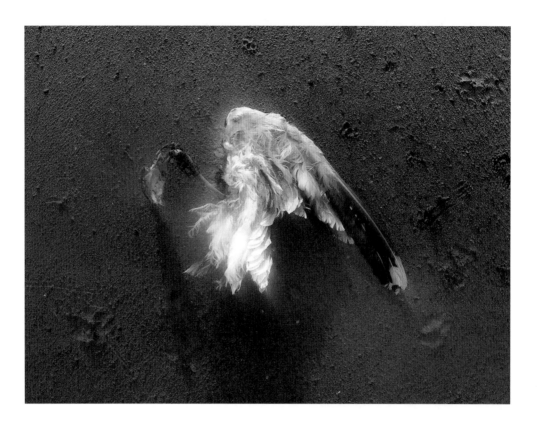

Set: June 23, 2018

At the latitude this picture was made the earth rolls east into the horizon at 733 miles per hour (1,180 kilometres per hour). The earth spins on its axis west to east and that means we are hurled off the shore of the Atlantic into the horizon toward Europe at just under the speed of sound. That we sublimate and take the forces of this ride for granted is a testament to the mystery of gravity. This planetary roll east might be part of the reason we are drawn to the horizon line and why we anticipate the future or think about where we've come from when we cast our eyes out across the sea.

Set: July 9, 2016

Published in "Spatial Collapse," *Prefix* (Toronto), no. 35 (May 2017).

When such an intense and complex light is absorbed by the apparatus of sight, the amplitude of the electrical disturbance rises along the pathways of the optic nerves, then dips, then rises again more gradually, forming a curve or wave of electrical sensation. The second rise corresponds with the phenomenon of after-vision, a micro-memory-based timing element in the optic nerves and the visual cortex of the brain.

Set: May 24, 2018

We have all experienced the transformation from the analog era to the digital. I have recently become fixated on some of the paradoxes resulting when analog realities are transformed into the digital. I think it is important to remind ourselves that we are analog creatures and that we convert our analog world into digital code largely for effective communication between machines and across networks. As flesh and blood creatures, we perceive and experience all things, analog or digital, as analog information through our wet brains, our analog perception and consciousness. It is therefore important to appraise digital simulations and exchanges with respect to their inherent analog characteristics and their resonance within the analog world. Reflecting on the limitations of digital simulations places value on the physical, plastic and living visual arts, as well as the more ephemeral media art forms. The texting abbreviation IRL ("in real life") spells out the severity of our split lives, the differences between the virtual and material world, where things are governed by gravity and skin and bodily fluids. The human imagination crosses the border between analog and digital every day, but we must necessarily reference and manifest our existence in the analog domain because we are living and breathing creatures. Digital simulations, machines and networks are still only extensions of our bodies and minds — they do not yet form entities we can consider our equals.

Set: October 21, 2012

Exhibited as *Project for the Unification of Germany* (videotape drawing on aluminum panel) in *Digital Hearts*, Galerie René Blouin, Montréal, January 1990.

Animals exist as one with their environments. Environments present options for interaction and exploration and actions undertaken are co-determined by environments and their inhabitants.

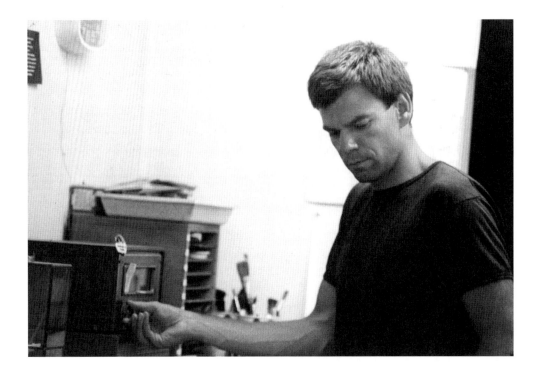

Set: October 7, 2015

A reminder that 1% of the animal kingdom is not bilateral. This elite group exhibits radial symmetry.

Set: August 6, 2016

This is the underside of a *Cyanea capillata*, a lion's mane jellyfish. *Cyanea* are composed of 94% water (the human body is only 55–60% water). This one is the size of a dinner plate and mature. *Cyanea capillata*, in its mature medusa form, reproduces sexually and has separate sexes. The ova and sperm are produced in bag-like projections of the stomach wall. The sperm are released through the male's mouth for external fertilization. Can anyone help me determine the sex of this particular jellyfish?

Set: July 17, 2016

Analog is akin to water, where digital is atmospheric and similar to static electricity in the air. It builds up in tiny atomistic events until a sheet of flashing light discharges the tension and resets the whole environment. The digital crosses the divide in an instant, if a path is available. Analog, meanwhile, sloshes around wet and cool in concentric circles, in materialized echoes, every connection a continuum. Analog instruments are vessels. They have to be sealed to prevent leaking. Analog signals overflow and flood circuits as a matter of course. Stability is a relative concept as depth creates pressure and there is always movement on the surface. Analog wetness can be contained if a little mess can be tolerated. Digital dryness has its own rigid structure until it reaches a climax and then snaps. This tendency to level its topology in a sudden collapse is a prime characteristic of digital.

Set: August 24, 2014

Published in "Is the Imagination Analog or Digital?," *Millennium Film Journal* (New York), no. 65 (Spring 2017).

On May 16, 1973, I unveiled my *Faraday Cage*, a six-foot-square cube of grounded aluminum sheeting at A Space in Toronto. This metal box created a shielded space completely free of electromagnetic radiation. People entering my *Faraday Cage* were thus shielded from all frequencies of radio waves. Today such a radio-free space would render smartphones useless and curtail the flow of wireless images and stories of war and terrorism and nationalist politics and fear-mongering zealots everywhere.

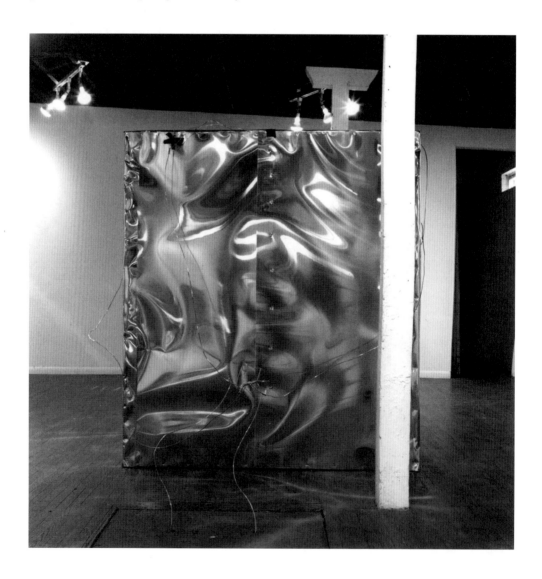

Installation view of *Faraday Cage* at A Space, Toronto, 1973.

This message is about the condition of your body.
All you need to know to live in more comfort.

This headgear is formed of copper wire connecting twelve capacitors
developing into a spiral tunnel of electrical shield.
The circuit makes inhaled air feel cool and light as you breathe.
It is close to the feeling you get smoking a menthol cigarette.

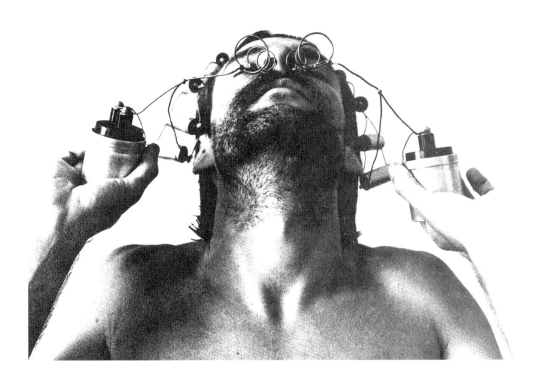

Breathing Apparatus, 1974, wearable negative-ion generator exhibited in *Text Works*, A Space, Toronto, November 1974.

The two side units on this police security camera are radio antennas linking video from our East University neighborhood with a police camera on the near–West Side and vice versa. To help make sense of this networked pairing of disparate neighbourhoods, we decided to park our cars facing these security cams and flash our bright lights on and off to a verbal count (one through ten) synchronized precisely through our phones. This choreographed action results in two bright points of flashing light simultaneously pulsing on opposite ends of a wall of colour flat screens at police surveillance headquarters, representing a pair of wirelessly networked video-monitored street corners two-and-a-half miles apart.

Wireless Ethernet, 4.9 GHz, point to point/point to multipoint, HD video, 150 Mbps: Ackerman Avenue and Stratford Street, + Seymour Street and Oswego Street, Syracuse, NY.

Set: February 17, 2018

Still from *I'm an insect but I love you like a mammal*, 2018, video, 13 min. 9 sec.

Neighbour: night and day. It moves around a lot. Very focused and methodical. Steady pace, nose to the ground, drawing a survey map off to the side of our house.

Set: May 21, 2017

Our international distribution is weak. Our outbound traffic is a dribble. The interactive channels are set up for two-way traffic, but they're jammed with incoming signals. In order to reverse this tide we must develop strategies for strengthening our cultural industries. The first step is to process their data into our information. Then we must send back their data, disguised in the form of our information, back to their screens for consumption.

Set: January 18, 2016

Published under the pseudonym Andrew Czeszak, "TBDF: Transborder Data Flow," *Impulse* (Toronto), 10, no. 1 (Summer 1982).

This young fox came out to see what we were doing in its neighbourhood (a dirt road). I took its picture. Our high beams illuminated the road as only artificial lighting can, selectively (darkness engulfed the roadside). Animals exist as one with their environments. Environments present options for interaction and exploration. And actions undertaken are co-determined by the environments and their inhabitants.

Set: June 21, 2016

Still from *Fox behaviour documented from automobile*, 2016, video, 9 min. 31 sec.

Is the imagination analog or digital? Clearly we are analog creatures, meat animals and not machines. We are certainly not digital organisms. Our brains house our minds and our imaginations are inconceivably free manifestations of our footloose intelligence. We can go anywhere we want, anytime, without our bodies. The brain is a transmitter of sorts of the imagination, but although an argument can be made that our brain's synapses are digital switches, the brain in its neural complexity cannot be copied by digital means. The human body, brain, mind and imagination cannot be rendered in digital code. This doesn't keep us from trying.

Set: April 27, 2015

Published in "Is the Imagination Analog or Digital?," *Millennium Film Journal* (New York), no. 65 (Spring 2017).

A long time ago a man went on television and said, "By the time you see this I'll be dead." He was telling the truth but he didn't die. Instead he seemed to be getting younger and younger and healthier and healthier. Or at the very least he didn't age a bit. Television used to be the fountain of youth when it was a mass medium. Everybody watched at the same time. In real life, when he wasn't on television, he was getting older and decrepit and leaving his televised body behind like a rocket.

Going to Mars is pretty cool but you only need a one-way ticket. It would be pointless to book a return ticket to Mars. Television has since disintegrated and it's possible to be many places at the same time — mundanely so. I know because I'm spread pretty thin. Light-headed I love the way my legs feel when I'm climbing a hill. My hair is black as coal.

Set: December 10, 2016

Still from *TVideo*, 1980, video, 28 min. Published in "Spatial Collapse," *Prefix* (Toronto), no. 35 (May 2017).

The other afternoon in a ship's bar I ordered a dirty vodka martini, very dry, easy on the dirty, olives. When the waiter returned to my table with my drink, he lingered to ask me a few questions. It was dead quiet in the bar, just after lunch. When I told him I was a university professor, he asked me what I taught. I said video art and he asked if I meant video art like in the 1970s? I was surprised when he followed up like this. Most of the time "video art" is a conversation ender. He had one of those haircuts where his hair was long on the top, shaved close on the sides, real hair that looked like a toupee. He didn't think people still made video art, assuming that film had absorbed any vestiges of video art at this point in the twenty-first century. I told him that video is still a vital, incredibly rich territory for exploring and making statements about contemporary reality. Just because film has a longer history and heftier cultural inertia than video art doesn't mean that all have been snowballed into film's sphere of influence. Granted we are living in a very conservative period of time, an era of conformity and the widespread worship and mimicry of tired and lifeless, low-risk forms, but anyone looking ahead and not in the rear-view mirror cannot miss the energy, power, and relevance of video today.

Set: September 1, 2015

Winter light opens up the horizon. I want to be out at sea where the air is so fresh it takes your breath away. Space forces the imagination to fill the vacuum outside of the mind's walls. The roof is torn off. Like a dance floor, the surface of the water offers an invitation.

Set: November 16, 2016

Published in "Spatial Collapse," *Prefix* (Toronto), no. 35 (May 2017).

I was coming up behind two crows foraging in the soft sand at the end of the beach at the river. They were being worked over by the stiff wind, their feathers ruffled and their wings flopping. It was a miracle they didn't just blow away. Somehow they stayed on task. Do you know how little a crow weighs? They weigh practically nothing. They're all feathers. They stay low to the ground and seem to walk around more than they fly.

Set: June 22, 2016

Back in late June I found a concentration of yellow pollen in a tidal pool on a beach off the North Atlantic. This rich deposit of yellow pollen was absolutely luxurious visually, especially suspended and intensified in a shallow pool of salt water. I shared this picture with a friend who paints this landscape, and he told me this colour is called Naples yellow.

Set: July 26, 2015

Published in "Is the Imagination Analog or Digital?," *Millennium Film Journal* (New York), no. 65 (Spring 2017).

There is a new psychological phenomenon emerging in this era of hyper-telemedia, information abundance, and information overload. People of all ages and walks of life are blanking, that is they are shutting down or experiencing momentary ruptures of consciousness . . . or, in very severe cases, blanking sometimes lasting for days. Blanking is not attention deficit disorder (ADD) or daydreaming (dd), but a breakdown in consciousness brought about by sensory and cognitive overextension induced by hyper-connectivity.

Tom Sherman, Bernhard Loibner, and Jean Piché, *Personal Human*, audio CD, Vienna: Kunstradio/Ars Electronica, 1997. Published as "Blanking," in *Re-Inventing Radio: Aspects of Radio as Art*, eds. Heidi Grundmann, Elisabeth Zimmermann, Reinhard Braun, Dieter Daniels, Andreas Hirsch, and Ann Thurmann-Jajes (Frankfurt: Revolver, 2008).

VR headsets strengthen the author's control of the reader. We once approached texts, foraging until we found something of interest, and were still as we read. Then, television and video captured our stationary, contemplative time, pushing us back into ourselves. Transfixed in a reading posture, we became vessels into which television, video, and alphanumeric text were poured. We used to move toward and through information. Now, the information is moving through us.

Set: October 1, 2014

I always like to say that written language is the first digital language. I have trouble defending this argument, because alphanumeric text is more complex and unruly than binary code, but it is also unnaturally concrete and explicit, not unlike 1s and 0s, and as a code it can be reproduced with absolute accuracy, repeatedly without distortion or degradation. This explicitness is why people always ask for things in writing (contracts, slanderous rumours, resignations, love letters), and this is why it is often so embarrassing to have a written statement reappear after many years — things people have written come back to haunt them in absolute alphanumeric fidelity. The written text was the first digital language.

Set: April 26, 2015

These delicious apples were picked by a machine with bedroom fingers. Not a bruise, caressed gently from trees that don't know what hit them. Being felt up by a hydraulic octopus, relieved of the weight of fruit nearly splitting branches, lifted quickly to the heavens, the whirring of a thousand bees. The perfection of metallic touch. Lightly, never dropping.

Set: November 9, 2018

Big data tells us that pears are bottom heavy.

Researchers at the Institut national de la recherche scientifique in Québec have announced they have invented the world's fastest camera freezing time at ten trillion frames per second. They believe it will be possible to increase the speed to up to one quadrillion frames per second in the near future.

Set: October 13, 2018

I am trying to count the shells and fragments of shells in my field of vision, but I keep losing count. I've used a camera to freeze the shells and put a finite edge on my field of vision because my peripheral vision is unfocused and makes the counting process even more difficult. I think this is a good problem for AI, artificial intelligence, because I don't think I can come up with a number I can trust on my own.

Set: October 3, 2018

A deer's eye breaks the quiet of night. An eye not well suited for detailed observation. Deer see well in the dark, but their strength is on the periphery; with their side-mounted eyes they see 300 degrees around. In daylight they have no UV protection and can't read warm colours like reds, oranges, and yellows well at all. They are far better with blues and greens. Images are never sharp, focal problems constant, day or night. Deer have horrible eyesight and rely on their hearing and smell and whiskers for close examinations. They literally brush my infrared camera to see it in the dark. The red glow is grey to them. The way deer stare blankly to surveil, they must have the biggest internal worlds, ways of knowing things beyond their reach, although certainly they cannot sense military activity in the South China Sea or detect clouds of tiny low-orbit satellites blanketing the sky over Syria or Iran or realize that crude oil is suddenly worthless and wonder how its value might be elevated quickly, as if on a rocket.

Set: April 26, 2020

In the late 1950s, I was living in Manistee, Michigan, across Lake Michigan from Green Bay, Wisconsin. I watched a lot of television from WBAY-TV. Television was still black and white only in the fifties. We bought these vinyl plastic sheets that could be stuck to the picture tube with static electricity. One of these plastic sheets was the colour of the sky and it made our Admiral television a colour set before colour TV hit the market. If there was a picture of a sky on TV, it was blue and cool with electronic light opening up the sky. Our TV was 24 inches, measured diagonally. These vinyl sheets covered the tube perfectly. The aspect ratio of television was 4:3. Film didn't fit the frame. Film had to be squeezed and distorted to fit the screen. Television was best when it was video. Those were the days.

Set: October 29, 2020

Viruses are currently in the doghouse for good reason. The coronavirus is wicked bad for humans! But there are plenty of good viruses in the world. For instance, marine viruses are in a colossal battle with marine bacteria in our planet's oceans. There are ten million viruses in a teaspoon of sea water and they are particularly adept at infecting and killing marine bacteria. These viral bacteriophages kill an estimated 20 per cent of the bacterial biomass in the oceans every single day, keeping bacteria from clouding and fouling the sea. This massive bacterial carnage releases nutrients for survivors and maintains a balance in the ocean's microbial ecosystem. To put this in perspective, if it were not for predacious marine viruses, we could not eat raw oysters.

Set: November 1, 2020

Look at every bird like it is the first bird you have ever seen.
Look at every bird like it is the last bird
you will ever see.

Video of Port Mouton Bay, Nova Scotia, on a flat screen. The LCD image is in colour but appears black and white due to conditions at capture. Then white light through tiny liquid crystal cells. The surface of the water absorbs the sun while the extra radiation bathes my retinas and sends impulses through my optic nerves to my brain. A solar-powered message with bioelectric expediency. A routine shift in speed internally. The sounds of the ocean tie the two displays together in my mind.

Set: March 14, 2021

AFTERWORDS

WRITING IMAGES:
TOM SHERMAN TEXTS AND PHOTOGRAPHS

— Peggy Gale

This book is a monster of discourse and speculation, a grand and substantial creature of dissimilar parts, its differing elements repositioned for evaluation over time. Beginning with Sherman's extended memoir fragment, "The Faraday Cage" (2006), which establishes the roots of his mature work as a writer, it follows innumerable shorter texts and projects, plus two previous books with media-oriented concerns, *Cultural Engineering* (1983) and *Before and After the I-Bomb* (2002). With *Exclusive Memory*, a sequence of newer texts accompanies photographs both urban and natural, added to an assembly of older writings brought together for the first time here. The "art" part surfaces at once, writing images through blooms of narrative that may bear little resemblance to stories and tales. A text may be smoothly conversational, anguished or amusing, aggressively instructional, or thoughtful and charming. In all cases we are carried along by Sherman's rigorous imaging, text becoming visual in the scenes it evokes or displays, with science and technology most often a springboard.

Time and experience accumulate. Age is a disconcerting reality. We all ignore our literal, physical calendar years in favour of current ideas and events, a life that is ongoing and — for a long time — treated as if infinite. The contents of this volume cover a near half-century, though the text elements were largely composed between 2002 and 2008, plus two much earlier essays and more recent text-image compositions. "The Appearance of Voice" (2003) is a central statement, with Sherman already fifty-six years old, taking the long view in assessing his trajectory of artistic production to date. It is also linked to his first writing experiments, detailed in "The Faraday Cage," and his first years in Toronto, having "escaped" in October 1971 from what he called "the culture of deceit and apathy in the States" during the Vietnam War. He was just twenty-four years old then, having recently finished his studies at Eastern Michigan University in Ypsilanti, Michigan. The appearance of voice denotes coming of age over the turn of the twenty-first century, as words and images flower and come to fruition.

Whether memory or anticipation, these writings are in the present tense, and trace changes in media and technology, weather and wildlife, through stories, bald facts and descriptions, interlaced with critical commentary. His thinking is both acute and wide-ranging, the product of prodigious reading and insistent evaluation. Enormous changes are quietly foregrounded, and it is important to note the publishing date for each text to recognize the extent to which terminology and practices have changed.

He speaks of *hearing* his words as he writes them, privately performing, and we the readers are hearing — in our heads — those words as original discoveries, evaluations of a present that continues to unfold. These ongoing narratives, including video and performance, bear little resemblance to traditional sculpture in the round, and offer an imagined experience of seeing and hearing and often touch and taste. The recent text-image pieces are the most sensual, often amusing or ironic: "Big data tells us that pears are bottom heavy." "Not all wildflowers are delicate." Or, "Winter light opens up the horizon. I want to be out at sea." Yet earlier text pieces have their own sense of inevitability: "This Message is about the Condition of Your Body." The mind is journeying, cataloguing, testing, as the view turns upward, down, or inward, dense and critical.

Sherman's university studies centred on sculpture, and "The Faraday Cage" was one of his earliest works exhibited, two years after moving to Toronto. It was large — a six-foot cube with heavy aluminum-alloy sheets on a solid interior frame, a "negative, radio-free space, in the middle of downtown Toronto, a major city with scores of radio and television stations and microwave transmitters, and an electrical grid pumping an electromagnetic smog of radio-frequency energy through every building and lung and every cubic centimetre of Toronto's air." Already, we imagine toxic surroundings buffered by wilful art and science: the Cage for temporary respite. Already, instructional and speculative. He recalls his own experience of using or inhabiting the work as slightly unpleasant physically, though clearly he was satisfied with its function for others as sculpture and as experience: as text, in fact, demonstration and explication. It was a "psychological space," "a conceptual space of refuge." Further, it offered a place fully shielded from the dangers of electromagnetic and wireless pollution outside.

For an exhibition of his work at the Electric Gallery in March 1973, Sherman constructs the scene: "With the gallery completely unlit, except for the subtle glow of ambient light from the television screens pressed against the walls, the space became acoustically sculpted." Audible noise from the TV "snow" filled the room unevenly, discomfiting or pleasing, depending on one's location there. As he notes, "I had chosen to reduce the apparent content of my work to an environment." The space was filled by the invisible waves and eddies of sound, and some visitors felt touches or heard voices, all induced by the unexpected physicality of subtle sonic tones. Similarly, perhaps, technology and media could offer to an audience a physical reaction

or recognition via electronic means. The written word would amplify this physicality into a visual sphere, using textual interface to shape visual cues: text as a concrete, sculptural variant.

Quickly, the narrative picks up again, tracing Sherman's arrival in Toronto, his chance meeting with Marien Lewis, and the earliest days at A Space: "The energy from the sixties was still happening and we were all thinking cultural revolution." These were the days of intermittent salaries and unemployment insurance, with round-the-clock art activity. "We were building the model for artist-run centres across Canada and the US, and we were building our scene in Toronto."

Toronto then was small and provincial, with *artscanada* the only national arts publication and CBC a central source of news coverage.

Comments are both tender and acerbic: the rough work under way, and the utter inadequacy of critical dialogue then. He muses aloud on the page as he roams through his life with Lisa Steele at A Space and at home, the agonies of early video editing with manual controls and half-inch open-reel video decks. He is clear on Michael Hayden and Canada Council sponsorship of Video Ring: "Here Lisa and I were trying to make decent tapes with outdated half-inch, black-and-white video equipment, basically junk, and Hayden had used our organization and the names of a bunch of well-known artists who had absolutely zero interest in the medium to put together a 'Batmobile' of a video studio for himself." This is a history we need.

Throughout, the discourse vacillates between clarifying facts and diverting stories, as (implicitly) he compares the artist-run activities of A Space with the very few commercial galleries then operating — the strong, mostly male personalities at the Isaacs Gallery, the cooler and more cerebral others at Carmen Lamanna: all providing the base for what developed later. Sherman is quick to judge, and notices both quality and style. Colourful yarns provide texture for people and art politics. He also describes the tragic disintegration and suicide of friend and writer Andrew Tuffin in 1974: "I asked the officer how Andrew had taken his life, and he told me he had blown his head off with a shotgun." Stark.

That year the aesthetic of A Space was changing from white-walled conceptual and experimental to something more colourful, with pianist Al Neil and performers Dr. Brute and Lady Brute from Vancouver: "Dr. Brute was horny and sick and believable with leopard spots behind him, all over his wooden horn, and in his mind's eye." In an evolving conversation, we meet Lynne Cohen and Andrew Lugg, Norman White, John Watt and Colin Campbell, Marty Dunn and Trinity Square Video, with random details and unexpected links. With Lisa Steele's breakthrough tapes of 1974, there is an excited recognition of video in Toronto. Though Sherman was hurt and angry that Steele, in *A Very Personal Story*, would tell a video camera

and unknown public what she couldn't tell the man she lived with, he "began to see how radical and powerful the tape really was. [Lisa and I] had talked so much about authoring video works in the first person — about the importance of telling our own stories as the substance of our work — and Lisa had definitely stuck her neck out by recording the most personal story she could tell. Watching the tape again and again, I could see the power in the naked truth of that recording."

Sherman doubles down on his writing, and begins to publish his texts in photocopy editions and circulate them widely. He was further inspired by Jay Jaroslav's installation of text pieces at A Space at that time, "beautifully designed with photo-enlargements of white blocks of text on slate-grey panels." Jaroslav had taken on the fictional identities of numerous long-dead individuals, fleshing them out with precise physical characteristics; for Sherman, these powerful and elegant textual images proved that the "I" could inhabit any number of personal identities, that writing "could take conceptual art a step further into the perceptual, sensual realm."

These intense weeks kept on coming, with their highs and lows. "The next thing I knew I was doing monologues on *This Country in the Morning* with Peter Gzowski," telling stories on himself and his friends, as more new opportunities arrived. Judith Merril, author and founder of Toronto's Spaced Out Library, helped him see his work as "conceptually experimental, future-oriented work." His friend Joe Bodolai, full of ideas, encouraged him further. There was lots of talk and joshing around among friends, but also, "By 1974, there was a backlash against all of us Americans ... seen to be more aggressive and confident and filling too many jobs."

Sherman could be tough in turn. Having found Marshall McLuhan with "the first relevant ideas" for his own art, one evening he dropped into McLuhan's famous open seminar at the University of Toronto, though anxious that he might feel out of place as an artist among academics, and further unsettled by McLuhan's comment that "video artist" was an improbable term. The memory is not a positive one, yet Sherman's rich evocation of an evening so many years before is remarkable, even to its floating miasma of idolatry and boredom. Around the same time, as the Art Gallery of Ontario (AGO) opened its Henry Moore Sculpture Centre and first large expansion in fall 1974, another bastion of privilege is repudiated. Sherman is resentful in advance. His own exhibition of text pieces immediately afterwards at A Space has more personal significance, for which he offers detailed description and discussion. As he notes, "I was beginning to get a sense of what the future would hold. I wanted to be an artist and to work with written language."

Though he knew the work of Sol LeWitt, Douglas Huebler, and Lawrence Weiner, he felt their use of text was dry and formal when compared with his own desire for descriptive prose

that offered rich imagery and sensuality, writing as *visual* art. If McLuhan found "video art" an unlikely notion, writing as visual and aural was all the more attractive. Sentences could be brief and deliberate and make vibrant images despite their immateriality. Sherman responded particularly to Gertrude Stein and Alain Robbe-Grillet, for formal invention on the one hand and semantic precision on the other. "Understanding Media Was Our First Big Mistake" (1979) details an erotic first-person episode for a reporter on assignment in Miami, as targeted by a luscious artist and media entrepreneur whose Spinal Ray Gun could make the body "speak in tongues from head to toe." Very convincing.

Sherman soaks up inspiration all around, obsessively reading a gift from AA Bronson, *By the Late John Brockman* (1969), throwing himself into his own writing. Perhaps it was inevitable that this manic drive would eventually close out others. After three years together, Lisa left him unexpectedly to live with Colin Campbell. Devastating. Now everything was imploding: access to institutions became tighter, and anything-goes open opportunities dried up; there was a new, less sympathetic curator at AGO; even A Space now had a program committee and a "process" for planning exhibitions. As he notes, "The expanding skyline was as impressive as it was distant and cool." Now alone, Sherman felt abandoned, with no job, no relationship, no "future" after all the immediately past drama of exceptionalism, big plans, new successes. Many of his American friends were leaving.

So, suddenly, "I decided I needed a change in scenery. I wasn't done with Toronto, but I needed a break. I stored my books and records and reduced my personal belongings to a single backpack. I went down to the bus station and bought a ticket to Cincinnati.... I was alone and hungry as I watched the lights of Toronto disappear. I took out my journal, turned on the overhead lamp, and began to write."

The abrupt ending is brilliant. It is also a beginning, offering a "present" that we are now engaged in reading. Right away, the low-key words suggest pictures in action.

These are Tom Sherman's memories, not mine, but my own story often intersects with the people and places of "The Faraday Cage," and I recognize the truth of this material. To be both an observer from outside, later, in reading these words, and also a long-ago witness, at least tangentially involved, makes me a double participant. I am certain, though, that these images and events have value and a particular fascination as both history and psychology for even an impartial reader. Artists' video, in particular, and the developing independent media arts, in general, were at their apogee in these years, establishing an identity particular to Toronto, based in (usually) scripted narrative and (often) personal fact. The interaction of persons and projects was vital and prolific, an abundance spurred on by the feeling of sheer vitality and invention in the city then. "The Faraday Cage" delimits these developments from the inside.

Sherman has written himself as anti-hero, without the customary "heroic" qualities of idealism, courage, and traditional morality, whose trajectory doesn't seek honour or virtue but chooses self-interest and the simple need to keep afloat, move forward. Picaresque, a young man seeks his rightful place as an artist in the world. He is wary, tending to reject others as a first defence. As Sherman notes now, "I tried to be honest and in that way I make myself vulnerable.... It was worth waiting thirty years to get into my head as a young man so I could actually describe what I was experiencing and feeling.... I put this story together sequentially and factually largely based on correspondence I had sent to my mother.... When she died, following the death of my father ten months before, I was left with boxes of letters I had sent her."[1]

Therein, another story: a distant only son and the sudden loss of both parents; a required reckoning of where-am-I-now and what-next. We value this plunge into the past, presented as far as possible with the eyes and attitudes of his early self.

Exclusive Memory is arranged for its readers, alternating exploratory essays dealing with complex issues and layered self-interrogation with more varied and accessible material. But "The Appearance of Voice" (2003) connects closely with "The Faraday Cage," in that Sherman sees *voice* as directly analogous to the writing experience and the phenomenon of thought itself. In this case, "appearance" is both "arrival" and "visual effect." Though predating the composition of "The Faraday Cage," this essay — while still autobiographical — presents conclusions rather than process. It is declarative, a position statement.

As later with "Faraday," he patiently outlines his beginning point and subsequent path, to understand the place he inhabits at time of writing. He notes his origins in sculpture and its shift toward including (or excluding) sound and electrical or other invisible phenomena. "I saw text as a purely visual phenomenon for the first few years. There was no oral voice in my text. The prose was absolutely silent." He experimented with reading aloud, while others performed actions, a voice-over effect, later enacted with video as *Television's Human Nature* (1977). Always, he is alert to context and the larger world of art and commerce, referencing standard TV "talking heads" in this case.

He writes: "Our voice, not our mere bodies, is our presence in the world." This is an unexpected statement from a sculptor, though in Canada, early video-makers with established training in the arts, did tend to come from sculpture rather than painting or theatre. As Sherman insists, "a recorded voice represents a point of view," as a formal statement of fact. "The voice itself denotes the presence of an individual," regardless of the meaning of that person's words. Video, for Sherman in 2003, is a seeing-hearing-visual-physical entity, a kind of

1 Tom Sherman, email to Peggy Gale, June 30, 2018.

living document, so that "Raw, real-time video recordings are the closest description of reality our species has come up with so far." The problem here is that "reality" and "description" do not cohere and can never be unmediated. Film does not deliver "truth at twenty-four frames per second," and video, though originally a continuous reel of magnetic tape with simultaneous visual and acoustic information, is a recording and not "real life." Agreed, though, that the effect on the viewer is one of physical presence.

Sherman's video works are truly experimental, with their unexpected juxtapositions of narrative, acoustic layers, image, reference, and formats. He is a conscious adaptor and speculator. "The Appearance of Voice" is an investigation into the artist's interior and the marking of a trail: a "portrait of the artist" that dispenses with narrative arc. The internet, then, was to open his audience infinitely for sharing and exchanging images, ideas, sounds, and texts with others globally. The essay begins in tight focus on Sherman's early works, flowering outwards into the cerebral realms and multiple voices of his maturity, clear and measured, with an engagingly elastic interpretation of both "art" and "I." He becomes euphoric as the text draws to a close, evoking his performances as Nerve Theory with musician Bernhard Loibner: "What an absolutely fantastic space for writing with the tongue, framed in 'real time' . . . And ultimately what a perfect opportunity to saturate the audience with an all-pervasive acoustic totality, an overwhelming musical reality, that sweeps away a person's spoken words, and subverts the dominant power of relentless streams of video, to give the audience the strongest possible sense of its whole body, down to each individual living and breathing speck of flickering, introspective self-consciousness."

Increasingly sonic and increasingly public, this is far distant from the "absolutely silent prose" of earlier years. Sharing!

Five years later, "Vernacular Video" (2008) is by comparison terse, coherent, and firm; Sherman writes with assurance and from experience. Beginning with his customary brief overview of "then," he moves quickly to "now," but we must remember that already a further decade and more intervenes with today's date. Even in 2008, he points out that "the culture of messaging is transforming art into a much more extensive social and political activity. . . . Today, messaging is all that matters. Instant messaging, voice messaging, texting, email, file sharing, social networking, video streaming, and all manner of interactive synchronous and asynchronous communication are the order of the day."

Sherman shows little patience for "institutionally sanctioned video art" shown in museums that are merely concerned with appearing up to date. Better, that artists be "storm chasers," using video's "real strengths" to alter behaviour and steer social movement. Information, not objects, is the goal, though audiences may struggle to see the value in these

innovations. His thesis is closely argued and his aims clear: the art of the past, its concerns and values, are fundamentally irrelevant today. And for video, formed from television, "The broadcast and auteur models, where control of content remains firmly in the hands of a few, have disintegrated. Speaking horizontally, one-to-one or many-to-many, now dominates our time." Not all would welcome this new utopia, though no one can deny the radical rule of smartphones, distributed authorship, and social media today. Sherman saw it all, early.

"We desperately seek concrete correspondences between our world of messages and the physical realities of our bodies and what remains of nature."

But moving from history and polemic to the recent photo-text works, Sherman opens into the natural world, seen with affection, curiosity, and, sometimes, a charming ambivalence. In "Not all wildflowers are delicate" (2018), he catches hardy shore greenery, tangled and wind-driven, against a grey sky, noting — as if apologetic — that "yellows are hard for all my cameras." In "First angel of the year," he remarks on the husk of a seagull against wet sand, admiring the slanting sunlight on its splayed feathers. And jellyfish! Deep cranberry-red ones, circular as a flattened umbrella in ripples of shallow water. Another one has a fleshy body, yellow, orangish and ochre on the underside, edged with a filmy halo, a "Lion's Mane." Gorgeous and mysterious visitors from the sea.

Light and water predominate in many of these text-image compositions, products of long summers spent on Nova Scotia's South Shore. The receding horizon encourages wide-ranging thoughts, "Like a dance floor, the surface of the water offers an invitation." This is not to say that rural life banishes philosophy, rather that the questions look outward instead of to a world of classroom, studio, and theory. His summer world appears as early in this book as 2002, with "On Shore" and "a landscape dominated by liquid and ether," where "there is no evidence that yesterday ever happened." The quiet is not silence, and being solo is not being isolated. Euphoria, here, is grounded in the elements and the present, in the sensing body.

"Rare Species Are Common" (2005) is from a similar time, beginning as a conversational tally of shorebirds and their habits. The puzzling title is quickly resolved by quoting Sam McNaughton, influential professor of biology, who points out that "rare species are common and common species are rare." As Sherman acknowledges, "We generally dislike very successful, common species like crows, seagulls, pigeons and sparrows, whereas we are thrilled to see a rare bird." In comparison with blockbuster mainstream movies and million-seller novels, the hard-to-find or endangered species are like independent films and small-press publications by individuals. A thoughtful consideration of the avian population has segued into a trolling of cultural commonalities: surprising, and suddenly revealed in a new light. Crows as *Dirty Harry*, piping plovers as — what? — folks working on a small scale

on an intensely considered personal project outside "industrial culture." "Thankfully common species are rare and only a few blockbuster hits are possible every season." But small art scenes continue to surface and proliferate, to share a "singular point of view." Always, there are many of these "rare" messages seeking their own audiences. "The rare species is common." And Sherman's narrative returns to the beach.

Throughout *Exclusive Memory*, we shift among genres and decades. The themes are personal, of long standing, weaving and reappearing unexpectedly.

As I wrote recently in connection with Sherman's video-text-performance works, "The process of writing here reflects an intentionally slowed, self-aware, consciously thoughtful process of discovery and, finally, expression. As if your mind has intentionally separated each aspect of the experience in order to examine it, then to state its characteristics."[2] Sherman's writing over the years has become particularly focused and spare, intimating commentary through visual evidence, a non-verbal narrative. His words evoke and quantify as they describe and decode: evidence of an inquiring mind and the long gestation of ideas and perceptions. Science is personal, an old friend and accomplice.

There is admiration for the machine world, an insistence on acting within and *with* its capacities and opportunities. But at the same time, a healthy caution lurks there. Surveillance and voyeurism shift in and out of focus. As Sherman noted recently, "Video as a medium is a cognitive accelerator, the machine sparks a certain vitality because of its speed and capacity for instant description and then it leaves this strange record for contemplation and the understanding of perception, a deceleration that is awkward and difficult to appreciate."[3]

Exclusive Memory is a record and a proposal, a cumulative intellectual memoir, with sculpture and text as physical, living entities. Words to live by.

2 Peggy Gale, email to Tom Sherman, January 22, 2018.
3 Tom Sherman, email to Peggy Gale, May 26, 2018.

TOM SHERMAN:
NATURALISM THROUGH VIDEO — INCREASING THE DEPTH OF FIELD

— Caroline Seck Langill

There is a moment in the opening voice-over for Tom Sherman's video *Half/Lives* when the viewer becomes acutely aware of the impending rupture of the state of technology as understood by its users. We hear an answering machine's recording: "Hey ya, is that you? I hate talking to machines. Is that you?" The speaker goes on to mourn the loss of friendship between the caller and receiver, confessing his loneliness and assumptions about the new relationships the friend might be engaged in. The juxtaposition of images of melancholic webcam video capture with this sad, somewhat paranoid, presumably analog-driven lament underscores the moment we found ourselves in at the turn of the twentieth century.

Produced in 2002, *Half/Lives* is a collaboration with Bernhard Loibner, with whom Sherman formed Nerve Theory. The video explores a point in time when our collective communication mechanisms were transforming. The video image in *Half/Lives* shows people, sitting in front of computers, who are stark, inert, only visible by virtue of the public webcams on their desktops, which look large and bulky, white and mawkish. Produced originally in 2000 for Kunstradio-Radiokunst with Austrian sound artist Bernhard Gál and Syracuse artist Peter Forbes as a live radio/web performance titled "earshot," the work reflects emerging presentation modes of live streaming through audio and moving image. In *Half/Lives*, the voice-over accompanying the deadened images of people lost in the reverie of the web demonstrates Sherman's ability to tap into critical moments in our collective experience of technological change. Situated between two worlds, with the message machine representing the waning analog device, and the computer users waxing through escalating digital modes of communication, *Half/Lives* is a prescient and foreboding piece, a warning about our future

as one where we are all "alone together."[4] Today we can barely make time to place a phone call, and if we do, more often than not, it is a scheduled call.

This key transition to the perception of being alone together, stemming from clinical psychologist Sherry Turkle's observations on our relationship with *technik*, describes the new normal created by the digital devices we live with. In fact, Sherman's engagement with the ideas that generated *Half/Lives* predates Turkle's text. While one can track Turkle's ideas within Sherman's as realized through numerous respective texts that examine our life intertwined with the screen, from large to tiny, it is Sherman's deep attention to our habituation to new technologies in the early 1990s that led him to recognize we were swiftly entering a period of living "alone together."[5] In *Blanking* (1996), he states: "we enjoy building bridges between audio and video and data, and touching and looking and tasting and being here and there, while wanting to be somewhere else, alone together in sweet intensity."[6] ("Alone together" is also a key idea within the performance piece *The Disconnection Machine*, performed by Nerve Theory, Sherman's collaboration with Bernhard Loibner, at Elektra in 2001 in Montréal. Considering that Turkle's book emerges sixteen years after Blanking and a decade after *The Disconnection Machine*, one could speculate on the influence of Sherman's work on Turkle's.)

In this essay, I track the emergence of Sherman's embodied relationship to video, his gravitation to narrative, and his text-image works which speak to his own meeting with technology, and to his relationships with living organisms and human communities — surprises to anyone reading his work anew, since he is most often associated with a critique of machine life. Sherman comes from the distinct perspective of a conceptual artist who grew up in the 1960s, when digital circuitry was slowly nudging analog machines toward their eventual obsolescence.

As a child Sherman had a ham radio licence and thereafter remained interested in high-frequency electricity and high-voltage systems, becoming particularly intrigued by Nikola Tesla's work. He gained proficiency in the material production of radio transmitters and Tesla coil transmitters of high-frequency electric forces, eventually to the point of ordering all Tesla's patents.[7] In the 1960s, while the Whole Earth Catalog was anticipating the World Wide Web and, ultimately, Silicon Valley, the United States was immersed in a cold

4 Sherry Turkle has extensively critiqued contemporary technologies for their effect in the user of distancing themselves from real-life and real-time interactions with others. In her recent book *Alone Together*, she notes: "In fact, being alone can start to seem like a precondition for being together because it is easier to communicate if you can focus without interruption, on your screen." Sherry Turkle, *Alone Together: Why We Expect More from Technology and Less from Each Other* (New York: Basic Books, 2011), 14.

5 Turkle, *Alone Together*, 155.

6 Tom Sherman, *Before and After the I-Bomb: An Artist in the Information Environment,* ed. Peggy Gale (Banff, AB: Banff Centre Press, 2002), 4.

7 Tom Sherman, interview with the author, Agnes Etherington Art Centre, Queen's University, Kingston, October 16, 2006.

war between superpowers, coupled with a ground war in Vietnam. The endless numbers of casualties mapped across the television screens — thanks to the portability of video technology by the late 1960s — generated dissent leading to mass migration north from the US.

Sherman followed his peers into Canada, and in 1972 immersed himself in Marshall McLuhan's Toronto, a city referred to by artist Michael Hayden as one where "the streets are lined with transistors."[8] With his boundless artistic passion, Sherman was met with enthusiasm by a community looking for artists eager to participate in the burgeoning artist-run culture of the city. He occupied himself with the work of building A Space, an artist-run centre (ARC) established by artists Robert Bowers, Marien Lewis, Stephen Cruise, Ian Carr-Harris, and John McEwan. As Sherman relates in "The Faraday Cage," A Space was a "cauldron for artists of all stripes to mix and collaborate and boil over."[9] It was a burgeoning time for ARCs, as they provided new public sites for exhibition, programming, and performance of work by emerging artists.[10] In *Policy Matters: Administrations of Art and Culture* (2006), Clive Robertson has described ARCs in Canada as embracing hybrid models of practice, where social activism and cultural entrepreneurship are interwoven within centres of aesthetic and social organization. Sherman quickly found himself deeply embedded and began to build his practice as an artist.

Art historian Charlie Gere has tied the seemingly disparate histories of technology, media, and art together to establish the significance of emerging real-time systems that challenged the traditional role of art. Gere cites art historian Jack Burnham's prescient proposal of new aesthetic forms enabled by the emergence of intelligent systems as paving the way for artists, like Sherman, to create work that was transactional in nature rather than abstract.[11] Gere notes the potential of a real-time intelligent system to create a *Gesamtkunstwerk*, or "total work of art." The seduction of technological affordance to produce work that hit all the right buttons is evident in Sherman's early work. At this point, sound had begun to compete with Sherman's interest in electronics. In 1971, at Eastern Michigan University, he produced an installation utilizing sub-audible low-frequency acoustic fields and began using transducers to vibrate walls and floors.[12] In March 1973, the Electric Gallery hosted a solo show by Sherman, where the artist explored acoustic media featuring plastic pipes distributing mid- and high-frequency pink noise and television sets generating static. No doubt Sherman's pursuit of the "total work of art" influenced his germinal work, *Faraday Cage*.

8 Norman White, interview with Langill, Durham, Ontario, May 31, 2006.

9 See page 34.

10 A Space was one of a handful of centres that opened across the country between 1972 and 1973, along with the Western Front in Vancouver, Artspace in Peterborough, Ontario, SAW Gallery in Ottawa, and Forest City Gallery in London, Ontario.

11 Charlie Gere, *Art, Time, and Technology* (New York: Berg, 2006), 131.

12 Tom Sherman, email exchange with the author, August 24, 2015.

In *Radical Museology*, art historian Claire Bishop suggests that "we need to ask why certain temporalities appear in particular works of art at specific historical moments."[13] Long before smartphones and the attendant health concerns regarding the proliferation of the electromagnetic fields (EMF) spectrum in our atmosphere, Sherman was thinking about the waves of electricity pulsing through human and other carbon-based bodies. Michael Faraday invented, in 1836, the cage that now bears his name, to demonstrate that enclosures constructed from electro-conductive metals, grounded to the earth, will redistribute any incoming electrical charges around the enclosure, leaving the interior free of the EMF spectrum. Like an isolation chamber, light-locked and electricity-free, Sherman's *Faraday Cage* (1973) spoke to a moment in time where noise, both audible and electrical, would only escalate as digital technologies rolled over and consumed their analog predecessors. The temporalities embedded in *Faraday Cage* speak to the nineteenth century, when, according to art historian Dieter Daniels, inventions "paved the way for the industrialization of production, but also for the technicalization of culture that characterizes our lifeworld today."[14] The work spoke intensely to its year of production and its location in Toronto, a time and place when and where artists were eschewing commercial success in favour of novel explorations of emerging media technologies.

While Sherman's strong ties to electronics and computation were established through his long-standing interest in science-fiction literature and having lived his formative years during the parallel escalation of the space program and the Vietnam War, it was the more ephemeral medium of video that began to override his penchant for electronic media sculpture and installation. With *Hyperventilation* (1970), his first video work produced with the assistance of John Orentlicher at Eastern Michigan University, Sherman began to tap the potential of an embodied relationship to technology and audience. Video had affective possibilities, unlike other electronic media emerging at the time, and manifested a more traditional relationship to the viewer, save for minor interactive opportunities. *Hyperventilation* documented Sherman's performance of radically hyperventilating until he lost consciousness. This work had three distinct iterations. First performed in December of 1970 in an empty gallery closed between semesters, it was recorded on half-inch reel-to-reel video. A second performance of the piece was executed via closed-circuit video display — making the second-floor hallway of Eastern Michigan University's Sill Hall unpassable in the spring of 1970. Finally, in late summer or early fall of 1971, in a film studio at the University of Michigan, a third performance was undertaken for the 16 mm film *Trace* by Andrew Lugg. A year before Chris Burden's *Shoot*, *Hyperventilation* enveloped the artist in a transactional relationship with the audience, one where their witness to a body in peril made them acutely aware of their own bodies as organisms under their own control and also of their responsibility as bystanders.

13 Claire Bishop, *Radical Museology: Or What's Contemporary in Museums of Contemporary Art* (Köln: Walther König, 2014), 23.
14 Dieter Daniels, "Artists as Inventors and Invention as Art: A Paradigm Shift from 1840 to 1900," in *Artists as Inventors, Inventors as Artists*, eds. Dieter Daniels and Barbara U. Schmidt (Linz: Hatje Cantz, 2008), 19.

According to cultural historian Dot Tuer, early video art was "embraced by artists for its conceptual intimacy and its potential to alter the parameters of the consciousness industry."[15] Sherman was drawn to these aspects of the video medium and for over five decades has remained committed to video as an art form. For Sherman, "Video is an instrument for examining a field in real time. It is a tool for discovering information, not making it," and as a medium is embraced for its instantaneous productive capacity.[16] Sherman has always written and recorded video as a way of processing and digesting his life. One can track this belief in video's capacity for real-time exposure and production of knowledge back to his less-than-satisfactory encounter with Nam June Paik and Shuya Abe's Paik/Abe video synthesizer on exhibition at A Space. He writes: "Why would anyone want to push the electronics of video into wildly oscillating colours and abstract forms when ideas and concepts were the name of the game, and video as an instrument could be used to deliver people and the way they saw their particular world to other people?"[17] His emphasis on content over form was shared by many of his colleagues working in early video in Toronto, and given A Space was one of only three sites in Toronto where video could be viewed, the gallery became instrumental in determining how the medium would develop as it established its stake in the art world. This is not to suggest any naivety on Sherman's part, for the Toronto community was well aware of the pitfalls of community-based video, having weathered the fallout from the National Film Board's Challenge for Change program. Janine Marchessault has suggested the aspirations of this program, as manifest by its work on Newfoundland's Fogo Island, contradicted its original intent and in fact, "could not challenge an authority that it worked to obscure."[18] According to Marchessault, the amateur nature of this and related brands of community video led artists to distinguish their work as art, and thereby non-functional, or at the very least not useful to state policy.

Sherman's burgeoning facility with narrative — wrapped around his commitment to video — was fortified by the vital writing scene in Canada in the early 1970s. According to Sherman, "there were conceptual artists that were writing, there was new narrative that was developing, there was a fantastic poetry scene that was going on, there were big names, there were people you never heard of, there was lots of travel from the west coast of the country."[19] Here, one gets a sense of not only Sherman's excitement with the potential of text but also his emerging style. While Sherman is acknowledged for his video, performance, and sculptural works, his text-objects dominate his œuvre. Deep within his 1991 text "Turning Television into Radio," Sherman describes the performative process he undertook to find "an

15 Dot Tuer, "Mirroring Identities: Two Decades of Video Art in English Canada," in *Mirror Machine: Video and Identity*, ed. Janine Marchessault (Toronto: YYZ Books, 1995), 111.

16 Tom Sherman, *Video Is a Perceptual Prosthetic* (Halifax: Centre for Art Tapes, 2012), 8.

17 See page 48.

18 Janine Marchessault, *Mirror Machine: Video and Identity* (Toronto: YYZ Books, 1995), 21.

19 Sherman, interview with the author, October 16, 2006.

effective personal methodology for generating [his] own descriptive voice prose."[20] With the goal of writing extended texts of visual symbols intended to act as visual art objects, Sherman constructed the environmental conditions that would enable him to function accordingly.

Initially, he experimented with anechoic chambers in an attempt to block out the "noise" pervading his thoughts. He then found that a pair of skeet-shooting earmuffs provided the necessary quiet. As the forthcoming narratives tended to fall into familiar patterns and structures, Sherman embarked on further experimentation in sensory deprivation, including work with isolation tanks. Finally, he placed half of a ping-pong ball over each of his eyes, bathing his visual field in a white light, enabling him to receive "free-flowing showers of internally generated images, which could be described and discussed by [his] clearly audible internal voice."[21] This image of Sherman with the text-generating ping-pong balls embraces the cover of Peggy Gale's *Video by Artists*, and remains an iconic image — one that signals performance as a reproductive site for early video and situates Sherman as integral to video art's continued dominance in contemporary Canadian art.

In *Before and After the I-Bomb* (2002), referred to as a personal history of the late twentieth century, Sherman evidences his attachment to the medium of artist writing. Situating himself as a conceptual artist where his medium is language, rather than as an ethnographer, Sherman is nevertheless aware of the role of technology in contemporary life. With his lyrical and accessible style, Sherman invites us into the twenty-first century with unexpected clarity, allowing his readers to navigate an unprecedented collective metamorphosis of digital converts. The necessary transfiguration has been achieved through an inculcation of the public by way of the evangelical techniques assumed by media corporations. Our complicity in this conversion is revealed through the digital apparatuses that are scattered across our desks, our cars, even our beds. The sheer mass of writing Sherman has produced is awe-inspiring, not just due to the number of works, but also because of the consistency of his communications. For Peggy Gale, text-images works cut two ways as narrative literature and performative document.[22] Often adopting a mode of retrospective anticipation, Sherman has a tendency to view the present as past, and as the object of a future memory. According to literary theorist Mark Currie, there are three "time loci" to consider with fictional narrative: "the time locus of the narrative, the time locus of the narrator, the time locus of the reader."[23] Unlike in life, stories can anticipate or flash-forward to future events; they "can make an excursion into a future which is already in place" and be teleologically retrospective, looking back from an end point.[24] The future Sherman almost

20 Sherman, *Before and After the I-Bomb*, 144.
21 Sherman, *Before and After the I-Bomb*, 144.
22 Sherman, *Before and After the I-Bomb*, xi.
23 Mark Currie, *About Time: Narrative Fiction and the Philosophy of Time* (Edinburgh: University of Edinburgh Press, 2006), 31.
24 Currie, *About Time*, 33.

always evokes is the one described by writer William Gibson in a 1992 interview: "The future is already here — it's just not very evenly distributed."[25]

I would argue that, in Sherman's work, the three loci are each generated from the same point in time, with the exception of instances where the artist adopts an alter ego, such as Andrew Czeszak in "TBDF (Transborder Data Flow)" (1982) and the Remote Volunteer in "The Changing Workplace" (1997). The stories he gives us are stories about the future in the past, which are now our present. His texts are not quite fiction, although they might be considered a kind of autofiction.

Theodor W. Adorno argues for the essay form as fragmentary and all-encompassing, as "more open and more closed than traditional thought would like."[26] It does not proceed blindly and automatically, "but must reflect on itself at every moment."[27] Adorno's rendering of the essay suggests ways to think through Sherman's text-image works beyond the autofictional genre.

In his prologue to *Before and After the I-Bomb*, Sherman tells us — at the dawn of the twenty-first century — that "the book is intended to be an instrument for negotiating the dense cloud of scrambled technobabble that obscures this period of transition."[28] He then tells us he is "an artist perceiving the world through media."[29] This is his narrative locus, and it is unwavering and unapologetic. He continues to speak to us as an artist. His observations on technology, culture, media, and nature — regardless of how the locus of his narrative shifts — are all from an artist's position. His speech is emphatic, declarative, unquestioning of the state of our information economy; his sentences are short and intense, symptomatic of the collective anxiety wrought by the Sisyphean task of keeping up with technology's rate of change.

Sherman does offer a panacea to the technological tumult of this century. The living organisms with which we share our progressively fragile environment enchant him, and the art produced as a result of close looking, and being with them, reflects someone who has not only respect for the organisms he encounters but also acknowledges the responsive nature of those interactions. Sherman has consistently applied the scientific curiosity that originally drew him to electronic circuitry production equally to the biological world. In *Cultural Engineering* (1983), a book produced as part of a solo exhibition at the National Gallery of Canada in Ottawa, Sherman includes a range of texts on his encounters with his companion species. "The Wild

25 Gibson first said this in an interview with the *San Francisco Examiner*'s Scott Rosenberg in 1992.
26 Theodor W. Adorno, *Notes to Literature*, vol. 1. ed. Rolf Tiedemann, trans. Shierry Weber Nicholsen (New York: Columbia University Press, 1991), 17.
27 Adorno, *Notes to Literature*, 22.
28 Sherman, *Before and After the I-Bomb*, xiii.
29 Sherman, *Before and After the I-Bomb*, xiv.

Pigeon" (1974) is a story of the passenger pigeon's extinction, of the division between wild and domesticated animals, of experiences of a biodiverse past learned through a taxidermied present. In "My First Tape Recorder" (1974), Sherman creates a correlation between his first tape recorder — a "Knight KN-4110 (35DU806), Allied Radio Corp., 100 N. Western Ave." — and the cockroaches that are infesting his apartment. But even in this encounter with pestilence, he maintains a curiosity and scientific eye, providing us with information about the morphological differences between the German cockroach and the brown-banded cockroach. In "Watching the Final Cockroach Harassment" (1975), Sherman uses an impending pesticide incursion — to rid him of those same cockroaches — as an opportunity to reflect on his routinized life. He knows that, in spite of all the scientific methods for eradication and our attempts at protecting ourselves from wild beings, intentional or otherwise, nature persists.[30] The behaviour of ravens in response to the stress of living with military combat in Kosovo is described in "The Third Bird" (1999). Wild animals at the periphery of human engagement are examined with no more inquisitiveness than are animals we commonly live with. "3 Cat Stories" (1977) describes Sherman's cat at the time and her displeasure at having living ants in her milk, her illicit meetings with her boyfriend, and her handling of a cicada Sherman had lovingly brought home after it had attached itself to his shirt. In the present volume, he continues his close observation and recording of shorebird behaviour, jellyfish morphology, mollusc shell proliferation, wildflowers, deer eyesight, and the nature of multitudinous other species in text and photographic images. The environments that we inhabit are not complete without recognizing the flora and fauna within and throughout.

Donna Haraway has examined our relationships with animals as a primatologist and as a scientific philosopher closely allied with the animals with whom she cohabits. She has diligently critiqued contemporary theory and philosophy for taking a position that uses the animal as figure, as allegory, as opposed to the study of animals as an opportunity to "becom[e]-with" them.[31] In a critique of Jacques Derrida's 1997 long essay "The Animal That Therefore I Am (More to Follow)," Haraway suggests the philosopher's relationship with his cat was limited by his inability to see his cat as more than figurative; his pity for the animal and shame in front of it constrains his curiosity. She wonders why Derrida does not ask further questions about his cat's life. Haraway asks, "What if work and play, and not just pity, open up when the possibility of mutual response, without names, is taken seriously as an everyday practice available to philosophy and to science?"[32] Her own position of being open to the responsiveness of our animal companions, to pay attention to interspecies interactions leads to practices of "becoming with." Sherman's attention to the animals in his life, and his text-objects, and video art revealing those relationships to his audience, is remarkable. This work — and here I reference not only artwork but also labour — constitutes a significant

30 Sherman, *Before and After the I-Bomb*, 339.
31 Donna Haraway, *When Species Meet* (Minneapolis: University of Minnesota Press, 2008), 23.
32 Haraway, *When Species Meet*, 22.

contribution to the philosophical and scientific research on relationships between humans and animals being conducted in these respective fields as we all grapple with a planet in crisis.

Sherman's activist video work with fishers in Nova Scotia regarding the environmentally destructive consequences of open-pen Atlantic salmon aquaculture proves his commitment to the project of video as a means of conveying the truth of a situation. As he has informed us, "video is like an X-ray technology. It sees through fiction."[33] The videos *The Word from Port Mouton Bay #1: Bob Swim Speaks — Justin Huston Listens* (2010), *The Word from Port Mouton Bay #2: Clyde Fisher Speaks about Lobster Behaviour* (2011), *CoastalCURA Visits Port Mouton Bay* (2011), and *Michael Swim's Catch* (2011) comprise a suite documenting the vulnerability of the independent fishing industry in the coastal waters of Nova Scotia, the collective loss of income for folks who make their living this way, and the effects of industrial fishing on coastal ecosystems. Sherman works with these communities in peril in much the same way he documents his relationships with non-human animals: with care and compassion. Rather than solely a witness to these events, Sherman is a "with-ness," one who is embedded within the action rather than only recording it.[34] His cognizance of the reciprocal relationships between human and non-human animals informs and enables the trusting relationships he has built with the fishing community, but it is his virtuosity with his tools of representation, in this case video, that guarantee dissemination of his intended message.

In 2012, the Centre for Art Tapes in Halifax commissioned an essay from Sherman to accompany a screening of his work at the Halifax Independent Filmmakers Festival. Titled "Video Is a Perceptual Prosthetic," the text tracks the history of video as it intertwines with our consciousness and as it adapts to digital interventions in culture. Sherman's belief in video as an extension of our bodies is borne out in this statement: "Video 'sees' and 'hears' the way we do as a species, engaging the senses of sight and hearing, describing actions and environments in visual and acoustic space simultaneously, in real time, in the exact same time it takes things to happen outside the domain of video."[35] Sherman's comprehension of the total integration of video in contemporary human nature is underpinned in "Primary Devices: Artists' Strategic Use of Video, Computers and Telecommunications Networks" (1991) and "Vernacular Video" (2007/2008) in this volume. His full, lifelong embrace of the video medium is responsible for the observational veracity and perceptual wholeness of his work across media. Despite, or perhaps because of, the ubiquity of moving-image technology — from snapchats to IMAX 3-D films — Sherman maintains video is a medium with incredible staying power for artists. It was this implicit belief that led him, between 1981 and 1987, to create the necessary infrastructure for video art at the Canada Council for the Arts, where he established the Media Arts Section, and also why he was chosen to represent Canada in the 1980 Venice Biennale.

33 *Cinematic Video*, n.p.
34 See Haraway, *When Species Meet*, 308, n. 19.
35 Tom Sherman, essay commissioned by the Centre for Art Tapes, 2012.

In closing, I evoke Karen Barad and their observation that "all real living is meeting. And each meeting matters."[36] In *Meeting the Universe Halfway*, Barad notes that "phenomena — whether lizards, electrons, humans — exist only as a result of, or as part of, the world's ongoing intra-activity, its dynamic and contingent differentiation into specific relationalities."[37] According to Barad, "intra-acting" comes from the entwining of theoretical and experimental practices. The scientific and media instruments we have developed provide data, and information, to which we would not otherwise have access. For Sherman, there is no distinction between the video camera and himself: the camera hears and sees the way we do, "as a species."[38] The entanglements that occur between humans, animals, and machines in Sherman's work and life are authentic, not sentimental or fetishistic. When Sherman asserts that "video engages the two primary 'windows' of our sensorium and also resonates with our senses of time and balance,"[39] he acknowledges the intra-action vital to video's power. For Barad, it is the advances in which we participate that bring forth "the world in all its specificities including ourselves."[40] For Sherman, "video seems very real, indeed."[41] It is a means to bring forth the world, to reflect our co-evolved lives of machine–human, human–human, and animal–human interactions back to us. In *Talking to Nature* (2002), Sherman writes/speaks through video: "Nature is a tough audience. It will listen to anything you want to say, and then there will be nothing but silence, unless you learn to read the signs. Nature speaks through sign language. Once you crack the code, you'll find that nature has a lot to say."[42] There is an obvious symmetry between the codes one finds in nature and the codes embedded in digital technologies. Sherman has cracked these codes, and his work is there to show us how to do the same.

36 Karen Barad, *Meeting the Universe Halfway: Quantum Physics and the Entanglement of Matter and Meaning* (Durham: Duke University Press, 2007), 353.
37 Barad, *Meeting the Universe Halfway*, 353.
38 Sherman, Centre for Art Tapes, 2012.
39 Sherman, Centre for Art Tapes, 2012.
40 Barad, *Meeting the Universe Halfway*, 353.
41 Sherman, Centre for Art Tapes, 2012.
42 Sherman, *Before and After the I-Bomb*, 361.

CHRONOLOGY

TOM SHERMAN

The following chronology of Tom Sherman's exhibitions, publications, performances, and broadcasts is distilled from hundreds of public displays of the artist's work. The public events noted are chosen because of their importance of venue, time, and audience and the content and relative value of specific works made public over five decades. This comprehensive chronology also includes positions Sherman has held in multiple organizations, and personal notes.

Tom Sherman was born in Manistee, Michigan, on August 5, 1947.

In 1970, Sherman completes his Bachelor of Fine Arts degree at Eastern Michigan University in Ypsilanti, Michigan, majoring in sculpture. He is hired as an adjunct instructor in the Department of Art at EMU to teach drawing.

In December 1970, Sherman makes his first video work, a recording of *Hyperventilation*, a performance in which he hyperventilates radically until he passes out.

In October 1971, Sherman emigrates from Michigan to Toronto and begins to establish himself as an artist in Toronto at A Space, one of the first artist-run centres in Canada.

In February 1972, he becomes a Canadian landed immigrant and begins working on staff at A Space, Toronto, becoming video access coordinator along with Lisa Steele. In spring 1972, he publishes *Hall/Room*, a text-image work in BeauxArts, Montréal. Andrew Lugg's 16 mm film *Trace*, a document of Sherman's Hyperventilation performance, is released, 1972.

In 1973, Sherman exhibits *Sound Sculptures* at the Electric Gallery, Toronto; audio works at Canada trajectoires 73, Musée d'art moderne de la ville de Paris; and *Faraday Cage* at A Space.

In 1974, he exhibits *Text Works* at A Space; text panels in *In Pursuit of Contemporary Art*; and video in *Videoscape*, Art Gallery of Ontario (AGO), Toronto. He publishes *The Art Style Computer Processing System*, in *Journal for the Communication of Advanced Television Studies*, London, England, fall edition.

In 1975, Sherman publishes *This Message Is About the Condition of Your Body* in the "Glamour" issue of *FILE* magazine, Toronto; he, Colin Campbell, and Lisa Steele perform three of Sherman's texts in *Text as Performance* at Art Metropole (AM).

In 1976, he provides the cover image and introduction to *Video by Artists*, AM. He collaborates with filmmaker Andrew Lugg on *Exceptional Moment A*, a 16 mm film where Sherman's texts appear as film subtitles to Lugg's visualizations of Sherman's texts. *Exceptional Moment A* is premiered at the Ann Arbor Film Festival and tours extensively, including screenings at Theatre Vanguard, Los Angeles; Canyon Cinema, San Francisco; and the Walker Art Center, Minneapolis.

Between 1976 and 1978, Sherman works at TVOntario, on the programs *Afterimage*, *Nightmusic*, and *Nightmusic Concerts*, producing music videos weekly and other video features (including General Idea's *Pilot*), functioning as co-producer, visual coordinator, graphics designer, assistant editor, assistant director.

In 1977, Sherman produces *Theoretical Television* and *Television's Human Nature*, 28-min. television artworks with production assistance and distribution through Roger's Cable 10, Toronto. He stages performance artworks at Optica, Montréal, and Alternative Space, Detroit. He publishes "Detroit Poison" in *Detroit Artists Monthly*; "My First Tape Recorder," in 03 23 03, Institut d'art contemporain de Montréal; "Is Scientific Thought Outrunning Common Sense?" and "They Introduced Me to My Homunculus," in *Only Paper Today*; "Writing," in *FILE*; "*Promise Me Warmer Weather*, *ABCDE*, in *Art Communication Edition*, Centre for Experimental Art and Communication; *In the Windows 24/7*, Cinema Lumiere; and *Writing from the Photographs of Lynne Cohen and Rodney Werden*, Cinema Lumiere, Toronto. His video is featured in *Another Dimension: Recent Video Works*, National Gallery of Canada, Ottawa; and *In Video*, Dalhousie University Art Centre, Halifax.

In 1978, he publishes an artist's book, *3 Death Stories*, AM; and another book in tabloid form, *Animal Magnetism* (in *Only Paper Today*). Sherman mounts an exhibition, *1 Traditional Methodology for Processing Information* (under the influence of Brian Molyneaux and Jay Yager), at the Metropolitan Toronto Library (now the Toronto Reference Library), a special project of the AGO. This exhibition also includes a tabloid catalogue under the same title and a performance at the AGO. He makes performances at AM; Gallery 7, Detroit; and the Teleperformance festival,

Fifth Network-Cinquième Réseau, Toronto. Sherman joins Clive Robertson, becoming an editor and regular contributor of *Centerfold* magazine, Toronto. He makes *Envisioner, Individual Release*, and *East on the 401* at a video production residency at the Western Front, Vancouver.

In the summer of 1979, Sherman becomes romantically involved with Jan Pottie of Liverpool, Nova Scotia, becoming her lifelong partner and husband. *Centerfold* evolves into *Fuse* magazine, Toronto, edited by Sherman, Clive Robertson, and Lisa Steele.

In 1979–1980, he is a Visiting Professor, Studio Arts, Nova Scotia College of Art and Design, Halifax. Sherman represents Canada at the 1980 Venice Biennale along with Pierre Falardeau and Julien Poulin, General Idea, Colin Campbell, and Lisa Steele in the exhibition *Canada Video*, curated by Bruce W. Ferguson. He produces *TVideo* for *Television by Artists*, A Space/Fine Arts Broadcast Service, Toronto; and *Transvideo* for cable television distribution.

In 1981, he works for TVOntario, researching and writing *Fast Forward*, a program on how digital technologies would affect various sectors of society, Toronto. Sherman later becomes Video Officer, Canada Council for the Arts, Ottawa, from 1981 to 1983. He publishes regularly in *Fuse, Impulse*, and *Parachute*. He has a solo exhibition titled *Un aspect différent de la télévision*, Musée d'art contemporain, Montréal, 1982. He co-authors *Banff Information Base* with Jan Pottie, the Banff Centre, 1982.

Sherman has a ten-year retrospective exhibition of his text-image and video art at the National Gallery of Canada titled *Cultural Engineering*, Ottawa, 1983, curated by Willard Holmes. The exhibition is accompanied by the publication *Tom Sherman: Cultural Engineering*, edited by Holmes, featuring forty-four of Sherman's text works. He becomes founding head of Media Arts section of the Canada Council for the Arts, Ottawa, 1983–1987. The Media Arts section includes funding for computer-integrated media, as well as film, video, audio, and holography. In 1983, he has an exhibit, *Physics, Control, Behaviour*, at the Museum of Modern Art, New York, and has work included in *From Object to Reference*, at the Lamanna Gallery, Toronto.

In 1984, Jan Pottie gives birth to their daughter, Yolande Pottie-Sherman.

In 1986, Sherman is appointed an International Commissioner, with Roy Ascott, Don Foresta, and Tommaso Trini for *Ubiqua: Art, Technology and Informatics*, a major art and telematics show at the 1986 Venice Biennale. He publishes "Amare la Macchina e Naturale" ("Machine Love is Natural") and "With Respect to Audience," in the 1986 Venice Biennale catalogue; "Appearance, Memory and Influence" and "Message to Electro Culture" in *Video by Artists 2*, AM.

In 1987, he leaves the Canada Council and exhibits ideogrammatic paintings, *Sleeping Robots*, at Galerie René Blouin, Montréal. Sherman produces *Exclusive Memory*, a multimedia, multi-channel installation, featuring a six-hour recorded monologue (experience transfers) directed to an intelligent artifact during a residency at the Western Front, Vancouver. Three hours of the six-hour monologue are never exhibited and remain exclusive memory between Sherman and his artificially intelligent machine.

In 1987, *Robot Errors* (paintings) and *Primary Devices* (text) are exhibited in *Siting Technology*, the Banff Centre.

In 1989, he exhibits *Exclusive Memory* at the Vancouver Art Gallery and YYZ, Toronto. He is appointed Acting Director of the Centre for Image/Sound Research, Simon Fraser University, 1989–1990. The centre is a non-profit, pre-competitive research organization for support of digital technologies in the arts, funded primarily by the Department of Communications, Government of Canada. He exhibits *Equidistant Relationships*, a two-channel video installation, in *Electronic Landscapes*, National Gallery of Canada, 1989. He has a solo exhibition of ideogrammatic wall works, *Digital Hearts* and *Mr. Boole's Lips* and multiple tape-drawings at Galerie René Blouin, Montréal, 1990.

Sherman is commissioned to design the Abbey Station's interior of Ottawa's Transitway. His full-station mural, *Accelerator/Decelerator*, based on his sleeping robot imagery, opens in 1991. Sherman is appointed Director of the School of Art, College of Visual and Performing Arts, Syracuse University, New York, 1991–1997. He becomes a citizen of Canada in Halifax, Nova Scotia, 1991. He publishes "Primary Devices: Artists' Strategies for Using Video, Computers and Telecommunications Networks," in the *Connectivity: Art and Interactive Telecommunications* issue of *Leonardo*, 1991.

In 1992–1994, an excerpt of *Exclusive Memory* (#8) is featured in a touring video show titled *Video and Orality*, National Gallery of Canada. Sherman begins a sustained radio presence in Austria with his *Kunstradio Monologues*, eleven late-night monologues over eleven weeks, wrapping up each Sunday night with thoughts on the rapid expansion of the videosphere: "Television is the history of video; The future of video is something that will produce frameless images; To be of value in the information age a work of art must be loaded with information," Austrian Broadcasting Corporation (ORF), Vienna, 1993.

In 1994, he makes *Cyber Cerbere*, an electroacoustic text/sound composition produced in collaboration with Jean Piché, which premieres at *ACREQ 94*, McGill University, Montréal.

In 1995, he performs and broadcasts *Tweak* and *WordWatch* in collaboration with Heidi Grundmann, Kunstradio, Vienna.

In 1996, Sherman performs and broadcasts *To Be of Value in the Information Age* on *Kunstradio* with Bernhard Loibner, the Viennese musician, composer, and media artist. He participates in *Tool2.0b*, Urban Exile, Sydney, Australia, making *SUBVERTICAL ORG*, a World Wide Web installation with Cary Pepperment.

In 1997, he publishes three *Remote Volunteer* texts and performs in a live remote teleperformance with Norbert Math, Sergio Messina, and Ludwig Zeininger to a live audience in Kassel and live on ORF-1 and FRK-Freies Radio Kassel, at *documenta X*, Kassel, Germany. He moderates "FleshFactor Net Symposium," an open, online six-month net symposium, Ars Electronica, Linz, Austria. He makes *Personal Human*, an audio CD with Sherman and Bernhard Loibner/writing/voice and Jean Piché/music, co-produced by Kunstradio-Vienna and Ars Electronica-Linz. He writes, records, and broadcasts *Nature is Perverse Sometimes*, version 4, with Sergio Messina, produced by Sender Freies Berlin (SFB), Germany. He takes part in *Recycling the Future IV/Kunstradio*, doing live radio performances: *DirectnEdgy* with Sergio Messina, Milan; and Suggested Sway and *Blanking* with Bernhard Loibner, Vienna, broadcast on ORF-4 and simultaneously webcast/video and audio. Sherman steps down as director of the School of Art and Design at Syracuse University and becomes a professor, teaching video art and media art history in the Department of Art Media Studies and later Transmedia.

In 1998, Sherman and Bernhard Loibner establish Nerve Theory as their collaborative identity. Nerve Theory performs *Shades of Catatonia* as part of *INFOWAR*, the Ars Electronica Festival, in Linz, Austria.

In 1999, he exhibits *Thoughts from the Antechamber: Tom Sherman's Video and Audio*, at the Antechamber, Regina, Saskatchewan.

In 2000, Nerve Theory performs *Shades of Catatonia*, version IP-2000, at Void in New York, New York, and at Rensselaer Polytechnic Institute in Troy, New York. Nerve Theory broadcasts *Wir wollen die Gedanken der Anderen lesen* (*People Want to Know What Other People Are Thinking*), at Sender Freies Berlin (SFB), Berlin, Germany.

In 2001, Sherman and Loibner as Nerve Theory perform "The Disconnection Machine" at the W. Carroll Coyne Performing Arts Center, Le Moyne College, Syracuse, New York, and at Elektra, Montréal.

Between 2001 and 2008, Sherman makes twenty-seven single-channel digital video works covering a broad range of subject matter. These video titles include his *Sub-Extros* (subversive extroverts) series on early online vernacular video communication, and *Half/Lives*, an example of the perils of such a migration into full mediation in 2001. *His Talking to Nature* (2002), opens up an extensive series of video titles that examine human nature in dialogue with the living environment, including biodiversity (sharks, mosquitoes, spiders, pheasants, etc.), and always involving descriptive language adapting to image and sound, his kind of literary conceptualism. During this period, he shows video widely across Canada, the United States, Brazil, and throughout Europe. Sherman receives the Bell Canada Award for Excellence in Video Art, Toronto, 2003.

In 2002, Sherman appears in *Corpus Callosum*, a feature film by Michael Snow (92 min.) as one of the tall male leads. He publishes *Before and After the I-Bomb: An Artist in the Information Environment*, edited by Peggy Gale, Banff Centre Press, an anthology of more than fifty of his texts, a millennial book of techno-cultural criticism detailing the transition to the twenty-first century.

In 2005, Nerve Theory premieres a performance of *Remote Possibilities* at the Generator, Wiener Konzerthaus, in Vienna, Austria; Sherman's essay "Video 2005: Three Texts on Video by Tom Sherman" is published by *Canadian Art*, spring edition; a program of seventeen of his video works, *Lines of Thought: Video Art by Tom Sherman*, is featured at Festival international du film sur l'art at the Musée d'art contemporain de Montréal; and his *Off-Kilter Series*, is exhibited at Canada House, London, United Kingdom.

In 2006, he and Bernhard Loibner are commissioned to record and broadcast a major Nerve Theory radio work, *H5N1: there is no privacy at the speed of light*, a thirty-seven week artists' broadcast news series on Kunstradio, Austrian National Radio, ORF, Vienna. Nerve Theory predicts a deadly pandemic of the bird flu, does the research describing the influenza pandemic in detail and spotlighting the shift from surveillance of microbial infections to a full-blown global surveillance culture, including socio-economic consequences and changes to all sectors of society. Fortunately, the H5N1 pandemic did not materialize in 2006, but as terrifying radio, Nerve Theory hits a number of nerves.

From 2006 to 2010, Sherman's video work tours extensively with *Analogue: Pioneering Video from the UK, Canada and Poland* (1968–88). And with Clive Robertson's *Then + Then Again: Practices within an artist-run culture 1969–2006*, from 2007 to 2011. A CD by Nerve Theory, *H5N1: there is no privacy at the speed of light*, is published for the exhibition by Voicespondence, Kingston, Ontario, 2007, and a live performance of Nerve Theory's *H5N1* is launched at the Palace Theater, Hamilton, New York the same year.

In 2008, Sherman publishes "The Nine Lives of Video Art" in GAMA (Gateway to Archives of Media Art), Amsterdam, Netherlands; "Vernacular Video," in *Video Vortex Reader*, Institute for Network Cultures, Amsterdam; and "Enduring Messaging: Are Microcommunications an Art Form?" in *Canadian Art*, Toronto.

In 2009, *Trace* (1972), Andrew Lugg's film of Sherman's *Hyperventilation* performance is featured at *Nuit Blanche, Fall In*, University of Toronto; and *Fall Out*, Blackwood Gallery, Mississauga, Ontario.

In 2010, Sherman receives the Governor General's Award in Visual and Media Arts in Ottawa. He exhibits in *Beyond/In Western New York*, Hallwalls Contemporary Arts Center, Buffalo; *Constellations & Correspondences: Networking Between Artists, 1970–1980*, National Gallery and Library and Archives Canada, Ottawa; and *Sorting Daemons: Art, Surveillance Regimes and Social Control*, Agnes Etherington Art Centre, Kingston, Ontario.

Between 2010 and 2013, Sherman exhibits in *Human + The Future of the Species* with Bernhard Loibner, Science Gallery, Trinity College, Dublin, Ireland; and in *Traffic: Conceptual Art in Canada 1965 to 1980*, at Vancouver Art Gallery; Leonard & Bina Ellen Art Gallery, Concordia University, Montréal; Art Gallery of Alberta, Edmonton; Dalhousie Art Gallery, Halifax; University of Toronto Art Galleries; and Badischer Kunstverein, Karlsruhe, Germany. He shows *Alley 9*, Foreman Art Gallery of Bishop's University, Sherbrooke, Quebec; T*om Sherman: Alley 9 and Michael Swim's Catch*, Art Gallery of Nova Scotia Western Branch, Yarmouth (*Alley 9* begins a series of video works made with Jan Pottie on karaoke as an interactive, "professional amateur" music form); *Nerve Theory: Always Nice to be Recognized*, Kunstradio, ORF, Vienna; and *Tom Sherman: Meditation on Video (&) Language*, Point of Contact Gallery, Syracuse, New York, 2012. In 2013, Sherman exhibits in *Biomediations: Art, Life, Media Symposium*, Goldsmiths, University of London, United Kingdom; *Portraits in Time*, Vancouver Art Gallery; *Transitio_MX*, Mexico City, Mexico; *Electric Visions: How DADA and Surrealism anticipated the Later Avant-Garde*, Ryerson University and the University of Ontario Institute of Technology, Toronto.

In 2014, Sherman exhibits *Everything for Someone*, Videographe, Montréal; and in *Is Toronto Burning? 1977/1978/1979: Three Years in the Making (and Unmaking) of the Toronto Art Scene*, York University Art Gallery, Toronto.

Between 2015 and 2019, he contributes to and exhibits in Lorna Mills's *Ways of Something*, at SAW Video, Ottawa; Western Front Gallery, Vancouver; Photographer's Gallery, London, United Kingdom; Art Athina, Athens, Greece; Carnegie Museum of Art, Pittsburgh, Pennsylvania; and in *Transfer/Spring Show*, The Stalls, Skylight ROW DTLA, Los Angeles,

and multiple other venues. He performs at *City as Classroom: The Invisible Village: Where is our cultural memory?*, McLuhan Centre for Art and Technology, University of Toronto; and *Radioradio* (a collaboration with Sergio Messina of Sherman's original song "Heading into the Summer of Hate"), Kunstradio, ORF, Vienna; and he publishes a reflection on *Cultural Engineering* (1983) in "Cultural Engineering," SAW Gallery/SAW Video, Ottawa, 2016. His texts on artists and networks are published in *Information: Documents of Contemporary Art*, Whitechapel Gallery and MIT Press, 2016.

His machine-vision video installation, *Learning to see the laboratory where the robot is programmed to work*, is featured at *All Watched Over by Machines of Loving Grace*, NEoN Festival/Hannah MacLure Centre, University of Abertay, Dundee, Scotland, 2016–2017; and *Automata: Art Made by Machines for Machines*, 3rd International Digital Art Biennial, Arsenal art contemporain / Arsenal Contemporary Art, Montréal, 2016. His video is shown in *Dreamlands: Immersive Cinema and Art, 1905–2016* in *Ways of Something*, Whitney Museum of American Art, New York; *Intangible Expedition*, no. 32, Beijigesantiao, Dongdan, Beijing, China; and *Toronto: Tributes and Tributaries, 1971–1989*, AGO, Toronto, 2017.

In 2017, Sherman publishes "Is the Imagination Analog or Digital?" in *Millennium Film Journal* 65, Millennium Film Workshop, New York; and related text-image works in "Spatial Collapse," *Prefix 35*, Toronto. He screens video work at Anthology Film Archives, New York; and an audio version by Nerve Theory of *Is the Imagination Analog or Digital?* is broadcast on Kunstradio, ORF, Vienna, Austria. In 2018, his video and performance are featured at *Being with Tom Sherman*, Vtape, Toronto.

In 2019, he shows in *Plasticity of the Planet/Toward a Humanless Earth*, Ujazdowski Castle Centre for Contemporary Art, Warsaw, Poland; and *Eschatological Autopsy: The Act of Seeing the End of the World with One's Own Eyes*, Vector Festival, Toronto; Video in America, Everson Museum of Art, Syracuse, NY; and as Nerve Theory in *Electric Cars and Electric Guitars*, a site-specific 8-channel audio installation is exhibited at TONSPUR Kunstverein Wien, MuseumsQuartier, Vienna, Austria.

In 2020, Kunstradio rebroadcasts Nerve Theory's *H5N1: There is no privacy at the speed of light* (2006), contextualizing the earlier pandemic work in the COVID-19 pandemic on Kunstsonntag and Kunstradio-Radiokunst, Austrian National Radio, ORF; and Nerve Theory's *Electric Cars and Electric Guitars*, full-hour radio broadcast marking the global transition from internal combustion engines to autonomous electric vehicles in a literary, musical sonic speculation, broadcast on Kunstradio-Radiokunst, Austrian National Radio, ORF, originating in Vienna, Austria.

INDEX

Page references in bold denote a reproduction. Page references in italic refer to footnotes.

CONTRIBUTORS

David Diviney is the senior curator at the Art Gallery of Nova Scotia in Halifax. He has practised as an independent curator and held positions at the Southern Alberta Art Gallery and Eye Level Gallery. An interest in conceptual art has led to such exhibition projects as *David Askevold: Once Upon a Time in the East* (2011), a career retrospective that opened at the National Gallery of Canada before travelling to other venues. He curated *The Last Art College: Nova Scotia College of Art and Design, 1968–1978* (2016), featuring the work of sixty-four artists from across North America and Europe. Diviney's writing has been published widely in journals and exhibition catalogues. He recently edited *Close to the edge . . . The Work of Gerald Ferguson: Collected Writings and Statements* (Halifax: AGNS, 2018).

Peggy Gale is a Toronto-based independent curator and critic specializing in media-related and time-based works by contemporary artists. Her curated exhibitions include *Videoscape*, AGO (1974–75); *OKanada*, Akademie der Künste, Berlin (1982–83); *Northern Lights*, Canadian Embassy, Tokyo (1991); *Tout le temps / Every Time*, La Biennale de Montréal (2000); and *L'avenir (looking forward)* for BNLMTL 2014. She edited three of Art Metropole's *By Artists* series (1976, 1979, 1983) and, with Lisa Steele, co-edited *Video re/View: The (best) Source for Critical Writings on Canadian Artists' Video* (1996). Her *Videotexts* book was published by Wilfrid Laurier University Press (1995) and *Artists Talk 1969–1977* by The Press of the Nova Scotia College of Art and Design (2004). Gale received the Governor General's Award in Visual and Media Arts in 2006, and in 2020, she was named to the University of Toronto's University College "Alumni of Influence" list.

Caroline Seck Langill is a writer and curator whose academic scholarship and curatorial work looks at the intersections between art and science, as well as the related fields of new media art history, criticism, and preservation. Her interests in non-canonical art histories have led her to writing and exhibition-making that challenges disciplinary constraints. Her recent publication, *Curating Lively Objects: Exhibitions Beyond Disciplines* (2022), co-edited with Dr. Lizzie Muller, is the result of SSHRC-funded research that looked at alternate forms of curatorial practice. Langill holds an MFA from York University, and a PhD in Canadian Studies from Trent University. Currently, she is in the position of Vice-President Academic and Provost at OCAD University in Toronto.

Edited by Ray Cronin and Charles Simard.
Copy edited by Paula Sarson.
Cover and page design by Amy Batchelor.
On the cover: Still from *Exclusive Memory*, the video performance, segment no. 19, recorded by Tom Sherman at the Western Front, Vancouver, 1987. Camera by Kate Craig.
Printed in Canada by Marquis Book Printing.
10 9 8 7 6 5 4 3 2 1

Library and Archives Canada Cataloguing in Publication

Title: Exclusive memory : a perceptual history of the future / Tom Sherman ; edited by David Diviney.
Names: Sherman, Tom, 1947- author, artist. | Diviney, David, editor.
Description: Includes bibliographical references and index.
Identifiers: Canadiana 20220415811 | ISBN 9781773103006 (softcover)
Subjects: LCSH: Sherman, Tom, 1947- | LCSH: Video art—Ontario—Toronto. | LCSH: Art and technology. | LCSH: Art, Canadian—20th century. | LCSH: Art, Canadian—21st century.
Classification: LCC N6494.V53 S546 2023 | DDC 709.2—dc23

Goose Lane Editions acknowledges the generous support of the Government of Canada, the Canada Council for the Arts, and the Government of New Brunswick.

Goose Lane Editions is located on the unceded territory of the Wəlastəkwiyik whose ancestors along with the Mi'kmaq and Peskotomuhkati Nations signed Peace and Friendship Treaties with the British Crown in the 1700s.

The Art Gallery of Nova Scotia stands on Mi'kma'ki (Mi'kmaq Territory) and supports arts, culture, and education on this land. We strive for meaningful partnerships with all the peoples of this province as we continue to live and learn in Kjipuktuk (Halifax). Through the Peace and Friendship Treaties, which the Mi'kmaq, Wolastoqiyik (Maliseet), and Passamaquoddy Peoples first signed with the British Crown in 1725-1726, there was no surrender of lands nor resources. Agreements within these Treaties outline a path for the ongoing relationship between Nations in mutual respect.

Art Metropole operates principally from the city of Toronto, situated on the traditional territory of the Anishinaabe, Haudenosaunee, Huron-wendat (Wyandot) and Mississaugas of the Credit. We are grateful to be here and reverent to over 12,000 years of human activity and stewardship in these lands.

Goose Lane Editions
500 Beaverbrook Court, Suite 330
Fredericton, New Brunswick
CANADA E3B 5X4
gooselane.com

Art Gallery of Nova Scotia
1723 Hollis St
Halifax, Nova Scotia
CANADA B3J 1V9
agns.ca

Art Metropole
896 College St
Toronto, Ontario
CANADA M6H 1A4
artmetropole.com

MIX
Paper from responsible sources
FSC
www.fsc.org
FSC® C103567